MOCTEZUMA
AZTEC
RULER

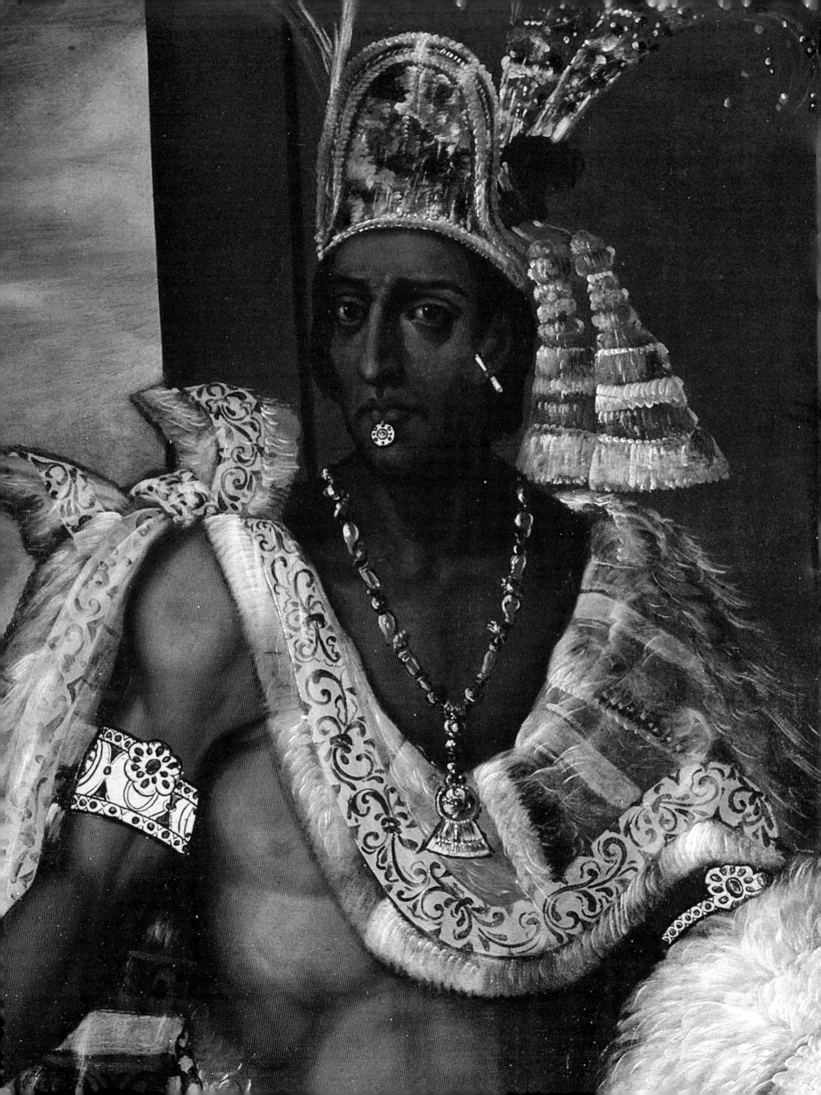

MOCTEZUMA

AZTEC RULER

In memory of Felipe Solís Olguín

This book is published to accompany the exhibition at the
British Museum from 24 September 2009 to 24 January 2010.

The exhibition is supported by ArcelorMittal.

Additional support for the exhibition has been given by
the airline partner Mexicana.

First published in 2009 by The British Museum Press
A division of The British Museum Company Ltd
38 Russell Square, London WC1B 3QQ

A catalogue record for this book is available from the
British Library

ISBN (cased) 978-0-7141-2586-2
ISBN (paperback) 978-0-7141-2585-5

Designed by Price Watkins
Copyedited by Kate Bell
Translation by First Edition and Univerba

Printed in Italy

Half title: Moctezuma's name glyph from the Codex Mendoza (detail of fig. 52)
Frontispiece: portrait of Moctezuma (detail of cat. 130)
Opposite: tripod plate (see cat. 55)
p. 9: Moctezuma travels to meet Cortés (detail of cat. 111).

Contents

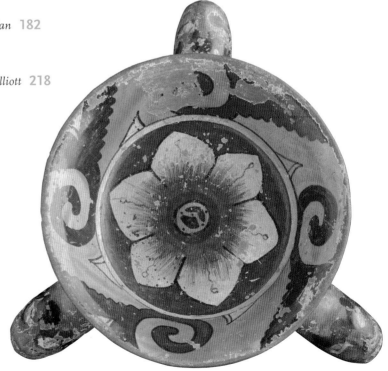

Editors and contributors

Philip Attwood [PA]
Curator of Medals, Department of Coins and Medals,
 British Museum, UK

Miguel Báez [BA]
Project Coordinator, Coordinación Nacional de Museos
 y Exposiciones (INAH), Mexico

Ximena Chávez Balderas [XCB]
Senior Archaeologist, Proyecto Templo Mayor (INAH),
 Mexico

Frances F. Berdan [FB]
Department of Anthropology, California State University
 San Bernardino, USA

David A. Brading [DB]
Reader in Latin American History, University of
 Cambridge, UK

John H. Elliott [JHE]
Professor of History, Oxford University, UK

Maria Concepción García Sáiz [MCGS]
Director, Museo de América, Madrid, Spain

Carlos Javier González González [CJGG]
Director, Museo del Templo Mayor, (INAH), Mexico

Patrick Thomas Hajovsky [PTH]
Assistant Professor, Department of Art and Art History,
 Sarofim School of Fine Arts, Southwestern University,
 Georgetown, Texas, USA

Leonardo López Luján [LLL]
Director, Proyecto Templo Mayor (INAH), Mexico

Colin McEwan [CM]
Head of the Americas Section, Department of Africa,
 Oceania and the Americas, British Museum, UK

Eduardo Matos Moctezuma [EMM]
Emeritus Professor, Museo Templo Mayor (INAH),
 Mexico

David Morales Gómez [CMG]
Director, Museo Baluarte de Santiago (INAH), Mexico

Guilhem Olivier [GO]
Senior Researcher, Instituto de Investigaciones
 Históricas, Universidad Nacional Autónoma de
 México, Mexico

Salvador Rueda Smithers [SRS]
Director, Museo Nacional de Historia (INAH), Mexico

Ethelia Ruiz Medrano [ERM]
Senior Researcher, Dirección de Estudios Históricos
 (INAH), Mexico

Felipe Solís Olguín [FSO]
Late Director, Museo Nacional de Antropología (INAH),
 Mexico

Richard F. Townsend [RFT]
Chairman, Department of African and Amerindian Art,
 The Art Institute of Chicago, USA

Roberto Velasco Alonso [RVA]
Chief of Loans Department, Museo Nacional de
 Antropología (INAH), Mexico

Elisenda Vila Llonch [EVLL]
Assistant curator, Department of Africa, Oceania and
 the Americas, British Museum, UK

Eleanor Wake [EW]
Lecturer in Latin American Cultural Studies,
 Department of Iberian and Latin American Studies,
 Birkbeck College, University of London, UK

Lenders

Apart from the British Museum, the objects exhibited have been kindly loaned by a number of public collections and institutions. The British Museum would like to thank all the lenders for their generosity.

Austria
Museum für Völkerkunde, Vienna

France
Bibliothèque Nationale de France, Paris
Bibliothèque de l'Assemblée nationale de France, Paris
Musée du Quai Branly, Paris

Germany
Museum für Völkerkunde Hamburg
Staatliche Museen zu Berlin, Preussischer Kutterbesitz, Ethnologisches Museum, Berlin

Italy
Museo degli Argenti, Galleria degli Uffizi, Florence
Museo Nazionale Preistorico ed Etnografico 'Luigi Pigorini', Rome

Mexico
Biblioteca Nacional de Antropología e Historia, Mexico City, CONACULTA–INAH
Dirección de Salvamento Arqueológico, Mexico City, CONACULTA–INAH
Instituto Mexiquense de Cultura, Toluca de Lerdo
Museo de Antropología e Historia, Estado de México
Museo Baluarte de Santiago, Puerto de Veracruz, CONACULTA–INAH
Fundación Televisa, Mexico City
Collección Familia Maillé
Museo Nacional de Antropología, Mexico City, CONACULTA–INAH
Museo Nacional de Historia, Castillo de Chapultepec, Mexico City, CONACULTA–INAH
Museo Nacional del Virreinato, Tepotzotlan, CONACULTA–INAH
Museo Regional Cuaunáhuac, Morelos, CONACULTA–INAH
Museo del Templo Mayor, Mexico City, CONACULTA–INAH

Spain
Biblioteca Nacional de España, Madrid
Museo de América, Madrid
Museo del Prado, Madrid

UK
The British Library, London
Bodleian Library, University of Oxford
University of Glasgow, Library

USA
The Art Institute of Chicago
Brooklyn Museum, New York
Dumbarton Oaks Research Library and Collection, Washington DC

Foreword

It only takes a moment to realise that business cannot be conducted in isolation from society. Commercial enterprise is such an integral part of modern life that to consider them separately is to miss the point, which is that businesses exist not only for their shareholders, but also for the societies in which they operate. It follows then that businesses have to be involved in society and culture not just through a sense of duty, although that is important, but also because by investing in society they invest in their own people.

These are the reasons why ArcelorMittal has, does and will continue to support a broad range of societal activity – even in these difficult times. And they are the reasons why I am so pleased that ArcelorMittal has the opportunity to support this fascinating exhibition, presented in one of the world's finest museums.

We are additionally delighted to be able to help with this event because of our strong links with Mexico, Moctezuma's country. Mexico has a special place in my heart – it was there that we completed our first full international acquisition – and I have many happy memories of the country. Now, we are Mexico's largest steel producer, with a real stake in the country's continued development and success.

I am sure that this exhibition will bring about a deeper understanding of the history of this great country.

Lakshmi N. Mittal
Chairman and CEO

ArcelorMittal

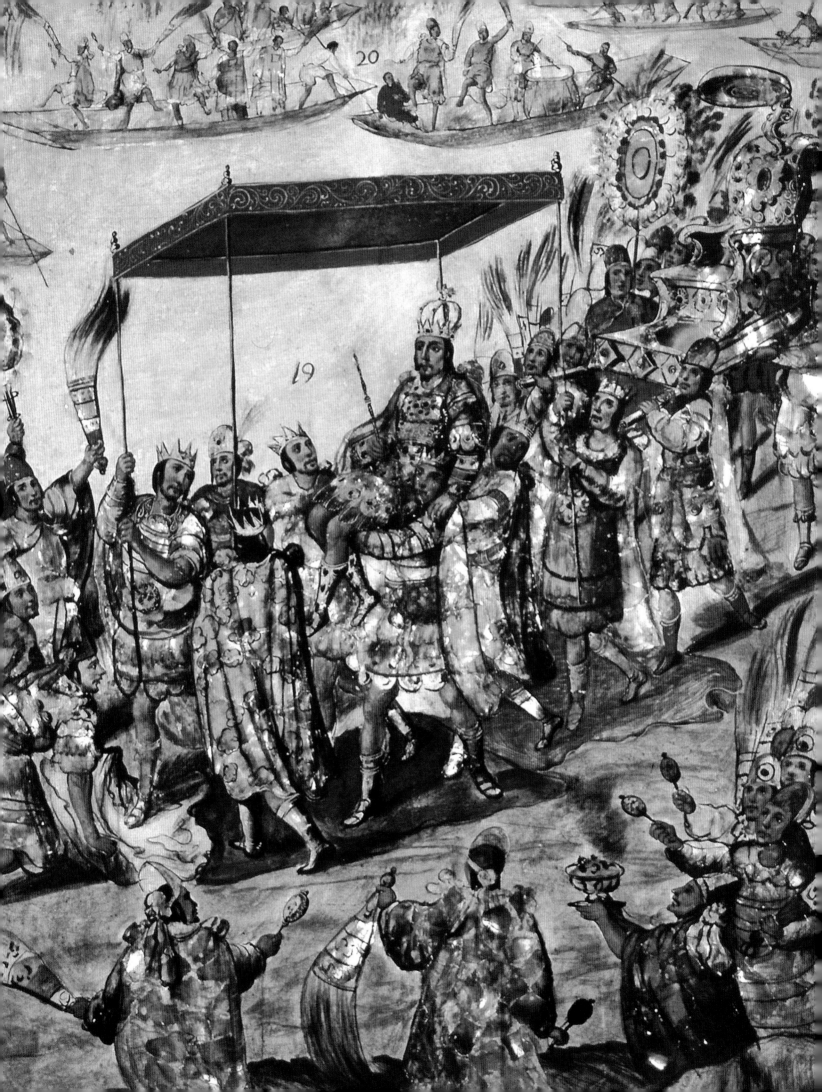

Foreword

The hardest thing to understand about the behaviour of the Mexica ruler Moctezuma during the first contact with the Spanish, which was to reconfigure the American continent forever, is perhaps the sense of absolute predestination that dominated every aspect of the indigenous world.

As part of Mesoamerican civilization, one of the fundamental pillars of Mexican culture was the belief that time was circular. This cycle was subject in turn to a rich mythological narrative in which the deeds of gods and semi-gods – their triumphs and defeats, their deaths and rebirths – were expressed like epiphanies in the world of men, bestowing meaning on everyday events through their ritual repetition.

The indigenous sense of history, the manner of understanding the present and how it projects into the future, is radically different to our modern experience. Whereas we see time in broad terms as a linear succession, for the Ancient Mexicans it was the circular repetition of a sacred calendar.

It is essential to take into account this fundamental difference between our cultural realities when examining how Moctezuma – and most of the nobility– received the Spanish. If the conquistadors were welcomed with 'open arms' and without the most basic of military precautions, it was because their arrival was interpreted as forming part of the divine cycles that governed the Mexica world. Although they were not considered specifically to be gods, their appearance was seen as the fulfilment of a sacred prophecy.

The Instituto Nacional de Antropología e Historia is delighted to join forces with the British Museum in bringing to the people of the United Kingdom a demonstration of the impressive cultural and artistic heights attained by the Mexicas just before the conquest. Moctezuma was in the process of consolidating an empire that, in less than a hundred years, had come to dominate a large swathe of Mesoamerica. Although as a people the Mexicas enjoyed great vitality, paradoxically, as individuals they were tormented with doubts about their destiny, as is apparent from their poetry. Visitors will find this tension between doubt and certainty reflected in every piece in the show, a quality that endows this ancient art with a strangely contemporary feel.

Consuelo Sáizar
Presidenta del Consejo Nacional para
la Cultura y las Artes (CONACULTA)

Alfonso de Maria y Campos
Director General, Instituto Nacional
de Antropología e Historia (INAH)

Consejo Nacional
para la
Cultura y las Artes

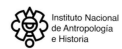
Instituto Nacional
de Antropología
e Historia

Foreword

The forthcoming celebration of the centenary of the Mexican Revolution and bi-centenary of Mexican Independence in 2010, make this an appropriate moment to think in depth about Mexico and its rich cultural and political history. The coincidence of these two anniversaries invites us to step back some 500 years to consider afresh one of the principal Mexica kings and his response to European invasion, and the place of Mexico's revolution in the great political upheavals of the Twentieth century.

Moctezuma: Aztec Ruler represents the culmination of a series of four extremely popular exhibitions held at the British Museum – *The First Emperor, Hadrian* and *Shah 'Abbas* – which have successively examined great rulers of world history.

Moctezuma II, the last elected ruler of the Aztecs and one of the key figures at a pivotal moment in the history of the Americas, reigned successfully for almost two decades (1502–20). As supreme military commander he battled rivals to secure control over much of modern highland Mexico stretching 500 miles from the Gulf Coast to the Pacific Ocean. Moctezuma's ascendancy was challenged by the arrival of strangers from across the ocean – the Spaniard Hernán Cortés and his expedition of adventurers seeking wealth and converts. After initially welcoming the Spanish, Moctezuma was captured and met his death shortly afterwards. In spite of fierce resistance, the Spanish went on to conquer his empire. The architectural and artistic achievements of the Mexica astonished the Spanish and the rest of the world, and have continued to wield a huge influence on Mexican art and society.

This exhibition would not have been possible without the wholehearted involvement of the Instituto Nacional de Antropología e Historia, Mexico City and the invaluable support of our curatorial colleagues Eduardo Matos and Leonardo López Luján. The Museum is greatly indebted to the Mexican Ambassador to the UK, HE Juan José Bremer, and his colleagues, especially Minister Ignacio Durán, for their invaluable help and assistance.

The British Museum is extremely grateful to ArcelorMittal who has so generously supported the exhibition and also to the airline partner, Mexicana and Visit Mexico. British Museum curators have worked for many years with CONACULTA, the Mexican National Council for Culture and the Arts, which has done so much to foster strong cultural ties between the UK and Mexico. On behalf of the Trustees of the British Museum I should like to express our thanks for the vision, commitment and extraordinary collaborative teamwork that have made this initiative possible.

Sadly at a late stage in the preparations for the exhibition our colleague Felipe Solís (Director of the Museo Nacional de Antropología) passed away unexpectedly and we respectfully dedicate this volume to his memory.

Neil MacGregor
Director, The British Museum

Acknowledgements

This project originated in an innovative collaboration between Mexico and the British Museum when, in January 2007, Mexican Ambassador Juan José Bremer and Director Neil MacGregor agreed that 'Moctezuma' would make a fitting finale for the Museum's exhibition series on renowned rulers.

From its inception the initiative enjoyed a remarkable spirit of collegial goodwill. In July 2007 our three principal Mexican curatorial colleagues Eduardo Matos, Leonardo López and Felipe Solís were invited to join John Elliott, David Brading, Hugh Thomas and Felipe Fernández-Armesto in London. All contributed thoughtfully to a lively seminar at the British Museum that did much to stimulate our ideas about how the life of the enigmatic and complex figure of Moctezuma II might be addressed afresh. Subsequent curatorial meetings in Mexico City helped advance our thinking about the themes and content of the exhibition. In particular Leonardo López Luján's deep knowledge of the subject and extraordinary generosity have made telling contributions at every turn in the development of the exhibition and the book. It has been a singular privilege to renew our collaboration with such an outstandingly gifted scholar and friend.

We owe a huge debt of gratitude to our institutional partners CONACULTA–INAH in Mexico, especially Consuelo Sáizar (President of CONACULTA) and Alfonso de Maria y Campos (Director-General of INAH) and his staff: Rafael Pérez Miranda, Luis Ignacio Sáinz Chávez, María del Perpetuo Socorro Villarreal, Miriam Kaiser (National Director of International Exhibitions), Alejandra Barajas (Project Coordinator), Gabriela López, Patricia Real, Leticia Pérez, Erasmo Trejo, Ileana Peña and Miguel Báez. All have generously hosted our visits and worked tirelessly in support of the exhibition and catalogue. In addition, we thank José Enrique Ortiz Lanz, Juan Manuel Santín, Teresa Aguirre, Jesús Álvarez, René Castellanos, Erika Gómez, Héctor Ceja, Trinidad Rico, Diego Sapién, Itzia Villicaña, Ana San Vicente, Ernesto Rodríguez, Alejandro Sarabia. In London, Ambassador Bremer, Minister for Cultural Affairs Ignacio Durán and Jimena Gorráez-Belmar have given unstinting support to promote the project and related events.

International exhibition projects call upon the expertise and goodwill of many individuals and institutions. We gratefully acknowledge the support of all the lenders to the exhibition who are listed on p. 7. We have counted time and again on museum Directors and curatorial colleagues who have received visits, advised us on object selection and guided us through often complex negotiations.

In Mexico, we thank the late Felipe Solís, Diana Magaloni Kerpel, Patricia Ochoa, Roberto Velasco (Museo Nacional de Antropología); Carlos Javier González and Fernando Carrizosa (Museo del Templo Mayor); Salvador Rueda, Juan Salvador (Museo Nacional de Historia); Cecilia Genel, Ana San Vicente (Museo Nacional del Virreinato); Juan Contreras (Museo Cuauhnahuac); Marco Antonio Carvajal, David Morales (Museo Baluarte de Santiago);

Ernesto Rodríguez (Dirección de Salvamento Arqueológico); Antonio Gasca, Victor Angel Osorio (Instituto Mexiquense de Cultura); Mauricio Maillé (Fundación Televisa).

In Europe, we thank Ilaria Bartocci, Alexander Brust, Maria Paolo Rufino, Ana Rita Fantoni, Ana Cassaza, Claudio Cavatrunci, Maria Antonietta Fugazzola, Maria Gaida, Christian F. Feest, Viola Koenig, Gerard van Bussel, Wolf Koepke, Paz Cabello Caro, Concepción García Sáiz, Ana Castaño Lloris, Christophe Pallez, Thierry Delcourt, Fabienne de Pierrebourg, Anne-Sophie Delhaye, André Delpuech, Milagros del Corral Beltrán, María Luisa López-Vidriero and Elena García. In the UK we thank Carole Holden, Bruce Barker-Benfield and David Weston and at the Spanish Embassy in London Ambassador Carles Casajuana, Juan José Mazarredo Pamplo and Beatriz Mérida Balcázar.

In the United States, we thank Richard Townsend, Nancy Rosoff, Mark Dimunation, James H. Billington, Miriam Doutriaux, Juan Antonio Murro, Jay and Jean Kislak, Arthur Dunkelman, Charles Spencer and Edward Widmer.

At the British Museum, the Moctezuma 'Core Team' under Carolyn Marsden-Smith's overall guidance originally comprised Emma Kelly and Susan Dymond, and we were sorry to lose both when they moved on to other positions. In February 2008 Elisenda Vila was appointed Assistant Curator and, amid myriad demands, her enthusiasm and passion have shone through all aspects of her organizational and intellectual involvement in the project. Sarah Scott, ably supported by Neil Casey, picked up the reins as Project Manager and we have especially appreciated her intelligent and thoughtful handling of the complexities and pressures. Paul Goodhead has contributed graphic skills of the highest order and Olivia Buck continued seamlessly seeing the interpretation through to completion. The exhibition designers Karl Abeyasekara and Bill Kerridge of Studio A have risen to the challenge and brought their combined creativity, skills and experience to bear to produce an exceptional outcome. The project has benefited greatly from the talents and expertise of colleagues in different departments throughout the Museum. Limited space precludes us from thanking everyone individually. We extend our sincere appreciation to all in International Loans; Conservation and Scientific Research; Photography and Imaging; Information Systems; Development; Marketing; the British Museum Company; Communications; Learning and Audiences; Human Resources; Finance; and Legal Services. In the Dept of Africa, Oceania and the Americas, Keeper Jonathan King, the Centre for Anthropology library team and curatorial staff Leonora Baird-Smith, Jack Davy, Julia Zumstein and Rosario (Charo) Rovira Guardiola have all provided dedicated assistance, supported by intern Delphine Cano and volunteers Juliana Holhauer-Conti, Margarita Luna, Andrea Kiernan, Maria Fernandes and Mariela Juarez.

An edited volume faces particular challenges of integrating very different kinds of material and individual writing styles not to mention translation. All the contributors (credited on p.6) have found time to deliver amid other pressing commitments and often at very short notice. Their diverse range of expertise and distinctive approaches reflect the interdisciplinary nature of the undertaking, interweaving archaeological, pictorial and textual sources. A great deal of credit must go to our copyeditor Kate Bell who has worked assiduously to help us achieve what we trust readers will find to be an accesible and coherent outcome. Her efforts have been matched by the book designer Ray Watkins and all at British Museum Press, in particular Rosemary Bradley, Coralie Hepburn and Melanie Morris.

Chronology

	Moctezuma and the Mexica world	Rest of the world
1000	**1000–1200** A nomadic group leaves the mythical homeland of Aztlan, guided by their patron deity Mexi or Huitzilopochtli	**1066** Norman Conquest of England
1200	*c.* **1200** The Mexica arrive in the Basin of Mexico, and settle on the shores of Lake Tetzcoco	**1206–27** Genghis Khan expands the Mongolian Empire
1300	**1325** Founding settlement at Tenochtitlan, on an island in Lake Tetzcoco, later to become the Mexica capital **1337** Founding of adjacent settlement of Tlatelolco	**1368–1644** Ming Dynasty in China
1400	**1428** Formation of the Triple Alliance comprised of the lake-shore towns of Tenochtitlan, Tetzcoco and Tlacopan **1440–69** Rule of Moctezuma I, great-grandfather of Moctezuma II	**1438** The Inca Empire emerges in the Andean Highlands of Peru, and becomes the largest empire in the Americas
1450	**1450** Prolonged drought afflicts Basin of Mexico **1454** New Fire Ceremony celebrated	**1451–81** Mehmed II the Conqueror reigns over the Ottoman Empire **1453** The Ottomans conquer Constantinople **1455–85** War of the Roses in England
1460		
1470	**1467** Moctezuma is born in the palace of Axayacatl, his father, in Tenochtitlan. Moctezuma grew up in the palace and later attended the *calmecac* (school for priests) and the warriors' school **1473** Tenochtitlan absorbs Tlatelolco to become the dominant power in the Basin of Mexico	
1480	**1486–1502** Rule of Ahuitzotl, uncle of Moctezuma II **1487** Ahuitzotl completes the Templo Mayor and sacrifices 20,000 captives to celebrate	**1485–1603** Rule of the House of Tudor in England
1490		**1492** The master navigator and explorer Christopher Columbus 'discovers' the Americas **1493** Columbus returns to Hispaniola and sets up a fortified trading post **1494** Treaty of Tordesillas creating a line dividing the world map in two between the Spanish and the Portuguese **1498** Vasco de Gama discovers a feasible sea route to India, initiating Portuguese commercial dominance over the Indian Ocean for the next century

	Moctezuma and the Mexica world	Rest of the world
1500	**1502** Major flood in Tenochtitlan **1502** Ahuitzotl is killed as a result of a collapsing aqueduct, and Moctezuma II is elected *huey tlatoani* ('supreme ruler') of Tenochtitlan and thus Mexica Emperor **1507** Moctezuma presides over a New Fire Ceremony, to celebrate the end of the fifty-two-year calendrical cycle	
1510		**1511** Shipwrecked Spaniards from Panama make shore in Yucatán. Two are still alive when Cortés lands in the region seven years later
		1516–56 Charles V reigns in Spain **1517** Hernández de Córdoba makes the first voyage to Mexico from Cuba, landing at Yucatán. He officially 'claims' the Yucatán for Spain **1518** A second Spanish expedition, led by Juan de Grijalva, leaves Cuba and arrives at the island of Cozumel
	1519 Moctezuma's fifty-second birthday. He has an image of himself carved into the hillside at Chapultepec 　　**21 April** Cortés and his fleet of ships reach the coast of central Mexico 　　**8–14 November** Cortés reaches Tenochtitlan and is received by Moctezuma	**1519** Charles V is elected Holy Roman Emperor 　　**18 February** Cortés leaves Cuba, despite urgent orders from Governor Velázquez recalling him 　　**22–25 March** Cortés fights the Maya 　　**April – May** Cortés meets the Totonac and Mexica emissaries **1519–21** Magellan circumnavigates the world
1520	**1520** *c.* **20 April** Cortés departs Tenochtitlan, leaving one of his captains, Pedro de Alvarado, in charge 　　**16 May** Alvarado massacres the Mexica nobility 　　**24 June** Cortés returns to Tenochtitlan 　　**30 June** Death of Moctezuma 　　Cuitlahuac replaces Moctezuma but dies of smallpox six months later **1521–25** Cuauhtemoc becomes ruler and puts up a determined resistance as Cortés lays siege to Tenochtitlan **1521** **13 August** Fall of Tenochtitlan **1524** First twelve Franciscan friars arrive	
1530		**1532** Francisco Pizarro and the Spanish army conquer the Inca Empire **1533** Atahualpa, last sovereign emperor of the Inca Empire, is executed by the Spanish **1534** The Church of England breaks with Rome
1540	**1535** First viceroy of New Spain, Antonio de Mendoza, arrives **1537** Printing press introduced in Mexico City **1542** New Laws of the Indies issued by King Charles I of Spain. Indian slavery outlawed **1545** First great epidemic: 800,000 Indians die	
1550		
1560		
1570	**1572** Arrival of Jesuits	**1588** English defeat of the Spanish Armada
1660		
1700		
	1737 Our Lady of Guadalupe made Patroness of Mexico	
1800		
	1821 Mexican War of Independence	

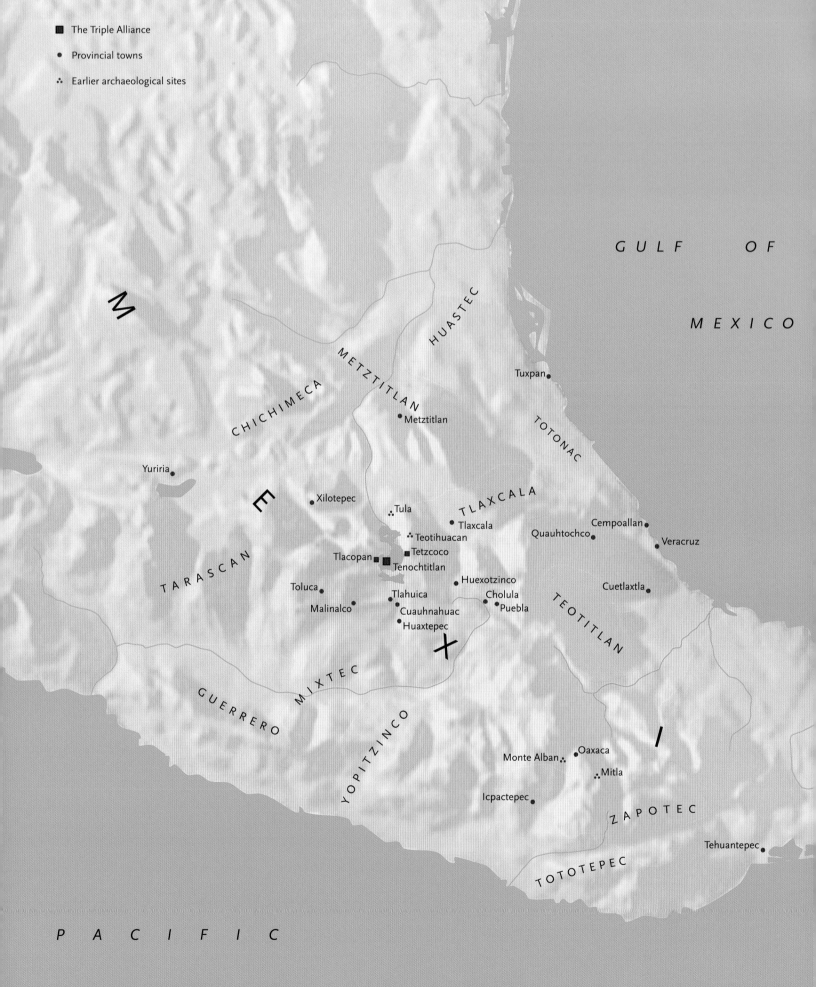

The Triple Alliance

■ The Triple Alliance
● Provincial towns
∴ Earlier archaeological sites

GULF OF

MEXICO

M

E

CHICHIMECA

METZTITLAN

HUASTEC

TOTONAC

Tuxpan

Metztitlan

Yuriria

Xilotepec

Tula

TLAXCALA

Teotihuacan

Tlaxcala

Cempoallan

Quauhtochco

Veracruz

TARASCAN

Tlacopan

Tetzcoco

Tenochtitlan

Toluca

Tlahuica

Huexotzinco

Cholula

Cuetlaxtla

Malinalco

Cuauhnahuac

Puebla

TEOTITLAN

Huaxtepec

X

MIXTEC

GUERRERO

YOPITZINCO

Monte Alban

Oaxaca

I

Mitla

Icpactepec

ZAPOTEC

Tehuantepec

TOTOTEPEC

PACIFIC

OCEAN

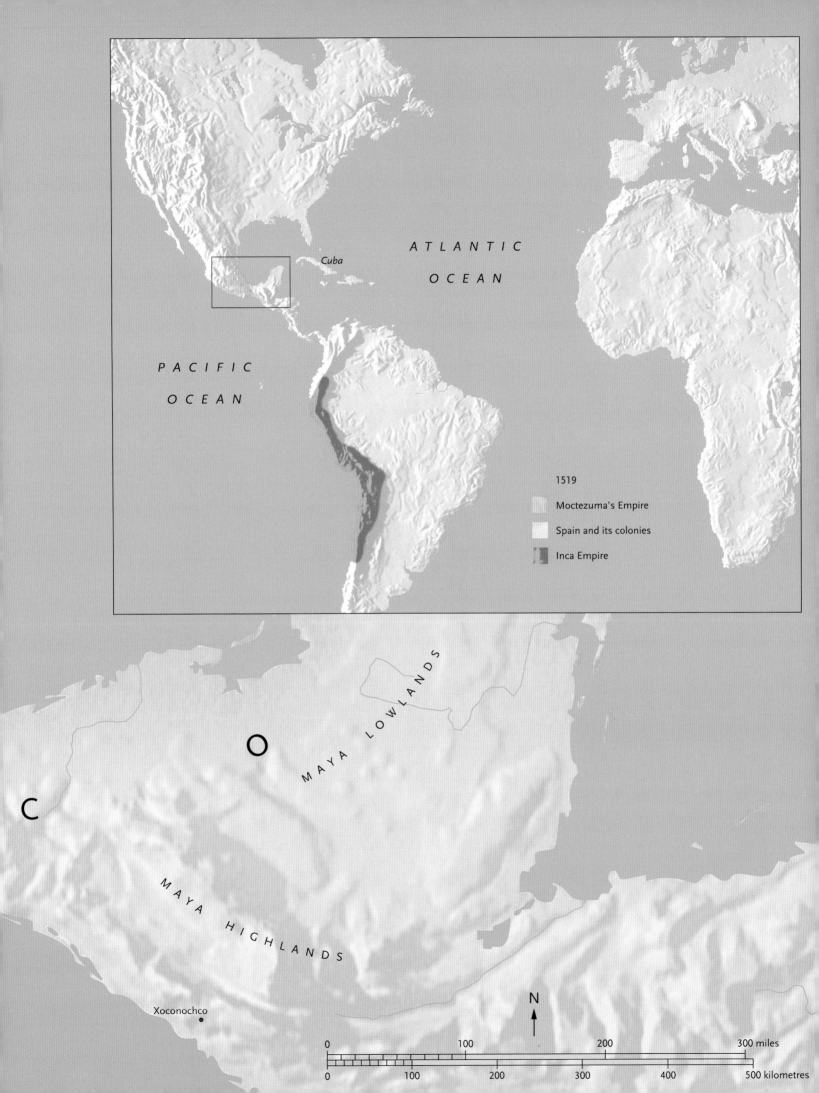

ATLANTIC
OCEAN

Cuba

PACIFIC

OCEAN

1519

Moctezuma's Empire

Spain and its colonies

Inca Empire

O

C

MAYA LOWLANDS

MAYA HIGHLANDS

Xoconochco

N

| 0 | | 100 | | 200 | | 300 miles |
| 0 | 100 | 200 | 300 | 400 | 500 kilometres |

Introduction

Colin McEwan and Leonardo López Luján

THIS VOLUME explores the famous yet enigmatic figure of Moctezuma II – the last elected ruler of an empire centred on the island metropolis of Tenochtitlan in the Basin of Mexico. Here Moctezuma ruled from 1502 until his death in 1520, holding sway over a powerful state that stretched from the Gulf Coast in the east to the shores of the Pacific Ocean in the west, and from the frontier of the Tarascan empire in the north-west to what is today Guatemala in the south-east. He is best known as a key actor in the momentous events that unfolded in the early sixteenth century at the time of Hernán Cortés's arrival and the Spanish conquest. The uncertain circumstances surrounding Moctezuma's death and the startlingly divergent interpretations of his place in history combine to make this a timely opportunity to examine afresh both the man and the mystique that has grown up around him.

Origins

Throughout the Americas, deep-rooted oral traditions find expression in objects and images that represent mythical origins. Mesoamerican origin myths often tell of human beginnings on a primordial island or in a cave, followed by a period of nomadic wandering before fully civilized life was achieved. In central Mexico a few surviving early colonial documents[1] record native histories describing a mythical place of origin called Aztlan ('place of whiteness').[2] This reference to 'white' is significant because it alludes

Fig. 1
Detail of the Sun Stone, one of the major monumental sculptures produced during Moctezuma's reign. His name glyph appears to the left of the triangular 'ray' immediately above the frontal face of a deity with clawed limbs. Museo Nacional de Antropología, Mexico City.

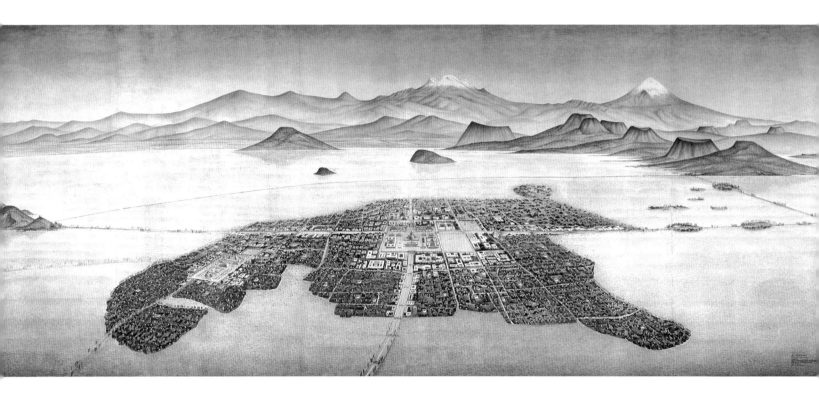

to primordial times, origins and to 'founding deeds'. Both texts and images portray Aztlan as a place that closely parallels the island setting of what was later to become Tenochtitlan. Many scholars now believe that Aztlan is likely to be a retrospective 'mythical' construction, rather like the primordial Jerusalem in western religious traditions. In effect this mythical place of origin was imagined as being practically identical to the site of the 'promised land' of Tenochtitlan itself.

Fig. 2
Reconstruction of Tenochtitlan-Tlatelolco, with the volcanoes Popocatepetl and Iztaccihuatl on the horizon. Painting by Luis Covarrubias (1919–1987).
Museo Nacional de Antropología, Mexico City.

Azteca and Mexica

The ruling lords of Aztlan are described in the sixteenth-century sources as 'Aztecs' who tyrannized their subject vassals, many of whom eventually escaped servitude by fleeing as a nomadic group of Chichimec guided by their patron deity Mexi or Huitzilopochtli, who gave them the new name of Mexica.

In due course the migrants are said to have arrived on the shores of Lake Tetzcoco in the Basin of Mexico around AD 1200. From the outset the Mexica endeavoured to co-exist with the established lakeside towns of Azcapotzalco (Tepanec peoples), Tetzcoco (Aculhua peoples), Culhuacan (Culhua peoples), and Xochimilco and Chalco (Chinampanec peoples). They found refuge by settling on islands towards the western side of the lake, in Azcapotzalco's domain. Two of these islands lay in close proximity and became the sites of the founding settlements of Tenochtitlan in 1325 and of Tlatelolco in 1337. The Mexica-Tlatelolcas were dependent on Azcapotzalco and adopted an Azcapotzalco ruler. The Mexica-Tenochcas were also in thrall to Azcapotzalco but in 1376 adopted a Culhua ruler, Acamapichtli, to establish through the people of Culhuacan a lineage of ancestors from the ancient city of Tollan-Xicocotitlan (the archaeological site of Tula in modern Hidalgo State) and its legendary ruler Ce Acatl Topiltzin Quetzalcoatl.

Their traditional administrative arrangement of four leaders was superseded by the newly created role of ruling lord or *tlatoani* (in Nahuatl, 'he who speaks'), who was in turn advised by a four-man council. The *tlatoani* was the supreme ruler in political, military, religious, administrative and judicial affairs. The two island settlements progressively reclaimed new land by creating the extensive system of canals and raised beds (*chinampas*) that eventually merged into a single, enlarged city. By the early sixteenth century the island metropolis is estimated to have extended over some 13.5 square kilometres and housed perhaps as many as 200,000 inhabitants.

The Triple Alliance and the application of the term Aztec

Beginning in 1325, we can trace a continuous line of elected rulers. Spanish administrators and friars such as Bernardino de Sahagún illustrate this lineage in their chronicles. The earlier rulers in the sequence used a small feather headdress (*cozoyahualolli*) as a Chichimec insignia of leadership and they are seated on bound bundles composed of reeds and canes. Following the war of independence in the years 1428–30 a new 'Triple Alliance' (*excan tlatoloyan*) was forged by the fourth ruler Itzcoatl and his allies. This comprised the cities of Tenochtitlan, Tetzcoco and Tlacopan, the latter replacing the defeated Azcapotzalco. From this point onwards, the rulers of Tenochtitlan, including Itzcoatl himself, are portrayed wearing the classic pointed royal diadem made of turquoise (*xiuhuitzolli*) and seated on a high-backed throne of woven reeds. By 1473 Tenochtitlan had absorbed Tlatelolco to become the dominant power with ambitions extending far beyond the Basin of Mexico. The city lay at the heart of an extensive network of tributary and strategic provinces that constituted the empire encountered by Cortés in 1519. The Mexica, comprising the Nahuatl-speaking Tenochcas[3] and Tlatelolcas, never at any point referred to themselves or their city-states, let alone their empire, as 'Aztec'. They simply considered themselves as ethnic Nahuas – speakers of Nahuatl – like many of their neighbours. At the time of the Spanish conquest they were likewise referred to by the Spaniards as Mexica – hence the name for modern Mexico. Unfortunately the misapplication of the term 'Aztec' originated in scholarly works of the nineteenth century such as those by the Prussian naturalist Alexander von Humboldt. The name was later popularized by the American writer William Prescott and has been widely and erroneously used ever since. Henceforth in this volume we use the correct term Mexica.

Moctezuma II: proud ruler on the cusp of history

Moctezuma ('He Who Grows Angry [like a] Lord') Xocoyotzin ('the Venerable Youngest Son') is also referred to as 'the Younger' to distinguish him from his great-grandfather Moctezuma Ilhuicamina ('He Who Pierces the Sky with an Arrow') or 'the Elder', the longest reigning Mexica ruler (ruled 1440–69).[4] We have adopted the conventional modern Spanish spelling 'Moctezuma' rather than the anglicized 'Montezuma'.[5] Trained as a priest and a warrior, Moctezuma was one of the empire's two highest military commanders and was elected as the ninth *tlatoani* by the council of elders in 1502. Although

in theory a new *tlatoani* could be selected from one of hundreds of male nobles, in practice the new ruler was always a brother, son, grandson or nephew of a previous *tlatoani*.

The *tlatoani* was regarded as an *ixiptla*, that is, a representative or personification of the gods. His public visibility was carefully managed. He generally ate alone and direct access to him was strictly controlled. An animal pelt (usually jaguar) or woven mat protected his feet from direct contact with the ground and normal human contact was forbidden, a taboo violated when the Spaniard Cortés reached out to embrace Moctezuma at their first meeting in November 1519.

In advance of the arrival of the Spanish, the Tenochca elders advised Moctezuma of their dreams presaging momentous changes, including his downfall and death. Other strange omens and portents of change are recorded in post-conquest documents that may represent a 'rationalized', retrospective reconstruction to explain what transpired. After the initial protocol of meeting and diplomatic exchanges there was a massacre of Mexica nobles, relations worsened and Moctezuma was taken captive by the Spanish. The precise circumstances of his death are not clear.[6] The prevailing narrative was constructed by the conquistadors themselves and reinforced by their descendants in the early colonial period. An alternative though barely visible indigenous interpretation of events can be detected. Added to this are the mythological and symbolic elements that embellish the portrayal of a ruler's death and funeral rites.

Aftermath and legacy

The conquest of Mexico represents a turning point in the history of the Americas. It resulted in the destruction of a sophisticated and successful Native American civilization and the imposition of an alien religion. Out of this emerged a new colonial economic, social and political order. The varied and often contradictory accounts and subsequent interpretations of Moctezuma's fate reflect very different Spanish and indigenous agendas. On the Spanish side the authors range from soldiers and friars to administrators while among native sources are individuals claiming royal descent, citizens of Tenochtitlan, those from other ethnic groups further afield as well as *mestizos*, each offering partial and subjective descriptions and interpretations.

The accidental unearthing of large Mexica sculptures in Mexico City between 1790 and 1810 stirred conflicting emotions. When the formidable sculpture of the earth goddess Coatlicue with its symbols of sacrifice, war and death was first publicly displayed at the Universidad Real y Pontificia it evoked curiosity and alarm. Fearing that it could exert a negative influence on the students and might provoke the rise of pagan cults among the indigenous populace, the Dominican priests ordered that it be re-interred. The Sun Stone (figs 1 and 28) and other monuments were put on public display as evidence of the Mexica's knowledge of mathematics, geometry, the calendar and astronomy.

Since then, attempts at reconstructing and interpreting the organization of Tenochtitlan have depended primarily on historical sources. Over the years these have been progressively complemented, augmented and modified by limited archaeological work, but this has consisted mainly of salvage excavations resulting from city construction

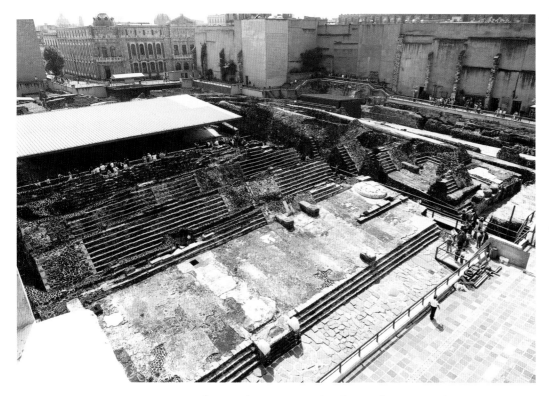

Fig. 3
Partial view of the front (east) façade and steps of the Templo Mayor, Mexico City.

which have uncovered small portions of houses, temples and palaces.

Scientific excavations of the Templo Mayor began in 1978, eventually extending over some 13,000 square metres and contributing greatly to our understanding of the ceremonial heart of Tenochtitlan. More is now also being learned about the outlying districts of the city and its peripheral settlements. Recent investigations have begun to explore the foundations of Moctezuma's Palace in the area beneath the modern National Palace adjacent to the main square known as the Zócalo. Current research in front of the Templo Mayor promises to add significant new insights into the funerary customs accorded to rulers, their insignia, symbols and beliefs.

At the time of his death, Moctezuma's demise was lamented by loyal followers who revered the office of *tlatoani* and all that it stood for. On the other hand, he was disowned and vilified by many, in sharp contrast with the final *tlatoani* Cuauhtemoc who was held in high regard for his heroic resistance. In Europe Moctezuma's fame lived on in idealized portraits, from early engravings to later oils. In the late nineteenth century the Academy of San Carlos in Mexico City, inspired by classical ideals, tended to romanticize images of Moctezuma and his court. In Mexico today Moctezuma is an ambivalent and little-celebrated figure. Nonetheless, his story poses questions of direct contemporary relevance. Are key individuals at pivotal moments in human affairs the makers of history or the victims of historical events? How are heroes idealized and the defeated branded as tragic failures? Moctezuma's story demonstrates how the interpretation and representation of history and its principal protagonists is never entirely impartial and objective but rather dependent on the diverse agendas and perspectives of its narrators.

Some 500 years after the events recounted here took place, Mocetzuma's name still carries a ring of familiarity. For many people, there is the comforting sense of a well-rehearsed drama – that 'we know' the conventional story of the Spanish conquest and Moctezuma's role in it. But whose history is being told, by whom and for whom, and how have the often chaotic and contradictory events of this tumultuous period been distilled into an intelligible narrative? Together, the essays gathered here undertake the task of positioning Moctezuma in a more inclusive history – one that embraces the Mexica world about which we still have much to learn and that also examines afresh the received wisdom about his fame, fortune and misfortune.

tlacuitli

acacoaul

occacoa

quauhcoatl

tezineuitl

tenuch

xocoyol

xomimitl

xiuhcaqui

atotoitl

tenochtitlan

colhuacan. pueblo. tenayucan. pueblo/

Family histories:
the ancestors of Moctezuma II

Felipe Solís Olguín

FROM THE sixteenth century onwards, chroniclers, historians and archaeologists have sought to reconstruct the history of the Mexica people, who since the nineteenth century have been widely, but incorrectly, referred to as Aztecs (see p. 21). The key sources are the historical accounts of the *tlatoque*[1] of Tenochtitlan, semi-divine figures comparable to the emperors of western tradition.[2] The most famous *tlatoani* is Moctezuma Xocoyotzin, 'the younger', who met his fate in 1520 at the hands of the Spanish. Much of what we now know of his story and the world of the Mexica in general is drawn from early colonial documents or codices. Many of these were based on ancient annals and pictorial histories, the great majority of which was destroyed during or just after the conquest. A few were translated into phonetic writing with annotations in the Mexica native language Nahuatl, as well as Spanish and Latin.

In addition, many archaeological objects survived the conquest, including sculptures, reliefs, architectural elements and funerary offerings, and some of these can be precisely dated, augmenting and often confirming the statements made by historic accounts. The name glyphs and the calendar dates inscribed on certain significant monuments enable us to identify key individuals and events. These provided an aide-memoire for the oral histories taught in schools and shared at celebrations and during ritual ceremonies.

Nevertheless, there are no surviving Mexica codices, archaeological reliefs or original testimonies from the founders of Tenochtitlan itself. There is no known account that reflects the history of the Mexica in its entirety, or details its key events, such as the

appointment and advancement of lords or chiefs, their participation in military conquests, marriages and births, and the accession of heirs to the throne.

Close analysis of the various early colonial chronicles and histories that relate the migration of the Mexica from Aztlan to the foundation of Tenochtitlan, or the life and history of each *tlatoani*, reveals many discrepancies. Different authors have added ideas and concepts in accordance with their own interests and purposes. Moreover, the fourth *tlatoani*, Itzcoatl, ordered the destruction of Mexica historical records, making the task of establishing a true picture of events even more difficult.[3]

The interpretation of the lives of Moctezuma II's ancestors presented here takes us back to their place of origin, Aztlan, and traces the signal events of their mythical two-hundred-year migration until their arrival in the marshland basin of central Mexico (see fig. 6).

Aztlan: the Mexica place of origin

The Mexica considered themselves a chosen people, destined to forge their own greatness. Like many other peoples around the world, they mythologized their origins. Their enigmatic place of origin was said to be Aztlan, 'place of whiteness' or 'place of herons', which, according to the chronicles, lay to the north of Mexico. This geographical orientation is closely linked to the meaning of its name, since indigenous thinkers conceived of the universe as being a flat structure with four directions and four corners, each identified by a different colour. The northern direction was dominated by the colour white, which is similarly linked to the white plumage of the heron.

The myths suggest that nomadic migrants left this land in the early twelfth century on a long journey that would eventually lead them to the place where they would settle and found their new capital. Following the decree issued by their tribal deity, Huitzilopochtli, the migrants founded their new city of Tenochtitlan on islands located in the west of Lake Tetzcoco.

Although all these accounts seem to suggest that Aztlan was in the north of Mexico, its precise location is unclear. Chroniclers situate it in the area between Zacatecas and New Mexico,[4] but more recent authors[5] have opted to search for a landscape that matches the descriptions in the historical texts, leading some to assert that Aztlan was located on the island of Mezcaltitlan in Nayarit or in the marshland of Yuriria in Guanajuato.

Notwithstanding the captivating images of Aztlan in various early-colonial pictographic manuscripts which illustrate the original site in an idealized manner,[6] no archaeological discoveries have yet proved its existence. However, most of the sources coincide in their description of the city and its natural surroundings as an island settlement on a lake or lagoon. It seems that the Mexica sought to fashion the city of Tenochtitlan, built in Lake Tetzcoco, in the image of Aztlan, a link that strengthened the power and sacred mission of the new Mexica capital.

One of the most graphic descriptions of the original Mexica city is given in the Tira de la Peregrinación, also known as the Codex Boturini, which is notable for the originality of its pictographs and the simplicity of its narrative (fig. 5). Aztlan is depicted as a typically Mesoamerican settlement with a ritual architecture resembling that used

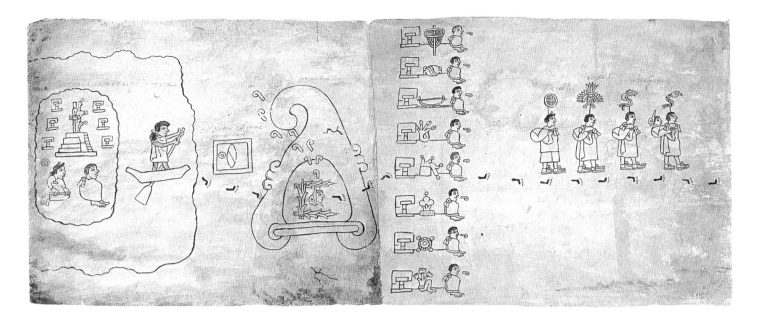

Fig. 5
The Mexica begin their migration from the legendary island of Aztlan (depicted at the left) with a procession (at right) led by a figure bearing an effigy of their patron deity Huitzilopochtli. Tira de la Peregrinación or Codex Boturini, sixteenth century. Biblioteca Nacional de Antropología e Historia, Mexico City.

centuries later in Tenochtitlan. It is characterized by the platform constructions built to support the devotional images of Huitzilopochtli and other deities, similar in its profile to the *Teocalli* of Sacred Warfare (see cat. 78), a monument commemorating the New Fire ceremony of 1507.[7]

An affiliation to ancestral Mesoamerican cultural symbols is evident in the historical accounts and pictographs. From these, it is clear that a complex political and hierarchical system existed in Aztlan, ruled by a great chief. The sixteenth-century historian Hernando Alvarado Tezozómoc[8] describes the Aztlan governors in his *Mexican Chronicles*, indicating that a monarch named Moctezuma governed in the Mexica place of origin.[9] It is conceivable that by drawing attention to this, Tezozómoc was attempting to legitimize the rights due to Moctezuma II's descendants in the difficult early years of Spanish rule.

According to the sixteenth-century chronicler Domingo Chimalpáhin, the Mexica who decided to leave Aztlan in search of new horizons were guided on their journey by four leaders who would also have held the status of *teomamas*, or 'god-bearers'.[10] This group leadership continued throughout the migration until the Mexica settled in Chapultepec, when their leader, Huehue Huitzilihuitl,[11] was apparently elevated to the status of *tlatoani*.[12] This ruler went on to suffer defeat at the hands of a coalition of local marsh-dwelling people and he was taken with his daughter as a prisoner to Culhuacan, where they were both executed.

Culhuacan: the origins of the Mexica dynasty

The city of Culhuacan was governed by the chieftain Coxcoxtli, who ruled over the Mexica after their arrival. Located to the south of the swampy basin, it enjoyed great prestige, although by the time the Mexica reached the city its territory had been somewhat reduced by the expansion of neighbouring peoples, especially the Tepanecs. Its cultural inheritance was nonetheless formidable and its people still had energy to undertake warring campaigns against other tribes, in particular the Xochimilcas. According to Chimalpáhin,

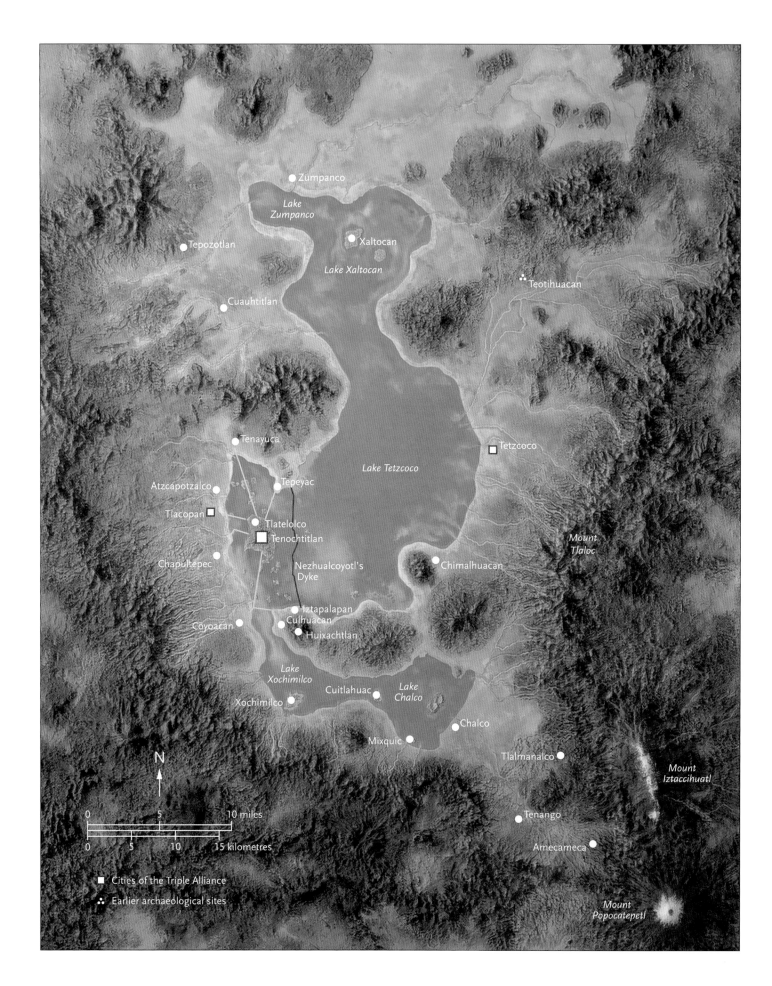

Zumpanco

*Lake
Zumpanco*

Tepozotlan

Xaltocan

Lake Xaltocan

Teotihuacan

Cuauhtitlan

Tenayuca

Tetzcoco

Lake Tetzcoco

Tepeyac

Atzcapotzalco

Tlacopan

Tlatelolco

Tenochtitlan

Chapultepec

Chimalhuacan

Nezhualcoyotl's
Dyke

*Mount
Tlaloc*

Iztapalapan
Culhuacan

Coyoacan

Huixachtlan

*Lake
Xochimilco*

Cuitlahuac

*Lake
Chalco*

Xochimilco

Chalco

Mixquic

Tlalmanalco

*Mount
Iztaccihuatl*

Tenango

Amecameca

N

0 5 10 miles

0 5 10 15 kilometres

■ Cities of the Triple Alliance

∴ Earlier archaeological sites

*Mount
Popocatepetl*

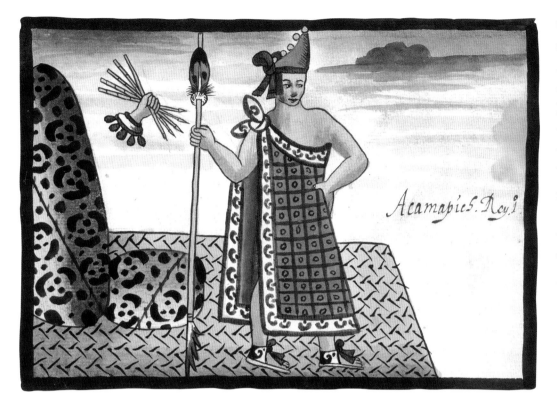

after his death Coxcoxtli was succeeded by his son Huehue Acamapichtli.[13] The founder of the dynasty that would later govern Tenochtitlan bore the same name, legitimizing the nascent royal lineage. With the enthronement of the first *tlatoani* Acamapichtli in 1375, the Mexica established the succession of rulers who were to precede Moctezuma Xocoyotzin.

The enforced stay of the Mexica in Culhuacan encouraged the assimilation of new and sophisticated cultural practices. It also resulted in marriages between the two peoples.[14] The Mexica lineage therefore represents a merging of the followers of the Mexica patron deity, Huitzilopochtli, and the bearers of ancient traditions from Culhuacan, particularly the Toltecs. The successive *tlatoque* who ruled over Tenochtitlan descended from these cultural roots.

Fig. 7
Acamapichtli (1375–1395) was the founding ruler of the Mexica dynasty. From the Codex Tovar (1583–87). John Carter Brown Library, Providence, Rhode Island.

The *tlatoque*: from Acamapichtli to Ahuitzotl

Following the death of Huehue Acamapichtli, the Mexica were forced to seek refuge in the inhospitable region of Tizapan under the leadership of Tenoch, who was by then their leader.[15] It fell to Tenoch to lead them in the final stages of their journey to find an eagle devouring a serpent, perched on a prickly-pear cactus growing from a rock.[16] Huitzilopochtli had promised that this sign would indicate the site where they should build their city, and from there dominate the known universe.

Tenoch undertook the legendary task of founding the city of Tenochtitlan in 1325 (the year 2 House according to the Mexica calendar system, see p. 141). His first act was to establish its boundaries and to organize the migrants into separate districts. The opening plate of the Codex Mendoza provides an elegant schematic illustration of the city-plan of Tenochtitlan (fig. 4), in which the island is depicted as a metaphor of the indigenous view of the *axis mundi*, a map divided into four sections linked to the four corresponding cardinal points. One group of migrants was unhappy with the space allocated to them, sparking a long-running conflict which was only resolved thirteen years later, when the dissidents relocated to neighbouring islands and founded their own city of Tlatelolco.[17]

Tenoch, in his role as guiding leader, also directed the key task of erecting a temple dedicated to Huitzilopochtli. This emblematic sacred building would in due course become

Fig. 6
The Basin of Mexico.

Inic ome capitulo ytechtlatoa intlatoan yutl.

Inic .i. parrapho ypan mitoa ynotlato
catque yn mexico ynte nochtitlan yoan
ynacolhuacan.

Mexico tlatoque inquipeualti tlatoca
yutl, veve acamapichtli: auh inictlatocatl
epoalxiuitl yoan matlacxiuitl, amotlei
pan mochiuh: yehica cayancuican
motecutlali, yntoltzala ynacatzala, yc
mitoaya.

Auh inquivaltoquili inicome tlatoani
mochiuh, iniquac omic acamapichtli:
ytoca Vitziliuitl, intlatocat cempoalxiuitl
oce: amo tleipan mochiuh imige tlatocat.

Auh inic ei tlatoani mochiuh mexico,
iniquac omicque imomenti ynacama=
pichtli ioan vitziliuitl: quivaltoquili teeca
mochiuh, mitoca chimalpupucatzin:
auh intlatocat camatlacxiuitl, auh=
ipan vmpeuh yyavyutl, y yeintech
nexicolo technochca:

Auh inomo miquili chimalpupucatzin=
niman ic ualmotlatocatlali yn itzcoatzi,
tenauhca mochiuh: ympan tlatocayutl:
auh yehoatl ypan mochiuh yn yavyutl
yehoatl quinpeuh intepaneca: auh in
tlatocat itzcoatzin castolxiuitl yc ipan
tzinpeuh yn yavyutl inic nouian tepeuh
que.

Auh inomic itzcoatzin niman val motla
li in Motecucomatzin veue iluicami
natzin: auh intlatocat cempoalxiuitl
vncastolli: impan mochiuh yehoatl
in mitoa nece toch huiloc .i. ypan mo
chiuh mayanaliztli ince xiuhtonali
ce tochtli.

Auh inomic veue Motecucomatzin
niman ic ualmotlali y Axayacatzin
impan tlatocayutl: auh inic tlatocat
matlacxiuitl, ioan nauhxiuitl: auh

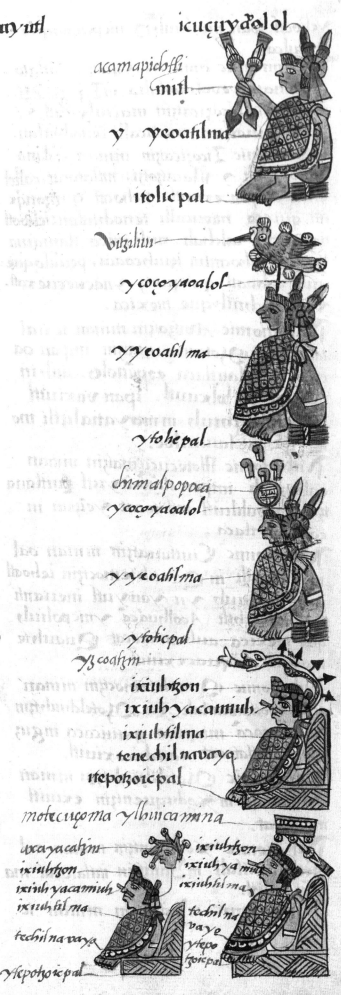

icucuy dolol

acamapichtli

mitl

y ycoatilma

itolicpal

vitzilitl

ycoçoyaoalol

y ycoahl ma

ytohepal

chimalpopoca

ycoçoyaoalol

y ycoahl ma

ytolicpal

yzcoatzin

ixiuhtzon

ixiuh yacamiuh

ixiuhtilma

tenechil navaya

rtepoçoicpal

motecucoma ylhuicamina

axayacatzin

ixiuhtzon

ixiuhtzon

ixiuh ya miuh

ixiuh yacamiuh

ixiuhtilma

ixiuhtilma

techil na
vaya

ytepo
zoicpal

techil navaya

ytepoçoicpal

Fig. 8
The succession of Mexica rulers
of Tenochtitlan portrayed in the
sixteenth-century manuscript
Primeros Memoriales. Real
Academia de la Historia, Madrid.

the Templo Mayor, or Great Temple of Tenochtitlan (see pp. 132–36). Some years after his death in 1363, the council of elders chose the first *tlatoani*, appointing Acamapichtli, who took as his wife Ilancueitl, an older woman with whom he would have no heirs. In their marriage ceremony, the royal couple were personified as the young sun god Xiuhtecuhtli and the ancient earth goddess Coatlicue. The past and present of the Mexica were finally united.

To instigate the royal lineage, a group of *pipiltin* or noblemen offered their daughters as wives to the first *tlatoani* in a collective marriage that ultimately established the division between the nobility and commoners.[18] One of Acamapichtli's wives gave birth to Huitzilihuitl, who succeeded his father as *tlatoani*.

In both the Codex Mendoza and in the tribute list, the Matrícula de Tributos, all of the rulers – from Acamapichtli to Moctezuma II – were identified by the *icpalli*, or throne, made from woven reeds, and the royal crowns or diadems known as the *xiuhuitzolli*[19] or *copilli*.[20] A speech scroll, also turquoise blue in colour, indicated their status as *tlatoani*. Illustrations in the manuscript compiled by the sixteenth-century Jesuit Juan de Tovar and in the Codex Mendoza exalt the figure of Acamapichtli as the founder of the dynasty. His *icpalli* is adorned with jaguar pelts, drawing attention to his position as the founder of the royal lineage (fig. 7).

Another account from the sixteenth century, the Primeros Memoriales, depicts the royal leaders, from Acamapichtli to the indigenous chieftains who governed under Spanish rule, rather differently (fig. 8). Here, the first three *tlatoque* are shown with insignia of lesser complexity and status: a headdress with two eagle feathers, and a yellow and blue band from which two strips hung, similar to the *cuauhpilolli* (a type of feather headdress); a *tilma* or ochre-coloured mantle and woven reed mat. From the fourth *tlatoani*, Itzcoatl, onwards, the leaders bear the insignia of the *huey tlatoani* or supreme ruler: the turquoise mosaic *xiuhuitzolli*, the bar-shaped *nariguera* (nose-plug) made from the same material, the *tilma* with turquoise designs and the reed mat.[21]

The Primeros Memoriales perhaps provides a more accurate picture of the political reality experienced by the Mexica in their first years at Tenochtitlan. In order to found their city, they had first to request permission from the chieftain Tezozomoc, the Tepanec ruler of Azcapotzalco who ruled over the territories of Lake Tetzcoco. They were effectively his subjects and thus obliged to pay tribute and render him service. Tezozomoc had been developing an aggressive policy of military expansion, eroding the former dominance of Tetzcoco and encroaching on the territory of Culhuacan. He ordered the Mexica to invade this city together with Tenayuca. Both conquests are recorded in the first plate of the Codex Mendoza as corollary to the founding of Tenochtitlan by means of mercenary actions. Hence the first three rulers of Tenochtitlan governed under the supervision of Azcapotzalco. The fact that Tezozomoc effectively used them as an army explains why, instead of the turquoise diadem of the *tlatoani*, they wore the insignia of great military warriors.

In spite of the contradictions of the different historical sources, in recent years the following royal lineage of Tenochtitlan has generally been accepted (fig. 9). Acamapichtli, the first *tlatoani*, is recognized as the father of the second and fourth *tlatoani*: Huitzilihuitl and Itzcoatl. The third and fifth *tlatoani*, Chimalpopoca and Moctezuma I, are the sons of the second chieftain, Huitzilihuitl. A daughter of Moctezuma I and a son of Itzcoatl were

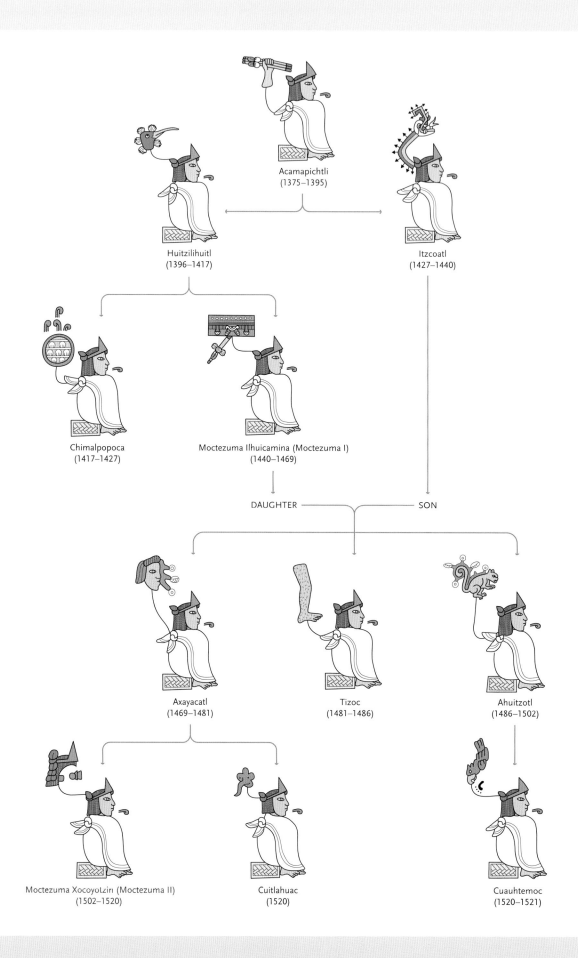

Acamapichtli
(1375–1395)

Huitzilihuitl
(1396–1417)

Itzcoatl
(1427–1440)

Chimalpopoca
(1417–1427)

Moctezuma Ilhuicamina (Moctezuma I)
(1440–1469)

DAUGHTER — — SON

Axayacatl
(1469–1481)

Tizoc
(1481–1486)

Ahuitzotl
(1486–1502)

Moctezuma Xocoyotzin (Moctezuma II)
(1502–1520)

Cuitlahuac
(1520)

Cuauhtemoc
(1520–1521)

Fig. 9
The succession of Mexica rulers,
their name glyphs and dates of rule.

the parents of the sixth, seventh and eighth *tlatoque*, Axayacatl, Tizoc and Ahuitzotl, three brothers who reigned successively. Axayacatl fathered Moctezuma II and his successor Cuitlahuac, who reigned briefly following Moctezuma's death but died of smallpox.[22]

Acamapichtli (1375–1395)

The name glyph, or pictorial symbol, of the first *tlatoani* identifies him as 'he who holds the rods or reeds in his hand'. Acamapichtli, who was Culhuacan in origin, governed in difficult times. Just a few years earlier, the Mexica had conquered his homeland on the orders of the ruler of Azcapotzalco. Furthermore, as he was not linked to this powerful monarch by marriage, his freedom to rule was severely constrained. He was barely able to fulfil his fundamental requirement to embellish the temple as lavishly as possible, since he was mainly engaged in the military enterprises ordered by Azcapotzalco, undertaking the conquest of the fertile lands of Mixquic, Cuitlahuac and Xochimilco to the south of Lake Tetzcoco, advancing towards Tlahuica, and conquering Cuauhnahuac.

Huitzilihuitl (1396–1417)

The son of Acamapichtli, this young ruler, whose name means 'hummingbird feather', continued the military campaigns ordered by Acapotzalco and succeeded in conquering a number of key territories.[23] He played an important role in the clash between Tezozomoc and Ixtlilxochitl, the ruler of Tetzcoco, whose assassination he ordered, obliging the legitimate heir, the young Nezahualcoyotl, to flee. However, he was killed during the course of this conflict.

As a means of strengthening his political power, Huitzilihuitl initiated a policy of matrimonial alliances between Tenochtitlan and various royal families in the region.[24] His marriage to the daughter of the ruler of Cuauhnahuac produced Moctezuma Ilhuicamina. Following drawn-out negotiations, he later married a Tepanec princess, the daughter of Tezozomoc, whose son, Maxtla, was vehemently opposed to the union. It also fell to Huitzilihuitl to lead the second New Fire ceremony, probably the most important Mexica ritual (see pp. 140–43), which was held on Mount Huixachtlan, known since colonial times as the Hill of the Star.

Archaeological excavation of the Templo Mayor suggests that its oldest phase of construction, with a dual pyramid, is linked to the reign of one of the first three *tlatoani*: Acamapichtli, Huitzilihuitl or Chimalpopoca. The pyramid preserves remains of the twin temples dedicated to the Mexica tribal god Huitzilopochtli and the rain god Tlaloc respectively. On the side dedicated to Huitzilopochtli lay the sacrificial stone on which the hearts of captive warriors were removed, as well as reliefs and sculptures dated 1390 (2 Rabbit[25] and 1 House in the Mexica calendar). Also discovered was a human head, perhaps the earliest manifestation of a ceremony commemorating the decapitation of Huitzilopochtli's sister, the moon goddess Coyolxauhqui (see pp. 133–34 and fig. 10). The image represents the triumph of the sun, since its rising brings about the death of the lunar goddess. On the side of the temple dedicated to Tlaloc remain the earliest traces of the wall

paintings that adorned sacred buildings as well as the polychrome *chacmool*, a statue of a recumbent human figure that served as an altar.

Chimalpopoca (1417–1426)

The accession of Chimalpopoca, whose name glyph is a smoking shield, heralded better times for the Mexica, since his ascendancy linked him to Tezozomoc, the ruler of Azcapotzalco. According to some chroniclers, he was not the legitimate son of Huitzilihuitl, although other histories present him as his brother. Many present-day historians consider that he is a direct descendant, although it is most likely that he was an illegitimate son borne by a secondary wife or even a concubine. Although a significant number of Tepanecs opposed him, Tezozomoc eventually approved of Chimalpopoca's election as *tlatoani*, granting him a temporary reduction of the tribute paid to Azcapotzalco. Accounts agree that Chimalpopoca was very young, between nine and twelve years old, when he ascended to the throne. Fortunately, during the first decade of his reign there were no major military campaigns in which he had to participate. The only confirmed activities were the taking of Tequixquiac in the north and support for the Tepanecs in their attack on Chalco.

Tezozomoc died in 1426 at an advanced age, leaving the throne to his youngest son Quetzalayatzin. This infuriated his eldest son, Maxtla, who subsequently killed his brother and usurped the throne. Since Chimalpopoca had supported Quetzalayatzin, Maxtla ordered his capture and had him thrown into a cage in the central square of Azcapotzalco, where he was stoned to death.

Itzcoatl (1427–1440)

The insulting death of Chimalpopoca inflamed the Mexica who decided to use his murder as a pretext for launching an attack on the Tepanecs. They chose as their leader Itzcoatl, 'obsidian snake', a skilled warrior capable of leading his people into battle and the son of Acamapichtli borne by a common woman or even a servant, a family lineage that in no way diminished his status.

The waging of war against the Tepanecs was an epic deed that exalted the bravery and daring of the Mexica in their quest to conquer the known universe. The people of Tenochtitlan gained the support of the Aculhua, the followers of Nezahualcoyotl – descendant of the last legitimate king of Tetzcoco – who had protected his own life by sheltering with his relatives, waiting for an opportunity for revenge. The people of Tlacopan (or Tacuba), who were affiliated with the Tepanecs, also reached an agreement with the insurgents to ensure their neutrality. The agreement between the three principal allies of Tenochtitlan, Tetzcoco and Tlacopan became known as the Triple Alliance, under which the partners agreed not to attack each other, to provide mutual support in case of attack, and to assist each other in military campaigns. It was agreed that any tributes gained by conquest would be shared equally between Tetzcoco and Tenochtitlan. In practice, however, the Mexica took the greater share of the payments and retained their military supremacy.[26]

The confrontation of Azcapotzalco and Coyoacan with the Mexica and Aculhuas represented the breakdown of the existing order in the central region of Mexico. Following numerous skirmishes in 1428, the great city of Azcapotzalco was captured. Its main buildings were damaged and it suffered terrible humiliation. One year later, the Triple Alliance conquered Xochimilco, but it was not until 1430 that they achieved ultimate victory over the Tepanecs, after which the ruler Maxtla was executed and Coyoacan conquered. The following year saw the fall of the neighbouring lake city of Tlatelolco, which had favoured the Tepanecs. Itzcoatl took advantage of his success, sending his armies beyond the mountainous borders, occupying areas in the tropical valleys, and taking the cities south of Tenochtitlan.

The victorious Itzcoatl and his allies imposed a new political order in the Basin of Mexico. Two figures that were particularly prominent during the military campaigns were Moctezuma Ilhuicamina and his brother Tlacaelel, who masterminded the political strategy that led the Mexica to victory. Tlacaelel became Itzcoatl's most important adviser. New noble titles were created and the recently captured lands were distributed and assigned to *pipiltin* in order to shore up their position and distinguish them from the commoners as part of the new social structure. Alongside the *tlatoani*, four supreme *pipiltin* were sworn in with new titles.[27] They advised Itzcoatl to burn the historical accounts that were kept in the main indigenous cities, erasing all information that existed prior to his glorious victory over the Tepanecs. Starting with the reign of Itzcoatl, history was rewritten.[28]

Tenochtitlan benefited greatly from its recognition as the seat of the *huey tlatoani*, the most powerful ruler in the empire, and from this time it grew in splendour. Archaeological findings from the Templo Mayor suggest that Stage III of the building process occurred during the reign of Itzcoatl, since one of the walls bears the date 1431 (year 4 Reed). Opposite the flight of stairs to the temple of Huitzilopochtli were found eight life-size sculptures of standard-bearers, which may have represented the Huitznahuas, warriors from the south who went into battle against the Mexica deity.[29] On the Tlaloc side, an unusual image of the earth goddess Cihuacoatl was discovered, in which the face of the deity is combined with a serpent. Alongside was a coiled snake, which may have been used as a ritual receptacle; it is very geometrical in style and bears the original polychrome decoration, pigments that have mostly been lost on Pre-Hispanic sculptures.[30] The urban infrastructure of Tenochtitlan expanded with the construction of a road linking the metropolis to Xochimilco, a task carried out by its defeated people, with Itzcoatl and his allies, by way of reparation.[31]

Moctezuma Ilhuicamina (Moctezuma I) (1440–1469)

A new stage in the status and grandeur of Tenochtitlan and the forging of the Mexica empire can be attributed to the reign of Moctezuma Ilhuicamina. His name means 'He Who Grows Angry [like a] Lord', but his name glyph exalts his great might as 'He Who Pierces the Sky with an Arrow'. From the very start of his reign, Moctezuma I organized military campaigns throughout the tropical valleys of Morelos, reinforcing his dominance. He defeated Chalco, seizing control of the western part of the marshland basin, which enabled him to launch campaigns towards the Gulf of Mexico and Oaxaca. Moctezuma also laid the ground for the future military expansion of the Mexica towards the west of Mesoamerica, leading

major conquests in the Toluca valleys and the area of Xilotepec, commanding victorious campaigns against the Huastecs and Mixtecs, and capturing the important city of Ahuizilapan.

The general strategy followed by this skilled military leader was to move in all directions at once. This is graphically represented in an extraordinary sculpture known as the *Cuauhxicalli* of Moctezuma Ilhuicamina, on which a sequence of eleven scenes depicting the conquest of different peoples is carried out under the protection of the shining solar disc.

Almost halfway through the reign of Moctezuma I, a series of natural disasters occurred. In 1450, just as the campaign against the Huastecs was under way, continuous rainstorms raised the level of Lake Tetzcoco, flooding Tlatelolco and Tenochtitlan, destroying the peasants' houses and undermining the foundations of many of the temples and palaces, some of which collapsed. This first inauspicious omen obliged Moctezuma to consult Nezahualcoyotl, now the ruler of Tetzcoco, who helped him by designing a barrier to protect the city against future floods. Nearly fifteen kilometres long, the dyke stretched from the Tepeyac on the north of Lake Tetzcoco to Iztapalapan on its southern banks, and took several years to build. At Moctezuma's request, Nezahualcoyotl also redesigned and oversaw the construction of an aqueduct to carry drinking water from Chapultepec to the heart of the city.

That winter, there was an unprecedented freeze that blanketed the land in snow, and the following spring, the unseasonably cold weather destroyed the few shoots that had survived. Then a great famine set in, along with an epidemic of respiratory illnesses, and, still worse, over the next few years there ensued the worst drought ever experienced. By 1454 there was nothing to eat and traders travelled from the coast to purchase the once proud Mexica as slaves in exchange for a few corncobs. It has been suggested that the population fell by fifty to eighty per cent during this period.[32]

The terrible famine that struck in 1454 (year 1 Rabbit) unsettled the entire central region of Mexico. It affected both friendly and hostile neighbours of the Mexica, sparking the *xochiyaotl*, 'flower wars', fought mainly against Tlaxcala and Huexotzinco. These military rituals, which enabled both sides to capture vigorous warriors to be sacrificed to the gods, became increasingly linked to the practice of war. The famine also led to the reorganization of key events in the Mexica calendar (see fig. 47) to avoid the bad luck associated with the year of famine.[33]

Despite the setbacks, the valuable tributes received by Tenochtitlan from conquered lands, and the abundant new sources of labour, enabled Moctezuma and Tlacaelel to impose their visions of grandeur on the city. The *tlatoani* built a beautiful palace for himself to the west of the Templo Mayor (see fig. 39), embellished the city with sculptural monuments, and undertook major renovation work to the base of the pyramid and the temples of Huitzilopochtli and Tlaloc. Stages IV and IVa of the structure have been attributed to the reign of Moctezuma I.[34] Findings from this period include those from chamber II, in the centre of the flight of steps opposite the sanctuary of Tlaloc, which contained numerous objects from Mezcala, south of Tenochtitlan, offered as precious tributes. On the Huitzilopochtli side, chamber I contained a beautiful sculpture of the goddess Mayahuel carved in diorite and associated with Huitzilopochtli's sister, the moon goddess

Coyolxauhqui.[35] When Moctezuma I foresaw that his end was near, he ordered his portrait to be carved into the bedrock at Chapultepec Hill (see pp. 80–81).

Axayacatl (1469–1481)

The prestige of Moctezuma I moved the council of elders to choose as his successor Axayacatl, the youngest of his grandsons, over the dead monarch's son. His mother was the daughter of Moctezuma I and his father was a son of Itzcoatl. Axayacatl was an outstanding warrior, whose name glyph defines him as 'he who has water on his face, the valiant one'. In the days of his grandfather he had conquered Tepeyacac in the Tlaxcaltec valleys. With the help of Nezahualcoyotl, Axayacatl advanced in his military exploits, mainly through the western region, allowing him to secure Tuxpan and the area north of Veracruz.

During his reign, a conflict took place that resolved the problematic relationship with the neighbouring city of Tlatelolco. Following the discovery of plans for a traitorous attack against Tenochtitlan, Axayacatl and Tlacaelel organized a swift campaign against

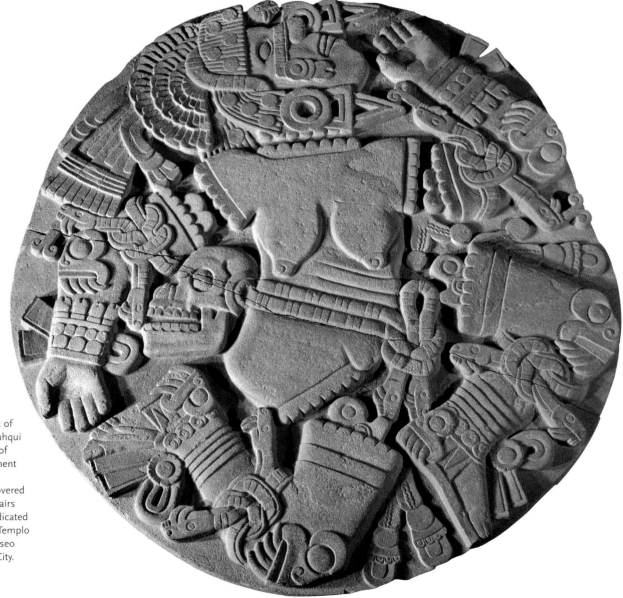

Fig: 10
The monumental stone disc of the moon goddess Coyolxauhqui commemorates the legend of her defeat and dismemberment at the hands of her brother Huitzilopochtli. It was discovered in place at the foot of the stairs leading up to the shrine dedicated to Huitzilopochtli atop the Templo Mayor. Diameter 3.2 m. Museo del Templo Mayor, Mexico City.

Tlatelolco that concluded with the death of its leader, Moquihuix. This put an end to the city's independence, leading to the imposition of a military governor allied to the Mexica.

The IVb construction stage of the Templo Mayor, which involved extending the western façade, is attributed to the reign of Axayacatl and dated around 1469. The symbolic nature of the building is highlighted by the survival of some extraordinary sculptural elements. Huge serpent heads flank the flights of stairs on each pyramid. Those on the Huitzilopochtli side are covered with feathers and those on the Tlaloc side have blinkers, framing the solar disc of Coyolxauhqui, discovered in 1978 (fig. 10). On the Tlaloc side, an altar was also found with frogs as standard-bearers, and numerous other objects.[36]

Tizoc (1481–1486)

The life and reign of Tizoc are somewhat enigmatic. His name glyph is a scarred leg, possibly the wounds from auto-sacrifice, which can be interpreted as 'he who does penitence'. Despite being Axayacatl's older brother, he reigned at a later date.

Fig. 11
The Stone of Tizoc celebrates the capture and subjugation of the deities of enemy towns taken in the course of conquests by his predecessors. Diameter 265 cm. Museo Nacional de Antropología, Mexico City.

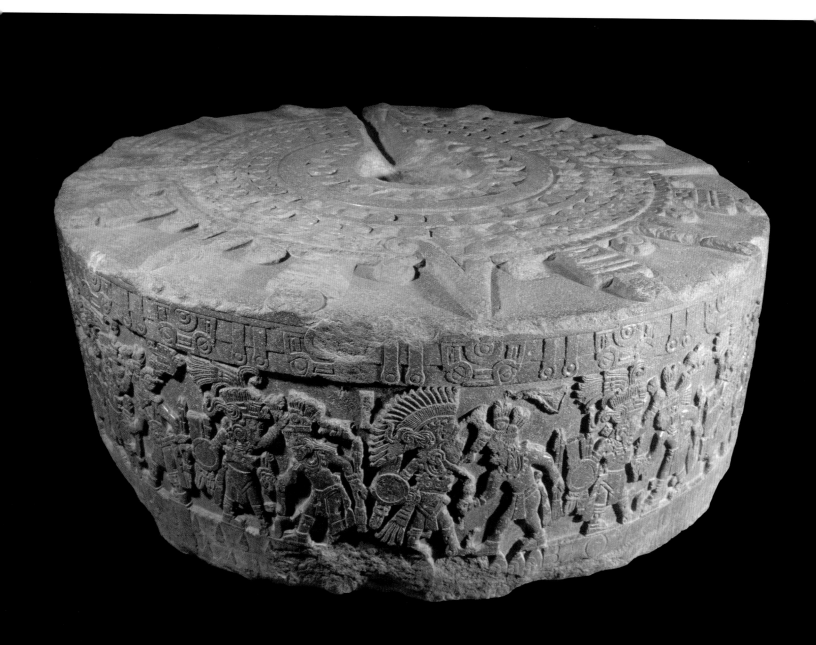

As a coronation war, Tizoc organized the attack on Metztitlan, which maintained its status as an independent area in the region of Hidalgo. The campaign was disastrous, since very few captives were taken for the sacrifice. Later, he led his armies to the Matlatzinca area of Toluca, whose people were threatening to rebel.

Tizoc initiated a new stage in the building of the Templo Mayor, which was never completed. Stage V has been dated from 1482, corresponding to his reign. The most important archaeological finding is the House of Eagles, a ritual palace containing sculptures of eagle warriors as well as two images of the god of death, Mictlantecuhtli.[37]

Tizoc's early death remains something of a mystery. Some believe that he was poisoned or cursed through sorcery.[38] During his brief reign was carved the magnificent *Cuauhxicalli* or Stone of Tizoc (fig. 11),[39] similar to the monument created for Moctezuma I. On it are represented the conquests of his ancestors and those he led in the Matlatzinca campaign.[40] His effigy is identified by his name glyph and he wears a spectacular hummingbird helmet evoking the Mexica patron deity Huitzilopochtli.

Ahuitzotl (1486–1502)

The name of the eighth *tlatoani* Ahuitzotl alludes to a mythical predatory otter that was thought to dwell at the bottom of the lake, posing a constant threat to those who lived on its banks (see cat. 13). Ahuitzotl's name defines him perfectly owing to the ferocity of his military enterprises. The archetypical Mexica warrior, he emulated the actions and bearing of his grandfather, Moctezuma I. His achievements in the expansion of the Mexica empire led some historians to confer on him the epithet 'Ahuitzotl the Great' or 'Lion of the Anahuac'.[41]

Ahuitzotl concluded the remodelling of the Templo Mayor in 1487 (year 8 Reed). He carried out military campaigns against the Huasteca and conquered territories including Tzicuac, Molango and Zapotlan. The commemorative stone that records this deed[42] shows the building's magnificent appearance, with its splendid flights of stairs and the eye-catching red temples decorated with murals that flanked the building to the north and south. The dramatic shrine bearing *tzompantli* or stone skull racks is also depicted.[43]

In around 1494, Ahuitzotl's armies dominated the central valleys of Oaxaca, and over the next few years their campaigns took them to Tehuantepec. He also conquered the territory of Soconusco, which gave Tenochtitlan guaranteed access to the valuable cacao-bean crops that flourished in that region.

In around 1500, the victorious *tlatoani* undertook an ill-fated hydraulic project to carry drinking water into the city. Despite warnings that disaster would ensue, he went ahead, consequently flooding a large part of Tenochtitlan. Some chroniclers state that Ahuitzotl died two years later from a blow to the head that occurred during the disaster. By his military campaigns, Ahuitzotl had extended Mexica dominance across a large part of Mesoamerica during his reign. These extensive territories, together with the immense wealth obtained from the flow of trade and the payment of tributes, laid the foundations for the powerful empire that would be inherited by his nephew Moctezuma Xocoyotzin.

Fig. 12 *following pages*
Rows of stone skulls, representing the dead. From Structure B adjacent to the Templo Mayor, Mexico City.

Cat. 1
Cuauhxicalli eagle

c. 1502, Mexica
Andesite, 82 × 139 × 76 cm
Museo del Templo Mayor, Mexico City, inv. 10-252747

Selected literature: Hernández Pons 1987; Matos Moctezuma 1988b, pp. 50–53; Hernández Pons 1997; London 2002, p. 462, no. 249

This sculpture depicts a golden eagle (*Aquila chrysaetos*), poised ready to attack. A circular cavity on its back, 41 cm wide and 19 cm deep, identifies the object as a *cuauhxicalli* or 'eagle vessel', a container used for sacrificial offerings. The carving is notable for its technical skill and realism, particularly in the plumage and anatomical details. Unfortunately, there are cracks in one part of the beak and in the right eye, possibly damage incurred during the Spanish invasion. The fine, flame-like feathers around the eyes emphasize the symbolic links between the sun and the eagle in Mexica culture.

This piece was found in 1985 in Pre-Hispanic foundations adjoining the Templo Mayor, close to where another *cuauhxicalli* sculpture, of a jaguar, was found in 1901 (now in the Museo Nacional de Antropología in Mexico City). In Mexica religion, the jaguar was related to the night and the earth, so the proximity of these two pieces could allude to the sun and the earth as the main recipients of the blood obtained from sacrifices.

The fact that this sculpture was found in the sacred precinct of Tenochtitlan and was a container for blood offerings suggests that it played a significant role in the daily rites of the Mexica elite headed by the *huey tlatoani* or supreme ruler. Documentary sources reveal that the latter played a leading role in ceremonies and dances held in the sacred complex during religious feasts.

CJGG

Cat. 2
Greenstone heart

c. 1500, Mexico
Diorite, 24.5 × 20.5 × 13.3 cm
Museo Nacional de Antropología, Mexico City, inv. 10-392930

Selected literature: Dahlgren *et al.* 1982; Solís Olguín 1991,
pp. 25–27; Solís Olguín 1991b; London 2002, pp. 437–38, no.
154; Bilbao 2005, p. 59, no. 261

According to Pre-Hispanic Mexican cosmology,
the heart is a vital organ containing the energy
required to feed the gods, particularly those
associated with the sun. The foundation myth
of Tenochtitlan regards the heart of Copil, one
of the foes of the original Mexica migrants,
as the seed that gave rise to the nopal
cactus on which an eagle perched, fulfilling
Huitzilopochtli's prophecy by marking the
site destined to be the capital of the Mexica
empire.

This sculpture combines both a naturalistic
and symbolic vision of the heart's anatomy.
The cross-sections of the veins and arteries
that connect the organ to the body are shown
as they would have appeared following a
human sacrifice. Here, they also resemble a
grotesque face with prominent fangs, similar
to those found on sacrificial knives and in
depictions of the earth goddesses Coatlicue
and Tlaltecuhtli.

The heart was found in a former palace
close to the north of the Templo Mayor, which
was used during the reign of Moctezuma II.
The sculpture was discovered inside a sacred
chamber with black-painted walls known as
tlillancalco, or place of blackness, thus it may
have symbolized the heart of the Mexica
people – the heart that was taken from the
sacrificed nephew of Huitzilopochtli – and
thus constituted part of the capital's
foundation myth. *FSO and RVA*

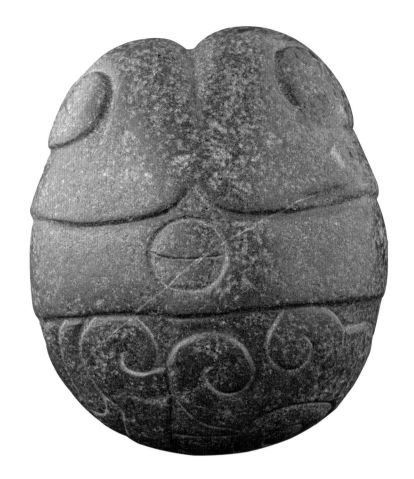

This Picture presents the number of 51.yeares : that is, the time of Tenuchs reigne : in this wheele or square (which, as all the like representing yeares, are in the originall picture coloured blew) the pictures of men signifie the ten Lords or Gouernours before mentioned ; their names are inscribed in the originall pictures, which here we haue by the letters annexed directly to a following glosse. A.Acasitli. B Quapan. C Ocelopan. D Aguexotl. E Tecineuh. F Tenuch. G Xomimitl. H Xocoyol. I Xiuh-caqui.

Cat. 3

The founding of Tenochtitlan

Title page of the Codex Mendoza, reproduced as a woodcut in Samuel Purchas, *Hakluytus posthumus or Purchas his Pilgrimes*
1625, London
Paper, 37 × 48 cm
The British Library, London, vol. III, G. 6840, p. 1068

Selected literature: Brotherston 1995, pp. 55–61, 145–53; Berdan and Anawalt 1997; Boone 2000, pp. 197–237

Between 1616 and 1626, the native-produced Codex Mendoza (see cat. 17) was in the possession of travel writer Samuel Purchas (*c.* 1577–1626), who published it under the title 'The History of the Mexican Nation'. To illustrate the work, woodcuts were made from several sections of the codex's pictographic text, including the title page, which narrates the founding and early history of Tenochtitlan.

The stylized plan of the island city is divided into four wards by two main canals drawing directly on the Pre-Hispanic genre of historical mapping that took the form of a basic cosmic diagram. Exemplified both in creation myths and in native graphic expression, the quincuncial or five-point configuration (see cats 14 and 15) probably found its origin in the four positions on the horizon of the rising and setting sun at summer and winter solstice, conjoined over the earth at its centre. 'Cosmic maps' thus inscribe the perceived circumambulation of space by time and narrate key historical moments, especially beginnings and ends.

The map offers two readings of Tenochtitlan. From the years 2 House (1325) to 13 Reed (1375), and by way of the characteristic unbroken strips of the *xiuhpohualli* (year count) at its border, time is seen to move anticlockwise around the first fifty-one years of the city's history, from founding to the death of its early leader Tenoch (pictured centre left). Distorted in the Purchas copy, the New Fire ceremony in year 2 Reed (1351) is also recorded in the fire-drilling glyph over the calendar year 3 Flint (bottom right-hand corner, to the immediate right of the warrior's foot). It should sit over the glyph of the previous year 2 Reed glyph. At the centre, the eagle, symbol of the sun and avatar of the deified migratory leader Huitzilopochtli, stands on the stone and cactus that make up the city's name, together encapsulating the mythical history of its foundation. Beneath, the arrow-backed shield, Tenochtitlan's power glyph, anticipates the history of conquests that will follow.

Scholars have proposed that the map is oriented to the west, as indicated by the House glyph at the top, one of the four year-bearers (House, Rabbit, Reed, Flint), each of which represented a cardinal direction. To the east (at the bottom) are narrated the first two 'conquests' of Tenayuca and Culhuacan, although these mainland towns in fact lay to the north and south of Tenochtitlan. While their absence from the codex's list of conquests suggests that they submitted peacefully, together with their position to the east their depiction offers a wider reading that alludes to the geographical extent of the empire and its means of subjection. The strategically placed power glyph echoes the three-directional thrust and, with the solar eagle and name glyph, places Tenochtitlan at the cosmic centre of the world. The actual geographical extent of the empire was mainly to the north, east and south. In comparative terms, it barely penetrated land to the west. Thus, Tenayuca and Culhuacan symbolize the northern and southern extensions, and the power glyph (placed in opposition to the House glyph) the eastern one. *EW*

Cat. 4

The Nuremberg map of Tenochtitlan

Preaclara Ferdinandi Cortesii ... epistola, Friedrich Peypus (publisher)
1524, Nuremberg
Paper, 35 × 65 cm
The British Library, London, C.20.e.9

Selected literature: Cortés 1986; Toussaint, Gómez de Orozco and Fernández 1990; Mundy 1998

Together with an outline of the Gulf Coast, the 1524 map of Tenochtitlan was first published as a woodcut in a Latin translation of Cortés's second and third letters from Mexico to the Habsburg emperor Charles V. The original map was probably prepared on Cortés's orders, although date and authorship are unknown, and it was most likely an indigenous prototype that became increasingly Europeanized through copying. Certainly, Cortés's written descriptions of Tenochtitlan could not have provided a European artist with the means of graphically reconstructing the city's layout. The map's commentaries identifying the sites of key events would therefore also appear to be translations of annotations made on the map or its copy (possibly by Cortés) before its despatch to Europe.

The map is possibly that mentioned by Cortés in his third letter as having already been sent to the king. In this case, the proportionally oversized standard bearing the crowned two-headed eagle of the house of Habsburg would suggest that it belonged to an interim despatch between the second and third letters, in which Cortés announced his consolidating victory over Tenochtitlan. The flag flies from a town located on the mainland to the south-west which must represent Coyoacan. It was here that Cortés established himself after the destruction of the city, and wrote his third letter describing the event. It is also unlikely that the flag was added to the woodcut on the basis of the second or third letter, for Cortés does not give Coyoacan's exact geographical location in either. The flag therefore complemented the commentaries by identifying the town and, thus, his victory in the king's name.

The representation of the central ceremonial precinct may offer the strongest clue to an original indigenous authorship, for some of its main elements – either omitted or misreported by Cortés – are present. The unfamiliar forms within the precinct nevertheless taxed the copyists. Although the notes refer to sacrificial decapitation, the skull racks were transformed into objects more closely resembling elaborate wrought-iron grilles. It seems possible that the headless figure in classical pose at the centre was added to qualify the commentary. The stepped, sloping walls of the Templo Mayor's dual structure were honoured but, as with all representations of Mexica pyramid-platforms on the map, recourse was seemingly taken to Cortés's descriptions: with flying parapet walkways and conical roofs (even the occasional Gothic spire), the '*torres y mezquitas*' (towers and mosques) of Tenochtitlan would certainly have fired the European imagination.

EW

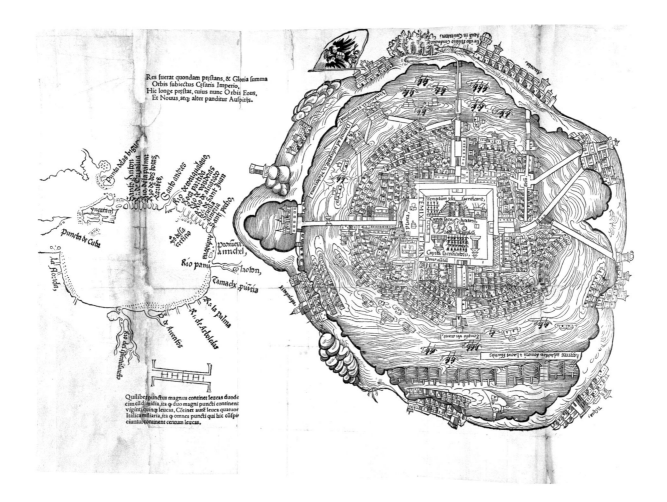

Cat. 5

Cactus

c. 1450–1500, Mexica
Basalt, 97 × 28 cm
Museo Nacional de Antropología, Mexico City, inv. 10-220928

Selected literature: Easby and Scott 1970, fig. 287; Pasztory 1983; Solís Olguín 1991, pp. 121–22; Amsterdam-St Petersburg 2002, p. 240; London 2002, p. 416, no. 68

The cactus is one of the most characteristic plants of the Mexican landscape, particularly in the arid and semi-dry regions. Its trunk and branches grow vertically, recalling a candelabrum, hence its botanical name of *Cereus* (wax candle). Large cacti have been used to mark out boundaries and streets since Pre-Hispanic times, and this variety has subsequently acquired the name *Cereus marginatus*.

This naturalistic sculpture of a cactus was discovered in the nineteenth century in the hinterland between the two indigenous cities of Tenochtitlan and Tlatelolco. Even today there is a nearby alleyway called Calle del Órgano (organ), probably in reference to the plant's function as a boundary marker between the two territories. The cactus is depicted complete with its roots. Such naturalism is a distinguishing feature of Mexica sculptures. Another characteristic trait is the relief on the base which conveys a symbolic or ideological message, a tradition that is also evident in famous sculptures such as the Great Coatlicue in the Museo Nacional de Antropología. The relief shows a face in profile, topped by a nopal cactus with prickly pears and flowers emerging from a stone. It is adorned with an ear-spool in the form of an eagle's beak grasping a rattlesnake. These are the attributes of Tenoch, the Mexica leader and founder of Tenochtitlan. *FSO*

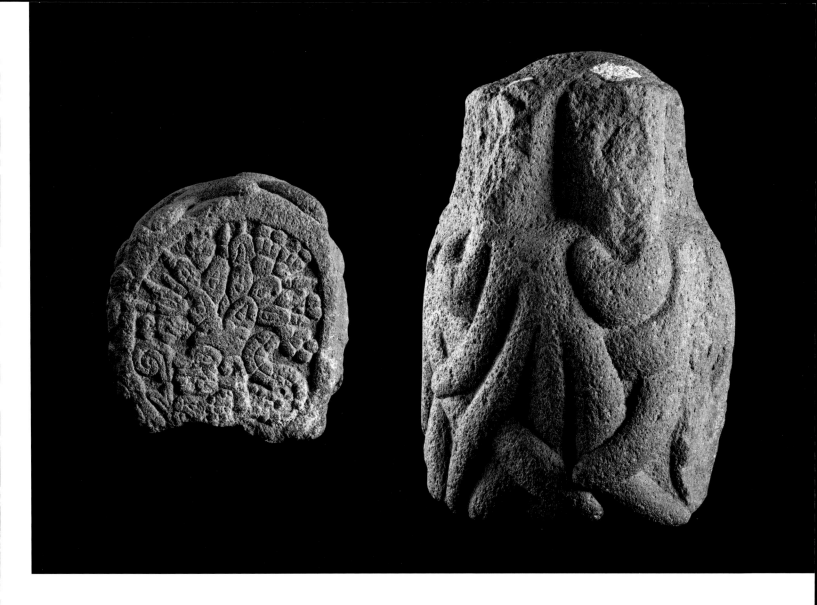

Cat. 6
Sculptural fragment of a cactus

c. 1430–1500, Mexica
Basalt, 37 × 29 cm
Museo Nacional de Antropología, Mexico City, inv. 10-46716

Selected literature: Barlow 1987, pp. 59–66; Alvarado Tezozómoc 1998, pp. 29–45, 63–70; Chimalpáhin 1998, vol. III, pp. 219, 361–63; Solís Olguín 2004b, pp. 357–75

Realistic sculptures of cacti such as the present example and cat. 5 were probably used to mark geographical boundaries in ancient Tenochtitlan. From a group of four monuments that share these characteristics, only cat. 5 has a known source. Solís Olguín believed that the Mexicas may have used them to mark the edges of their island, especially to the north where, until the mid-fifteenth century, Tenochtitlan was separated from the islet of Tlatelolco by a canal only a few metres wide. Solís Olguín pointed out the presence of reliefs on two of the sculptures, featuring the profile head of Tenochtitlan's founding leader, Tenoch, after whom the city was named.

Numerous archaeological monuments bear carvings in concealed areas, including their bases. These have been interpreted as written messages for Tlaltecuhtli, ('lord of the earth'), or for the earth itself (Coatlicue). If this is the case, the reliefs on the bases of this group of plant sculptures may have served not only to indicate the city's surface area but also to highlight the distinction between Tlatelolco and the earth gods.

The two Mexica factions had shared a fierce rivalry since 1337, almost thirteen years after the founding of Tenochtitlan, when a group of Mexicas with grievances about land distribution decided to establish their own city on islets to the north of the spot where Tenoch had seen the eagle perched on a cactus. By 1473, Tlatelolco had been defeated by Tenochtitlan and the rebels were deprived of all their privileges – including the right to appoint their own *tlatoani* and receive tributes – while their ceremonial compound was turned into a dung-heap. It is possible that the reliefs on the bases of these monuments commemorate this victory, as well as reminding the earth gods that, although the two Mexica groups formed a single conurbation, only Tenochtitlan had been built on the land promised by Huitzilopochtli, from which its inhabitants would go on to conquer all the known world. *RVA*

Cat. 7
Anthropomorphic sculpture

c. 1350–1521, Mexica
Andesite and shell, 63 × 20.5 × 18 cm
Museo Nacional de Antropología, Mexico City,
inv. 10-40607

Selected literature: London 2002, p. 410, no. 36; Bilbao
2005, p. 18

During the reign of Moctezuma II, the
sculpture workshops of Tenochtitlan
produced stone images that were unrivalled
in Mesoamerican art. Although incomplete,
this fragment, with its detailed depiction of
the male anatomy, is one of the best
surviving examples. Like many other objects
in the collections of the Museo Nacional de
Antropología, it has an unusual story. After
its excavation, the sculpture arrived at the
museum in two pieces (the torso was split
just above the loincloth). This is how it was
photographed in the 1930s. But at the
opening of the first Museo de Antropología
in Chapultepec Castle in 1940, only the
upper part of the bust was exhibited. The
other section had been mislaid in the
basement during the transfer of the
collection from the historic centre to its new
home. The bust was displayed in this way
until the lost section was found during a
refurbishment in 1999, and the two parts
of the torso that is so admired today were
reunited.

The subject's body is slightly stylized in
its elongation, but the sculptor has achieved
an extraordinary naturalism, particularly in
the torso area with its prominent collarbones
and flat stomach. The rectangular cavity in
the chest was once filled with jade serving
as a 'heart' to endow the statue with life.

The facial features reflect the idealized
Mexica model of beauty for young men.
The inlaid shells around the eyes enliven
the expression, and the pupils would have
been made of obsidian. The perforations
in the lobes indicate that in its full glory
the figure must once have worn ear-spools
made from semi-precious stones. The figure
wears a *maxtlatl* (loincloth), a garment
worn only by men, comprising a length of
cotton material passed between the legs
and knotted in front with two strips (here
broken) hanging down. FSO

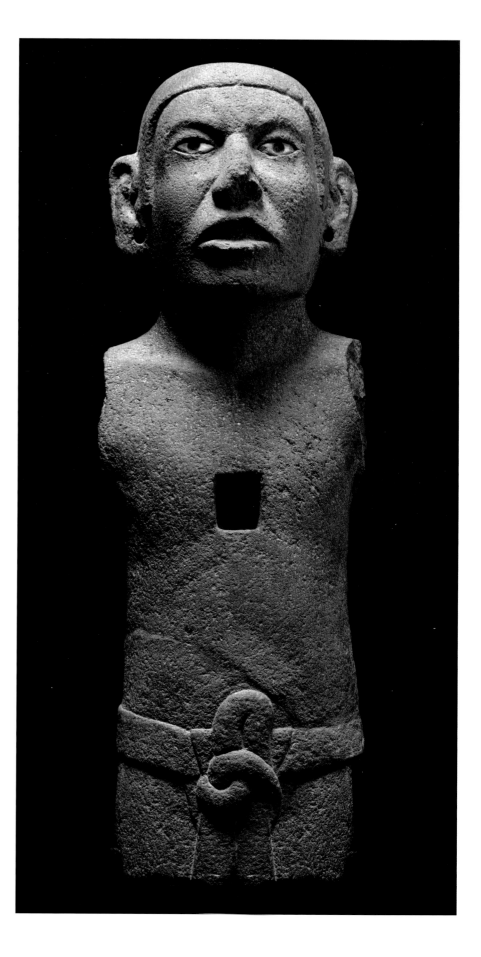

Cat. 8
Female figure

c. 1325–1521, Mexica
Stone, 43 × 19.6 × 26.5 cm
Trustees of the British Museum, London, AOA Am 1922,1211.1

Selected literature: Durán 1971, pp. 221–28; Anawalt 1981, pp. 211–14; Pasztory 1983, pp. 218–22; Baquedano 1984, p. 64; Madrid 1992, p. 207, XLVI; London 2002, p. 412, no. 46; New York 2004, no. 22

This figure's kneeling pose is typical of the women of all ages and classes, as well as deities, depicted in sculptures and illustrations from the early colonial manuscripts. The woman is dressed in an ankle-length skirt wrapped round her body and tied at the waist with a belt. While everyday garments for commoners were usually plain, noblewomen wore colourfully embroidered and painted textiles. Traces of pigment indicate that the sculpture might originally have been painted, and elaborate and colourful decorations may have been applied to her garments denoting her rank or status. The hair is carefully styled into two tight braids and she wears simple ear-spools. The eye and mouth cavities in her youthful face may once have been inlaid with shell or stone to convey a more vivid expression. Her hands rest on her knees, lending her a relaxed posture.

Rather than wearing an upper garment, such as the *quechquemitl* (similar to a poncho) or *huipil* (tunic), the woman is shown bare-breasted, emphasizing her femininity. Sculptures of women with naked breasts are usually related to the fertility goddesses such as Cihuateotl, the goddess of childbirth, Coatlicue, the mythical mother of Tezcatlipoca, his sister Coyolxauhqui, the maize goddesses Chicomecoatl and Xilonen, and the earth goddess Tlaltecuhtli. However, this sculpture does not incorporate any of their religious attributes.

In Mexica society a woman's place was in the home, apart from visits to market or to religious ceremonies. Although we cannot rule out the hypothesis that this sculpture might have represented a fertility goddess, it could also have formed part of a temple's decoration, representing an attendant to a female deity. *EVLL*

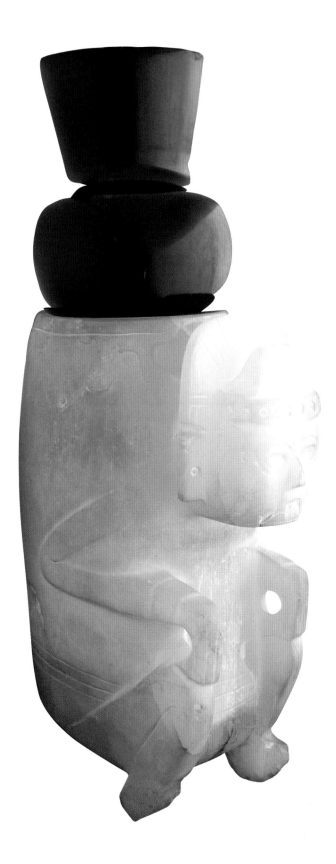

Cat. 9
Funerary urn with lid

c. 1390, Mexica
Urn: travertine, 16.5 × 9.6 × 7 cm
Lid: obsidian, 8.1 × 7.2 × 7.2 cm
Museo del Templo Mayor, Mexico City, inv. 10-264431 (urn) and 10-220307 (lid)

Selected literature: Matos Moctezuma 1986, pp. 80–81, 92; López Luján 2005, pp. 172–83, 260–62; Chávez Balderas 2007, pp. 263–85

The relief on this white travertine urn depicts a seated figure with arms bent and his hands resting on his knees. This could be Mictlantecuhtli, the god of death, as he wears a conical headdress with a paper rosette behind it. The urn's lid is made of obsidian and its spherical body has a hollow centre.

The urn was found in offering 39 at the Templo Mayor, under the floor of the temple of Huitzilopochtli corresponding to Stage II of construction, one of the earliest parts of the building, dating from around 1390. It was discovered close to the place where the image of Huitzilopochtli was located. It contained, among other items, the cremated remains of a male (the ends of his longer bones were still intact), a gold bell and various greenstone objects. The significance of this site and the cremation of the corpse suggest that it was the tomb of an important Mexica dignitary, perhaps even that of the *tlatoani* himself. *CJGG*

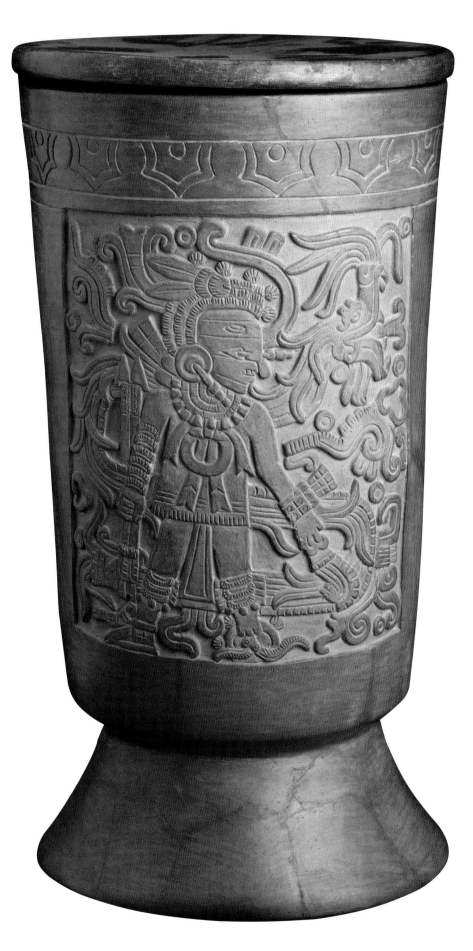

Cat. 10
Funerary urn with lid

c. 1469, Mexica
Ceramic with paint, 32.9 × 17.5 cm
Museo del Templo Mayor, Mexico City, inv. 10-168823 0/2

Selected literature: Matos Moctezuma 1986, pp. 80–81, 88;
Matos Moctezuma 1988b, p. 58; Madrid 1992, p. 351;
London 2002, p. 469, no. 279; Olivier 2004, pp. 122, 435,
509; López Luján 2005, pp. 172–83, 260; Chávez Balderas
2007, pp. 297–308, 317–21

This orange ceramic urn has straight sides
and a conical base with a matching disc-
shaped lid. It is decorated with a relief
depicting a deity. Although very similar in
appearance to the highly-prized fine orange-
ware from the Gulf Coast, recent analysis has
shown that it is an excellent imitation made
with clay obtained near the Basin of Mexico.

The relief portrays Tezcatlipoca, the
supreme god of the ancient Nahua groups.
He is primarily identifiable by the smoking
mirror that replaces his left foot, as well as
the ring-shape *anahuatl* pendant hanging
from his neck. In his left hand he carries an
atlatl or spear-thrower in the shape of a snake,
while in his right hand he holds two spears.
The background is dominated by the presence
of a plumed serpent, which could refer to
Quetzalcoatl, the main creator-god, along with
his rival Tezcatlipoca. A band of shells in cross
section can be seen above the central image.

The urn was found under the stucco floor
of the large platform of the Templo Mayor
pyramid from Stage IVb of its construction,
on the south side dedicated to Huitzilopochtli,
close to the Stone of Coyolxauhqui. Its
contents included partially cremated human
remains, bone awls for bloodletting,
zoomorphic obsidian beads and a fragment
of an obsidian ring. The skeleton is fairly
well preserved, making it possible to identify
it as that of a young male adult, between 21
and 24 years of age.

The characteristics of the offering, the
presence of human remains and its position
in the part of the temple associated with the
principal Mexica god of war, suggests that
the site was the tomb of a particularly
distinguished warrior from the transitional
period between the reigns of Moctezuma I,
Moctezuma II's great uncle, and Axayacatl,
his father. CJGG

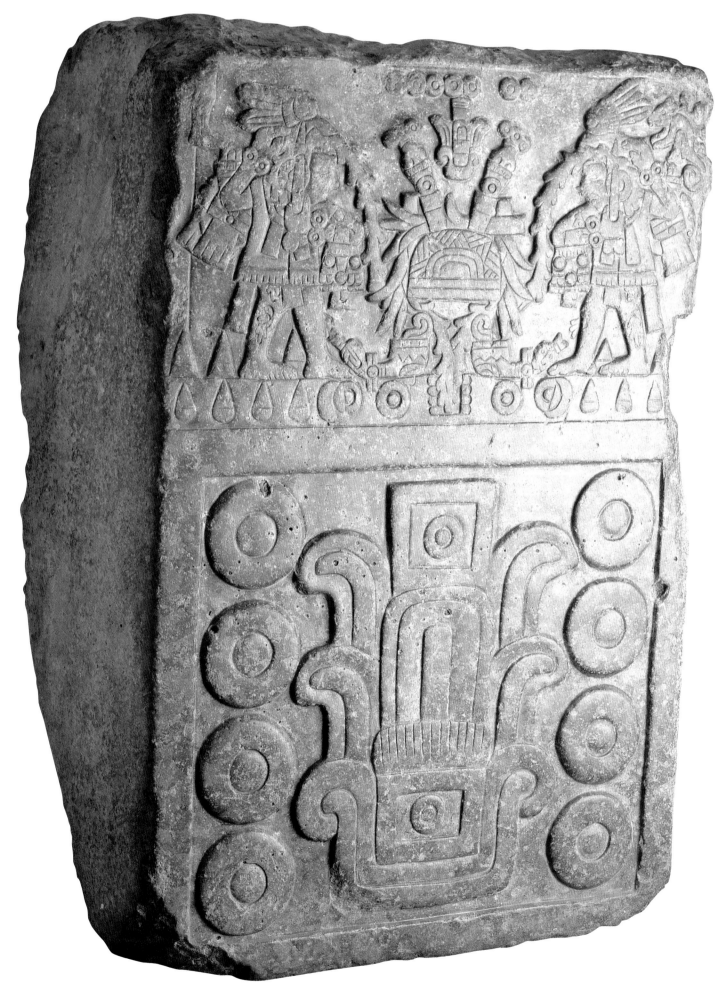

Cat. 11
Dedication stone from the Templo Mayor

19 February 1487, Mexica
Diorite, 92 × 62 × 30 cm
Museo Nacional de Antropología, Mexico City, inv. 10-220919

Selected literature: Ramírez 1846; Ramírez 1864, pp. 49–50;
Bernal *et al.* 1979, pp. 304–05; Umberger 1981, pp. 127–29,
Washington 1983, pp. 52–55

This magnificent stone is one of the earliest archaeological monuments in the Museo Nacional de Antropología of Mexico. It is linked to other pieces associated with the Mexica rulers. The museum's former director, José Fernando Ramírez, identified it as the 'Stone commemorating the dedication of the Templo Mayor of the Mexicans' as it formed part of the ornamentation from the construction phase completed by the eighth *tlatoani*, Ahuitzotl (reigned 1486–1502).

The carving in green diorite is one of the most exquisite examples of the work of Mexica sculptors. The composition is dominated by the date 8 Reed, corresponding to the year 1487. It occupies almost two-thirds of the monument, thereby endowing the date glyph with a square shape.

The more complex image on the upper section shows the seventh *tlatoani* Tizoc (reigned 1481–86) on the left and Ahuitzotl on the right. Both are identified by their respective anthroponyms: a scarred leg and a type of otter with a tail in the form of a human hand. The figures are shown standing in profile, wearing clothing associated with Huitzilopochtli. As befits great warriors, they are offering a sacrifice by perforating their earlobes. The streams of blood running down their faces fall into the mouth of Tlaltecuhtli, goddess of the surface of the earth, where the entire ritual unfolds. Between the kings there is a *zacatapayolli* (a grass ball used to hold the bloodletting instruments) with two sacred spikes, beneath the day sign 7 Reed. From this information, some experts have proposed that the extravagant ceremonies and numerous rituals marking the dedication of the temple took place on 19 February 1487. This would indicate that Tizoc began the refurbishment of the Templo Mayor and that it was completed by his successor Ahuitzotl. *FSO*

Cat. 12
Casket

Late fifteenth century, Mexica
Andesite, 23 × 33 × 18 cm
Trustees of the British Museum, London, AOA Q82 Am 860

Selected literature: Joyce 1912, fig. 9; Pasztory 1983, figs 122, 123, 164; Washington 1983, p. 120; Baquedano 1984, pp. 89–91, fig. 59; López Luján 1994, p. 221; London 2002, pp. 245–46, 449, no. 200; López Luján 2006, pp. 232–35; McEwan 2009, p. 97

This stone casket (*tepetlacalli*) (see over) may once have been decorated on all sides, inside and out, but only one carved side on the front of the box has been fully preserved. On it is depicted an anthropomorphic figure against a background of feathered scrolls representing clouds and 'U'-shaped elements with *chalchihuites* representing raindrops (see cat. 13). A square goggle-mask identifies the figure as a tlaloc, one of the four attendants of the rain god Tlaloc (see cat. 66). The figure is arranged horizontally with his legs extended behind him, giving the impression that he is flying or floating in the sky. He is fully dressed in male clothing and wears a feathered headdress, bracelets, anklets and sandals. His large beaded necklace bears the symbol for gold, a round disc (*teocuitlacomalli*) with a cross dividing the space into four equal parts contained in a circle.

Tlaloc holds a round jar from which he pours streams of water terminating in *chalchihuitl* (the symbol for greenstone) and conch shells. Corncobs and luxuriant amaranth plants are interspersed with water symbols, indicating the fertility of the waters that irrigate the soil. The jar itself is also adorned with a large *chalchihuitl*.

On the inside is depicted an *ahuitzotl*, a fantastic aquatic animal similar to a river otter or a dog. It was also the glyph name for the eighth *tlatoani* Ahuitzotl (reigned 1486–1502) who preceded Moctezuma II (see also fig. 9 and cat. 11). The *ahuitzotl* is presented against a schematic background of water with conch shells and *chalchihuitl*, probably symbolizing the terrestrial waters of its natural environment.

Evidence of similar iconography can be seen on both faces of the two fragmentary sides. The craftsman may have originally portrayed the four *tlaloque* around the outer sides of the box, symbolically watering the four corners of the universe, and four *ahuitzome* on its inner faces, representing a complete aquatic environment. The sixteenth-century chronicler Bernardino de Sahagún describes how the *ahuitzotl* was both a subject and friend of Tlaloc. The creature first attracted its victims by crying like a child, and then drowned them so that their souls would go to Tlaloc.

Colonial sources make reference to the use of stone caskets to bury the bodies of children who were offered to Tlaloc, and in contexts strongly related to water and fertility. López Luján has pointed out that most of the *tepetlacalli* excavated in the Templo Mayor were decorated with aquatic elements including Tlaloc imagery, greenstones, shells, seeds, fish skeletons and representations of hunting and fishing implements.

On the base of the box and its underside are two different portrayals of the earth goddess Tlaltecuhtli. In both, the deity is

depicted in a squatting position, with clawed feet and hands, wearing large ear-spools and with elbows and knees decorated with skull masks, but variations in the adornments of hair and costume denote the two figures' different characters. The Tlaltecuhtli on the outside has short curly hair, typical of monsters and figures associated with the dark, a circle on her cheeks, a paper decoration hanging from a bracelet and a feather ornament attached to an anklet. These elements can also be seen in a representation of Tlaltecuhtli excavated at the Templo Mayor.

This box has traditionally been associated with Ahuitzotl himself and it may also be linked to the stone lid with the figure of an *ahuitzotl* now in Berlin (see below, cat. 13). *EVLL*

Cat. 13
Lid of a casket with an *ahuitzotl*

Late fifteenth century, Mexica
Andesite, 13 × 33 × 30 cm
Staatliche Museen zu Berlin: Preussischer Kulturbesitz, Ethnologisches Museum, IV Ca 3776

Selected literature: Seler 1960–61, vol. 4, pp. 513–18; Pasztory 1983, pp. 164–65; Solís Olguín 1993, p. 80; London 2002, p. 449, no. 199; Aguilar-Moreno 2007, p. 200

This lid may belong to the stone casket (*tepetlacalli*) at the British Museum (cat. 12). It combines three-dimensional sculpture with relief carving, a feature that is characteristic of the imperial artistic style under Moctezuma II's reign. On top of the lid is an *ahuitzotl*, a fantastic aquatic mammal, believed to have a human hand at the end of its tail. It is depicted crouching on all fours, resting on its coiled tail. Carved on the creature's back are water symbols terminating in discs symbolizing greenstone (*chalchihuitl*) and conch shells. The sides of the lid are covered with greenstone discs and 'U' shapes like hooks, representing rain and the elements.

Carved on the underside of the lid, framed in a partially damaged cartouche, is the year sign for Reed, with four circular numerical signs to its left and one at top right. A second numerical sign is partially visible in the damaged corner and the missing piece may have borne an additional number. The date that has been proposed is 7 Reed.

The *ahuitzotl* was the glyph of Moctezuma II's predecessor, the eighth *tlatoani* Ahuitzotl (reigned 1486–1502). The year 7 Reed (1499) relates to the year in which he celebrated the construction of the Acuecuexcatl aqueduct, built to supply fresh water to the growing metropolis of Tenochtitlan. The aqueduct was not completed until the year 8 Flint (1500), but it was destroyed soon afterwards in a terrible flood. *EVLL*

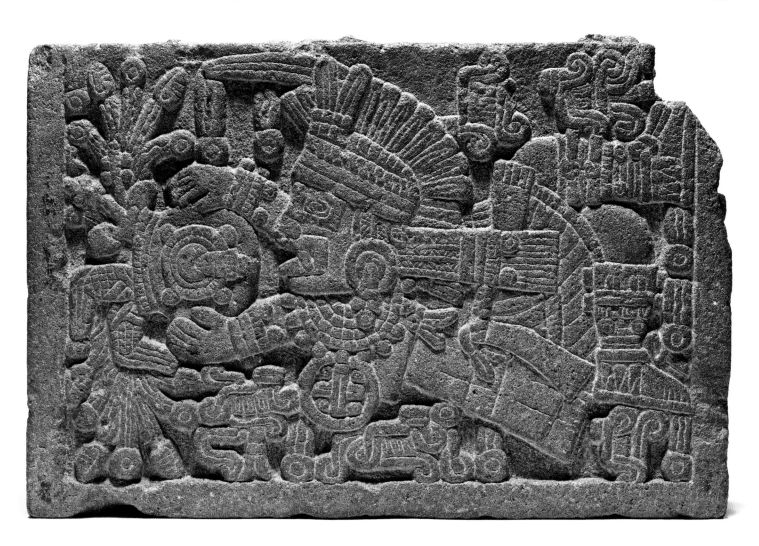

Opposite
A tlaloc carved on the front of the casket (cat. 12).

Above right
A fragmentary side of the casket, perhaps showing one of four *tlaloque* (cat. 12).

Right
An *ahuitzotl* depicted on the inside of the casket (cat. 12).

Above
The figure of an *ahuitzotl* forming the lid of a casket (cat. 13).

The coronation of Moctezuma II

Eduardo Matos Moctezuma

EARLY IN 1502, the city of Tenochtitlan was preparing the funeral rites of Ahuitzotl, its sovereign or *tlatoani* ('he who speaks well' or 'he with the power of the word'). He is supposed to have died as a result of a blow to the head when trying to flee from flooding following the collapse of an aqueduct. Other historical sources tell us that he succumbed to an unspecified illness. As the eighth *tlatoani* of Tenochtitlan, Ahuitzotl, had governed between 1486 and 1502. Whilst his remains were cremated in front of the Templo Mayor, it was decided who would succeed the man who had expanded the empire to the different regions of Mesoamerica.[1] Succession to the throne did not necessarily pass from father to son, as occurred in the European ruling houses, but instead a council of elders looked amongst the members of the royal house for an outstanding candidate who excelled in two main areas: matters related to religion, and the wars of conquest. It was of crucial importance that the new *tlatoani* should be a profoundly religious individual who was deeply versed in these issues, whilst also being an outstanding warrior. This was hardly surprising since the two aspects on which the empire depended was personified in the figure of the *tlatoani* in his role as high priest and as a general.

The council, made up of high-ranking Mexica along with the rulers of Tetzcoco and Tlacopan, cities that constituted the Triple Alliance with Tenochtitlan, met to deliberate over who would be Ahuitzotl's successor. They identified an individual who possessed outstanding qualities making him the ideal candidate to acede to the throne. This was Moctezuma Xocoyotzin, son of Axayacatl, the sixth ruler of Tenochtitlan, who had

Fig. 13
Moctezuma is presented with his royal diadem (*xiuhuitzolli*). His woven reed throne is seen standing behind. From *Historia de las Indias de Nueva España e islas de tierra firme*, Codex Durán. Biblioteca Nacional, Madrid.

piedra esta oy dia esta ala apuerta dela ygłea,
maior, Junto all enterao Jl. e mas tesoro q̃
nos quemo, q̃ trato. dlo q̃ los gr̃a dste auiã sta
gido, ytodo quanto El Rey aui. tzoll temã en

nueua españa, El Rey dsl cuco mando que
nengun senor saliese dela ciudad, hasta
que la llestion del nueuo Rey fuese he cha
porq̃ queria fuese he cha cobene pla sto dhrs,

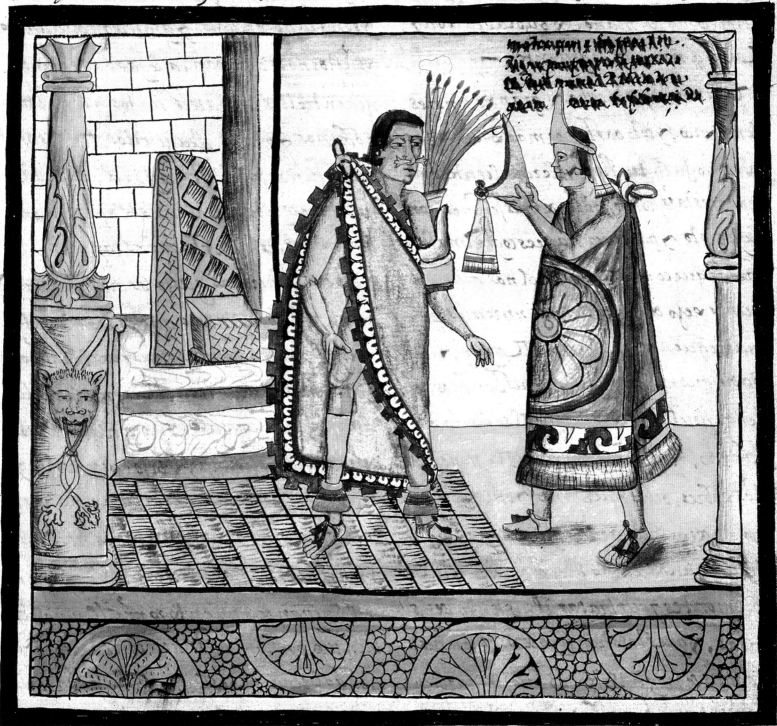

q̃ Capitullo, lij, de la Junta sol ene q̃
se hizo sobre la e lestion del nueuo Rey de mexi
co y xsomo Salio Electo Jl po seroso, y gran
senor Montecuma, segundo dsste nõbre
y de sus gran ezas—

a luego Jl dia siguiente que las cenizas dsl Re
y auitzott fueron enterradas, yacabadas
las dbsequias y cuimomas dstn tan mages
tad, Jl Rey necaual pilli detez cuco, y de
tacuba, con todos los senores delasprouin

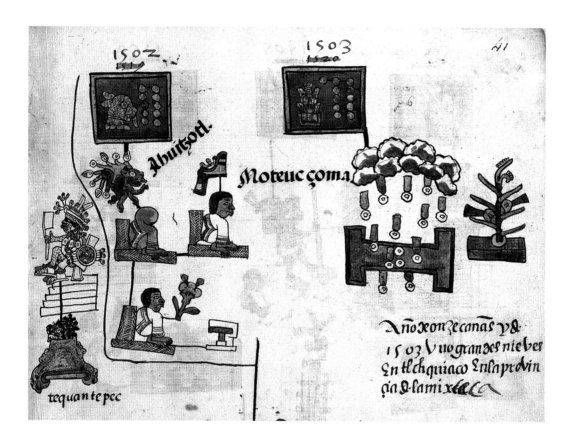

governed the empire from 1469 to 1481. Moctezuma was nephew of the previous ruler, Ahuitzotl, and had excelled in religious matters, being a modest person who knew the religion well, having attended the *calmecac* (school for priests). He had also played an important role as captain of the Mexica army.

In 1581, the Spanish Friar Diego Durán described Moctezuma's attributes in his *History of the Indies of New Spain*:

> ... he is of the right age and very modest and virtuous and very generous and with an invincible mettle and adorned with all the virtues that a good prince should have, whose counsel and opinion was always very sound, especially in matters of war, in which they had seen him give orders and engage in certain acts that were of invincible mettle.[2]

Some of his characteristics are also described in the sixteenth-century *Mexican Chronicles* of Hernando Alvarado Tezozómoc. He wrote:

> ... that *Tlacochcalcatl*[3] *Moctezuma*, son and heir of King Axayacatl, be elected and named and crowned king because he is not a boy but rather a grown man of thirty-four years old, he suits us and he suits the Mexican Republic, that he rules, governs and takes responsibility for this empire on his shoulders, that he is a valiant youth and brave and skilful...[4]

Once elected, Moctezuma was taken before the council where the traditional rituals

were to be performed. He received the investiture of *huey tlatoani* (supreme lord), was seated before a lit brazier and attired with the vestments appropriate to his high rank. His hair was cut and he was adorned with ornaments in gold and precious stones, including fine ear-spools, a lip-plug in the lower lip and a long pendant that crossed the bridge of the nose. He also wore special sandals, a loincloth, the royal mantle and the crown, a golden diadem known as the *xiuhuitzolli* in Nahuatl, the language of the Mexica. The new *tlatoani* got to his feet and walked around the brazier, offering up smoke to the gods, in particular to Xiuhtecuhtli, the god of fire, by burning aromatic copal resin. Immediately afterwards he drew blood from his ears, arms and legs with sharpened jaguar and eagle bones, after which quails were sacrificed. He then retired to the royal palace where he was awaited by the people and the governors. There he listened to the words of welcome from his allies, the lords of Tetzcoco and Tlacopan.

After several days had passed, the *tlatoani* prepared to capture enemies to be sacrificed at the public celebration of his enthroning. He was aware that some villages like Nopallan and Icpactepec, subjects to the empire, had risen up against Tenochtitlan and refused to continue paying tribute. Moctezuma sent his troops to quash the uprising and to stock up with prisoners for sacrifice. He marched against the rebels and overwhelmed them to such an extent that, according to Durán, he seized almost five thousand captives who were then taken to Tenochtitlan.[5]

After this victory, Moctezuma ordered his men to travel to the hostile villages of Cholula, Huexotzinco, Tlilihuquitepec, Tlaxcala, Cuextlan, Metztitlan, Yopitzinco and the distant Michoacan, to invite their rulers to attend the celebrations of his naming as *tlatoani*. None of his predecessors had ever done such a thing. The enemy rulers reached

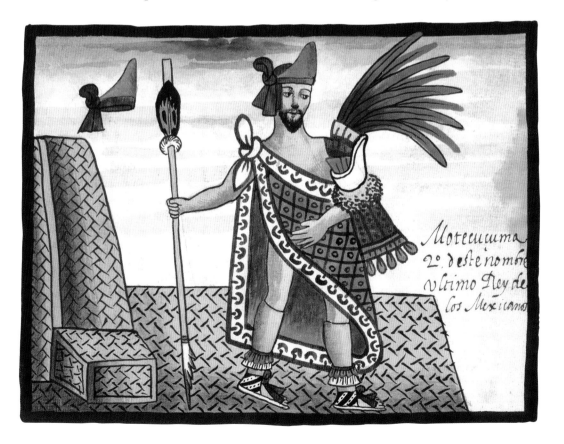

Fig. 15
Moctezuma II holding a spear and wearing the royal cloak, feathered arm ornament and the royal turquoise diadem (*xiuhuitzolli*). This royal diadem also forms Moctezuma's name glyph, seen at top left. From Codex Tovar, 1583–87. John Carter Brown Library, Providence, Rhode Island.

Tenochtitlan in secret and stayed there to avoid angering the Mexica people. Moctezuma showered them with attention and gifts, and once the celebrations were over they returned home without incident.

The festivities lasted four days, filled with dances and other events. On the fourth and final day, enemies captured in recent combats were sacrificed in honour of Huitzilopochtli, god of sun and war. The new ruler was crowned in public by the high priest and the lords of Tetzcoco and Tlacopan who placed the *xiuhuitzolli* on his head and invested him as king with the respective attire. The ceremony ended at the moment when his face was blackened with tar to accentuate the divine nature of the *tlatoani*. Durán tells us that:

> ... he promised to favour divine things and defend his gods and law and to wear the Royal vestments and bear the crown and all other insignia of the King, he swore and promised to obey the civil laws and privileges and pre-eminences of the city, and to uphold wars and defend the Republic or die if required.[6]

Moctezuma's idea of inviting the enemy chiefs may have held an ulterior motive; he wanted them to see the power of the Mexica and to understand how the conquered were treated. Witnessing these events must have undoubtedly impressed these leaders a great deal. Indeed, the chronicles point out how the enemy chiefs took part in the dances at night in disguise so that they would not be recognized, whilst ingesting hallucinogenic mushrooms that transported them to a state of ecstasy; it can be assumed that they rather enjoyed their stay in the Mexica city.

Moctezuma's palace

One of Moctezuma's first actions after his coronation was to replace everybody who served in the royal palace. He ordered that his staff of servants should be made up of the sons of nobles and that people from the villages should no longer have carry out household tasks. He also made sweeping changes in administrative and government affairs and became so powerful that nobody was allowed to look him in the face. His palace, known as Moctezuma's New Houses,[7] was built just outside the ritual centre of the city of Tenochtitlan, a site which had contained about seventy-eight temples or places of worship, the main one being the Templo Mayor, or *Huey Teocalli*, which symbolized the centre of the universe for the Mexica. This vast square, measuring about 400 metres on each side, formed the chamber of the gods making it the most sacred place in the city (see fig. 39). It was surrounded by a platform with four exits leading to the causeways joining the city to terra firma across Lake Tetzcoco. To the south there was a further square, on the east side of which rose Moctezuma's palace. Its position in relation to the ceremonial site was chosen because of the significance of the south for the Mexica: this direction was identified with the colour blue, its glyph was the rabbit and it was considered a place of abundance. Huitzilopochtli ruled the direction of the universe, and occupied one of the two sanctuaries in the highest part of the Templo Mayor. Since the

Fig. 16
Map of Tenochtitlan, showing
the different causeways leading
to the island, the main section
of the city and the location of
Moctezuma's palace adjacent to
the Sacred Precinct.

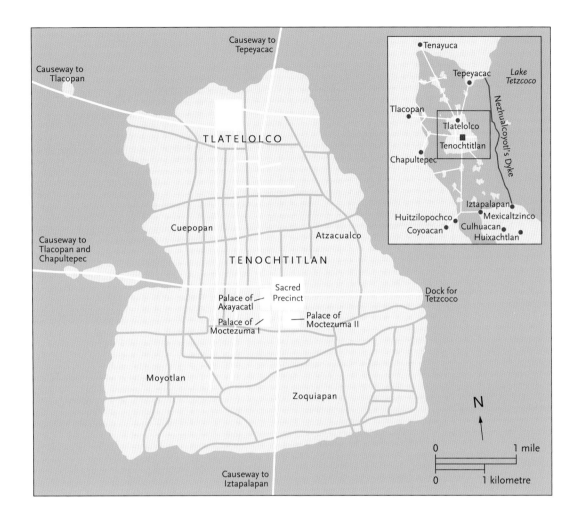

Fig. 17 *following pages*
Map commissioned by Hernán
Cortés showing the Gulf of Mexico
on the left and the Basin of Mexico
and Tenochtitlan on the right, with
the disproportionately large Sacred
Precinct at the centre of the city.
Nuremberg 1524. Newberry
Library, Chicago. See cat. 4.

role of *tlatoani* was associated with the sun, it seems logical that his palace would occupy this location.

Spanish soldier chroniclers such as Hernán Cortés and Bernal Díaz del Castillo knew the palace well and described it in great detail. According to Cortés:

> His domestic appointments were within the city, so marvellous that it seemed almost impossible to describe their wonderful grandeur. And therefore I will not try to talk further about them, more than saying that there is nothing of the like in Spain.[8]

Descriptions by different chroniclers serve to corroborate what we are told by the Spanish captain. Two maps of the palace survive: a plan that Cortés had made, which was published in Nuremberg in 1524 (fig. 17 and cat. 4), and a painting in the Codex Mendoza (cat. 17). In the former we can see the palace's location just outside Tenochtitlan's main square, and we can appreciate the enormity of its dimensions as it occupies a large area of the plan. An inscription in the palace reads 'dom. D. Moctezuma' (house of Moctezuma). Three entrances lead to a central courtyard surrounded by buildings. Behind these complexes are other buildings in the form of an 'L', which may correspond to the Pre-Hispanic floors and walls that were recently discovered by the

Res fuerat quondam prestans, & Gloria summa
Orbis subiectus Cesaris Imperio,
Hic longe prestat, cuius nunc Orbis Eous,
Et Nouus, atq alter panditur Auspitijs.

Punta d las higueras,

Santo Anton
R: de Brufalus
Rio de la palma
Las corrientes

Canto andres

Rio de coquiualauo
Rio d partida
Rio de vanderas
Rio d almazal
B: de Sant Juan
Almeria
Guitla de Sant Juan
Sant pedro

Archona

Yucatan

Ys della tertio

Puncta de Cuba

prouincia
annchel,

Rio panu

co laoton,

Camacho puicia

Ys de la Florida,

R: la palma

R: de Arboledas

Bol
d Arecifos

Rio del Espiritu sancto

Estepania cam

Quilibet punctus magnus continet leucas duode
cim cu dimidia, ita q duo magni puncti continent
viginti quinq leucas, Cotinet aute leuca quatuor
Italica miliaria, ita q omnes puncti qui hic cospi
ciuntur continent centum leucas.

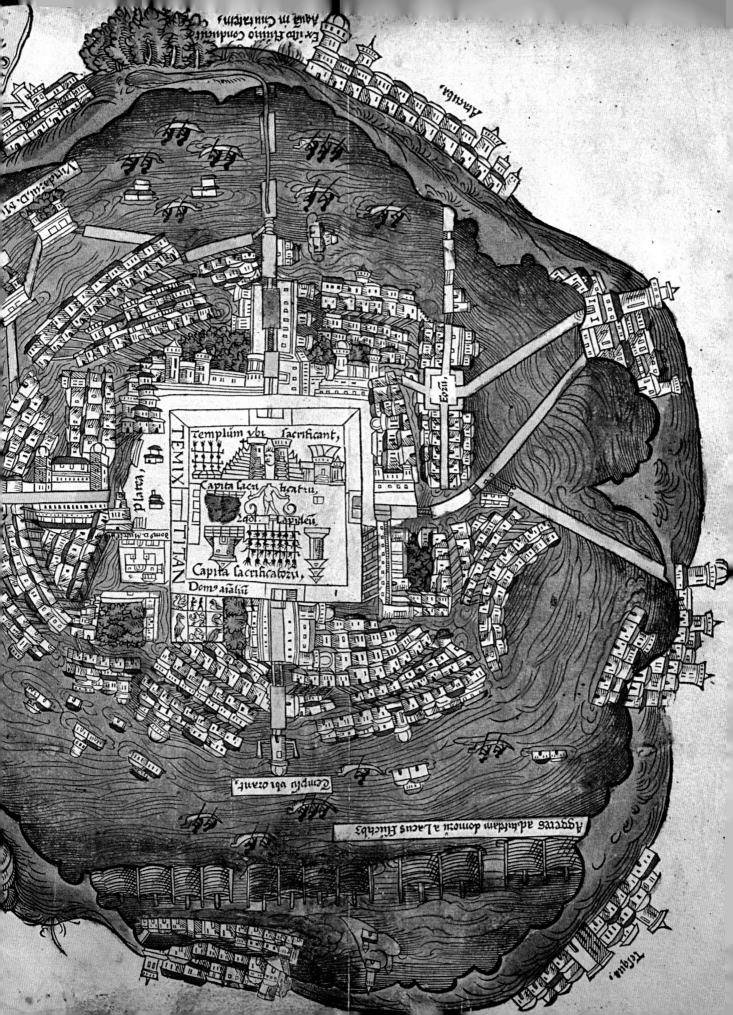

Ex illo flumio conduit Aqua in Ciutatem

Amaqua

Templum vbi sacrificant,

TEMIXTITAN

Capita laci theatru,

Eçot. lapileu

Capita sacrificatoru,

Domo aialiu

Templi obeorant,

Aggeres adhifam domou a Lacus Fluchbs

archaeologist Elsa Hernández beneath the Casa de Moneda (the Mexican Mint) in Mexico City. This complex surrounds what appears to be the wood or wooded garden described by Bernal Díaz del Castillo:

> We must not forget the gardens of flowers and sweet-scented trees, and the many kinds that there were of them, and the arrangement of them and the walks, and the ponds and tanks of fresh water...[9]

To the north of this wood is what seems to be the zoo, made up of a square with eight enclosures. At least five of them contain birds, while another contains what looks like a feline. Two further enclosures contain figures that could be humans or representations of monkeys. A final figure is difficult to identify. The zoo also attracted the attention of Díaz del Castillo:

> Let us move onto the aviary. I cannot possibly enumerate every kind of bird that was in it. There was everything from the royal eagle, smaller kinds of eagles and other large birds, down to multi-coloured little birds...

He later adds that he saw in other areas:

> ... many kinds of carnivorous beasts of prey, tigers and two kinds of lions, and animals something like wolves which in this country they call jackals, and foxes,

Fig. 18
Illustration of the different species of animals and birds held in the zoo and aviary located inside the architecutural complex of Moctezuma's palace. From the Florentine Codex, Book 8, fol. 30v.

Fig. 19
Detail of Moctezuma seated in the central upper chamber of his palace. From the Codex Mendoza, Plate 69. Bodleian Library, Oxford. See cat. 17.

and other smaller carnivorous animals, and all these carnivores they feed with flesh.... They also have in that cursed house many vipers and poisonous snakes.[10]

These three large spaces – palace buildings, gardens and zoo – together occupy a site of immense dimensions, as described by the various chroniclers.

Plate 69 in the Codex Mendoza (cat. 17), shows an image of the palace seen from the front with three entrances (thus coinciding with Cortés's plan). One of the entrances or doors has an inscription at the top 'War Council Hall' and another has the inscription 'moteczuma's [Moctezuma's] council hall'. Within this room there are four seated figures with a speech scroll by their mouths. Above these figures is another inscription that refers to the task of these lords, saying 'These four were party to moteczuma's counsel, wise men'. Between the two doors is a staircase or walkway that leads to a courtyard where we can read 'courtyard of moteczuma's royal houses'. There are three rooms at the back (see fig. 19): the one on the left bears the words 'house where dwelled the lords of tenayuca and chiconautla and cuhuacan [Culhuacan] who were friends of moteczuma' and on the right we read 'house where dwelled the great lords of texcoco [Tetzcoco] and tacuba [Tlacopan], who were friends of moteczuma'. In a position of great prominence amongst these houses is the chamber of the *tlatoani* with a sign that says 'moteczuma's throne and podium where he sat down to his court and to judge'. The figure of Moctezuma can be seen seated upon his *icpalli* or royal throne wearing the diadem or *xiuhuitzolli* that identifies him as *tlatoani*. Above and below him we read his name 'moteczuma'.[11]

Both these images of the royal palace coincide with the accounts written by Cortés and Díaz del Castillo, as well as other chroniclers such as Bernardino de Sahagún. Moctezuma's palace included a large number of chambers and rooms for different uses. There were halls dedicated to justice and to hearing disputes; the judges were instructed

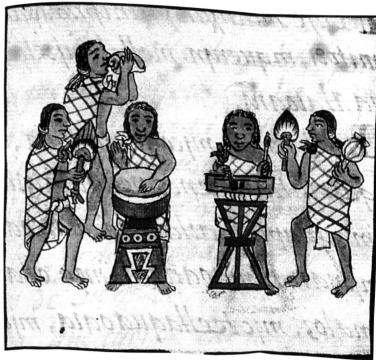

to act with total fairness or they would in turn be judged and sentenced. There was also another court, the *tecpilcalli,* which was used specifically for noble soldiers and warriors. It is said that a top military chief who committed adultery was sentenced to be stoned to death. This court provided a means of getting justice under such circumstances. A further building was set aside for meetings of the war council, made up of the most senior military commanders. Warriors who were taken prisoner in the empire's wars of expansion were housed here under close guard. Different types of edible grains were stored and accounted for in the hall known as *petlatalco.* Sahagún tells us about this in *The General History of the Things of New Spain*:

> A steward of the lord lodged in this place, and took charge of maintaining all
> the corn that was stored in the granaries to provide for the city and republic,
> each of which held two thousand *fanegas* [approximately 3,000 bushels] of corn,
> in which there was corn that had been there twenty years without spoiling;
> there were also other granaries where large amounts of beans were stored.[12]

Many other products were stored here for use in the event of shortages in the city, which were liable to strike at any time. This was linked to another hall known as *calpixcacalli,* where all the tribute from the different provinces subject to the empire was kept. Anybody caught stealing goods stored in the palace buildings was immediately brought before the judge and all his belongings seized. The tribute was paid mainly with the products of each region such as cotton mantles, cocoa, corn, beans and other agricultural products; different types of raw materials including skins, warrior garb, rich feathers, shells and conches (see chapter 5). The nearby villages subject to the empire, however, were also required to pay by supplying workers to help with state

Figs 20 and 21
Left: A juggler and an acrobat performing at a festival. From the Florentine Codex, Book 8, fol.19v. Right: Festival participants playing a conch shell, drums and rattles. From the Florentine Codex, Book 8, fol. 41r.

construction projects. During his reign, Moctezuma suc-
ceeded in expanding the frontiers of his empire by
conquering many different regions and villages. Added
to those conquered by his predecessors, a total of 370 vil-
lages were paying tributes to the emperor on the arrival
of the Spanish.

Another area was designated for the singers and
dancers at the service of the emperor. There were also
rooms for many of the palace servants. Interestingly, there
were further spaces set aside for a whole series of craft
specialists such as goldsmiths and silversmiths, sculptors,
painters and craftsmen working with feathers, from which
the most exquisite masterpieces were made. There were
also craftsmen who worked with copper and stone. Recent
studies suggest that stone figures were often carved to imi-
tate objects from other regions and were placed in the
Templo Mayor.

All of this speaks volumes about the magnificence
and dimensions of the royal palace. As we have seen, not
only was it the *tlatoani*'s dwelling, but it was also where
all services under his control were organized; this
included anything related to war, justice, payment of trib-
ute, grain storage and chambers for distinguished visitors,
as well as recreation areas, such as the zoo, fountains and
parks with trees and animals of all kinds. The conquista-
dors were understandably amazed at so much grandeur.

Fig. 22
Specialist craftsmen hammering
and smelting gold for use in
objects for the elite. From the
Florentine Codex, Book 9, fol. 53v.

Cat. 14
Coronation stone of Moctezuma II

1503, Mexica
Basalt, 67.3 × 57.7 × 22.8 cm
The Art Institute of Chicago, Major Acquisitions Fund, 1990.21

Selected literature: Beyer 1921, pp. 36–56; Townsend 1982, pp. 111–40; Washington 1983, pp. 41–42; Townsend 1987, pp. 371–409; Townsend 1992, pp. 170–85; Townsend 2000, pp. 135, 168, figs 106, 107; León-Portilla 2002, pp. 20–27, ill. p. 25; London 2002, pp. 455–56, no. 226

Carved on all six sides, this stone block was probably originally placed flat on the ground. The date glyph 1 Rabbit on the back relates to the creation of the earth and is also the calendar name of the earth goddess Tlaltecuhtli. On the front, five glyphs relate to mythical dates while the other two may refer to a historical event.

The four past eras, or cosmogonic 'Suns', are represented at the four corners of the front face. They can be read counter-clockwise, starting with the glyph 4 *Ocelotl* (Jaguar) at the bottom right. This was the Ocelotonatiuh (Jaguar Sun) that ended with a plague of jaguars. It is followed by 4 *Ehecatl* (Wind), at the top right, known as *Ehecatonatiuh* (Wind Sun) that ended in hurricanes. 4 *Quiahuitl* (Rain), at the top left, was Quiauhtonatiuh (Rain Sun), which ended in rains of fire. The last glyph 4 *Atl* (Water), at the bottom left, represents Atonatiuh (Water Sun), which ended in floods. Each of these eras was associated with a cardinal point symbolizing the four corners of the cosmos: north for *Ocelotl*, east for *Ehecatl*, south for *Quiahuitl* and west for *Atl*.

The present era, or 'Fifth Sun', is represented by the glyph 4 Movement (*Nahui Ollin*), carved at the centre in the form of an 'X'. A cosmic eye marks the point at which the two lines meet to form this glyph. Crossroads were considered unstable, dangerous places, threatening collapse or destruction, and the symbol reflects the belief that the fifth era was destined to end with an earthquake. The four circles marking the numerical character of each era are positioned at the four corners of each glyph. As such they create a quincunx that is replicated by the overall composition of the five ages, visually reinforcing the concept of the fifth era as a paradigm of instability at the centre of the universe.

On the vertical axis are two other glyphs, the day sign 1 *Cipactli* (Crocodile) and 11 *Acatl* (Reed), the latter carved within a square cartouche to indicate a year date. It has been proposed that these indicate the probable date of Moctezuma II's coronation, 15 July 1503, which this monument may have commemorated. The date 1 Crocodile was related to the beginning of time, and thus associated with coronations.

Four representations of Tlaltecuhtli surround the central scene. Crouching in a vertical position, the goddess is depicted with clawed hands and feet, wearing a skirt decorated with skull and crossbones and a skull at the waist. Her open mouth and bared teeth remind us of the constant sacrifices needed to feed the earth and to maintain the stability of the present era.

The carving on this stone is both a cosmological and cosmogonical representation of the Mexica world, transcending mythical and historical time. It provides us with a clear depiction of the ideological tools used by Moctezuma to assert his power and consolidate his empire, as he places historic dynastic events, and more specifically the beginning of his rulership, within this framework.

EVLL

Cat. 15
Funeral casket

c. 1500, Mexica
Stone, 22 × 24 × 24 cm
Museo Nacional de Antropología, Mexico City, inv.
10-223670

Selected literature: Galindo y Villa 1897, pp. 48–49;
Peñafiel 1910, pp. 124–26; Umberger 1981; London 2002,
p. 449, no. 201

The sixteenth-century chronicles record that
when a Mexica ruler died, his prepared body
was wrapped in blankets forming a bundle.
This was adorned with a mask showing the
monarch's appearance as a young man.
Ritual objects were placed around him and
the body was incinerated. The ashes were
preserved in symbolic containers.

This lidded rectangular container carved
from stone is one of the few surviving
funeral caskets associated with the Mexica
royal lineage. Its main distinguishing feature
is the *xiuhuitzolli* or *copilli*, the crown of the
tlatoani of Tenochtitlan, which was made
from a sheet of gold covered with turquoise
mosaic. The crown thus combined two
precious elements – *cuitlatl* (gold)
associated with the sun god Tonatiuh, and
the bluish turquoise stone associated with
Xiuhtecuhtli – reflecting the two patron gods
of the indigenous rulers.

The container and its cover form an
almost perfect rectangular block, which is
carved both inside and out. The casket is
decorated with eight quincunxes, two on
each side, framed above and below by
feathers. The date 11 Flint appears on the
top of the lid while the bottom of the casket
bears the date 5 Serpent. Inside the lid is a
profile portrait of the monarch, characterized
by its long hair with a *copilli* tied behind,
turquoise or greenstone ear-spools and the
glyph of the *tlatoani* ('he who speaks').

This casket probably comes from
Tetzcoco, the capital of the Aculhuas. It has
sparked great controversy, as the rulers of
Tetzcoco did not wear the *xiuhuitzolli*.
Peñafiel has claimed that this funeral casket
was made for Nezahualpilli, while Umberger
considers that it could have been a tribute
presented by the ruler of Tenochtitlan to his
dead ally. *FSO*

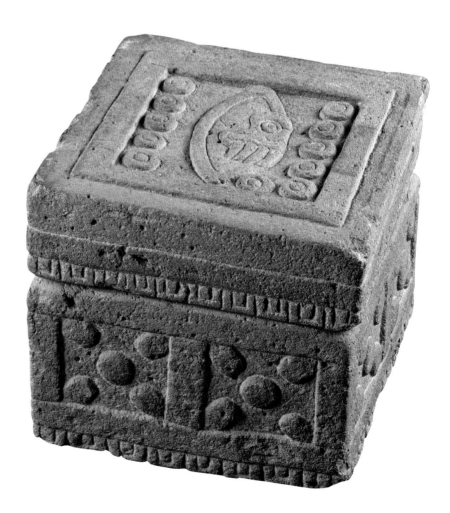

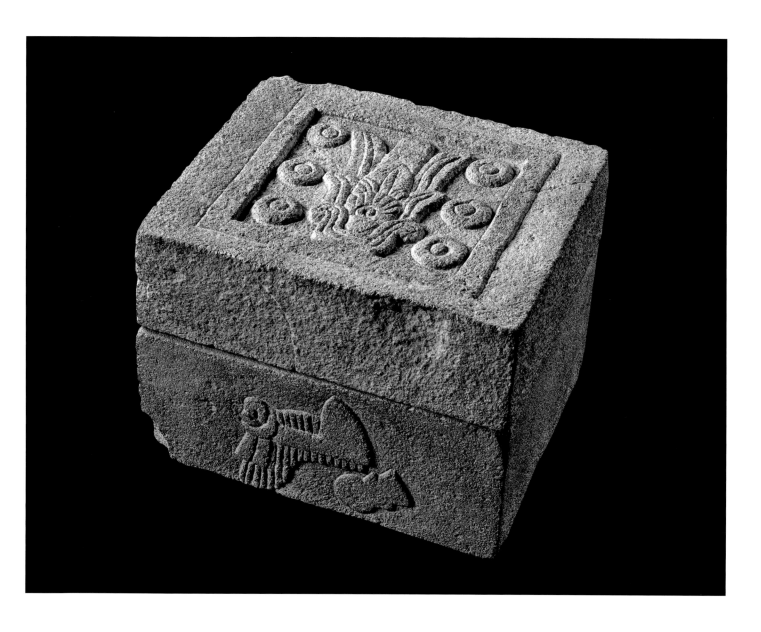

Cat. 16
Casket with the date 6 Reed

c. 1511, Mexica
Stone, 29.5 × 25.5 × 20 cm
Staatliche Museen zu Berlin: Preussischer Kulturbesitz, Ethnologishes Museum,
IV Ca b26921 a-b

Selected literature: Gutiérrez Solana 1983, pp. 54–55; Pasztory 1983, p. 255; Washington 1983, p. 66; Solís Olguín 1993, pp. 78–79, 96–99; London 2002, p. 440, no. 168; López Luján 2009b

There are several known Mexica stone caskets or *tepetlacalli*, literally 'stone baskets'. According to ethno-historical sources these boxes contained the ashes of cremated warriors and great rulers, or the bodies of children sacrificed to the rain god Tlaloc (see cat. 12). In some examples the carved iconography on the box includes depictions of figures perforating their earlobes, suggesting that they may have held bloodletting instruments belonging to royalty or the nobility (see cat. 58).

While some of the surviving boxes bear extensive carving of glyphs combined with figurative imagery, only three include the name glyph of Moctezuma II with the *xiuhuitzolli* (turquoise diadem), hair, ear-spool and nose ornament (see also cats 15 and 58). In this example Moctezuma's glyph is reproduced on the front of the casket, however, the speech scroll symbolizing the *tlatoani*'s skill as a great speaker is absent.

The year glyph 6 Reed is inscribed within a cartouche that extends over the top of the lid. This glyph could refer to a historical or mythical date, which may have fallen in 1459 or 1511. The former coincided with the reign of Moctezuma I (1440–69), and the latter with that of Moctezuma II (1502–20). Both rulers used the same onomastic glyph that included the *xiuhuitzolli*, but this glyph is more frequently associated with Moctezuma II, both in the colonial manuscripts and in imperial sculpture. This makes 1511 the most plausible date, especially when considered alongside the later carving style of the lid. *EVLL*

Cat. 17
Moctezuma's palace

Codex Mendoza
c. 1541, Mexica
Paper, 30–31.5 × 21–21.5 cm
Bodleian Library, University of Oxford, Ms. Arch. Selden A.1, fol. 69r

Selected literature: Brotherston 1995, pp. 55–61, 145–53; Berdan and Anawalt 1997

Some twenty years after the Spanish conquest, the Codex
Mendoza was prepared by native *tlacuiloque* (artist-scribes) at
Tenochtitlan, ostensibly at the request of New Spain's first viceroy,
Antonio de Mendoza. Together with its celebrated title page (see
cat. 3), the pictorial manuscript is divided into three main parts:
an imperial history of Tenochtitlan, Moctezuma II's tribute lists
and a description of life in the city and the laws and institutions
that governed it. An alphabetical transcription in Spanish
accompanies most pages, together with explanatory
commentaries.

Moctezuma's palace is depicted with the *huey tlatoani*
(supreme speaker) seated on a covered dais within. Wrapped
almost completely in his mantle, he squats on the woven mat

of authority in the traditional posture given to high-ranking males.
His royal status is indicated by the turquoise mantle and
triangular jewel-encrusted diadem (*xiuhuitzolli*) tied at the side
of his head with a red knot.

The four remaining chambers are identified as lodgings for
visiting allied lords or halls of council. The council of judges
pictured to the lower right speak the turquoise words of
Moctezuma's authority as they listen to and discuss appeals from
litigants bringing or claiming lawsuits. The layout of the palace
compares well with the flattened plan of the same building
included on the Nuremberg map (cat. 4), which might suggest
some degree of architectural accuracy. Although employing a
three-dimensional perspective, the Mendoza artist nevertheless
adhered to the internal logic of the quincuncial, or five-point,
cosmic plan. Topped by a parapet carrying five sets of concentric
circles (iconographic details common to government buildings),
the throne room and its extended courtyard lie notionally at the
centre of the four chambers. Symbolized by the 4 + 1 litigants,
and 4 + 1 presiding judges (to include Moctezuma), the structure
of government under this Mexica ruler is thus also qualified as
cosmically ordered. *EW*

trono y estrado d moteccuma
dond se sentaua sor cortes y su gor

moteccuma

casa dond se presentauon a los 93. de te
nayuca y chieunaustla y culhuacam
q eron sus amy
gos y confede
rados/ de
moteccuma

casa dond aposenta
uon a los grandes señores de tezcuco
y tacuba q eron
los amygos de
moteccuma

moteccuma

patio. delas casas
reales d moteccuma

patio delas casas
reales d moteccuma

sala del conçejo de guerra

estos fajas
uom subien
do/ tom a dar
al patio delas
casas de mote
cuma q son
estas figuras

estos quatro son como los alldes
del conçejo de moteccuma son
bres sabios/

sala del conçejo d moteccuma

pleyteantes/ q en grado de apelasion
delos alldes se presenta apareçe
ante los los aldes del con
çejo/ se moteccuma

69

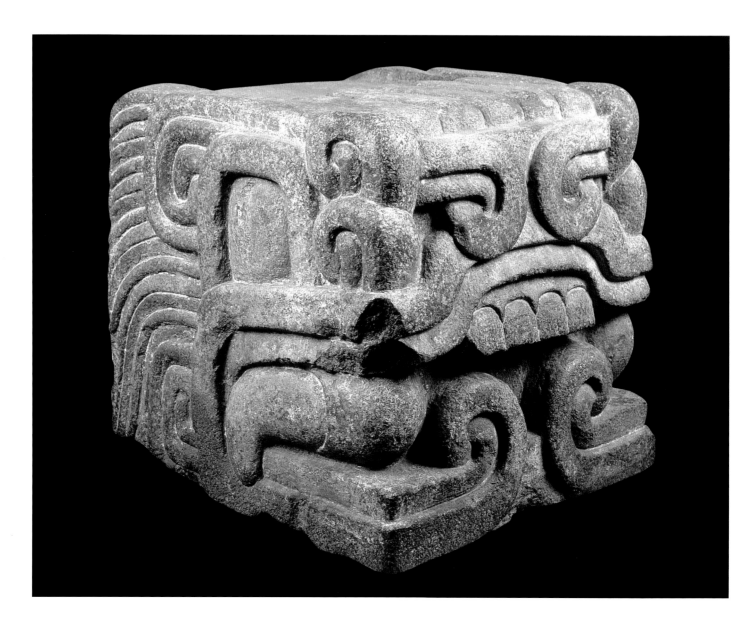

Cat. 18
Head of a feathered serpent

c. 1507, Mexica
Basalt, 54 × 55 × 61 cm
Museo Nacional de Antropología, Mexico City, inv. 10-81558

Selected literature: Bernal 1967, p. 161, no. 84; London 2002, p. 450, no. 202

This striking serpent's head once formed part of the ornamentation in Moctezuma II's palace in Tenochtitlan. Steps preserved *in situ* in the Templo Mayor suggest that it may have formed part of a balustrade at the top of the building's staircases.

The cube shape is the carving's most obvious feature, distinguishing the reptile's head from the naturalism more commonly found in statues from this period. The geometric design was undoubtedly intended to endow the figure with an ancestral authority. At the front, the row of teeth is framed by four scrolls,

the bottom two suggesting a forked tongue. The formidable curved fang, large eye and wavy bands on either side of the serpent's profile suggest the movement of this mythical creature's feathers and identify the carving as a depiction of the feathered serpent, Quetzalcoatl.

A similar piece in the Rautenstrauch-Joest-Museum, Cologne, may also have come from Moctezuma's palace. The present serpent is also very close stylistically to the three rectangular serpent's heads found in 1944 at the junction of two streets, the Calle de Cuba and Calle de Palma in Mexico City. The bases of these sculptures bear the number 8 carved in the 'Xochicalco style', which substantially predated the Mexica and is linked with the date 2 Reed (1507), marking the New Fire ceremony during the reign of Moctezuma II. It is therefore likely that this serpent's head was carved in a deliberately archaic style, serving the same commemorative purpose as the others in Moctezuma's palace, even though it bears no calendar date.

FSO

Cat. 19
Rattlesnake fragment

c. 1500, Mexica
Basalt, 101 × 138 × 60 cm
Museo Nacional de Antropología, Mexico City,
inv. 10-220935

Selected literature: Pasztory 1983, pp. 234–35; García
Moll, Solís Olguín and Balí 1990, p. 31; Solís Olguín
1991, p. 121; Bilbao 2005, p. 220

The chronicles left by Hernán Cortés and his entourage describe the opulence and enormous scale of the palace built for Moctezuma II. Little remains of this legendary building situated to the south of the ritual precinct. The original structure was dismantled and demolished to make way for the Viceroy's Palace, which was later transformed into the Palacio Nacional of Mexico after the wars of independence in the early nineteenth century.

However, some ornamental fragments from the original palace have been salvaged, most of them uncovered during conservation work carried out in the twentieth century. One such fragment is this snake's tail, which is notable for the rattles it contains.

The carving on the snake's enormous body is especially striking. Although it is appropriately covered with scales, set among them are six corncobs, transforming the reptile into a metaphor for the earth which generously supplies nourishment to the Mexica people. This fragment undoubtedly formed part of an image of the goddess Cihuacoatl ('woman serpent'). This deity symbolized the female power of nature by providing life and sustenance, and closed the human cycle by playing host to the corpses of the dead. *FSO*

Cat. 20

Fragment of a frieze

c. 1500, Mexica
Stone, stucco and paint, 30.5 × 233.5 cm
Museo Nacional de Antropología, Mexico City, inv. 10-333560

Selected literature: Solís Olguín and Morales Gómez 1991, pp. 20–22, 303–06

In the 1930s the former Plaza del Volador was excavated to make way for the imposing Supreme Court of Justice on the south-west corner of the Plaza de la Constitución. The work unearthed not only the Pre-Hispanic platform base containing a huge offering of ceramic vessels (see cats 48–50) but also architectural remains, most of which were destroyed. The few pieces that were retrieved include slabs and fragments of friezes or ornamental borders with *chalchihuitl* (the symbol for greenstone). The former are decorated with stepped fretwork motifs (*xicalcoliuhqui*) in the form of large rectangles, while the latter were subsequently identified as part of a ritual banquet hall linked to a palace building. These elements resemble the pieces found more recently during the restoration of the northern section of the Palacio Nacional. When the Mexica Gallery in the Museo Nacional de Antropología was refurbished in 1999, this banquet hall was reconstructed with the surviving fragments from the Plaza del Volador.

Also discovered were fragments from a second, narrower, frieze, similarly decorated with stepped fretwork, this time culminating in a spiral so that the circular pattern predominates. Seven of the fragments fitted together, and these are exhibited in the Mexica Gallery today.

According to the archaeologist Eduardo Noguera, who classified the objects found in the excavations in the Plaza del Volador, the present fragment would have formed part of a frieze adorning the walls of these pyramid platforms. This unusual architectural discovery is reminiscent of the images of temples and other buildings from the Mixtec region of Oaxaca recorded in the Pre-Hispanic codices. As this fragment corresponds to the southern part of Moctezuma II's palace, it suggests that by the time of his reign, Mixtec-style decoration had influenced architecture in Tenochtitlan as well as gold and ceramics.

FSO

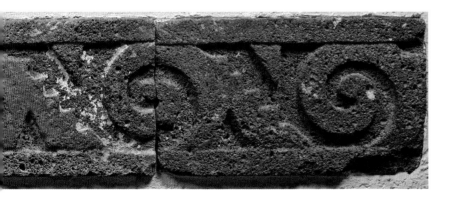

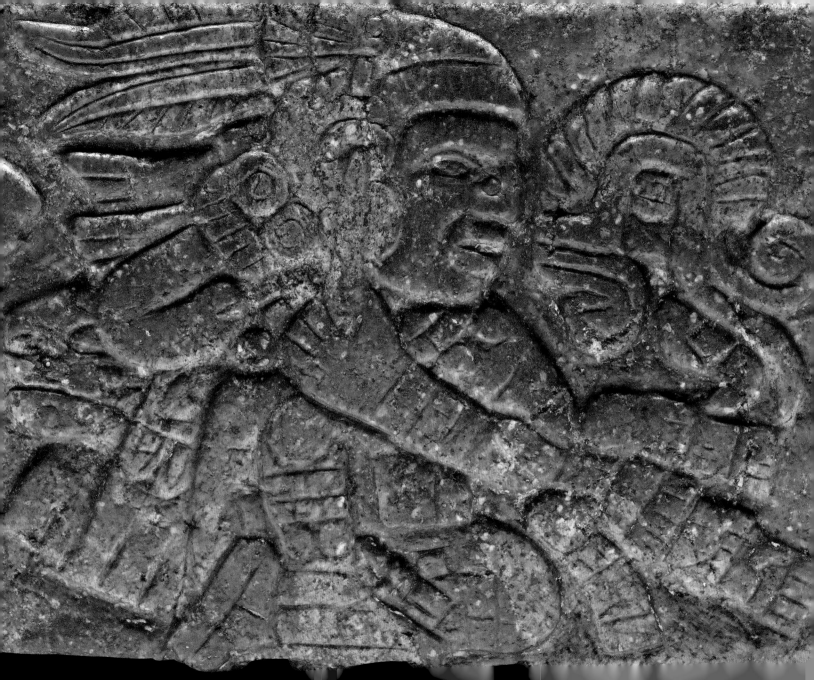

Images of Moctezuma and his symbols of power

Guilhem Olivier and Leonardo López Luján

NUMEROUS DIRECT and indirect historical accounts agree that by the time of his death in 1520, Moctezuma was a grown man, but it is still not clear whether he was fifty-two years old, as some believe, or whether he was still in his forties. He is repeatedly described as being a person of medium height, of slender build and with a long, thin beard,[1] which coincides with European-style images of him in the Mendoza and Florentine codices (figs 19 and 71).[2] The soldier Bernal Díaz del Castillo recalls him as being:

> ... of good height and well proportioned, slender and spare of flesh, not very swarthy, but of the natural colour and shade of an Indian. He did not wear his hair long, but so as just to cover his ears, his scanty black beard was well shaped and thin. His face was somewhat long, but cheerful, and he had good eyes and showed in his appearance and manner both tenderness and when necessary, gravity.[3]

Friar Francisco de Aguilar completes the picture by describing Moctezuma's character as well as his physical appearance:

> The king and lord was of medium height and slender build, with a large head and somewhat flat nostrils. He was very astute, discerning and prudent, learned and capable, but also harsh and irascible, and very firm in his speech.[4]

Fig. 23
Detail of the Hackmack Box, showing Moctezuma II performing self-sacrifice by drawing blood from his earlobe with a bone perforator (see cat. 58). Museum für Völkerkunde Hamburg.

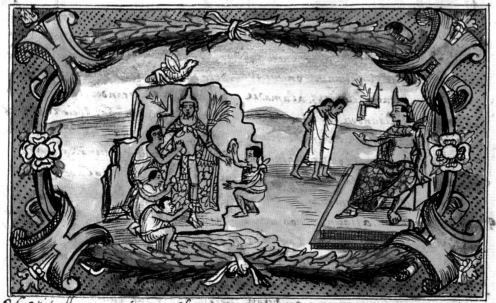

None of these traits are apparent in the indigenous-style images of Moctezuma, simply because the Mexica did not practise the art of portraiture before the arrival of the Europeans. In indigenous sculptures and paintings it is easy to recognize the rulers of Tenochtitlan by their costume, regalia and context; however it is impossible for us to distinguish between them based on their faces or gestures, as they were all portrayed conventionally and in a stereotyped manner. The Mexica artists obviously made each one different, but they did this through the use of onomastic or name-glyph complexes that gave expression to the heads of the characters represented.[5]

In the case of Moctezuma II, the *xiuhuitzolli* – a royal diadem in gold covered with turquoise mosaic – was used as the main glyphic element, as his name meant 'He Who Grows Angry [like a] Lord'. The *xiuhuitzolli* was shown in profile, with its characteristic blue triangular silhouette, as well as two red thongs used to knot the diadem to the nape of the neck. When it was part of an onomastic complex it was usually accompanied by one or more complementary glyphic elements, including a straight and well-cut head of hair; a nose piece (*yacaxihuitl*), an ear-spool (*xiuhnacochtli*) and/or a stepped pectoral (a pendant worn by warriors) also in turquoise; a double speech scroll, sometimes in the form of a *teoatl-tlachinolli* war glyph ('divine water and bonfire'); feathers or parallel strips, associated with penitence and fasting, known as 'fasting cords'. However, the *xiuhuitzolli* glyphic complex is problematic as it is also used (although not on their heads) to identify Moctezuma I (reigned 1440–69), Tenochtitlan's main military leaders, and also royal judges.

In Mexica sculptural art there is a small group of monuments and another of ritual objects with the *xiuhuitzolli* glyph complex. Given the problems of identification, it is still being debated whether the former were commissioned during Moctezuma II's reign (1502–20), and whether the latter group were part of the sovereign's prized

Fig. 24 *above left*
Moctezuma I supervising the sculpting of his own image at Chapultepec Hill, Mexico City. From the Codex Durán, fol. 91v. Biblioteca Nacional, Madrid.

Fig. 25 *above*
Surviving details of Moctezuma II's image carved in relief in the bedrock at the foot of Chapultepec Hill, Mexico City.

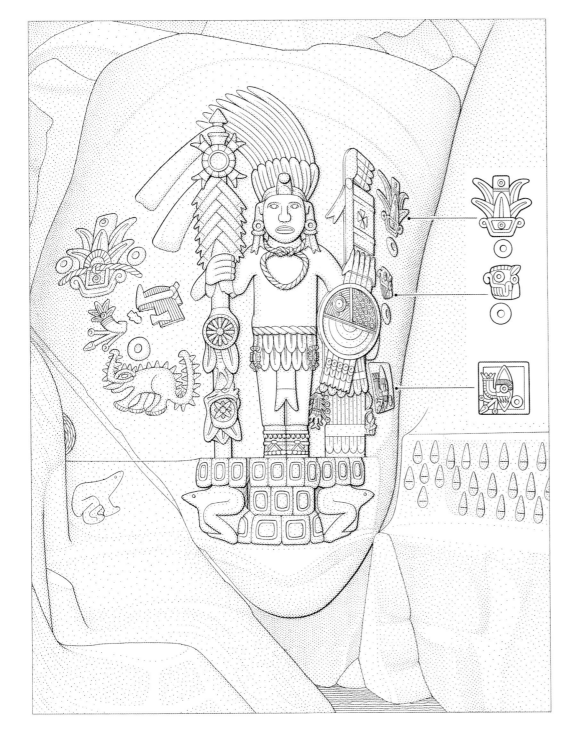

Fig. 26
Hypothetical reconstruction of the sculpted relief at Chapultepec Hill showing Moctezuma II dressed as Xipe Totec. This reconstruction is based on careful examination of surviving details of the sculpture and also draws on representations of Xipe Totec in codices.

possessions. The most interesting monument, and that which offers fewest doubts as to its origin, is the half-relief found at Chapultepec Hill in modern-day Mexico City.[6] Descriptions in the historic sources of the sixteenth century tell us that the Mexica sovereigns had their effigies sculpted in the andesite outcrops at the base of this hill. The custom seems to date back to the era of Moctezuma I. Although the reliefs were badly damaged in the eighteenth century on the orders of the viceregal government, enough remains for us to be able to see that the best-conserved figure, at 1.35 metres high, shows Moctezuma II. He is shown at full-length, standing erect and facing forwards, and has insignia of Xipe Totec,[7] a Mesoamerican god of war. As well as the aforementioned

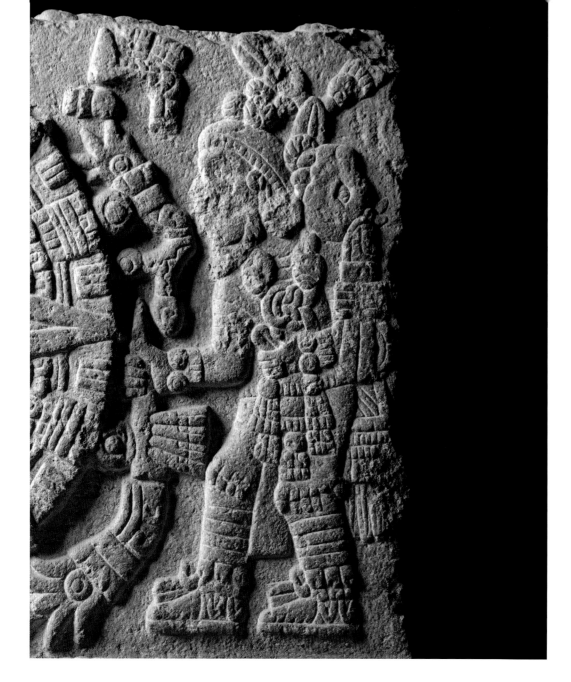

Fig. 27
The figure of Moctezuma II,
identified by his name glyph.
A detail from the *Teocalli* of
Sacred Warfare (see cat. 78).
Museo Nacional de Antropología,
Mexico City.

onomastic glyph complex, calendrical signs that specialists have linked to the most important events in his life accompany the portrait: 1 Reed (1467, the possible year of his birth), 1 Crocodile (the day of his coronation, see cat. 14) and 2 Reed with a knotted rope (the last New Fire ceremony, held in 1507; see p. 140).

A similar effigy, though much smaller in size, is the so-called *Teocalli* of Sacred Warfare (fig. 27).[8] This is also of indisputable origin. Here, Moctezuma and Huitzilopochtli, the patron god of the Mexica, did penance before the sun and the earth. The ruler appears in full-length and in profile, attired in the typical priest's garb and carrying his auto-sacrifice bloodletting instruments. He is wearing a feline skin, as well as the feather headdress known as a *cozoyahualolli*, a Chichimeca emblem that connects him to the first rulers of the dynasty. The image of Moctezuma, again wearing his priestly attire, was also sculpted on the famous box in the Hackmack collection (cat. 58). This is a tiny two-piece quadrangular receptacle that may have been used to hold his blood and instruments of penitence.[9] On one side of the box we see him seated, perforating an earlobe and turning his back on his onomastic glyph. The presence of symbols and dates relating to the creator-god

Quetzalcoatl underline Moctezuma's power and devotion, whilst the date 1 Crocodile, carved on the back of the box, refers back yet again to his coronation ceremony.

Other sculptures linked to Moctezuma

Although they do not bear the standardized effigy of a *tlatoani*, other stone ritual objects have the glyph complex of the *xiuhuitzolli* accompanied by calendrical dates that fall within the reign of Moctezuma. Two of these are quadrangular basalt boxes: one has the date 6 Reed (1511) (cat. 16)[10] and the other 11 Flint Knife (1516) (cat. 15).[11] A further sculpture, although in green stone and free standing, shows a beautiful fire serpent; again, on the base is a relief with the royal diadem and the 2 Reed with a knotted rope that probably corresponds to the final celebration of the New Fire ceremony (cat. 76).[12] The Sun Stone (fig. 28) could also be included within this small group of sculptures as it bears the *xiuhuitzolli*.[13] According to some researchers this monument was sculpted in 1512.[14]

Other images that appear to recall crucial moments in Moctezuma's life also survive, although they lack the sovereign's onomastic glyph complex. On the so-called 'Metro Block' (cat. 56), a seated figure in priest's garments and set against a background of human

Fig. 28
The Sun Stone, a monument commissioned by Moctezuma II. At its centre is the frontal face of a deity with clawed limbs embedded within the *Ollin* symbol that represents the present era or Sun. (see also fig. 1). Museo Nacional de Antropología, Mexico City.

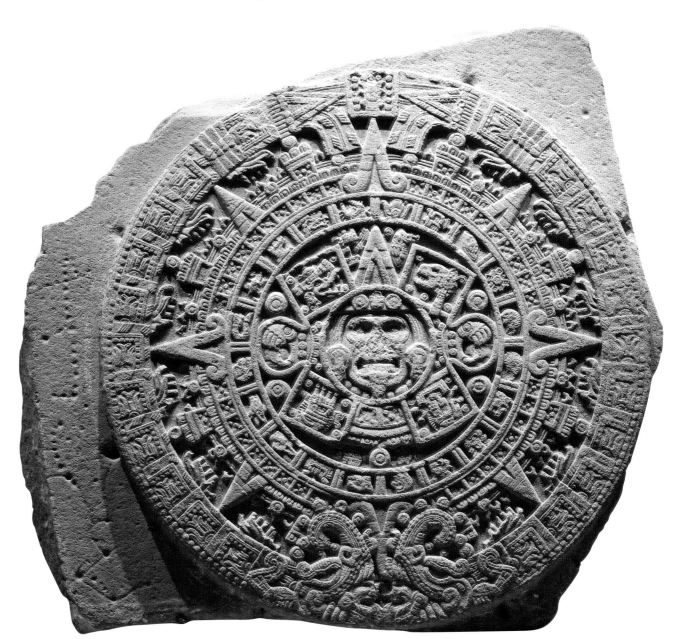

hearts draws blood from his chest, arms and legs in an act of penitence.[15] There are three revealing dates on the different faces of this block: 10 Rabbit (1502), the year – according to many sources – when Moctezuma II was enthroned; 2 Reed, the year of the last New Fire ceremony; and 1 Deer, the day on which new-born noble children were believed destined to become rulers. Another interesting example is the monument in Amecameca, carved on a large rock in the foothills of the Iztaccihuatl volcano to the south-east of Mexico City.[16] This shows a scene where an individual burns an incense ladle alongside a large brazier, as well as the aforementioned year of 10 Rabbit and the trecena of 1 Crocodile. The final example is the Stone of the Five Suns (cat. 14),[17] a basalt coronation stone that was named after the presence on its main face of the calendrical names of the five Mexica cosmic ages (4 Jaguar, 4 Wind, 4 Rain, 4 Water and 4 Movement). To these dates were added the day 1 Crocodile and the year 11 Reed (1503), the latter being mentioned by certain sources as the year Moctezuma was enthroned. In this case it is clear how official Mexica art combined mythological and historical dates, placing dynastic events within the legitimizing frame of reference of the cosmic ages.

The priestly insignia

From the moment they were chosen, Mexica rulers were expected to prove their faith by offering the gods their own blood and the aromatic smoke of copal resin. This involved a process of separation and withdrawal that started at the bottom of the Templo Mayor of Tenochtitlan.[18] The ruler-elect, wearing nothing but a *maxtlatl* (loincloth), was conducted to the summit of the pyramid by the allied kings of Tetzcoco and Tlacopan and two of his officers. On arrival at the Huitzilopochtli sanctuary he paid reverence to the image of the god. The supreme priest then dyed his body black to indicate his temporary status as a penitent, sprinkled him with sacred water in the same manner in which he would scatter the ashes of the rulers and his family members during their funerals, and clothed him in a mantle adorned with skulls and cross-bones symbolizing his ritual death.

The supreme priest then handed over the insignia of penitence. These consisted of a *xicolli*, a short, fringed and sleeveless jacket tied in the front; a *yeitecomatl*, a gourd that hung down the back on red thongs and contained powdered tobacco that was chewed for its energizing and narcotic qualities; a *copalxiquipilli* bag to hold the copal resin; a *tlemaitl* or ceramic incense ladle in the form of a fire serpent; a pair of bone auto-sacrifice bloodletters; and blue sandals known as *xiuhcactli*. Once the ruler had burnt incense before the image of Huitzilopochtli, he listened to an exhortation in which his position was reaffirmed and recommendations made on his future role. When this finished, he descended to the foot of the pyramid where the dignitaries awaited him to pay him reverence and present him with gifts as a sign of obedience. The ruler then made his way to the building known as *Tlacatecco*, which has been identified with the archaeological site known as the House of the Eagles.[19] Here he carried out his ablutions, fasting and physical mortification for four days and four nights. Finally, he retired to his palace to prepare for his investiture and coronation ceremony.

This ritual sequence symbolized the initiation death of the recently elected

tlatoani in its entirety, marking the radical modification of his religious and social status. The ruler was attired similarly on the occasion of other important events in his life during which he also made offerings of copal resin and blood. Such events included the death of his first captive; before setting out to war; after a military victory; as an act of submission to the god of a conquering city; and in festivities such as that of the day 4 Movement, devoted to the solar cult.

The symbols of political power

The aim of the coronation ceremony was to install the new sovereign so that he could begin his duties. The most important Mesoamerican symbols of royal power, the mat and throne ('*in petlatl, in icpalli*'), played an essential part in the proceedings as they embodied the material expression of the concepts of dignity and authority.[20] The mat was usually used as the base of the throne. In the case of the first three rulers of Tenochtitlan, the latter was a simple *tolicpalli* or bundle of reeds, which identified them as lords of Chichimeca origin who were still subordinate to Azcapotzalco's reign. By contrast, when succeeding rulers became independent they gained the right to be seated on a *tepotzoicpalli*, a high-backed throne made from woven reeds and adorned with jaguar skins.

Images of Acamapichtli, Huitzilihuitl and Chimalpopoca, rulers of Tenochtitlan before the war of independence of 1428–30, show them wearing on their heads a *cozoyahualolli* – a feather headdress connected to the Chichimeca past.[21] In contrast, their successors boasted the royal diadem or *xiuhuitzolli*,[22] a word that can be translated as a 'pointed turquoise thing' and which appears to represent schematically the tail of the *xiuhcoatl* or fire serpent. The *xiuhuitzolli* has its most ancient roots in the Olmec era, during the so-called Middle Preclassic period. Many authors have studied the iconographic sequence that takes the sign of the diadem as its starting point and moves on to the sign of the year, as well as the symbolic link where the diadem, turquoise, time and rain are strongly associated with political power. We know that the *xiuhuitzolli* was used by the rulers of Tenochtitlan, Tlatelolco, Tetzcoco and many provinces in the empire, but never by the enemy lords of Tlaxcala. In Tenochtitlan it was also worn by the *tetecuhtin* (lords),[23] senior military leaders and by warriors who had died in battle. The fire priests and gods such as Xiuhtecuhtli, Tonacatecuhtli, Mictlantecuhtli, Tonatiuh, Tlahuizcalpantecuhtli and Chalmecatecuhtli also used it as a symbol.

The new sovereign's septum was pierced at the investiture using a jaguar bone, and a tubular nose ornament known as a *xiuhyacamitl* was put in place. The Mixtecs performed this ritual on a sacrificial stone, symbolizing the sovereign's death ritual.[24] In addition, in the case of the Mexica ruler, he was dressed in the *xiuhtlalpilli tilmahtli*, a blue cotton tie-dyed net cape embellished with turquoise stones. This cape was usually edged with a *tenixyo* border ('eyes on the edge'). This was one of the most prestigious motifs of the iconography of power. Other

Fig. 29
Moctezuma II dressed as the fire god Xiuhtecuhtli during the Izcalli festival. From the Codex Borbonicus, fol. 23. Palais Bourbon, Paris.

symbols bestowed on him for the occasion included a pair of gold sandals, a shield and a sword-club, and a bundle of darts that symbolized his judicial power.

The *xiuhuitzolli* and other turquoise ornaments directly connected the sovereigns with the ancient god of fire Xiuhtecuhtli, the mother and father of all deities that resided in the centre of the universe. This relationship can be understood when we take into account that this god, along with Tezcatlipoca, was the protector of royalty.[25] The sovereign evoked Xiuhtecuhtli in his acceptance speech after being chosen,[26] paid him special homage during his enthroning ceremony[27] and personified him in the Izcalli ceremony, which celebrated new growth (fig. 29).[28]

Warrior emblems

The *tlatoani* embodied the Mexica ideal of bravery. His main task was to feed the sun and earth with human blood, using arms to take captives for sacrifice. After he was chosen to be ruler he therefore beseeched Tezcatlipoca, the god of fate and destiny, to support him in war: 'Also, concede him, let him experience, send him to the midst of the desert, to the centre of the desert, to the field of battle. May he know the home of the sun...'[29] In other words, the *tlatoani* was expected to be present time and time again at military confrontations, resulting in his definitive journey to 'the home of the sun' (*in tonatiuh ichan*), the final destination of warriors killed in battle or sacrificed on the sacrificial stone. Following this logic, at the enthroning ceremony the ruler was compared to a fearsome beast (*tecuani*, 'eater of people'), armed with powerful claws and sharp teeth.[30] The eagle and the jaguar were the most powerful predators in ancient Mexico and these animals were therefore kept as protectors of the main military order of the Mexica: the *cuauhtli ocelotl*.

Like any other distinguished member of the Tenochtitlan nobility, Moctezuma had received an education that included learning the arts of war and the correct handling of arms. A later anecdote that was probably apocryphal presents him as a boy, playing at war in the role of a great general and punishing one of his young friends for being a coward.[31] Whether or not this happened, we know that Moctezuma took part in several military campaigns during his youth, accompanying experienced warriors who showed him how to take prisoners. Other witnesses specify that over the course of time he obtained the prestigious title of *cuachic* (shorn one); this was granted to those who had captured several enemies, especially brave warriors from the Valley of Puebla. Díaz del Castillo also tells us that Moctezuma had been the victor in three different hand-to-hand fights.[32]

As supreme chief of the army, the *tlatoani* wore special garments and rich insignia during battles to distinguish him from the other generals. The indigenous informants of the sixteenth-century chronicler, Friar Bernardino de Sahagún, left us with a long list of headdresses, capes, emblems and exclusive arms

Fig. 30
Gold labret in the form of an eagle head. Museo Civico d'Arte Antica, Palazzo Madama, Turin, 2.2 × 5.4 × 4.7 cm.

Fig. 31
King Nezahualcoyotl from
Tetzcoco wearing a gold labret
in the form of an eagle head.
From the Codex Ixtlilxochitl, fol.
106r, Bibliothèque Nationale
de France, Paris.

of the sovereigns. These items included the 'costly red spoonbill headdress set off with gold, having very many quetzal feathers flaring from it'; 'a red shirt, made of red spoonbill feathers decorated with flint knives fashioned of gold'; 'a necklace of round, large, green stone and fine turquoise combined'; 'the wooden sword provided with obsidian blades set in a groove at its edges'; and 'a shield covered with blue cotinga feathers with a disc of gold in the center'.[33] Other historical documents describe or illustrate a wide variety of royal shields. A splendid surviving example, decorated with feathers and gold leaf, depicts a feathered blue coyote from the mouth of which emerges the Mexica glyph for war.[34]

Another ornament of war is the gold labret in the form of an eagle's head. Several examples have been preserved and are now on view in museums in Europe and the United States (fig. 30).[35] The labret also appears in the Codex Ixtlilxochitl in the beautiful image of Nezahualcoyotl (fig. 31).[31] Here we see the poet-king of Tetzcoco in his dress uniform,

brandishing an obsidian-edged sword and a shield with rich feather mosaics. On his back he carries a small blue war drum that he used to order his army to attack the enemy with violence or start to withdraw. Significantly, at the end of the sixteenth century, whilst staying in Tetzcoco, the Spanish protomedico Francisco de Hernández declared that the city still had, 'with immense religious respect', the shield, flags, flutes, drum, arms and other ornaments that the old Aculhua sovereigns used both in war and in their dances.[37]

The warrior rulers habitually dressed like gods. For example, in the Codex Vaticanus A, in which the Mexica conquest over Toluca and Xaltepec is depicted, Moctezuma is dressed as Xipe Totec, as on the Chapultepec rocks mentioned previously (pp. 80–81).[38] Traditionally, the first captive taken in the field of battle was sacrificed and his cadaver skinned. The *tlatoani* put on this skin, thereby frightening away rivals. In other images of Mexica art, the rulers are shown holding their enemies by the hair, an ancient gesture of capture that was widespread across the whole of Mesoamerica. On the so-called Tizoc Stone (fig. 11) and the Stone of the Old Arzobispado,[39] several scenes portray the ruler in this pose and displaying insignia of Huitzilopochtli, Tezcatlipoca and Xiuhtecuhtli. His adversaries, in a position of submission, are dressed in the trappings of the patron gods of their respective cities. The toponymic or place glyphs of these cities are found at the top of the scene. In other words, the Mexica rulers, like the sovereigns of Mesopotamia or ancient Egypt, embody their whole army defeating their enemies.

The privileges of palace life

Besides his religious, political and military duties, Moctezuma was required to coordinate the tasks of the central administration and impart justice in matters of state. Starting first thing in the morning, he gave instructions of all kinds, examined lists of tributes and spoke to provincial lords who lived in the royal palace. He also spent a good part of the day dealing with disputes and petitions. The complainants usually presented codices to the judges to support their arguments, a practice that would continue throughout the colonial period. The judges summarized the cases and expressed their opinions to the ruler, who proclaimed the final sentences. On these occasions, everybody apart from governors of allied kingdoms had to approach Moctezuma barefoot. By the same token, visitors had to change their elegant cotton robes for humble maguey-fibre mantles, and when addressing the sovereign, they had to look submissively at the floor. Many Indians informed the Spanish that nobody had ever seen Moctezuma's face.

In their chronicles, the conquistadors marvelled at the abundance and refinement of the dishes that made up what was later dubbed 'Montezuma's Dinner'.[40] According to Díaz del Castillo:

> ... they daily cooked more than three hundred dishes, fowls, turkeys, pheasants, native partridges, quail, tame and wild ducks, venison, wild boar, reed birds and pigeons and hares and rabbits, and many sorts of birds and other things that are bred in this country, and they are so numerous that I cannot finish naming them in a hurry.[41]

Fig. 32
A noblewoman preparing a
foaming brew of chocolate. From
the Codex Tudela, fol. 3r. Museo
de America, Madrid.

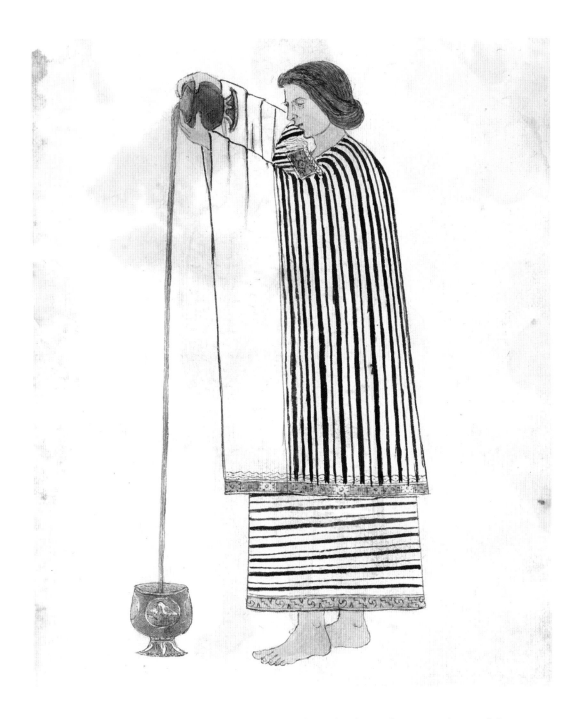

Hernán Cortés's soldier goes on to describe how 'four very beautiful women' washed Moctezuma's hands before eating whilst he remained seated before a low table covered with white cloths. They served him the food on polychrome ceramic plates made in the city of Cholula, and he was accompanied by four elder chieftains who ate standing at his side. After the meal, Moctezuma smoked tobacco with liquid amber in a painted pipe and was entertained by singers, dancers, buffoons, dwarves and hunchbacks.

Chocolate was the royal beverage par excellence, meaning that it was off limits for the commoners. After toasting and milling the cacao beans, the drink was prepared by adding water and beating it rapidly with gold, silver or wooden spoons, and then poured from a height to produce a foamy solution (fig. 32). Served cold and sometimes mixed with milled corn, aromatic spices or honey, the chocolate was presented to Moctezuma in fine gold cups

at lunch and dinner. One source states that during the funeral rites of Moctezuma's father, Axayacatl, several cups were placed before the statue of the deceased.[42] Another exclusive privilege of kings and nobles was to enjoy the fragrance of flowers. We know that Moctezuma liked to be seen holding a bouquet of flowers, which symbolized fire and its unequalled power over the earth. Xochipilli, the 'Prince of Flowers', was another of the deities that protected the nobility. During the annual Toxcatl celebrations, a young warrior was chosen to personify the god Tezcatlipoca for one year. This youth, selected for his physical beauty and capacity for eloquent speech, moved freely through the streets of the city smoking tobacco and smelling flowers, thereby impersonating both gods and sovereigns.[43]

Moctezuma was said to be a great enthusiast of hunting. Before the arrival of the Europeans, he often led expeditions dressed as Mixcoatl, the god of hunting, and handed out generous rewards to those who had captured or killed prey. Whilst in captivity under Cortés's orders, Moctezuma was given safe conduct to go hunting outside of Tenochtitlan accompanied by a large group of Spanish guards and three thousand Tlaxcaltec warriors. On his return he 'gave gifts to them all and made them many concessions',[44] as though continuing to play the role of the great distributor of wealth from his time of freedom. It is unlikely, however, that he wore the insignia of Mixcoatl during this final excursion.

In the same vein, historical sources point out that Moctezuma was a good shot with a blowgun, another important symbol of the nobility.[45] The king is described hunting birds and rabbits by the lake or in the woods, orchards and gardens of Cuauhnahuac and Huaxtepec, towns in the modern-day state of Morelos. In the allied city of Tetzcoco, large rocks with holes filled with water were placed in the royal gardens to attract birds, so that the kings

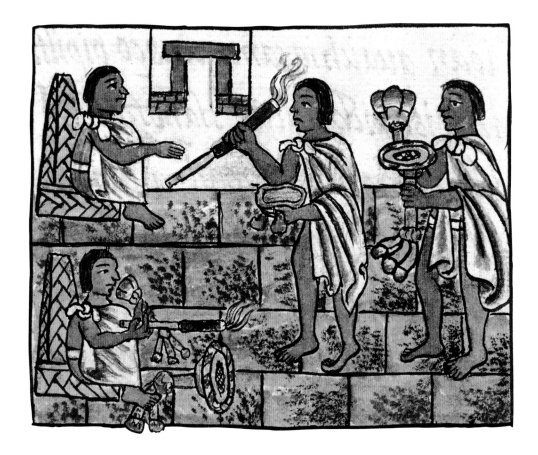

Fig. 33
Mexica lords smoking tobacco and smelling flowers. From the Florentine Codex, Book 9, fol. 28v. Biblioteca Medicea Laurenziana, Florence.

could entertain themselves shooting them with their blowguns from the palace windows. In his famous letters, *Cartas de relación*, Cortés refers to a dozen splendid blowguns, painted with motifs of birds, trees and flowers, presented by Moctezuma as gifts for the king of Spain. Because of the blowgun's association with the sun god, one of the deities identified with the ruler, this no doubt represented a worthy gift for an emperor of Charles V's high status.

Another royal pastime was a ball game known as *tlachtli* (fig. 34) in which two or more players, protected by a wide leather belt, struck a heavy rubber ball with their hips. Spectators bet all kinds of 'costly goods: golden necklaces, greenstone, fine turquoise, slaves, precious capes, valuable breech clouts, cultivated fields, houses, arm bands of quetzal feathers, duck feather capes, bales of cacao.' Moctezuma and Nezahualpilli, the ruler of Tetzcoco, apparently came face to face in a game that was to have an ominous outcome. Nezahualpilli, who was famous for being able to predict the future, announced to the Mexica sovereign that foreigners would arrive who would lay both of their respective kingdoms to waste. To prove it, Nezahualpilli did not hesitate in betting his kingdom in exchange for three turkeys. Although Moctezuma started off in the lead, Nezahualpilli ended up the winner, proving that his predictions were correct.[46] Tellingly, sources tell us of other games between gods or between rulers, which symbolized the passing from one era to another and the alternating reigns of deities and emperors.

The obsidian mirror was an instrument that was closely linked to royalty. Several examples survive, including the mirror belonging to the famous English mathematician, astronomer and astrologer John Dee (1527–1608), who was an adviser to Queen Elizabeth I.[47] In ancient Mexico, such mirrors had a significant divinatory role and were widely used to reveal men's destiny. The mirror was also a symbol of the royal power granted by Tezcatlipoca, 'lord of the smoking mirror'. Mexica rulers owned an obsidian mirror with two faces: on one side it was said that the ruler saw the behaviour of his subjects in its surface; on the other side, the subjects saw their own reflection, thus revealing a close interdependence.[48] However, the mirror was to reveal to Moctezuma the ill-fated destiny of his empire. One day, some fishermen took to the palace a remarkable 'bird of ashen hue like a crane' with a mirror on its head. In the mirror Moctezuma saw a starry sky followed by a group of warriors riding on the backs of deer, presumably, the Spanish on horseback. However, even as he fearfully consulted his astrologers, the vision melted away....[49]

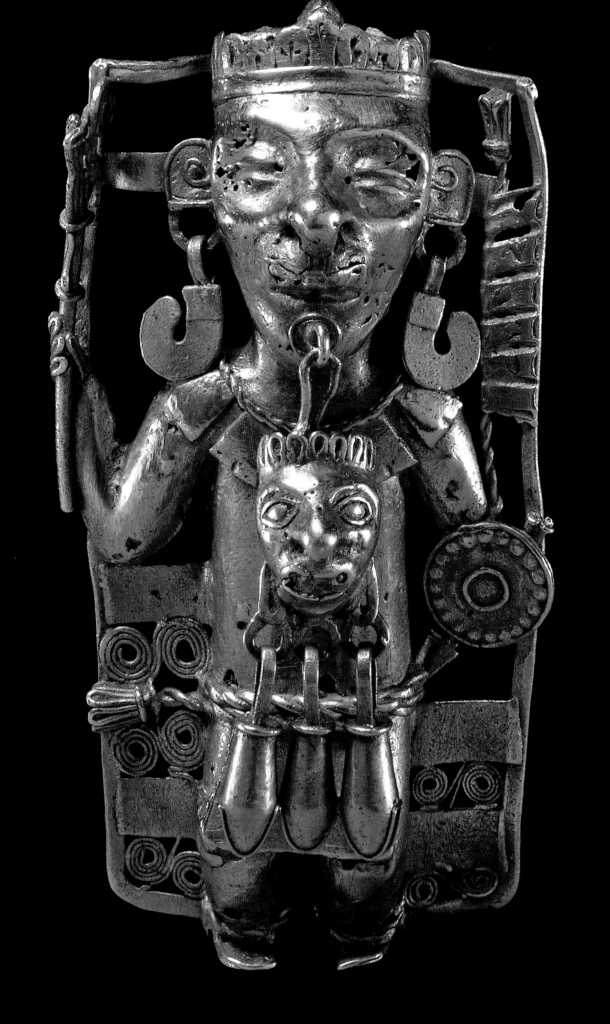

Cat. 21
Pendant

c. 1200–1521, Mixtec–Zapotec
Gold with silver and copper, 8.5 × 4.6 × 2.3 cm
Trustees of the British Museum, London, AOA Am +. 7834 / ESA 5682

Cat. 22
Pendant

c. 1200–1521, Mixtec–Zapotec
Gold with silver and copper, 12.8 × 2.4 × 1 cm
Trustees of the British Museum, London, AOA Am +. 1669 / ESA 5925

Selected literature: **cat. 21** London 2002, p. 445, no. 185; McEwan 2009, p. 62;
cat. 22 McEwan 1994, p. 65; La Niece and Meeks 2000, p. 227, figs 11, 13

These two gold ornaments, unearthed during excavations in the city of Tehuantepec, share interesting stylistic, technical and structural features. Made in gold and silver with a small amount of copper alloy, they were both cast using the lost-wax technique (see cat. 27).

Both objects are made from a central cast piece that is hollowed out at the back. One pendant (cat. 21, left) depicts a full-length standing figure, wearing a feathered headdress and necklace, holding a shield, similar to the one carried by the deity Xipe Totec in Mexica iconography, spears in his left hand and a spear-thrower (*atlatl*) in his right. The background is cast from the same mould with false filigree and openwork elements. The complexity of the detail is especially notable in the fingers of the right hand, the spirals in the background and the double-twisted belt and necklace. In the other pendant (cat. 22, right), a square background constructed from false-filigree loops and spirals frames an anthropomorphic head bearing a flat suspension loop at the top.

The mobile components of these objects are unique. Both heads are adorned with dangling ear ornaments. The ones seen in cat. 21 are similar to those worn by Ehecatl-Quetzalcoatl, the god of wind. The standing figure wears a lip-plug in the shape of a head with three bells. This is made using a different alloy to the rest of the ornament, suggesting that it was a later addition. To produce chains without any soldering link, the craftsman would have created a separate mould for each component and cast them in turn. Once the main body was cast, it would have been cleaned and then covered in clay slip. The next movable element made in wax would then be added and covered in slip before metal was poured inside. The other elements were added by repeating the same process.

From the pendant head hang four chains, each made up of three consecutive links and a bell. These are of a slightly different alloy. The disembodied heads added to these pendants may have represented trophy heads, exemplifying the power of the warrior who took them captive. Decapitation was associated with Xipe Totec, and during the Tlacaxipehualiztli, the springtime festival of renewal, a dance known as *motzontecomaitotia* was performed in which the performers brandished the heads of sacrificed captive warriors. *EVLL*

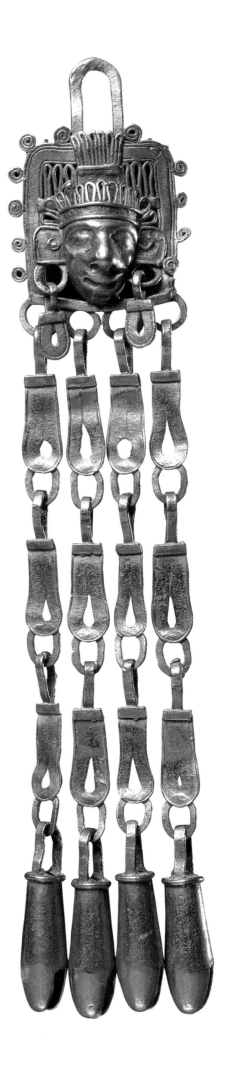

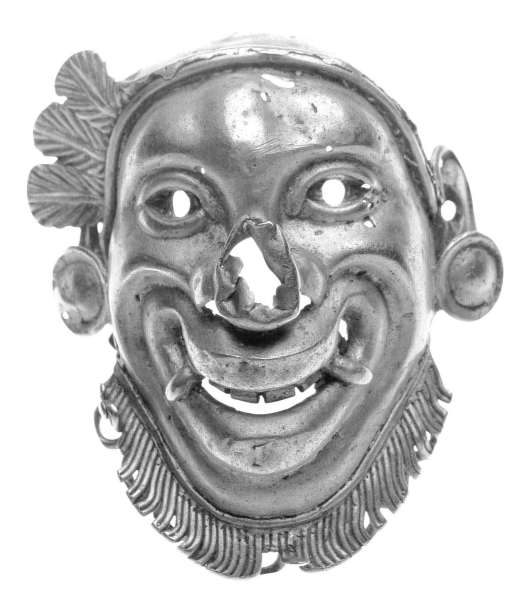

Cat. 23
Xiuhtecuhtli pendant

c. 1470–1521, Mexica–Mixtec
Gold, 4.2 × 3.8 × 2 cm
Museo Nacional de Antropología, Mexico City, inv. 10-8543

Selected literature: Solís Olguín and Carmona 1995; Seville 1997, pp. 114–15; London 2002, p. 444, no. 181

In the first half of the twentieth century Mexico City's historic centre underwent a process of urban transformation involving the destruction of buildings from the colonial era and the second half of the nineteenth century. To prepare the way for the new buildings workmen excavated to a depth of over two metres, unearthing the remains of the old Mexica capital in the process. This gold ornament in the image of the god Xiuhtecuhtli, the lord of turquoise and fire, was one of the discoveries from this period. It entered the collections of the Museo Nacional de Antropología after 1945.

Xiuhtecuhtli, whose face is strikingly depicted on this pendant, is linked with Huehueteotl, the ancient fire deity who lived in the centre of the universe at the intersection of the four cardinal directions of the cosmos. Goldsmiths used the lost-wax technique to animate the god's facial features. His enormous open mouth is extended in a smile, revealing his fangs but the protuberant nose is damaged. Three feathers on the left of his head symbolize the god's association with the number three, which is also reflected in the humble hearths of the common people who used three stones to support their cooking utensils. The face has the characteristic beard of the ancient gods and the ears are adorned with circular ear-spools.

FSO

Cat. 24
Tortoiseshell necklace

c. 900–1520, Mixtec
Gold, 2.86 × 1.27 × 0.64 cm (each)
Dumbarton Oaks Pre-Columbian Collection,
Washington DC, PC.B.103

Selected literature: Washington 1983, pp. 159–60,
no. 74; Matos Moctezuma 1988b, pp. 135–36;
Olmedo Vera 2002; Carrasco and Matos Moctezuma
2003; López Luján 2005, p. 52

Gold and greenstone were materials
reserved for the Mexica nobility. They
marked the status of the wearer, setting
them apart from the commoners and
closer to the gods. Mixtec artists were
included in the Mexica court and excelled
in the production of gold ornaments
such as large pendants and necklaces.

This gold necklace is made of sixteen
spheres decorated with incised zigzags and
circles in the stylized shape of a tortoiseshell.
In Mesoamerica both marine and terrestrial
turtles were associated with water and
their shells were often used as musical
instruments. Tortoiseshells were sometimes
made into drums, which were played using
drumsticks fashioned from antlers or other
implements. Tortoises were symbolically
associated with Xochipilli, the god of
music, dance and song, who is sometimes
represented as an anthropomorphic figure
inside a tortoiseshell. A number of excavated
offerings in the Templo Mayor contained
tortoiseshells and their representations in
stone and ceramic, or carved from a deer
antler, reinforcing their role as musical
instruments.

In Mesoamerican belief, tortoises
were a symbol of the earth, floating on the
primordial waters, and in Maya myths corn
is born from the turtle-earth. As López
Luján has pointed out, the location of the
tortoiseshells excavated in the Templo
Mayor suggests that they symbolized
the earth.

In this necklace each shell is cast
from a separate mould using the lost-wax
technique (see cat. 27). The three tassels
forming the lower part of each piece are
made using false filigree casting and were
part of the same moulds. Some miscasts in
the necklace indicate the complexity of this
technique, which required great precision
both in the construction of the moulds
and in the pouring of the molten precious
metal. A bell is attached to each of the
tassels. These were cast from individual
moulds created around the loop. When
worn, the reflections cast by the moving

parts would have animated the necklace while
the bells would have produced a distinctive
metallic tinkling (see also cats 21 and 22).

Other Mixtec gold necklaces composed
of cast elements in the shape of tortoise or
snail shells have been found in excavations
such as the impressive findings of the
Mixtec Tomb 7 at Monte Albán. Similar
gold necklaces are also described in the
inventories of goods shipped to Spain after
the conquest and illustrated in the Codex
Tepetlaoztoc, a colonial pictographic
manuscript listing tribute paid to the Spanish
(see cat. 124). *EVLL*

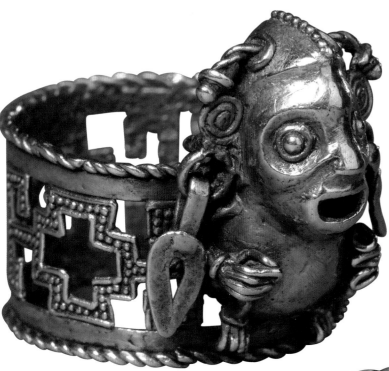

Cat. 25
Gold monkey ring

c. 1200–1521, Mixtec
Gold, 1.9 × 1.8 × 2.5 cm
Trustees of the British Museum, London, AOA Am 1977, 13.1

Cat. 26
Ring with a feline head

c. 1200 –1521, Mixtec
Gold, 2 × 1.1 cm
Trustees of the British Museum, London, AOA Am 1914, 0328.1

Selected literature: McEwan 1994, p. 6; Vienna 1997, p. 50, no. 22; Carrasco 1998, p. 179, note 117; La Niece and Meeks 2000, figs 11, 17, 18; London 2002, p. 442, no. 175; López Luján and Fauvet-Berthelot 2005, pp. 137–41

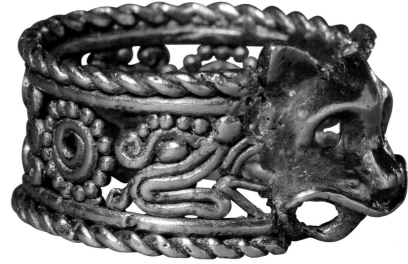

Cast using false filigree and lost-wax techniques (see cat. 27), these two rings are fine examples of Mixtec craftsmanship. Mixtec artisans were specialists in working gold, which was extracted by panning in rivers and imported from tributary provinces. Gold was the preserve of rulers and gods, an elite material that was used for high-status ornaments. Its Nahuatl name, *teocuitlatl*, comes from the words *cuitlatl*, meaning excrement, and *teotl* meaning god, and thus literally translates as 'excrement of the gods'. Moreover, in Mesoamerica gold was associated with the sun, and silver with the moon. In historical accounts goldsmiths described themselves: 'thus I make things beautiful; thus I make things give off rays.'

Both rings depict a zoomorphic figure, one with a feline head and the other with a monkey. The two figures were probably first created in wax as separate pieces, and then attached to the wax hoop for casting in one piece. In Mesoamerica animals were often used metaphorically to exemplify both godly and human characteristics. Felines are usually associated with powerful predators and great hunters. In Mexica and Mixtec societies the jaguar and eagle warriors constituted the highest military order, *cuauhtliocelotl* (eagle-jaguars). The jaguar was also an animal associated with the lower part of the cosmos, the cold and humid side, and was related to Tezcatlipoca and Tepeyollotl ('mountain heart').

The spider monkey (*Ateles geoffroyi*),

with hands and feet made from false filigree, wears dangling earrings (see cats 21 and 22) in an inverted raindrop shape known as *oyohualli*. One of the gold earrings hangs freely whereas the other is a miscast and has become fixed in place. The clay used to pin together the cast of the earring and the ear may have been imperfect, or the wax may have fused together before casting. Monkey figures with such dangling ear ornaments are often associated with Xochipilli, the god of flowers, song and dance, while those wearing different ear ornaments are identified as the wind god Ehecatl-Quetzalcoatl. Those born under the Monkey calendar glyph were considered to have a good character and were expected to be skilled artists, singers and lovers of the fine life. EVLL

Ring with an image of Xiuhtecuhtli

c. 1325–1521, Mexica
Gold, 2.7 × 2.9 cm
Museo Nacional de Antropología, Mexico City, inv. 10-594809

Selected literature: Saville 1920; Codex Florentino 1979, Book 9,
chapter XVI; Seville 1997, pp. 114–15

Moctezuma II followed the tradition of his
ancestors by accumulating ornaments and
jewellery, largely made from gold set with
turquoise or other semi-precious stones. Very
few such pieces are known, although a number
were unearthed following the conquest of
Tenochtitlan and during subsequent nineteenth-
century excavations in the city.

This distinctive ring was created using the
lost-wax technique, which was popular with the
metalworkers of Oaxaca and Michoacan. Friar
Bernardino de Sahagún meticulously described
and illustrated this method, recording how the
native craftsmen prepared the model to be
reproduced before covering it with clay to make
a mould in two sections. The model was then
removed and the mould hardened in an oven
or fire before being filled with melted beeswax
through a hole in the top. Liquid gold was
poured through the same hole, while the wax
was allowed to drip out through another hole in
the bottom of the mould. The first appearance
of drops of metal meant that the liquid wax had
all been eliminated and the casting was
complete. The final stage involved opening the
mould to reveal the precious jewel inside.

The ornamentation is characteristic of the
Mixtec tradition. The body of the ring is decorated
with a *xicalcoliuhqui*, a band with a spiral pattern
evoking the movement of a fire serpent. The
main feature, however, is the head of the god
Xiuhtecuhtli, the lord of fire and turquoise, who
wears a conical headdress with feathers on the
top and a crest at the nape of the neck. His nose
is covered with a diminutive mask in the form
of a *xiuhtototl*, a turquoise bird associated with
Xiuhtecuhtli, here pierced by a ring with a small
bell (now lost). Similar ornaments hang from the
ear-spools. Both the beard and the fangs are
attributes of this deity, who is also related to the
sun and to Huitzilopochtli.

This type of ring – of which other examples
have been found in Tomb 7 at Monte Albán in
Oaxaca – would have associated those who wore
them with a specific deity and made a harmonious
tinkling when the hand was moved. *FSO*

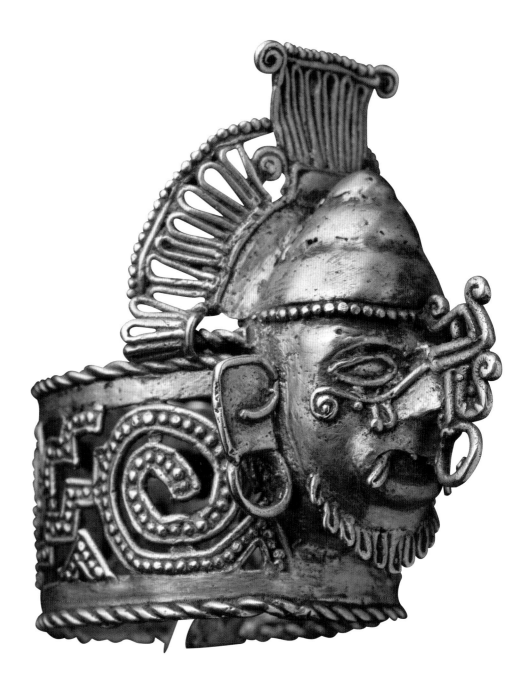

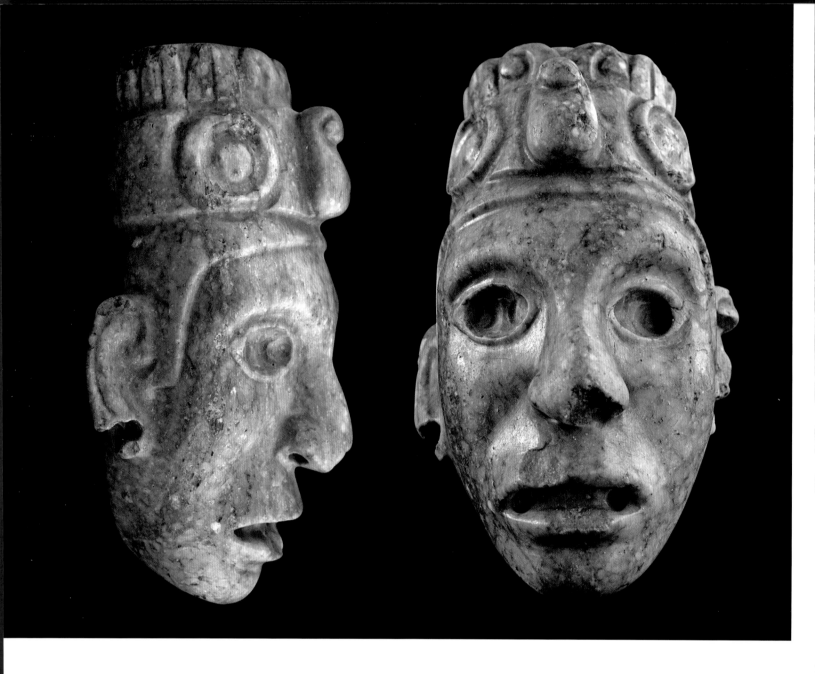

Cat. 28
Xiuhtecuhtli pendant

1325–1521, Mexica
Greenstone, 7.5 × 4.5 × 3 cm
Museo Nacional de Antropología, Mexico City, inv. 10-594485

Selected literature: Mena 1927; London 2002, p. 447, no. 191

This pendant's archaeological context is unknown, but its finely wrought symbolism suggests that it was a valuable ornament connected not only with Xiuhtecuhtli, the turquoise lord and god of fire, but also with the individual who might have worn it or to whom it was offered as a gift.

The greenstone is carved into an elongated shape, emphasizing the verticality of the face, whose skilfully crafted features belong to a young man wearing the headdress characteristic of the god. Xiuhtecuhtli can be identified by the diadem or crown (the *xihuitzolli* or *copilli*), made from a sheet of gold. The crown is not in the traditional triangular shape but is constructed from two pieces attached at the sides and topped with spheres. The band on the *xiuhuitzolli* is decorated with *chalchihuitl* (the symbol for greenstone) while the stylized ornament on the front represents the pheasant associated with Xiuhtecuhtli. The perforations in the ear lobes are damaged but they indicate that the ears were once ornamented with ear-spools.

Since this pendant was associated with the insignia of the Mexica rulers, it may have been given as a gift to their neighbouring allies, the rulers of Tetzcoco. *FSO*

Cat. 29
Duck bead

Sixteenth century, Mexica or colonial
Amethyst and malachite, 3.1 × 1.2 × 1 cm
Museum für Völkerkunde Wien (Kunsthistorisches Museum mit MVK und Ötm), Vienna,
10.407, Ambras Collection

Selected literature: New York 1970, no. 218; Feest 1990, no. 19; London 2002, pp.
447–48, no. 193 and p. 469, no. 279; López Luján 2006, vol. 1, pp. 172–73

This stylized duck's head, with a perforation at one end, probably
formed part of a strung ornament. Beads with similar iconography,
commonly made from obsidian, are scattered around museum
collections, but the best example of a complete necklace
composed of duck beads was excavated at the Templo Mayor in
Tenochtitlan. This was found among ashes inside a funerary urn
(see cat. 10), associating it with the rituals surrounding death.

This bead is carved from deep blue amethyst with a contrasting
inlaid green eye made of malachite. A series of such semi-precious
stones would have formed a colourful and visually striking
ornament, probably worn by a high-ranking figure. The colour blue
was highly valued by the Mexica, possibly because it was associated
with fertile aquatic environments. The setting of the Mexica capital
Tenochtitlan in the middle of Lake Tetzcoco led to a unique
relationship between the city's inhabitants and the surrounding
ecosystem. While some of the lake's birds would have been hunted
for their bright feathers, others were valued as a source of food.

Beads in the shape of stylized duck heads are usually found in
funerary contexts. Ducks traversed the three spheres of the universe
as they fly in the sky, walk on the earth, and swim on and dive
beneath the water. As López Luján has pointed out, the fact that
ducks migrated from the north, believed to be a place of death, may
have led the Mexica to associate these birds with the souls of the
dead. Four days after death, the essence of the soul
of the deceased, the *teyolia*, was believed to depart from the body.

Ducks were additionally associated with the god of wind,
Ehecatl-Quetzalcoatl (see cats 33 and 69), who is represented
wearing a mask in the shape of a duck's head. Duck's heads with
prominent beaks are also sometimes found on clay pipes. *EVLL*

Cat. 30
Ear-spools

c. 1500, Mixtec
Gold, 2.1 × 7.7 cm and 1.9 × 7.6 cm
Museo Nacional de Antropología, Mexico City, inv. 10-187 and 10-186

Selected literature: Solís Olguín and Carmona 1995; London 2002, p. 448, no. 194

The skill of the goldsmiths in the ancient Mixtec kingdoms was famed throughout Mesoamerica. They assimilated developments in Central and South America, where copper, gold and silver had long been used in a variety of techniques, creating a distinctive style that spread throughout ancient Mexico. In 1932, Alfonso Caso's discovery of Tomb 7 during excavations in Monte Albán revealed the incredible opulence with which the Mixtec rulers and princes in some regions of Oaxaca were bedecked with jewellery for their elaborate burials, and demonstrated the great range of techniques used by goldsmiths to create these striking ornaments.

These ear-spools were found in the early twentieth century on a royal burial site in the ruins of Coixtlahuaca, west of Tenochtitlan. They are known as 'bobbins', owing to their shape, and were made from embossed gold. Taking advantage of its malleability, the metal was hammered to form a sheet that was then folded over to achieve this striking tubular form, which was later cut to size with a chisel. The tube of the bobbin ear-spool keeps it in place in the perforated ear lobe, while the thinness of the gold makes the ornament very light to wear. The addition of ornaments is well documented in sculptures and masks in both stone and clay, demonstrating how they elegantly framed the face and emphasized the ears. *FSO*

Cat. 31
Ear-spools

1460–1521, Mexica
Greenstone (jadeite), 3.8 × 7.8 cm and 3.4 × 8 cm
Museo Nacional de Antropología, Mexico City, inv. 10-594482 and 10-594483

Selected literature: Durán 1995, pp. 264–65, 320–21; Sahagún 1997, Book 9, chapter III, pp. 524–25

The great empire of Tenochtitlan was the culmination of eighty-nine years of successful military campaigns that enabled the Mexica to control hundreds of nations, city-states and peoples of ancient Mexico. Despite this impressive demonstration of power, opulent greenstone jewels only started to flow freely into the capital in the 1460s, the last years of the reign of Moctezuma I. Highly prized by the gods, greenstone was for some time a luxury article reserved exclusively for the Mexica gods and rulers. As new raw materials

such as turquoise, silver and gold started to find their way into the royal coffers, greenstones began to be incorporated into the ornaments worn by nobility and warriors.

Such ornaments were not only symbols of power and wealth: they also reflected courage and honour, military prowess and membership of the inner sanctum of a religious cult. These objects can therefore be described as insignia, bestowing attributes on those who wore them, clearly conveyed by the objects' symbolism.

Moctezuma II devised a system whereby some of the spoils of war were sent to the palace workshops to be turned into emblems for distribution during the twenty-day feasts that followed a great victory. Not only did this motivate his troops and win their loyalty, it also created a hierarchy within the army, independent of nationality. Generations of soldiers could wear their insignia to affirm their participation in famous battles and individual acts of heroism. *RVA*

Cat. 32
Gold ornaments

c. 1200–1521, Mixtec
Gold, diameter 2.1 cm
Museum für Völkerkunde, Vienna, IV Ca 239/240

Selected literature: Fischer and Gaida 1993, p. 17; Matos Moctezuma
and Solís Olguín 2003, pp. II, XXV, figs 3, 23

Each of these circular gold ornaments consists of a frame of
twisted false filigree linked to an avian head with solar rays. The
strong, curved beak of the head emerging from the solar disc
identifies it as a bird of prey. This central piece has been cast
using the lost-wax technique (see cat. 27), with intricately detailed
feathers and a three-pointed crest on top of the head. These two

gold ornaments, made using the same techniques and bearing
similar iconography, may have been part of a larger set.

The Mexica associated the eagle with the sun, which it was
thought to accompany on its daily passage through the sky.
However, the crest suggests that it may be a *Cracidae* or *coxcoxtli*
(*Crax rubra*), both species of woodland bird associated with
Xochipilli, the god of flowers, song and dance, and with the sun.
A similarly crested bird of prey also appears in a gold lip-plug
(see cat. 36).

While Western concepts of adornment suggest that these
ornaments could be a pair of earrings, there is no evidence to
support this interpretation. Their exact use is unknown but they may
have been used as body ornaments or to decorate garments. *EVLL*

Cat. 33
Ear-plug with image of the god of wind

800–1521, Mixtec
Gold, 2.2 × 5.7 cm
Museo Nacional de Antropología, Mexico City, inv. 10-79577

Selected literature: Saville 1920; García Moll, Solís Olguín and
Bali 1990; Solís Olguín and Carmona 1995

In the Early Preclassic period, the
Mesoamerican people developed the custom
of enlarging perforations in the earlobes and
inserting a circular ornament known as an ear-
spool. At first these jewels were made of shell,
bone, greenstone or fired clay. The emergence
of goldsmithing led the indigenous nobility,
particularly the kings, to wear ear-spools made
predominantly of gold.

The Mixtecs were master metalworkers
who produced elaborate gold jewellery. Over the
years, the decoration of ear-spools gradually

Cat. 34
Nose ornament

c. 1480, Mexica
Gold, 7.7 × 7.7 × 0.05 cm
Museo Nacional de Antropología, Mexico City, inv.
10-220922

Selected literature: Batres 1979, pp. 69–70; Anders and
Jansen 1996, pp. 203–04; London 2002, p. 467, no. 272

took on a greater complexity, with the addition of ornamentation. This precious object, adorned with the god of wind, is the largest section of a Mixtec ear-spool. The tube would have fitted into the lobe, but it now lacks both its end piece and the plate that slotted onto the back of the disc decorated with small balls.

Two techniques were used in the creation of this ornament. For the cylindrical part the gold was rolled to make it thinner, while the deity's head was made with the lost-wax method. During the reign of Moctezuma II the god of wind was known as Ehecatl, and the Mixtecs referred to the sound of the wind as *tipijpee*. The god's prominent nose is pierced by a nose-plug and his eyes are half-closed. He wears a halo of feathers and a half-mask in the form of a bird's beak, and a plate protrudes from his nose. *FSO*

In 1900, public works for a new drainage system created a drain that traversed the Plaza Mayor (now Plaza de la Constitución) in Mexico City from west to east. It also cut through the south part (the Huitzilopochtli side) of the Templo Mayor of Tenochtitlan, which had hitherto lain undiscovered below the Calle de las Escalerillas. The subsoil gradually revealed a host of objects including sculptures, ceramics, shell, greenstone and gold. Among them was this superb nose ornament in the shape of a stylized butterfly, with trapezoidal wings and a flint knife in place of its proboscis. Since this excavation was in effect a salvage operation, intent on rescuing as many objects as possible, the archaeological

context was barely recorded and we know little about the offering's precise significance.

We do know, however, that the indigenous rulers were cremated after being shrouded in mats and cotton blankets, and that their ashes were interred along with ornate feathers, jewellery with precious stones, copper rattles and objects made of shell and gold. These offerings were buried in temples or under commemorative monuments in the sacred precinct. In 1978 the monolith to Coyolxauhqui – the moon goddess who lay dismembered at the foot of the steps to the Templo Mayor – was found just a few centimetres from the drain. It is very possible that this offering belonged to an important dignitary or priest from the era of Axayacatl (reigned 1469–81). On fol. 67v of the Codex Magliabechiano there is a description of the funerary bundle of a 'merchant' containing similar objects to those found in Las Escalerillas, including a butterfly-shaped nose ornament or *yacapapalotl*. It is unlikely, however, that merchants enjoyed such high status during the reign of Moctezuma's father. *RVA*

Cat. 35
Head with lip-plug

1250–1521, Mexica
Clay, 19.5 × 15 cm
Museo Nacional de Antropología, Mexico City, inv. 10-392909

Selected literature: Bilbao 2005, p. 28

This clay fragment from the famous Martell collection is a realistic depiction of a Mexica dignitary, complete with the insignia of the lip-plug, an adornment that distinguished great warriors and leaders. We do not know its exact origin, but its technique and style indicate that it must have been made in Tenochtitlan or in a neighbouring city which produced not only stone sculptures but also large figures in fired clay, including those found in the Templo Mayor and the Puebla region.

The figure's hair is worn in the style of an elite warrior. After capturing live prisoners in battle, a warrior's hair would be cut leaving only a single lock to which a *cuahpiyolli* – an insignia made from two long and one short feathers taken from a bird's breast – and other feathered ornaments would be attached. He also wears a variant of the regal diadem known as the *copilli*. The large and striking lip-plug was presented to nobles during a public ceremony. The priest used an obsidian knife to make an incision running from the lower lip down to the chin. The ornament was then inserted, the rim at each end preventing it from falling out when the scar healed.

A wide range of these ornaments made from obsidian, rock crystal and gold has been found. The wearer was obliged to create the ferocious grimace seen here to hold the lip-plug in place, particularly if it was circular in shape.

FSO

Cat. 36
Lip-plug in the shape of a bird

Fifteenth or sixteenth century, Mixtec–Mexica
Gold and rock crystal, length 6.2 cm
Museum für Völkerkunde Wien (Kunsthistorisches Museum mit MVK und Ötm),
Vienna, 59-989, Becker Collection

Selected literature: New York 1970, no. 300; Aguilera 1983; Pasztory 1983, p. 31, fig. 16; Hildesheim-Munich-Linz-Humlebæk-Brussels 1986, no. 254; Vienna 1992, p. 205, no. 155; Madrid 1992, p. 158, XXXIV; Vienna 1997, no. 20; London 2002, p. 446, no. 187; Olmedo Vera 2002

Labrets or lip-plugs (*tentetl*) were symbols of status, profession or social class in Mexica culture. Images from the historical codices and sculptures show how these ornaments were inserted through a hole in the lower lip (see cat. 35 and fig. 31). Produced in a wide range of materials and decorated with various iconographic motifs, *tentetl* were exclusively worn by rulers, elite military leaders and deities. Warriors taken as captives had their labrets removed as an act of humiliation; from then on, they salivated constantly though the hole left by the missing adornment.

This unique example is made up of three separate pieces, which may not have originally been intended to function together. The two ends are made from gold. The flat curved part would have rested against the wearer's gum to help support the plug. The elaborate bird's head decorating the other end was cast using the lost-wax technique (see cat. 27). The Mixtec craftsmen were fine goldsmiths, and many joined the Mexica court to work for their new patrons alongside the most highly skilled Mexica artisans. A hollow rock-crystal tube connects the two gold ends. This translucent central section may once have been filled with brightly coloured feathers.

Eagles are a frequent motif in gold lip-plugs associated with the elite order of eagle warriors. Both eagles and gold were symbols of the sun. However, the bird on this lip-plug has a prominent crest, which has led to an alternative identification as a *Cracidae* or *coxcoxtli* (*Crax rubra*), both species of woodland bird associated with the sun and with Xochipilli, the god of flowers, music and song. *EVLL*

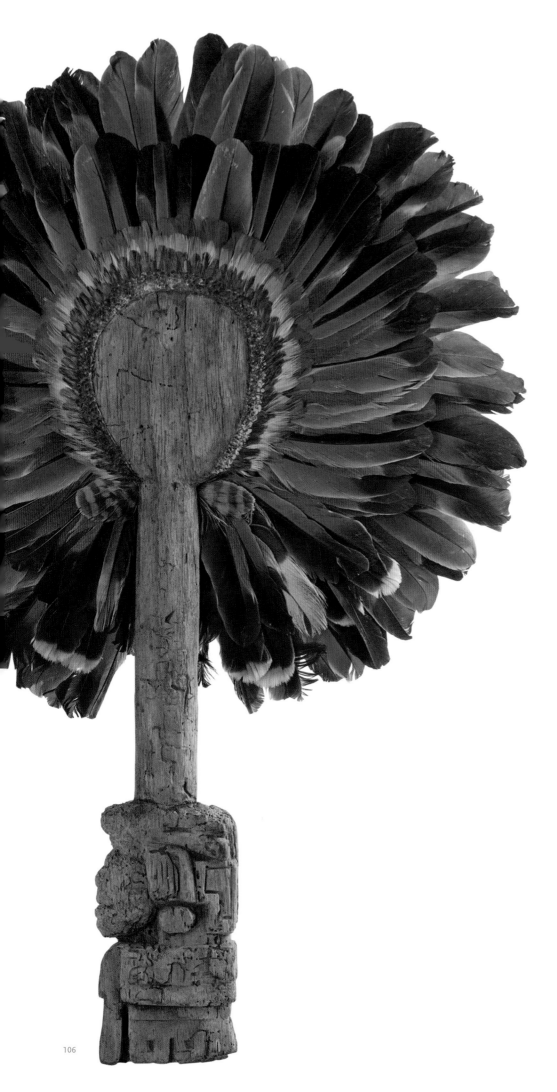

Cat. 37
Fan

Handle: *c.* 1500, Mexica; feathers: 1999
Wood with parakeet and hummingbird feathers,
40 × 10.5 × 4.5 cm
Museo Nacional de Antropología, Mexico City,
inv. 10-393455

Selected literature: García Moll, Solís Olguín and Bali
1990; London 2002, p. 449, no. 198

In the 1940s numerous buildings were
erected on the site of the sacred precinct
in Tenochtitlan. Several objects of great
value were unearthed in the process,
including this carved-wood fan handle from
the Mexica era. Complete with its halo of
feathers, it would have been used as a fly
swatter (*yecacehuaztli*) as well as a cooling
device (*ehecacehuaztli*). The handle
terminates in a carved male head. Although
it has been badly damaged by insects and
the ravages of time the headdress, ear-
spools and five pendants are still visible.
The feathers fit ingeniously into a groove
around the top.

For many years the handle was
exhibited in the wood and bone technology
section of the Mexica Gallery at the
Museo Nacional de Antropología. When
the museum was refurbished in 1999
a contemporary feather-worker was
commissioned to recreate the fan's
original appearance using parakeet and
hummingbird feathers. The fan's restored
glory reminds us that a Mexica noble
would once have carried such an object
as a symbol of rank. *FSO*

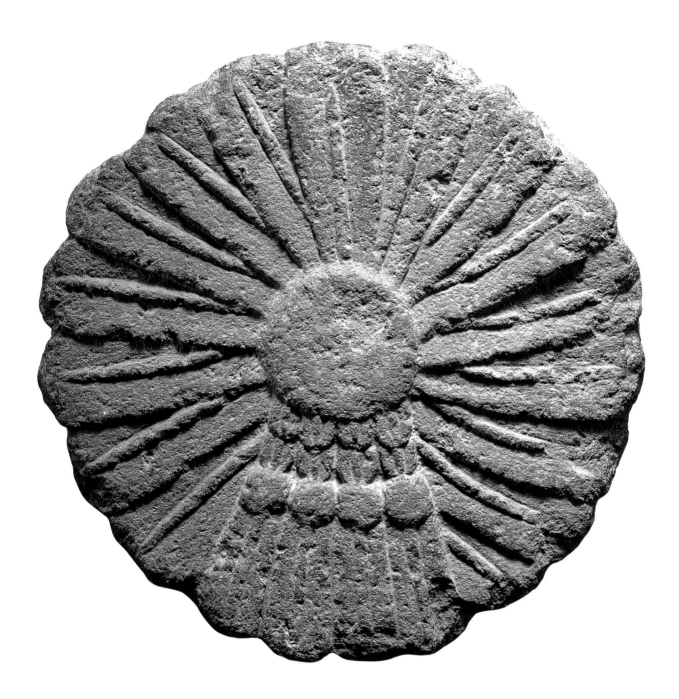

Cat. 38
Feather ornament in stone

c. 1325–1521, Mexica
Volcanic stone, 34.2 × 33.7 × 7.8 cm
Musée du Quai Branly, Paris, 71.1878.155.123

Selected literature: Pasztory 1983 pp. 278–80; López Luján and Fauvet-Berthelot 2005, pp. 178–79

Mexica artists often reproduced objects made from perishable materials in stone, thus making them durable so that they could be used as architectural and votive objects. Such is the case with this stone feather ornament, which may once have decorated the façade of a religious building. A peg at the back, originally used to attach it to a structure, was probably removed in modern times.

The carving depicts sixteen long feathers radiating from a central point, with four additional ornaments made from shorter feathers and circular balls of down hanging from the centre. Similar ornaments are depicted in the codices worn by warriors and deity impersonators as part of their costume decoration (see fig. 81). This object provides clear evidence of the complex structure of feathered ornaments and the skill of their construction, as well as indicating the range of feathers used for such adornments. *EVLL*

Cat. 39
Ceremonial shield (*chimalli*)

Reeds, leather, feathers, 67.5 × 4 cm
Modern replica of a sixteenth-century *chimalli*
in the Museo Nacional de Historia, Castillo de Chapultepec, Mexico City,
inv. 10-92265 (original shield)

Selected literature: Mendoza and Sánchez 1885, p. 45; Núñez Ortega 1885,
pp. 5, 7–8, 11–12, 16, 19–208

This may be the last surviving shield of the dozens owned by Moctezuma II, although just over a century ago another was apparently sighted in Ambras Castle in the Tyrol. The rarity of these shields can be explained by their fragility. They were made with thin reeds bound together with cotton or maguey fibre, before being covered and richly decorated with fine animal skins and feathers. Such decorative shields were used more as ritualistic, festive emblems rather than as defensive weapons, since warriors generally went to battle bearing solid shields made of wood, cotton and leather with geometrical ornaments but devoid of any other decoration.

Nevertheless, objects like this *chimalli* also had an aggressive function: it is said that when Moctezuma's men declared war 'it was customary to send the enemy some *chimalli* as a threat or challenge'. However, the *chimalli* in the Museo Nacional de Historia in Chapultepec Castle was not sent to Hernán Cortés on the Gulf Coast as a challenge, but was intended to send him back to the realm of the gods, from which he was believed to have come.

A catalogue of the collections of the Museo Nacional published in 1882 states that the original *chimalli* 'belonged to King Motecuhzoma II and was given, along with other objects, by the Conquistador Cortés to the Emperor Charles V, and it was conserved from that time in the Vienna Museum until theArchduke Maximilian returned it to Mexico'. In fact, the history of this piece is

marked by long periods of peace during which it slumbered among treasures in museums, interrupted by perilous peregrinations during unstable times of war in both Mexico and Europe.

This *chimalli* was very probably one of the wheel-shaped 'feathered bucklers' sent by Moctezuma to Cortés in 1519. The latter despatched the *chimalli* to Spain from the Villa Rica de la Vera Cruz. In 1520, the emperor Charles V took it to Flanders where it was housed in his armoury at the Royal Palace in Brussels. A catalogue from 1782 states that 'Moctezuma's weapons were kept' in the royal stables amidst the Habsburg spoils of war. Around 1796, in the context of the expansionist wars of revolutionary France, the shield was taken to Vienna to prevent it being captured as booty. Seven decades later, in 1865, the Count of Bombelles, a captain in Maximilian's Palatine Guard, was entrusted to take it to Mexico, where it arrived in January 1866. It was deposited in the Imperial Museum, during a war that cost the Habsburg emperor his life and led to the triumph of the Republic.

By then the *chimalli* was in a fragile state having lost almost all its decorative feathers and skins, although it still retained something of its original magisterial appearance. It conformed to an accepted artistic convention, as depicted in engravings in history books about Mexico and in academic paintings on Pre-Hispanic themes from the nineteenth and twentieth centuries. Examples appear on the cover of the first volume of *Mexico over the Centuries* by Alfredo Chavero, the first edition of which appeared in 1880; in the oil painting by Adrián Unzueta, *Sacrifice of the Spanish in the Templo Mayor of Tenochtitlan* (1898; Museo Nacional de Historia, Chapultepec Castle); and in the charcoal drawing on paper by Saturnino Herrán, *The Ancient Gods: The Offering* (1917; Instituto de Cultura de Aguascalientes).

In 2004 the shield's components were studied and an exact replica was made using leather and intertwined reeds decorated with parrot, eagle and hummingbird feathers, and jaguar and ocelot skins. SRS

Cats 40 and 41
Flutes

c. 1486–1520, Mexica
Ceramic and paint, 3.5 × 5.2 × 18.5 cm and 4.5 × 4 × 13.2 cm
Museo del Templo Mayor, Mexico City, inv. 10-252480 and 10-253047

Selected literature: Both 2005, pp. 129–39, 279–81; López Luján 2005, pp. 264–65;
Matsumoto *et al.* 2007, p. 100

These two ceramic flutes each have four finger-holes. Cat. 40 (left) bears the figure of a young deity wearing a pleated paper headdress and circular ear-spools. His mouth is open, as if singing. He has been linked with Xochipilli, the 'prince of flowers' and the god of song and dance, but also with Cinteotl, the young god of maize. Different moulds were used for the resonating tube, the mouthpiece and the anthropomorphic section, with the latter parts being attached to the tube after firing. The flute was burnished and fired before being covered with a layer of stucco as a base for the paint which is predominantly Maya blue, although the deity's face is black, in a simulation of face paint. Some details, such as the paper headdress and the ear-spools, were applied to the clay itself. This flute was found among building rubble in offering 84 of the Templo Mayor, from Stage VII of its construction (about 1502).

The front of cat. 41 (right) is adorned with an anthropomorphic head wearing a feathered headdress, which could be the stylized depiction of a god. It was discovered in offering 89 of the Templo Mayor, which is associated with Stage VI of its construction (about 1486). This offering was found completely submerged below the water table, which made excavation work difficult. The Mexica also buried another eleven pottery flutes here, along with numerous depictions of *teponaztli* (horizontal drums) and *chicahuaztli* (rattle-sticks) made from volcanic rock, all of which clearly indicate the musical theme of this group of objects.

Music, singing and dancing were fundamental to the religious ceremonies held within the sacred precinct in Tenochtitlan. Moctezuma II participated in some of the ritual dances, including the 20-day festivals of Tlacaxipehualiztli, dedicated to the god Xipe Totec, Huey Tecuilhhuitl, related to the goddesses of maize, Ochpaniztli, linked to Toci-Tlazolteotl (earth mother), Tititl, dedicated to the goddess Ilamatecuhtli, and the particularly solemn celebration held every four years to mark the festival of Izcalli, dedicated to Xiuhtecuhtli, the god of fire. *CJGG*

Cat. 42
Flute

c. 1325–1521, Mexica
Ceramic and paint, 16 × 5.2 cm
Trustees of the British Museum, London, AOA Am 1856, 0422.69

Selected literature: Vienna 1997, nos 178–79; Olivier 2003, pp. 214–26; Both 2005

Music was an important aspect of Mexica culture. Flutes, whistles, bells and various types of drum (see cats 83 and 84) were among the wide range of musical instruments used during dances, rituals and performances. Music also had a special role in military campaigns and religious ceremonies, accompanying chants and prayers while maintaining the rhythm of the performances. Flutes were played during the burials of warriors and rulers, and were used to attract the attention of the gods.

Flutes were the most common of the wind instruments produced by the Mexica. Most of the surviving examples are made of ceramic, like the one seen here, with burnished red pigment, while some bear interesting iconography and polychrome decoration (see cats 40 and 41). At this flute's wider end is a moulded flower, indicating that the instrument is a 'flower-flute', traditionally associated with Tezcatlipoca. The impersonator of the god paraded though the city playing the flute, smelling flowers and smoking, thus imitating the manner of noblemen and rulers. In the Mexica creation myth Tezcatlipoca brings music to the world, with the help of the wind god Ehecatl-Quetzalcoatl, to keep the sun moving on its path. The flute represents the arrival of culture to the world and its music embodies the power of the creator gods.

During the Toxcatl festivities dedicated to Tezcatlipoca the god used his flute to communicate his will to the ruler. When the Tezcatlipoca impersonator broke the flute at the foot of the steps to the temple, all communication with the gods was symbolically broken, as is related in the Florentine Codex. The god's presence was not felt again until new flutes were played in the city. *EVLL*

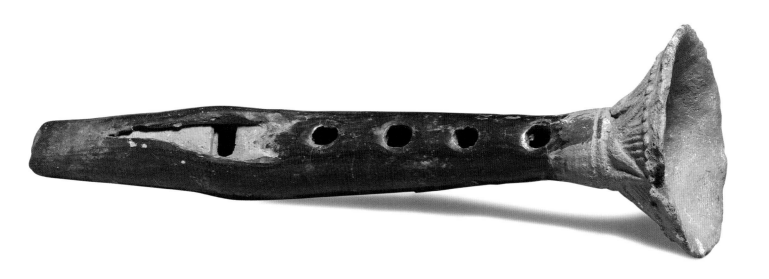

Cat. 43

Copper bells with silver

c. 1469, Mexica
Copper alloy with silver, 2.7 × 1.4 cm
Museo del Templo Mayor, Mexico City, inv. 10-262491 0/39

Selected literature: López Luján 2005, pp. 257–58

This group of 39 piriform (pear-shaped) bells made of copper alloy and silver undoubtedly formed part of a necklace, as they are fitted with a ring at one end. Bells ornamented the costumes worn for dances at religious ceremonies, and their tinkling harmonized with the other percussion instruments.

These bells were found in offering 3 of the Templo Mayor, one of six batches of objects deposited by the Mexicas to consecrate the great circular sculpture of the goddess Coyolxauhqui, whose name refers to the fact that her face was adorned with bells. The construction period of the Templo Mayor – Stage IVb – reveals that this consecration took place around 1469, at the start of the reign of the sixth *tlatoani* Axayacatl (reigned 1469–81), Moctezuma II's father. The fact that silver constitutes one of the main materials in these bells suggests that they were worn by an important dignitary or warrior.

It is very likely that these bells were brought to Tenochtitlan from the Mexica provinces of Tepecoacuilco and Quiyauhteopan (the region that is now part of Guerrero State to the south of the Basin of Mexico). They specialized in mining, particularly the extraction of copper, silver and gold. The Mexica began their military incursions into this area under Itzcoatl's rule (1427–1440) to obtain these sought after raw materials as tribute, none being available in the Basin of Mexico itself. Initially these metals arrived in quite small quantities along with the knowledge and skills required to smelt and work them. It wasn't until Ahuitzotl's reign (1486–1502) that the Mexica secured complete control, and with Moctezuma's accession the volume of tribute began to increase considerably.

CJGG

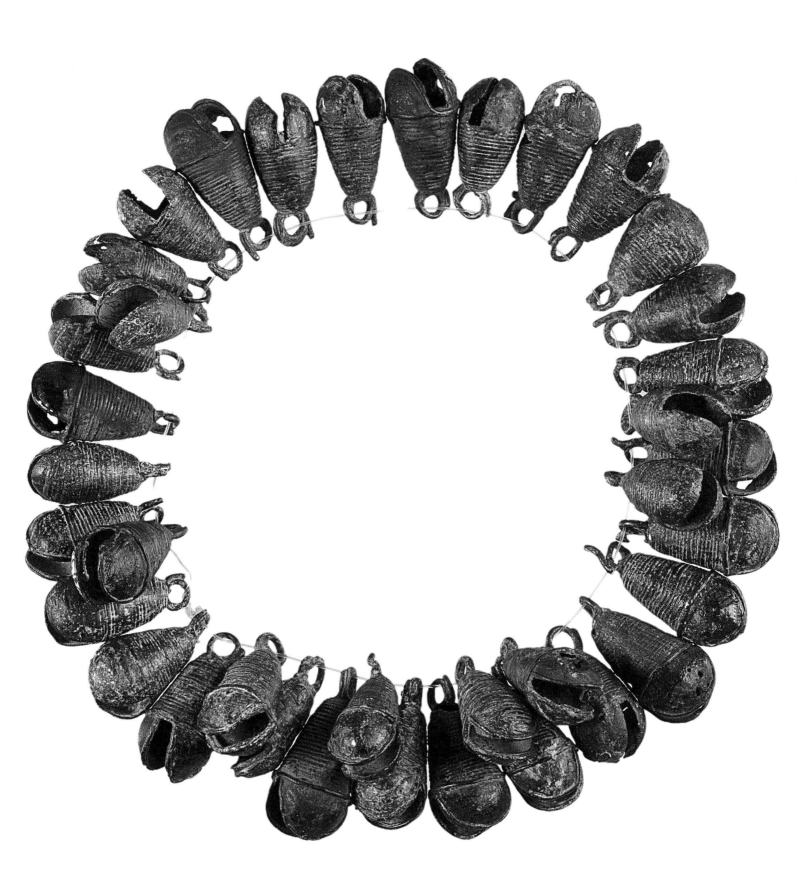

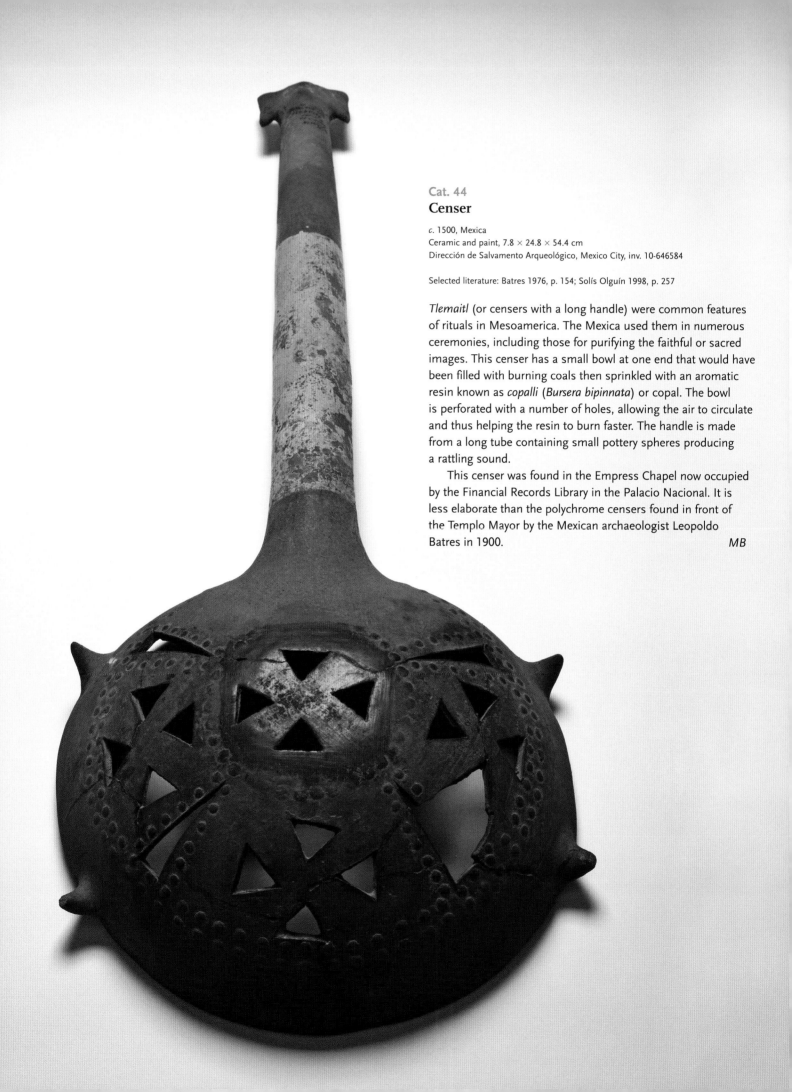

Cat. 44
Censer

c. 1500, Mexica
Ceramic and paint, 7.8 × 24.8 × 54.4 cm
Dirección de Salvamento Arqueológico, Mexico City, inv. 10-646584

Selected literature: Batres 1976, p. 154; Solís Olguín 1998, p. 257

Tlemaitl (or censers with a long handle) were common features of rituals in Mesoamerica. The Mexica used them in numerous ceremonies, including those for purifying the faithful or sacred images. This censer has a small bowl at one end that would have been filled with burning coals then sprinkled with an aromatic resin known as *copalli* (*Bursera bipinnata*) or copal. The bowl is perforated with a number of holes, allowing the air to circulate and thus helping the resin to burn faster. The handle is made from a long tube containing small pottery spheres producing a rattling sound.

This censer was found in the Empress Chapel now occupied by the Financial Records Library in the Palacio Nacional. It is less elaborate than the polychrome censers found in front of the Templo Mayor by the Mexican archaeologist Leopoldo Batres in 1900. *MB*

Cats 45 and 46
Hourglass-shaped goblets

c. 1500, Mexica
Ceramic and paint, 53 × 21 cm and 45.6 × 20.5 cm
Dirección de Salvamento Arqueológico, Mexico City, inv.
10-646507 and 10-646509

Selected literature: Solís Olguín and Morales Gómez
1991, p. 123; Miller and Taube 1993, p. 188

These goblets were recently discovered
in the Palacio Nacional of Mexico City,
in the Empress Chapel now occupied by
the Financial Records Library. Numerous
sixteenth-century documents indicate
that this was the site of the most
important palace in Tenochtitlan, known
as the Moctezuma's New Houses.
Here archaeologists excavated a square
flowerbed where they found a spectacular
offering comprising fifty goblets similar

to these ones, as well as three earthenware
pots and six tripod plates.

These hourglass-shaped pieces are
painted with a layer of red pigment
and decorated with white vertical bands.
Although they take the form of goblets,
they may also have been used to burn
aromatic resins. Their decoration may
be associated with Xipe Totec ('our flayed
lord'), the god of war and the renewal
of nature.

The cult of Xipe Totec acquired a
special importance during
Tlacaxipehualiztli, the second twenty-day
period of the solar calendar, which came
before the rainy season. The festival
was marked by the sacrifice of slaves
and prisoners of war whose hearts were
extracted. The bodies were then flayed
and their skins worn by the priests for
twenty days. *MB*

Cat. 47
Pulque jug

c. 1450–1500, Mexica
Ceramic and paint, 29.7 × 17.6 × 18 cm
Museo Nacional de Antropología, Mexico City, inv. 10-78234

Selected literature: Pasztory 1983

Jugs such as this one were traditionally used for *pulque*, an alcoholic drink made from cactus sap. Identifiable by their elegant spherical bodies and high necks with a spout, they were fitted with a curved handle, adding solidity to the form. They are among the most striking vessels produced by the Mexicas and their neighbours (particularly the Mixtecs in Oaxaca), and were used during ceremonies related to Ome Tochtli, the god of drinking.

This jug is typical of the polished red ceramics produced in the Tetzcoco region, decorated with a base coat of bright red pigment over the entire vessel with designs in black. Potters sometimes added ornamental motifs after firing, although they tended to use a watery white pigment that quickly faded.

The tables of Moctezuma II and the rulers of Tetzcoco were undoubtedly laden with elegant jugs such as this one. Its body is decorated with a wide band bearing spiralling bands alternating with small bells. The neck is also embellished with spirals, evoking the movement of the liquid inside. *FSO*

Cat. 48
Pot

c. 1507, Tetzcoco
Ceramic and paint, 22.4 × 24 cm
Museo Nacional de Antropología, Mexico City, inv. 10-116785

Selected literature: Solís Olguín and Morales Gómez 1991, p. 270

The former Plaza del Volador, the site of a famous colonial market that flourished until the first decade of the twentieth century, was excavated between 1936 and 1937. Historians believe that the great palace of Moctezuma II in Tenochtitlan extended southwards into this part of the present-day capital, now the site of the Supreme Court of Justice. The construction of the latter prompted the excavations, which revealed the remains of a pyramidal base filled with over a thousand pots. Beneath them was a casket bearing the image of Xiuhtecuhtli, the god of fire. The archaeologist Eduardo Noguera, who was responsible for this discovery, has suggested that this offering may be linked to the New Fire ceremony of 1507, held during the reign of Moctezuma II (see p. 140).

This collection of ceramic goods is unrivalled in both its size and diversity. It comprises a wide range of vessels intended for both daily and ritual use during meals taken by the nobility and religious ceremonies. The offering is further enhanced by the presence of imported pieces, mainly from the regions of Morelos, Puebla and Oaxaca.

This two-handled pot, typical of the Tetzcoco area, is one of the most outstanding examples of its kind. It would have been used to store a range of items from foodstuffs and seeds, to clothing, precious objects and manuscripts. The decorative bands around the pot's exterior are painted using very thin white paint. This symbolic design is known as a *xicalcoliuhqui*, a repeating pattern representing the movement of the *xiuhcoatl*, or heavenly fire serpent. *FSO*

Cats 49 and 50
Skull goblets

c. 1507, Mixtec
Ceramic and paint, 30 × 12.5 cm (each)
Museo Nacional de Antropología, Mexico City, inv. 10-77820 and 10-3344

Selected literature: Solís Olguín 1991; Solís Olguín 1991b, p. 257; Solís Olguín and Morales Gómez 1991, p. 294; Amsterdam-St Petersburg 2002, pp. 236–37, nos 190, 191; London 2002, p. 432, no. 134

The large offering discovered in the former Plaza del Volador (see cat. 48) included these unusual ritual goblets. Their main decorative features are the hollow sculpted human skulls, resembling the real ones displayed in the *tzompantli* or skull racks at the Templo Mayor.

The patches of blood-streaked fat covering the skulls, reflecting the practice of flaying sacrificial victims, are depicted with remarkable realism. The polychrome decoration of these goblets is typical of the so-called international style, which was popular during the reigns of the last Mexica rulers. This style extended throughout most of central Mexico, including the indigenous capitals of Tetzcoco, Tlaxcala and Puebla, and into Oaxaca.

An elegant silhouette is created by the double-cone shape, in which the bowl of the goblet is confined to the upper section. The decoration of these two vessels links them to sacrificial offerings. They were probably filled with blood which was fed to the effigies of the gods by means of *popotl* (straws) inserted into their mouths, simulating their absorption of the sacred liquid. *FSO*

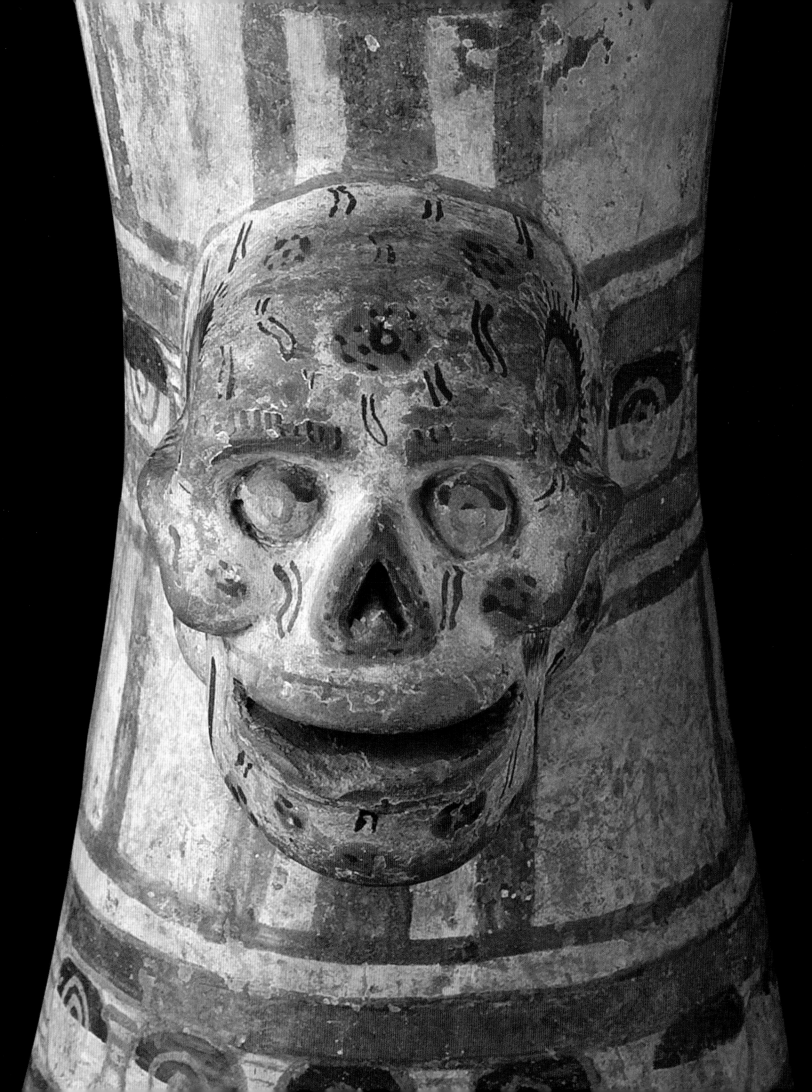

Cat. 51
Ceramic plate

c. 1325–1521, Mexica
Ceramic with paint, 8.6 × 21.3 cm
Trustees of the British Museum, London, AOA Am 1892,
1109.5

Cat. 52
Ceramic plate

c. 1325–1521, Mexica
Ceramic with paint, 5.5 × 17 × 11 cm
Trustees of the British Museum, London, AOA Am
1940,02.31

Selected literature: Diaz del Castillo 1963, p. 197, no. 132;
Pasztory 1983, pp. 292–99; Solís Olguín 1991b, p. 260,
no. 401

The colonial chronicler, Bernal Díaz del
Castillo, reported that Moctezuma II ate
from colourful dishes produced in Cholula,
a type that was also used for offerings to
the gods and in burials. However, everyday
ceramics, for eating and cooking, were very
different from the wares used by
Moctezuma II during his private meals or
in state banquets and rituals.

Servants and attendants living in the
court used simpler ceramics for their daily

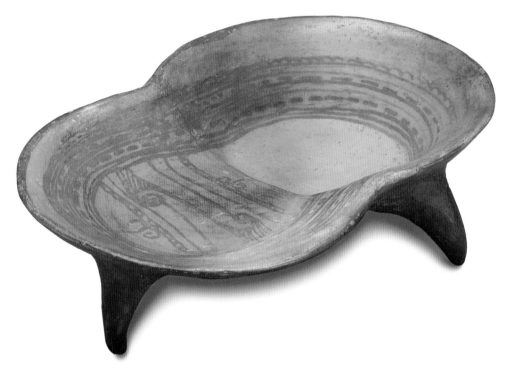

needs. Fine black-on-orange-ware tripod
plates were common. Some of them had
two tiers, which kept the dry food separate
from the wet. Decoration was applied to
fine orange-ware pieces before firing using
very thin brushstrokes. Linear decorations
and abstract motifs were most often used
before the reign of Moctezuma II. During
the final period of Mexica ceramic
production, however, examples with
naturalistic imagery were created, usually
portraying animals and plants in fine black
lines. These examples here are associated
with the style of ceramics known as Mexica
III (1300/1350–1521), produced in the
Basin of Mexico, and more specifically in
Tenochtitlan, Tetzcoco, Chalco and to the
east of the Iztapalapa peninsula. *EVLL*

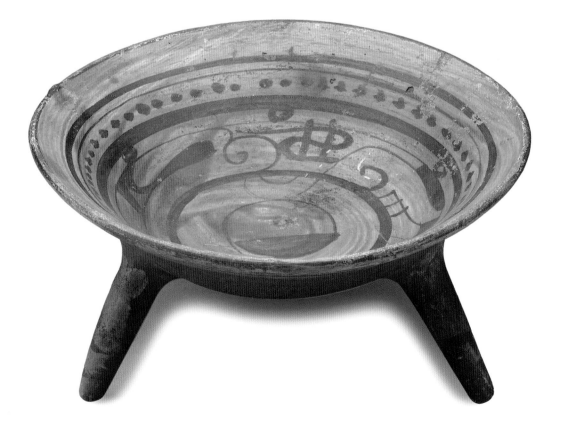

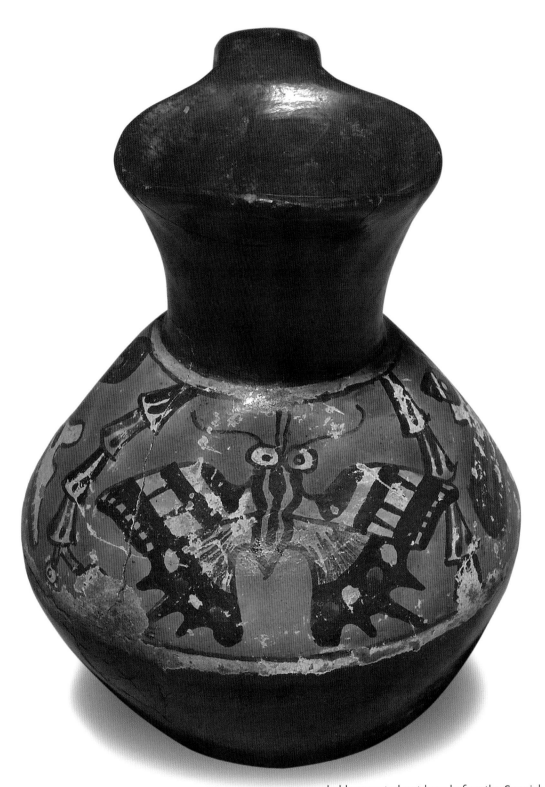

Cat. 53
Polychrome jar

c. 1500, Cholula–Tetzcoco
Ceramic, 10.8 × 6.4 × 7.9 cm
Trustees of the British Museum, London, AOA Am 1892,0618.7

Selected literature: Diaz del Castillo 1967, p. 197, no. 132; Pasztory 1983, pp. 292–99;
Solís Olguín 1991b, p. 260, no. 401

This small ceramic jar may have contained a precious liquid. Its style, fine production and delicate decoration on a red background indicate that it was made in Cholula or Tetzcoco. Both areas were well known for their colourful ceramics, which were used in the court of Tenochtitlan. The naturalistic iconography indicates that it was probably executed not long before the Spanish conquest.

The central decorative element is a butterfly with extended wings flanked by two wreaths of flowers. Butterflies had been represented in Mesoamerican art, probably since the Preclassic times, and became a common iconographic motif in Teotihuacan. In Mexica iconography they symbolize fire, renewal and metamorphosis. They were also thought to embody the souls of warriors killed on the battlefield, accompanying the sun on its daily journey through the sky.

At either side are depicted large marine conch shells, possibly the queen conch (*Strombus gigas*), decorated with a laced red ornament at its tip, resembling the headdress worn by Xochipilli, the god of flowers, music and dance.

EVLL

Cat. 54
Censer

1400–1521, Mexica
Ceramic and paint, 30.5 × 29.5 cm
Museo Nacional de Antropología, Mexico City, inv. 10-78081

Selected literature: Flores Gutiérrez 1991; Bilbao 2005, p. 279; Hernández Sánchez 2005

The Mexica believed that when a warrior died in battle or on a sacrificial stone one of his three souls ascended to the skies, joining the solar army in its daily battle against darkness for a period of four years. After completing this arduous task, the soul's energy was transmogrified into butterflies and hummingbirds, returning to the earth in order to fertilize flowers and feast on their pollen.

This censer is decorated with four painted butterflies interspersed with two sculpted dog's heads. These represent Xolotl, Quetzalcoatl's twin, both gods associated with the planet Venus. This planet is distinctive as it has a dual cycle of visibility during day and night, disappearing only for a short period in the year, when it was believed to descend to the underworld to consult the lord of the dead.

The pictorial narrative on this object may provide us with information about its use. Modelled hooks, through which cords could be threaded to hang down like a pendulum, flank each of the heads. The censer was filled with burning coals mixed with copal resin and the burning incense would be wafted over the gods or the captives awaiting their death on the sacrificial stone. The ritual thus prepared the latter for their next task – that of combating and defeating death in the domain of death itself, just as Xolotl (Venus) did every year.

RVA

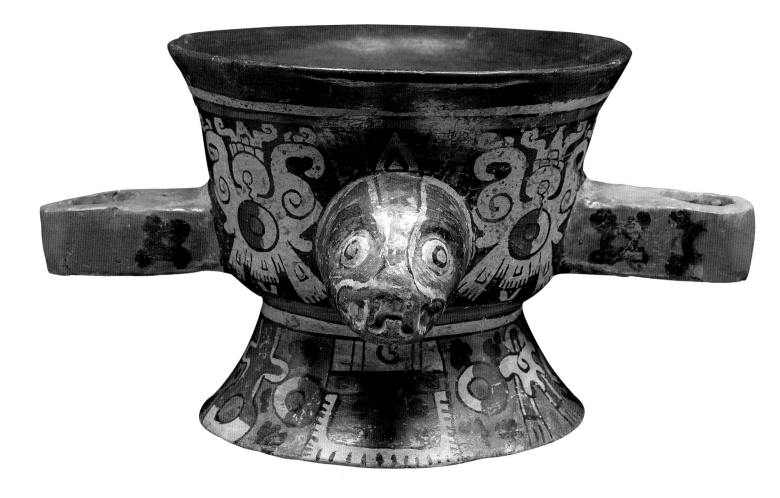

Cat. 55
Polychrome tripod plate

c. 1500, Mexica–Mixtec
Ceramic and paint, 5.3 × 15 cm
Museo Nacional de Antropología, Mexico City, inv. 10-9817

Selected literature: Solís Olguín and Morales Gómez 1992; Solís Olguín, Velázques and Velasco Alonso 2005, p. 92

The Late Postclassic era (1325–1521) witnessed the flourishing of polychrome ceramic production in the 'international style'. This style was found in towns and cities of the Puebla-Tlaxcala region and of the Mixtecs, as well as the kingdoms bordering the Mexica empire in central Mexico, stretching as far as the Gulf Coast. The potters in this vast area shared the techniques enabling them to apply different colours on a white or orange base. Multi-coloured pottery of this kind is typically decorated, both inside and out, with a range of repeating signs and motifs. Thus, whatever the stylistic or technical variants used, the basic message could be clearly understood by priests and dignitaries.

This three-legged plate is typical of the polychrome ceramics that undoubtedly appeared on Moctezuma II's table, and which would have impressed the conquistadors who joined in his imperial feasts. The supports often took the form of symbolic animals – in this case yellow serpents with circular patches on their bodies, reminiscent of the spotted skin of the jaguar. Inside, the base of the plate is adorned with an elegant six-petalled flower celebrating the renewal of nature, made possible by rain and sun and the victorious campaign of the warriors. The pattern is composed of four *xicalcoliuhqui* (stepped fretwork) motifs, featuring whirls in alternating black and red, symbolizing the movement of the fire serpents carrying the sun through the firmament.

FSO

Moctezuma and the renewal of nature

Richard F. Townsend

IN THE Plaza de la Constitución of Mexico City, visitors see the long façade of the National Palace, once the seat of Spanish viceroys, the massive towers of the Metropolitan Cathedral, and the tricolour flag of the Republic raised in the middle of the square, displaying the eagle and serpent on a cactus – a reminder of the Mexica inheritance and the archaeological foundations of the Templo Mayor or Great Pyramid of Tenochtitlan nearby. Beyond the centre of the old downtown area, gleaming high-rise buildings line the Paseo de la Reforma and other arteries and boulevards. Miles of residential districts and industrial zones spread across the dry Lake Tetzcoco basin and adjacent mountain-sides, enveloping ancient towns and cities around the Basin of Mexico. At the beginning of the twenty-first century, this immense urban zone of some 20,000,000 inhabitants has become one of the most densely populated places on the planet. Here, as in Cairo, Rome, Istanbul or London, the city and the surrounding landscape bear the record of a succession of different societies reaching into the remote archaeological past.

When Moctezuma II received Hernán Cortés and his expedition of Spanish and Tlaxcalan Indian allies on the causeway entering Tenochtitlan in November 1519, the island city in the glittering lake was inhabited by over 200,000 people. The ceremonial precinct with the Templo Mayor stood in the middle, surrounded by royal palaces and the houses of magnates (figs 16 and 39). Four wide pedestrian streets led toward the cardinal directions, traversing residential zones and horticultural *chinampas* or 'floating gardens' on land reclaimed from the shallow lakebed. The independent allied city-states of Tenochtitlan,

Fig. 35
Stone sculpture of the fire god Xiuhtecuhtli (see cat. 79). Museo Nacional de Antropología, Mexico City.

Fig. 36 *following pages*
View across the Basin of Mexico, towards the snow-capped volcanoes Iztaccihuatl on the left and Popocatepetl on the right.

Tetzcoco and Tlacopan commanded a vast tribute-paying empire that reached beyond the mountains rimming the Basin. This Triple Alliance, formed in 1428, led to a dynamic programme of conquests and a cultural synthesis that was destined to be the last flowering of Mesoamerican civilization. It was not until the Spanish conquest in 1519–21 that Mesoamerica encountered a radically alien form of social and cultural existence. The conquest was a major turning point in the history of the Americas, because the violent encounter profoundly changed the ancient indigenous frame of existence. New forms of economy, religion and government were imposed in the image and ideals of Spain. Yet even as the process of religious conversion unfolded, missionary friars such as Bernardino de Sahagún, Diego Durán and Toribio de Benavente, as well as descendants of the old Mexica nobility and intelligentsia such as Fernando de Alva Ixtlilxóchitl, Hernando Alvarado Tezozómoc and Domingo Chimalpáhin, began compiling invaluable records of indigenous history and cultural life. These encyclopedic texts reflect a probing intellectual concern for accurate, comprehensive descriptions. The knowledge preserved in these written sources has been vastly expanded by archaeology, ethnology and linguistic studies from the late nineteenth century to the present. Notable advances have also been made – especially since the 1970s – in the interpretation of art, architecture, hieroglyphic writing and ritual performance. These findings have amplified our understanding of the basic structure of the Mexica world-view, and the functions of ideas and visual art in affirming a dynamic integration of human society and the system of order seen and experienced in the natural environment. An exploration of the monuments, rites and sacred features in the Mexica landscape illustrates the workings of this cosmological way of thought and activity during the reign of Moctezuma II.

A cosmological vision

Mexica monuments from the fifteenth and early sixteenth centuries commemorating conquests and royal accession, express a fundamental notion of correspondence between the social and the natural orders. The Stone of Tizoc (fig. 11) for example, shows an ordered cosmos with Tenochtitlan at its centre. The Coronation Stone of Moctezuma II is related to this earlier monument, although designed as a rectangular block carved on all six sides (cat. 14). The bottom (obverse) features the day sign 1 Rabbit, signifying the first day of world creation. The four sides are identically carved with representations of a squatting earth deity, corresponding to the cardinal directions. On the upper surface, hieroglyphs represent five successive cosmogonic eras, the mythological five 'Suns' of the world's evolution. The sequence begins on the lower right, with 4 Jaguar representing a first imperfect 'Sun' or era that ended in a plague of jaguars. Moving counterclockwise, the next sign 4 Wind is represented by the mask of the wind god Ehecatl, signifying an era that ended in hurricanes. The mask of the rain god Tlaloc with the number four corresponds to the era that ended in a rain of fire, while an effigy of the goddess of ground water Chalchiuhtlicue with the number four represents the era that ended in flood. At the centre of the rectangle, the X-shaped sign 4 Movement stands for the present 'Fifth Sun' prophesied to end in earthquakes. Below this sign a square cartouche encloses the year

sign 12 Reed (1503), while the day sign 1 Crocodile appears above, corresponding to 11 June in the Christian calendar. According to some accounts, this was the year and day of Moctezuma's months-long process of coronation, which began unfolding in stages with a retreat and investiture after the death of Ahuitzotl in late 1502, and concluded in Tenochtitlan with the sacrifice of prisoners taken in his coronation war. The monument certifies that Moctezuma II held title to the earth in the present era, the Fifth Sun, a sacred inheritance validated and transmitted since the time of origins. The earth itself is represented as the Mexica empire.

By the time Moctezuma was invested, the office of *tlatoani* (speaker, commander – hence ruler) was strongly defined in terms of successful leadership in war. Yet the concept of kingship was also rooted in an ancient tradition of obligations to conduct the annual rites and to build the shrines of world renewal. The sixteenth- and early-seventeenth-century accounts describing the recurring festivals and their monuments in Tenochtitlan and around the Basin of Mexico, plus the archaeological sites and monuments, reveal metaphors and mythical themes explaining the way the Mexica ceremonial system functioned in a network of connections that reached outwards from the cities to major topographic features and the deified forces and phenomena of nature upon which life depended. The annual cycle of cultivation was linked to a religious identification with the physical forms of the land and the alternating seasons of drought and rain. It was the obligation of Mexica rulers to ensure, through ritual means, the predictability and regularity of the seasons, the fertility of the soil, the abundance of plants and animals, and the prosperity of society from year to year.

The Basin of Mexico

At 2,240 metres above sea level, the Basin of Mexico is contained by mountains on three sides (fig. 36). The Sierra Nevada rises to the east, with Cerro Tlaloc and the snowcapped volcanoes Popocatepetl and Iztaccihuatl crowning the range, and the Valley of Puebla beyond. To the south, the rugged Ajusco heights separate the lake basin from the low, semi-tropical Valley of Morelos. The forested line of the Sierra de las Cruces defines the western side, with high passes leading to the Toluca Valley. The basin opens to the north, with wide fields and low-lying hills stretching towards the tawny reaches and desert ranges of the Great Plateau of Mexico. Lakes Chalco and Xochimilco lay to the south, fed by copious springs from Ajusco; Xaltocan and Zumpanco were to the north, surrounded by waving reed beds and marshes; and in the centre of the basin at a slightly lower level, the broad expanse of Lake Tetzcoco was saline from evaporation. Late-nineteenth-century paintings by José María Velasco portray the Basin of Mexico when it still looked very much as it was seen in the 1500s, with broad sheets of shallow lakes, the long causeway from the northern shore into Mexico City, and the snowy heights in the distance (fig. 37).

The long dry season begins in late September and lasts until early June, followed by the rainy season from June until late September. The tall volcanoes and other high mountains play a key role in this annual shift in the seasons. Warm moist air flowing

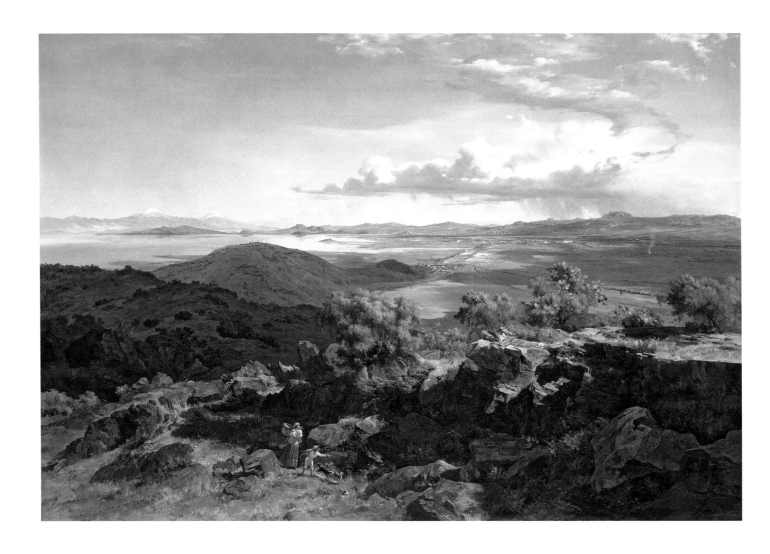

Fig. 37
The Valley of Mexico from Sta. Isabel Hill, 1875, by José María Velasco (1840–1912). Oil on canvas. Museo de Arte Moderno, Mexico City.

inland from the Gulf of Mexico and the Pacific rises around the lower slopes in the morning hours, condensing slowly around the heights and billowing up by mid-afternoon in towering cumulo-nimbus formations, before spreading across the horizon in blue-black curtains with flashes of lightning and deafening thunder. Winds gather strength and storms begin sweeping westward along Ajusco and across the Basin before moving over the Sierra de las Cruces. The land responds, changing in days from yellow-brown hues into deepening green. This was the time for planting, for staying close by and tending the fields, collecting first fruits, and harvesting the full crops thereafter.

The eagle and the cactus

By the time Moctezuma II assumed office after the death of Ahuitzotl, the obligations of Mexica rulers were well established in supporting agricultural endeavours, sponsoring the construction of ceremonial places and conducting the critical rites calling for rain and renewal. These duties stemmed from deeply rooted Mesoamerican custom, and can be traced in an old form of social organization suggested by the founding image of Tenochtitlan depicted on the opening page of the Codex Mendoza (fig. 4, cat. 3), and on the rear of the *Teocalli* of Sacred Warfare (fig. 38). The image of the eagle, cactus, stone

and water was at once the place glyph of Tenochtitlan (*tetl*, rock, *nochtli*, nopal cactus), the name of the primitive tribal leader Tenoch, and the record of a founding vision said to have been witnessed by the tribal leaders as a sign given by the deified hero, Huitzilopochtli, as a mark of where the migrating Mexica would finally settle. In addition, the eagle, cactus, stone and water device has been interpreted as the cosmological sign of a dual social system (or moiety system) linked symbolically and through the annual cycle of activities to the sky, the earth and the surrounding waters.[1] In such a system the *tlatoani* functioned as external affairs chief, commanding the warriors in offensive actions and conducting relationships with foreign peoples. In this capacity he was symbolically associated with the sky, the sun, and great birds of prey, especially the eagle. He was complemented by the internal affairs chief, known as the *cihuacoatl* ('woman serpent'), responsible for matters concerning agriculture, defence and administration. The *cihuacoatl* was symbolically associated with the earth, ground water and food production. As the Mexica empire expanded, the *tlatoani* steadily gained prestige and power, accruing more responsibilities up to and including the reign of Moctezuma II, whom the Spanish regarded as an absolute monarch. Nevertheless, in his ancient core function of external affairs chief, Moctezuma remained primarily in charge of the range of activities taking place in the dry season – the 'male' time of year for long-distance travel, trade, hunting and war, as well as activities taking place on the periphery or beyond the outer circuit of Mexica sacred geography. As we shall see, in the latter capacity the *tlatoani* held a pivotal responsibility as the dry season reached its climax and the time of seasonal change approached, for summoning and propitiating the remote, all-powerful forces of rain and fertility upon which life depended.

Fig. 38
Back view of the *Teocalli* of Sacred Warfare (see cat. 78), depicting an eagle on a cactus, marking the place where the Mexica were to settle and found their capital. Museo Nacional de Antropología, Mexico City.

The Templo Mayor

The division of social organization and corresponding seasonal activities and ceremonial events was reflected in the design and functions of ritual places. In downtown Mexico City, archaeological excavations of the Templo Mayor foundations have disclosed the stages by which the monument grew. Every ruler since the early 1400s added a new layer to the pyramid, following the Mesoamerican practice of enclosing earlier constructions and expressing a collective rededication to the principal cults of the rainy and dry halves of the year.[2] As excavations bared the concentric foundations, vast quantities of offerings buried in the foundation caches were unearthed, revealing the universe of associations connecting the people, the city and the empire to the world of nature and its deities.

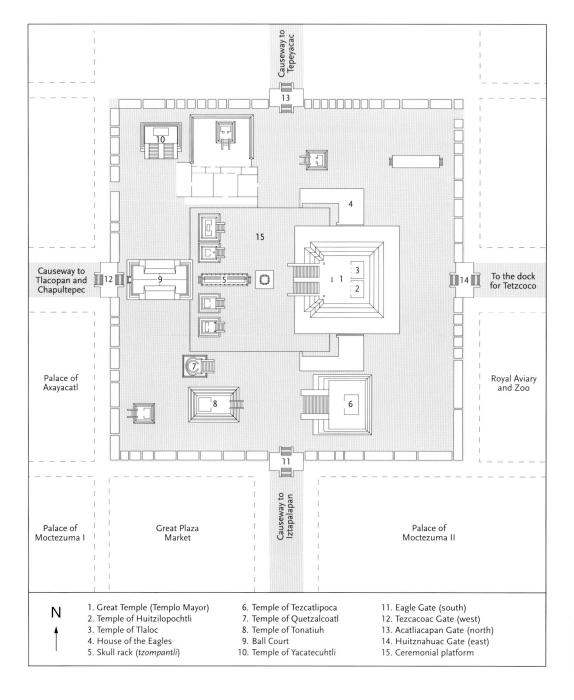

Causeway to Tepeyacac

Causeway to Tlacopan and Chapultepec

To the dock for Tetzcoco

Palace of Axayacatl

Royal Aviary and Zoo

Causeway to Iztapalapan

Palace of Moctezuma I

Great Plaza Market

Palace of Moctezuma II

N

1. Great Temple (Templo Mayor)
2. Temple of Huitzilopochtli
3. Temple of Tlaloc
4. House of the Eagles
5. Skull rack (*tzompantli*)
6. Temple of Tezcatlipoca
7. Temple of Quetzalcoatl
8. Temple of Tonatiuh
9. Ball Court
10. Temple of Yacatecuhtli
11. Eagle Gate (south)
12. Tezcacoac Gate (west)
13. Acatliacapan Gate (north)
14. Huitznahuac Gate (east)
15. Ceremonial platform

Fig. 39
Plan of the Sacred Precinct and its principal temples and adjacent structures.

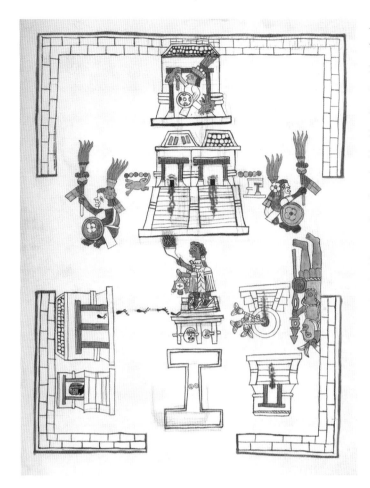

Fig. 40
The Templo Mayor, showing the
twin temples of Tlaloc and
Huitzilopochtli. From the Primeros
Memoriales, fol. 269r. Biblioteca
Real, Madrid.

An especially important effort to renew the monument began with Moctezuma I (reigned 1440–69), who aimed for a rededication at the turn of a 52-year cycle in the year 1454. Compounding the urgency of this traditional renewal of time, a prolonged famine began afflicting the land in 1450. The rains faltered and crops withered and failed; seed-corn reserves were eventually eaten; and thousands of people throughout the Basin and the neighbouring highlands weakened, languished, and began to die. As starvation set in, accusations of witchcraft flew about and dire omens appeared. In this atmosphere of fear and uncertainty the pyramid renewal went ahead with labour required from tributary communities. The project assumed the character of an *ex-voto*, a plea for life-giving rain and world renewal. The project was marked by success, as the new 52-year period began in 1454. Rains arrived in due course, renewing the cycle of agricultural activity. Major work again took place as the year 1506 approached, and widespread fears of a recurrence of the great famine haunted the Mexica imagination. Moctezuma II now presided over the rites for another 52-year renewal.

In the middle of Tenochtitlan, the Templo Mayor rose in four superimposed tiers with a broad upper platform upon which rested the twin temples of Tlaloc, the rain god, and Huitzilopochtli the deified Mexica ancestral hero (see cats 66 and 67). People ascending the wide dual stairway faced eastwards. On equinoctial days the sun would be seen rising between the two temples. The Tlaloc temple stood to the north where the sun's trajectory inclines during the 'summer' season of rain, between the middle of June and late September, while the Huitzilopochtli temple stood to the south of the equinoctial divide, where the sun inclines during the dry 'winter' season. The dual stairway expressed the symbolic division of the pyramid, corresponding to Tlaloc's Tonacatepetl ('mountain of sustenance'), and Huitzilopochtli's Coatepetl ('snake mountain').

The Coatepetl side with the temple of the Mexica tribal hero Huitzilopochtli ('hummingbird to the left') symbolically replicated the place of his magical birth and triumph over his sister Coyolxauhqui ('bell adorned' – images of this mythological character show bells on her cheeks). According to legend, during the long migration of the tribe from their original place of origin in Aztlan, they reached the mountain Coatepetl. A shrine was located at the summit, kept by an aged priestess, Coatlicue ('serpent skirt', also the title of an earth goddess). One day a ball of feathers fell from the sky, magically impregnating Coatlicue with the soon-to-be hero Huitzilopochtli. On the plain down below, a host of warriors and Coatlicue's fierce daughter Coyolxauhqui soon learned of this outrageous pregnancy. Coyolxauhqui vowed to kill her disgraced aged mother and led a force of four hundred warriors up the slope of the mountain. However, one of them ran ahead and whispered to Huitzilopochtli within the womb of the impending danger. As the

warriors led by Coyolxauhqui approached, he was suddenly born, springing forth fully armed as a supernatural warrior. Wielding a ray of the sun, he cut off Coyolxauhqui's head, dismembered her body, and the parts rolled down the mountain as he chased and slew the enemy host. This tribal legend of triumph was commemorated at the Templo Mayor on the platform above the temple of Huitzilopochtli, and an imposing sculpture of the dismembered Coyolxauhqui was placed at the foot of the stairway below. The mythic action was also ritually enacted when Mexica armies, returning from conquests, held human sacrifices of prisoners on the high platform before Huitzilopochtli's shrine. The bodies were rolled down the steep stairs to rest on the sculpture of Coyolxauhqui. There can be little doubt that this essential myth was in fact appropriated and adapted by the Mexica, for other pyramids identified as 'serpent mountain' have been located at archaeological sites from earlier Mesoamerican history.

Fig. 41
Image of Ehecatl-Quetzalcoatl. From the Codex Magliabechiano, fol. 61r. Biblioteca Nazionale Centrale, Florence.

On the Tlaloc side of the Templo Mayor, offerings recovered during archaeological excavation of the foundations included symbolic water pots with Tlaloc's blue-coloured mask, innumerable remains of aquatic creatures, mother-of-pearl necklaces, models of canoes and implements for gathering food from the lake, symbolic lightning-bolts, and diverse containers and sculptural figures with imagery alluding to water and maize (fig. 42). Such powerful symbolic assemblages also clearly addressed the female deity Chalchiuhtlicue, 'jade skirt', whose ground-water domain embraced springs, rivers, lakes and the sea (fig. 43). The configuration of the Tlaloc side thus mimicked the ecological stratification of the Basin with lakes, fields and mountain heights wreathed with summer rain clouds and storms. The cult of Tlaloc was ancient; the name means 'he who is the embodiment of earth', suggesting Tlaloc's remote origins as a deity associated with earth and ground water contained within mountains. As we shall see, it was a ritual obligation of Moctezuma II and his predecessors to lead an annual pilgrimage to the summit of Mount Tlaloc on the eastern side of the Basin of Mexico, to initiate the rainy season by calling forth water from within the mountain.

Moctezuma also inherited powers and attributes associated with the cults of other ancient heroes and deities. The first was Quetzalcoatl, 'quetzal [plumed] serpent' (see cat. 69), the metaphoric title of the wind and storm deity.[3] Quetzalcoatl was also a title of rulership, for there are imposing pyramid-platforms where rulers were seated, adorned with plumed-serpent sculptural panels or columns, at Teotihuacan and elsewhere. Quetzalcoatl was the title of a celebrated ruler who presided over a prosperous kingdom of skilled farmers and craftsmen, renowned warriors, wise councillors, and storehouses filled with tropical feathers, shells and woven goods. Yet he fell foul of a calculating rival, Tezcatlipoca ('smoking stone') whose name refers to the black, polished obsidian mirror that identified him (see cat. 71). At a feast Quetzalcoatl was made drunk, lured into an incestuous relationship

with his sister, and was forced by Tezcatlipoca's faction to flee over the mountains into southern Mexico.[4]

The name Tezcatlipoca was not only associated with the rival of the legendary Quetzalcoatl. It was also widely known as the name of the omnipotent deity with both beneficial and destructive powers (see cats 71 and 72). In Tenochtitlan, a pyramid dedicated to the deity Tezcatlipoca was placed south of the Templo Mayor. Its foundations have been located beneath the ex-Archbishop's Palace, next to the National Palace facing the Plaza de la Constitución of Mexico City. The spiritual connection between Moctezuma and Tezcatlipoca is recorded in numerous coronation speeches, whereby priests intercede on behalf of the new ruler, or the new ruler himself asks for divine help to fulfil his mission.[5]

The Templo Mayor was a fearsome monument, surrounded by other pyramid temples, meeting houses, and terrifying skull racks or *tzompantli* strung up with the impaled heads of thousands of sacrificed victims (fig. 12). The looming monument with all its layers was charged with the accumulated power of thousands of offerings and the memory of a succession of rulers. Blood sacrifices consecrated the site. Blood was offered by the

Fig. 42
Ritual vessel representing the rain god Tlaloc found during the excavation of the Templo Mayor. Height 34.5 cm. Museo del Templo Mayor, Mexico City.

Fig. 43
Chalchiuhtlicue, the 'sister' of Tlaloc, goddess of water in the form of springs, rivers and the ocean. From the Codex Borbonicus, p. 5. Bibliothèque de l'Assemblée Nationale, Paris.

rulers by pricking their own bodies at the time of investiture and coronation; blood was offered with war captives brought for sacrifice upon Coatepetl in the triumphal conclusion of conquests; blood was required for securing the fertility of the soil, the regular progression of the seasons and the abundance of crops. In Nahuatl, blood is referred to in several ways: *tocelica* ('our freshness'), *totzmoliuca* ('our growth'), *nemoani* ('that which gives life'). Terms used in connection with blood offerings to the earth or to water include *nextlaoalioia* ('payment of debt') and *nextlanlli* ('the debt paid'). Sacrifice expressed a profound theme concerning the transformation of death into life, and was a critical part of the religious recycling of life-energies between the social and natural orders (see cats 56, 57 and 62).

The annual rites on Mount Tlaloc

Under successive rulers, the Templo Mayor grew incrementally as a state-sponsored architectural icon, marking the centre of the Mexica world. It was also linked by sight lines and pilgrimage routes to a system of shrines and sacred features in the surrounding Basin of Mexico. This network formed a sacred geography with specific locations in which history, mythology and the cycle of seasonal activities were engaged with the great

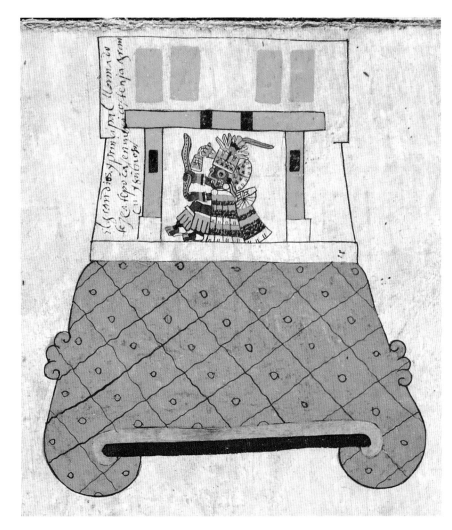

Fig. 44
Tlaloc housed in his temple sanctuary on top of the green glyph for mountain. From the Codex Borbonicus, p. 25. Bibliothèque de l'Assemblée Nationale, Paris.

powers of the natural environment and their corresponding deities. Among all the places where the Mexica rulers celebrated seasonal rites, the most evocative and mysterious was the remote temple on Mount Tlaloc.[6] The ruins of this temple lie at the 4,000-metre level, with a view of the snow-capped volcanoes Iztaccihuatl and Popocatepetl to the south, the Basin of Mexico to the west, and the Valley of Puebla to the east. On the cold height of Mount Tlaloc a dry-stone-wall enclosure is reached through a corridor-like processional way with walls that formerly rose high above the narrow path. The corridor opens on a wide quadrangle with walls that once rose to similar height, blocking out the surrounding view.

The chronicler Friar Diego Durán describes an annual pilgrimage made to the temple in late April or May by the rulers of Tenochtitlan, Tetzcoco, Tlacopan and Xochimilco. This is the height of the dry season, when fields have lain parched and fallow since late September and the dusty winds of February and March have leached out the remaining moisture. It was time for the rulers to perform the crucial seasonal rite of passage, initiating the transition from the time of drought and death to the time of rain and renewal.

> ... upon a small platform, stood the stone idol of Tlaloc, in the same manner in which Huitzilopochtli was kept in the temple [of Tenochtitlan]. Around [Tlaloc] were a number of small idols, but he stood in the centre as their supreme lord. These little idols represented the other hills and cliffs which surrounded this great mountain. Each one of them was named for the hill he stood for. These names still exist, for there is no hill lacking its proper designation. Thus the small idols which stood around the great god Tlaloc had their own names, just like the hills which encircle the great mountain.[7]

The fragment of a Tlaloc figure was photographed at the site in the 1920s and again in the 1950s, but no sculptured pieces remain there today. The assembled figures around the principal effigy were symbolic mountains, and Durán's description together with recent aerial photographs of the enclosure convey the sense of a cosmogram, an abstract landscape of Mount Tlaloc and the adjacent peaks. A rock-cut shaft on the eastern side corresponds to a place of communication with *tlalli yiollo* ('earth heart'), or *tepe*

yiollo ('mountain heart'), the locus of life and fertility. The royal parties set up camp just below the temple. On the following day all was ready and Moctezuma, followed by the rulers of Tetzcoco, Tlacopan and Xochimilco, began processions along the narrow corridor into the precinct interior:

> Just after dawn these kings and lords with their followers left [their shelters]. They took a child of six or seven years and placed him within an enclosed litter so that he would not be seen. This was placed on the shoulders of the leaders. All in order they went in the form of a procession to the courtyard, which was called Tetzacualco. When they arrived before the image of the god Tlaloc, the men slew the child within the litter [hidden from those present]. He was slain by the god's own priests, to the sound of many trumpets, conch shells and flutes. King Moteczoma [Moctezuma] together with all his great men and chieftains approached [the idol] and presented finery and a rich garment for the god. They entered the place where the image stood, and [Moctezuma] with his own hands placed a headdress of fine feathers on its head. He then covered it with the most costly, splendid mantle he had, exquisitely worked in feathers and done in designs of snakes. [The idol] was also girded with a great and ample breechcloth as splendid as the mantle. They threw about its neck valuable stones and golden jewels. Rich earrings of gold and stones were placed upon him, and on his ankles also. [The king] adorned all the smaller idols who stood next [to Tlaloc] in a similar fashion.[8]

The other rulers followed suit. In effect, the dressing of the effigy was an act of coronation, repeating the acts of investing a new ruler in Tenochtitlan. The Codex Ixtlilxochitl depicts an effigy of Tlaloc within a crenellated precinct dressed in his royal attire (fig. 45). A pause followed, after the rulers and their attendants withdrew from the precinct. Then, again following rank order, they returned successively with attendants bearing a magnificent feast. The platters and bowls were first laid out by Moctezuma acting as steward, covering the chamber with such abundance that some of it had to be left outside. The rulers of Tetzcoco, Tlacopan and Xochimilco followed at intervals, each contributing more newly-made bowls and platters with turkeys and game, stews, gourds filled with chocolate, and baskets with various breads all beautifully prepared and cooked.

Then the priests who had sacrificed the child came in with the blood in a basin. One wet the hyssop which he held in his hand and sprinkled blood over the feast. So important was the event at the Temple of Tlaloc that only something of supreme value such as

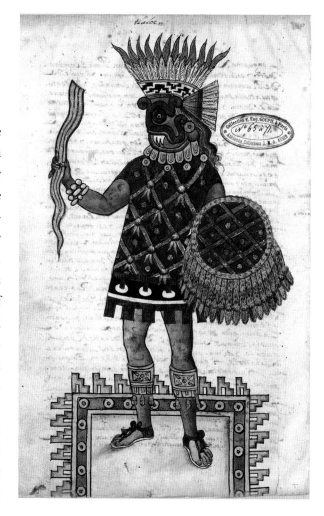

Fig. 45
Ritual impersonator of Tlaloc standing within a crenellated precinct. He wears a feather headdress and holds a shield and serpentine staff. From the Codex Ixtlilxochitl, fol. 41. Bibliothèque Nationale de France, Paris.

a child could be offered. The purpose of the elaborate performances, prayers, foods and the sacrificial offering was to fulfil an obligation to recycle food and energy from human society to the clouds and moisture waiting to rise from within the mountain to form around the high peaks. The Nahuatl word for sacrifice is *uemmana*, composed of the terms *uentli* ('offering') and *mana* ('to spread out'), in the sense of spreading a feast. The root stem *mana* is also used in reference to patting out a thin round tortilla.

The Tlaloc enclosure and the movement of the processions towards the sanctuary suggest that the setting was designed as a symbolic womb of the mountain, entered by the Mexica kings on their annual mission of fertilization. In the Codex Tolteca-Chichimeca there is a depiction of the mountain Culhuacan with the interior drawn in womb-like form and the priest outside, striking the entrance with his staff to summon the tribes from within. Emergence from the earth's interior is a widespread theme of indigenous belief throughout the Americas. Another image bearing on the Mount Tlaloc enclosure is from the Codex Borbonicus, depicting the masculine and feminine creative forces, Ometecuhtli and Omecihuatl, ('two lord' and 'two lady'), seated within a sacred enclosure from which water flows at the beginning of time. The pivotal ritual at the Temple of Tlaloc came to a close as everyone withdrew to attend a concluding feast at the camping place below the precinct. The royal parties then began the return trek to Lake Tetzcoco, where they were to reassemble for the second part of the seasonal rite.[9]

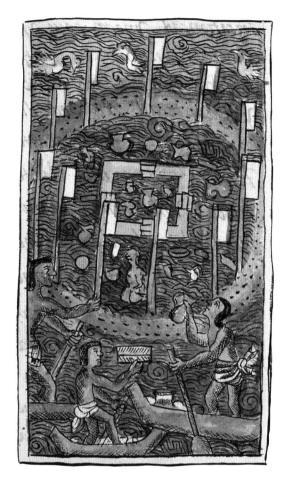

As the events on Mount Tlaloc were taking place, the next episode was in progress in Tenochtitlan. A large tree had been cut in the mountains, carefully lowered without touching the ground, and transported by a priestly party across one of the causeways. The tree was then erected before the Tlaloc side of the Templo Mayor. The tree was named Tota ('father'), and was surrounded by four smaller trees forming a symbolic forest. A young maiden attired as the ground-water goddess Chalchiuhtlicue ('jade skirt') was brought to sit within this grove as a living personification of the lake, springs and streams (fig. 43). A long chant was begun. Presently a messenger arrived with news that the rulers had completed the rites on Mount Tlaloc and were reassembling at the lakeshore by Tetzcoco. The Tota tree was taken up, carefully bound on a raft, and paddled out on the lake to a shrine called Pantitlan, 'place of banners', accompanied by a fleet of canoes with priests and attendants, the Chalchiuhtlicue child, musicians and a multitude of singing people. Pantitlan was encircled by banners and defined by a low quadrangular masonry wall in the water, as illustrated on a page from Sahagún's Florentine Codex (fig. 46). It appears to have been the site of a spring from an aquifer welling up in the shallow lakebed. Soon another fleet of canoes drew close by, bearing the four royal parties. As the population, priests and royalty watched, the Tota tree was unbound and set up in the shallow water by Pantitlan as a symbol of the regeneration of plant life. Chalchiuhtlicue was then sacrificed and her blood poured into the water together with greenstone jewellery. The

rite concluded and all departed, leaving the Tota tree standing with others from previous years around Pantitlan in Lake Tetzcoco. The lake was a sustainer of life and was spoken of as a mother by the peoples of the Basin of Mexico. The Pantitlan rites, in connection with those of Tlaloc, acknowledged this perception of water as the element that precedes solid form, the support of all earthly creation.

The New Fire ceremony and the Binding of the Years

Among all the religious responsibilities of the Mexica *tlatoani*, a most critical obligation concerned the renewal of time itself. This entailed sponsoring a rite in the concluding hours of every 52-year cycle to encourage the rise of the sun on the morrow. This event is best understood by first outlining the Mesoamerican calendar system that the Mexica inherited.

There were two systems of day counts in the calendar system. One was a cyclic 260-day *tonalpohualli* count, originating far in the past, seemingly based on the annual passage of the sun from south to north and back again as it crosses a zenith point at a latitude near the Classic Maya city of Copan in Honduras. In this count the sacred 260-day cycle was composed of 20 groups of named and numbered days. Each cycle of 20 days intermeshed with a rotating cycle of 13 numbers, so that after each complete rotation, each number was engaged with a new day. Thus within the 260-day period each day was identified by the combination of one of the 20 day names with one of the 13 numbers (20 x 13 = 260). The sacred 260-day cycle was then divided into 20 'weeks' of 13 days each, called 'trecenas' by the Spanish. Each trecena began with the number 1 and the day name, which came up in the rotational sequence. Each combination was thus unique within the *tonalpohualli* cycle, for no day in any one trecena could be confused with that of another.

Tonalpohualli counts were kept in gatefold books with pages depicting a 13-day trecena, each governed by a dominant deity and each day influenced by its own day-lord and night-lord. Professional diviners interpreted the influences displayed in these *tonalpohualli* on important occasions for people seeking information on auspicious or inauspicious days for state or individual endeavours.

In addition to this divinatory 260-day calendar, Mexica life was governed by the annual ceremonial calendar consisting of a 365-day solar count, the *xiuhpohualli*. This period was divided into 18 months of 20 days each, called 'veintenas' by the Spanish, plus a 5-day period of inactivity and danger between the old year and the next. Each veintena had its own festival, correlated to the annual activities of the rainy and dry seasons. The years were named for one of the four possible day names in the *tonalpohualli*, which could begin a new year with its appropriate number according to the rotation system. The year names were Rabbit, Reed, Flint Knife and House, and each was further distinguished by numbers – thus 1 Rabbit, 2 Reed, 3 House, 4 Flint Knife, until the 13 numbers and the 4 day and year names began to repeat themselves every 52 years (13 x 4).

The conclusion of a 52-year cycle (which we may think of as a 'century' in the Mexica system), and the beginning of a new cycle, was marked by New Fire ceremony and tying up a symbolic bundle of 52 rods representing the old cycle of time – The Binding

Fig. 47
A portion of the interlocking
Mexica lunar (ritual) and solar
calendars.

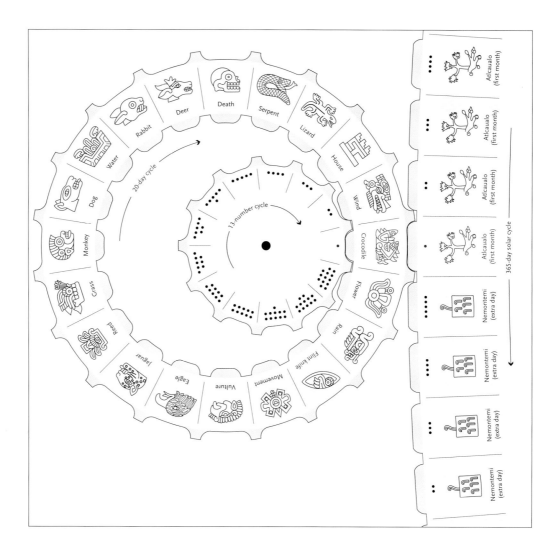

of the Years. The New Fire rites were pivotal to this sequence, for it was their purpose to re-enact the events of first creation in order to begin a new cycle of time.[10] Four years after Moctezuma II's coronation, as the year 1506 approached, dire memories of the great drought and famine of 1450–54 haunted the Mexica imagination. All scraps of foods were hoarded, even mildewed maize, lest catastrophic conditions return. These fears were added to doubts ever-present at such recurring times of transition, that the New Fire ceremony might prove ineffectual, that the last night of the cycle might last forever, that a plague of wild beasts might descend and eat people.

At dusk on day 20 of the feast Panquetzaliztli, dedicated to Huitzilopochtli (10 December), a procession of fire-priests and men dressed as gods walked silently out of Tenochtitlan. Their route led along the straight southern causeway towards a distant temple on the summit of Mount Huixachtlan, 'thorn tree place', today called Hill of the Star. The height was visible from around the Basin, and the temple platform was prepared with an altar where firewood was stacked and waiting.

The last glow of light dyed the snows of Popocatepetl and Iztaccihuatl, but in the deepening shadows below no evening fires appeared. In the towns and cities around the lakes, in pyramid-temples, palace kitchens and domestic hearths, workshops and pottery

kilns, all embers were extinguished. The three stones upon which cooking pots rested, old utensils and small figures of gods had all been cast into water and everywhere was swept clean. Thousands of people ceased preparations and began gathering on rooftops and open places to wait in hushed expectation. Moctezuma and his court and other rulers around the valley sat out on flat roofs with a view to Huixachtlan. Pregnant women put on blue-painted masks and were enclosed in granaries to be guarded by warriors lest they turn into fearsome beasts in the night. Small children wore masks lest they turn into mice. Stillness settled in the ashy twilight filling the basin.

The procession of gods assembled to witness the New Fire rites, summoning the powers of nature as had once happened in darkness before the world's ages began. As the stars appeared everyone watched the constellation *tianquiztli* 'marketplace' (the Pleiades) rising over the dark mountains east of the Basin. *Tianquiztli* would herald the next constellation *mamalhuaztli* 'fire drill' (partly corresponding to Taurus). As *tianquiztli* crossed the meridian line at 10.02 p.m. a fire-priest drilled fire from a board placed on the chest of a sacrificial victim, and carried the flame to the wood stacked nearby. As *mamalhuaztli* crossed over at 10.44 p.m., the sacrifice was performed and the heart was offered in the fire. By midnight the pyre was burning furiously and the body was cast in, sending a great cloud of sparks billowing up in the night, visible from everywhere throughout the waiting towns in the basin. A great whooping cry arose as runners lit torches from the sacred fire and points of light could be seen descending the hill to footpaths and causeways leading to the fire-temple hearths of every waiting village and town. The runner's torch could be seen from Tenochtitlan, coming across the southern causeway and into the city, where the first fire was lit in the temple of Huitzilopochtli before continuing to the fire temple in the ceremonial precinct. The Codex Borbonicus (cat. 73) depicts the spectacular conclusion as new fire blazed in the great open hearth and four priests lit torches to carry the flame to the four wards of the city. There the populace swarmed and blistered themselves in the tumult to carry new fire to their homes. New mats were laid out with new hearthstones and pestles, and householders dressed in new capes and tunics. Incense and quail were offered to the household hearth, and maize cakes with honey were eaten. Night was passing as the pre-dawn twilight began turning yellow. The orange-red sun disc rose from behind the dark indigo mountains. In the ritual precincts of Tenochtitlan, Tetzcoco, and other cities, bundles of 52 rods, *xiuhmolpilli*, were bound up to signify the cycle's completion.

The making of fire at Huixachtlan in the darkness, the presence of gods and the burnt sacrifice, the cycle's renewal and rebirth of sunlight, had magically suspended the historical present, re-enacting a drama of primordial creation and the first sunrise in the beginning of time. This myth was of great antiquity and was diversely recounted and re-enacted for at least two thousand years before the Mexica arrived in the Basin of Mexico:

Fig. 48
Figure of the deity Xipe Totec, dressed with the flayed skin of a sacrificial victim. Smithsonian Institution, Washington DC.

It is told that when yet [all] was in darkness, when yet no sun had shone and no dawn had broken – it is said – the gods gathered themselves together and took counsel among themselves there at Teotihuacan. They spoke; they said among themselves: come hither, o gods! Who will carry the burden? Who will take it upon himself to be the sun, to bring the dawn?[11]

Two gods offered to sacrifice themselves, and after four nights of penance and retreat, they were ceremonially dressed and brought before a blazing hearth. At midnight, the assembled gods urged the first volunteer, Tecuciztecatl, to cast himself into the heart of the immense glowing heap of coals and flame. But he dared not, and it was left to the second candidate, Nanauatzin, to throw himself in, whereupon Tecuciztecatl followed. The gods turned about to see where Nanauatzin would eventually rise, until finally, towards the east, they saw the first sunrise. 'Intensely did he shine. He issued rays of light from himself; his rays reached in all directions; his brilliant rays penetrated everywhere.'[12] Tecuciztecatl afterwards rose as the moon, and Ehecatl (another name for Quetzalcoatl, lord of the wind) blew to set them in motion.

The New Fire ceremony expressed this paradigm of the bestowal of light, heat, and time itself on a world still dark and unformed. This original genesis episode, when life-giving forces were brought into being and the essential geometry of the heavens was traced, led on to the cycles of destruction and renewal and eventually the appearance of humankind.

Moctezuma and the idea of eternal return

Moctezuma II held sway over an ascendant empire that continued to advance and adjust to changing conditions and circumstances. Almost a century of empire building had called for changes in Mexica social structure, the formation of alliances and networks of family connections, the creation of a new legal system, the organization of a tribute system and agricultural production, and a remarkable effort to develop a programme of religious rites and festivals that reached out and included a multi-ethnic society. Yet the Mexica cast of mind also rested in a deep-seated sense of order, engaged in the natural features of the land and recurring seasons seen and experienced in the world around them. The fundamental organization and activities of society reflected the structure and processes perceived in the order of nature. The principle of eternal return governed the pulse of creation, flowering, destruction and renewal. The world ruled by Moctezuma II in the cosmogonic era of the Fifth Sun was not, after all, destined to end in earthquakes. The catastrophe of 1521 was precipitated by the Mexica's own predatory policies, the enmity of subjected or threatened peoples who lived in a state of resentment and antagonism, and the arrival of strangers from beyond the known world seeking new lands to conquer.

Cat. 56
Altar with the date 10 Rabbit

1325–1521, Mexica
Stone, 59 × 41.5 × 29.5 cm
Museo Nacional de Antropología, Mexico City,
inv. 10-116583

Selected literature: INAH 1970, p. 47, fig. 52; Umberger, 1981, pp. 132–33, fig. 100

This stone altar was unearthed in Mexico City during excavations for the Metro line traversing the southern part of the former Tenochtitlan. It celebrates sacrificial offerings made to the gods, particularly human hearts. This devotional act provided nourishment for Huitzilopochtli and constituted the most important ceremony undertaken during the coronation of the Mexica rulers. The presence of the calendar date 10 Rabbit on a panel above the head of the main figure indicates that it was made in 1502, when the death of the eighth *tlatoani* Ahuitzotl prompted the election of Moctezuma II. It is therefore one of a group of monuments marking the beginning of Moctezuma's reign.

The altar is in the form of a rectangular block, although one side is broken and the carving on the three sides has been deliberately erased. The monument was originally placed horizontally, with the main relief, on which the sacrifices were performed, facing upwards.

The largest relief portrays a man sitting in 'oriental' fashion, with one foot placed on top of the other, toes downwards, on the hanging bands of his *maxtlatl* (loincloth). The figure is extravagantly dressed and adorned with a feathered headdress emphasizing his status as an elite warrior destined to be sacrificed to the Mexica tribal god. He is wearing an *anahuatl* – a symbol for the earth contained by the ancestral waters – on the back of his head, linking him with Huitzilopochtli. In his right hand he holds a sharpened femur with which he indicates the position of his heart, the site of the supreme sacrifice. He also wears highly ornate bracelets and bangles, and the triangular cloth apron of the warrior. The background is decorated with human hearts arranged alternately in upright and downward positions to create a sacred pattern appropriate to the altar's function.

Despite the damage to the side reliefs the mask of the rain god Tlaloc is still identifiable. This symbolic element, along with the date, associates the altar with the floods that engulfed the Mexica capital around this time. *FSO*

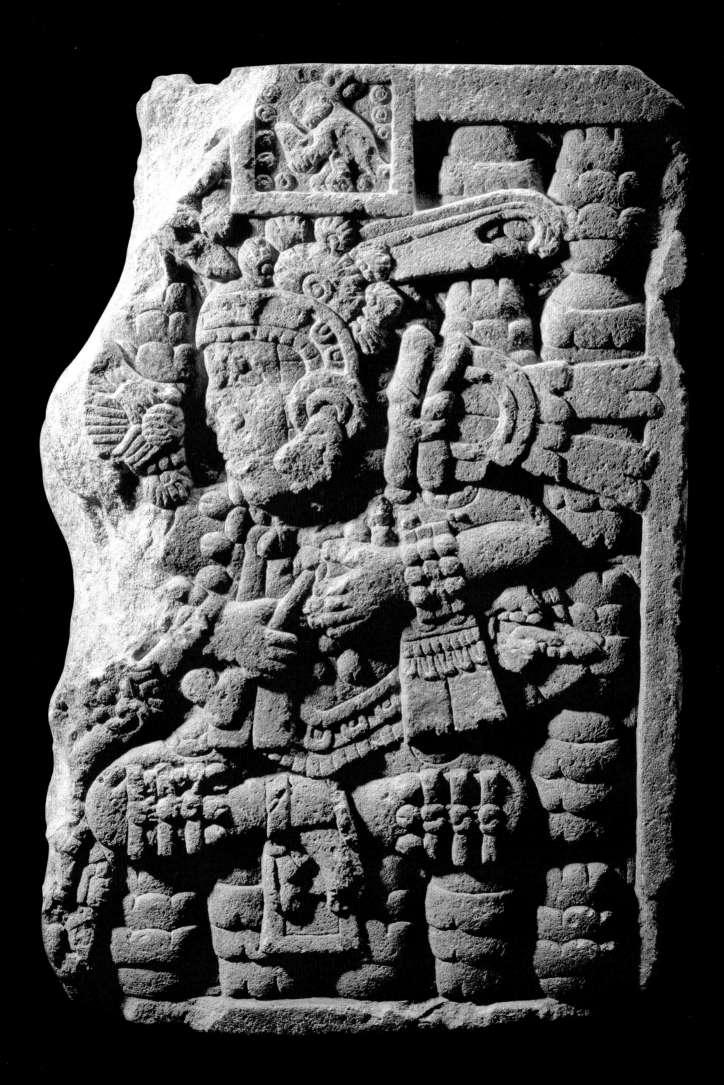

Cat. 57
Sacrificial knife

c. 1400–1521, Mexica–Mixtec
Wood, turquoise, shell, chalcedony, malachite, cord and resin, 9.3 × 31.7 cm
Trustees of the British Museum, London, AOA St. 399

Selected literature: Joyce 1912, fig. 16; Saville 1922, fig. 38; Carmichael 1970, p. 16; Pasztory 1983, fig. 55; García Moll, Solís Olguín and Bali 1990, p. 178; Matos Moctezuma 1993, pp. 18–21, 20–21; Townsend 1995, p. 106; London 2002, p. 474, no. 296; McEwan *et al.* 2006, pp. 12, 24–26, 71–77; McEwan 2009, p. 130

This ritual knife (*ixcuac*) was made by knapping a semi-translucent flint into a long blade. One tapered end is fitted into a handle made from carved Spanish cedarwood (*Cedrela odorata*) and secured with a resin-coated maguey (agave) fibre cord. Mexica knives were also made from obsidian, which has similar dark and light qualities. Technical examination has indicated that only a small part of the blade is embedded in the wooden handle and that there are no traces of blood on the knife, suggesting that it was a ceremonial object and probably never used for ritual sacrifices.

The wooden haft is carved into the form of a crouching figure, wearing ritual attire and clasping the blade between his hands. A winged cloak covers his shoulders and his face emerges from the open beak of a headdress in the shape of a bird's head. He probably represents an eagle warrior, as this is one of the two insignia worn by members of the highest military orders, *cuauhtliocelotl* (eagle-jaguars). These were sun warriors who celebrated the Fifth Sun (*Nahui Ollin*). Two similar knife handles are preserved in the Museo Nazionale Preistorico ed Etnografico 'Luigi Pigorini', Rome, and in the Museo Nacional de Antropología, Mexico City.

Eagles were strongly associated with the sun, and the eagle warriors were charged with the duty of feeding the sun with

sacrifices, hence their appearance on sacrificial knives. Sacrifices were used both as an instrument of political power and to nourish the gods, ensuring the sun's movement on its daily course through the sky and the underworld.

The artistry of a Mexica–Mixtec craftsman is evident in the execution of the mosaic. The mosaic tiles, glued to the wood using pine and copal resin, have been carefully selected to emphasize the various details of costume and ornament. The figure is covered with the finest tesserae of pale blue turquoise. Minute details such as fingernails, teeth and eyes are rendered in different coloured conch shells and dark green malachite. The jewellery and body adornments are also elaborately crafted. The partially damaged bracelets and anklets are composed of decorative mosaic bands made from conch shells and incised mother-of-pearl. A green malachite nose ornament provides a contrast to the orange-red shell of the lips and gums. Bands of white shell and malachite run across the forehead.

The half-closed eyes representing night stars are depicted using white and orange shells on a malachite background. They are repeated across the costume, including the headdress and the upper thighs of the warrior, where they appear with double bands in white shell mosaic. The motif also appears on the *maxtlatl* (loincloth), which is tied around the waist with a white band. A garment hanging down the figure's back, depicted in white conch shell and malachite, resembles a solar ray and bears the same eye motif. On the chest a rectangle of pink conch shell is outlined with *Spondylus* shell. *EVLL*

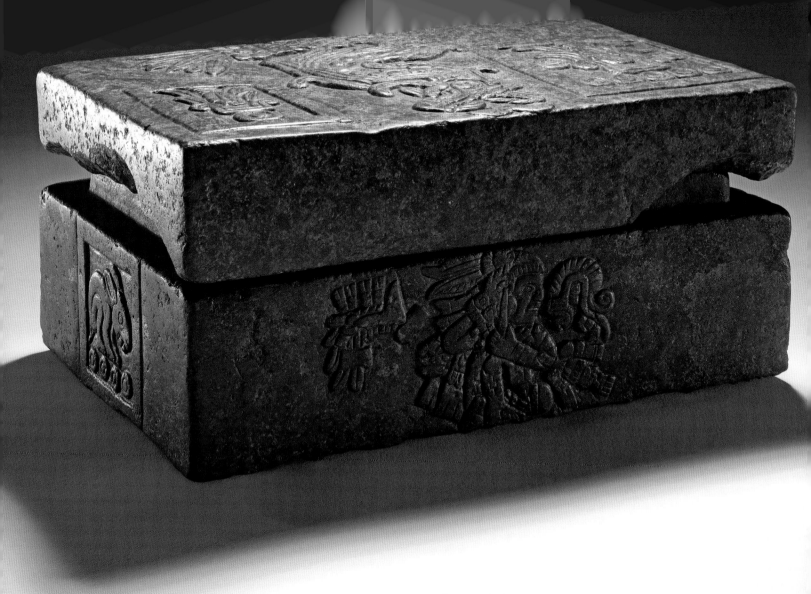

Cat. 58
Casket with lid

c. 1506, Mexica
Granite, 15 × 33.5 × 21 cm
Museum für Völkerkunde Hamburg, B.3767

Selected literature: Nicholson 1961, pp. 64–66; New York 1970, no. 284; Gutiérrez Solana 1983, pp. 41–45; Pasztory 1983, pp. 255–57; Washington 1983, pp. 64–66; Umberger 1984; Hildesheim-Munich-Linz-Humlebæk-Brussels 1986, vol. 2, p. 214; Seler 1990–98, pp. 87–113; Madrid 1992, p. 202–04, XLIV (a–n); London 2002, p. 473, no. 293

This small rectangular greenstone casket (*tepetlacalli*) and its lid are unique examples of Mexica craftsmanship. Carved on eight of its faces, including the lid, the iconography combines dates from the Mexica calendar with anthropomorphic and zoomorphic images in different scales.

In the centre of the lid is an image of a descending feathered serpent (Quetzalcoatl) flanked by two year-glyphs, 1 Reed and 7 Reed, enclosed in cartouches. Both dates are associated with Quetzalcoatl, marking his mythical death and birth in the Mexica calendar. Furthermore, 1 Reed coincides with the date 1519, the year in which the first news of strangers on the coast reached the Mexica capital during Moctezuma's reign.

On each of the longer sides is depicted a cross-legged figure.

The bearded figure, looking to the left, is dressed in a jaguar costume and holds a tasselled incense pouch in his right hand and a curved object resembling a club or staff. A *tezcacuitlapilli*, or circular mirror is attached to the belt, and an *anahuatl* with two hanging ornaments with cleft ends. Below, a feathered ornament resembles the tail of a feathered serpent. A scroll indicating speech or song emerges from the figure's mouth. The date 1 Reed behind him may be the name glyph for Quetzalcoatl, but other authors have identified this image as Tezcatlipoca's nocturnal alter ego, the night jaguar or Tepeyollotl ('mountain heart').

The seated figure on the opposite side of the box looks to the right. He is drawing blood from his earlobe with a bone perforator and also carries an incense pouch. On his back is an elaborate jaguar's head ornament and his headdress combines two down balls with a pair of long feathers. Behind him is the name glyph associated with Moctezuma II, comprising a *xiuhuitzolli* (diadem), nose-plug and ear-spool. The speech scroll that completes Moctezuma's name glyph is here carved emerging from his mouth, rather than from the glyph itself, reinforcing the relation of the figure with the glyph and fully integrating both in this image. The four plaited-grass strips on the top of his head symbolize penitence and fasting, thus emphasizing the act of self-sacrifice.

On each end of the box is carved a date glyph within a cartouche – 4 Rabbit and 1 Rabbit respectively – both represented by a complete rabbit rather than the more usual disembodied head. The year glyph 1 Rabbit may represent the year in which the present earth was created, but it may also refer to 1506, perhaps the year in which the box was made under Moctezuma's patronage.

Inside the lid is a skull carved in profile wearing an ear-spool and a head ornament. Enclosed in three concentric bands, the outer band is decorated with eyes symbolizing the stars. Similar skulls appear on greenstone sculptures of Quetzalcoatl (see cat. 69) signifying his association with Venus. Inside, the base of the box is carved with the glyph 1 Crocodile, a date associated with the beginning of the *tonalpohualli* (260-day cycle), the creation of the earth and coronation of rulers in Tenochtitlan including Moctezuma's own investiture (see cat. 14). On the outside, the base is carved with an image of Tlaltecuhtli, the earth goddess, who frequently appears on the bottom of stone monuments and caskets (see cat. 12). Thus, the lid with Venus and the stars symbolizes the night sky, while the Tlaltecuhtli at the base of the box represents the earth, forming a visual opposition between sky and earth.

Pasztory has suggested that the varying scale and the blank spaces around the figures hold iconographic significance. While the earth deity on the base 'suggests the closed and all-encompassing darkness of the earth', the carving in the lid may represent the 'openness of the sky'. The box thus presents a cosmogram reinforcing the role of rulers in communicating with supernatural forces. *EVLL*

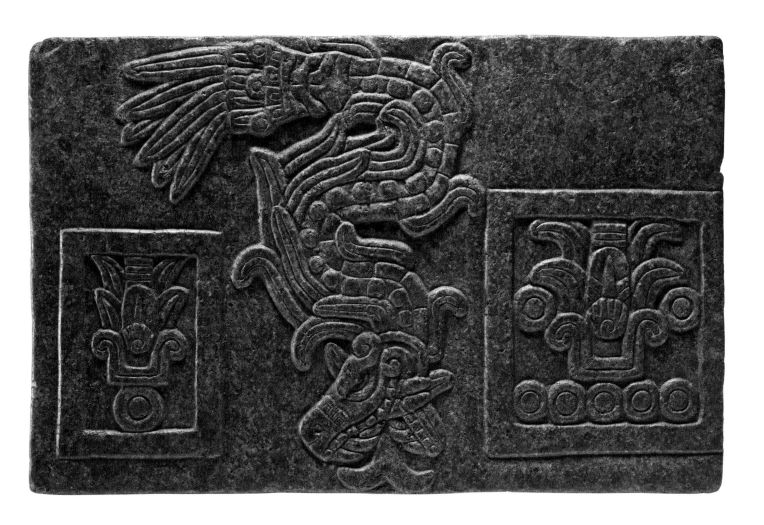

Below
A cross-legged figure carved on one of the longer sides.

Bottom
The earth goddess Tlaltecuhtli, carved on the base.

Opposite, above left
A skull carved inside the lid.

Opposite, above right
The date glyph 1 Crocodile, carved inside the base.

Opposite, below
The date glyph I Rabbit, carved at one end.

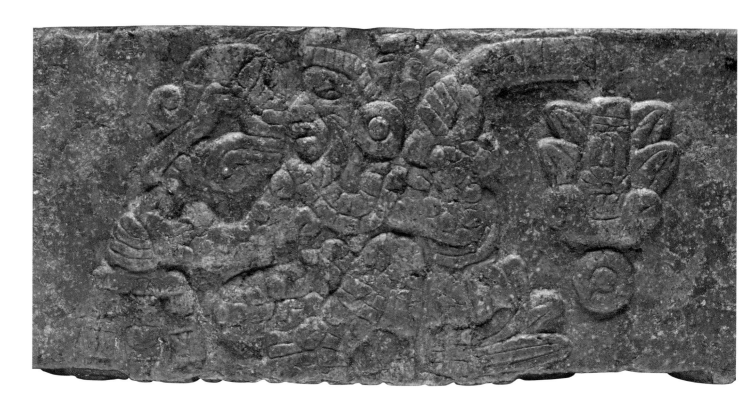

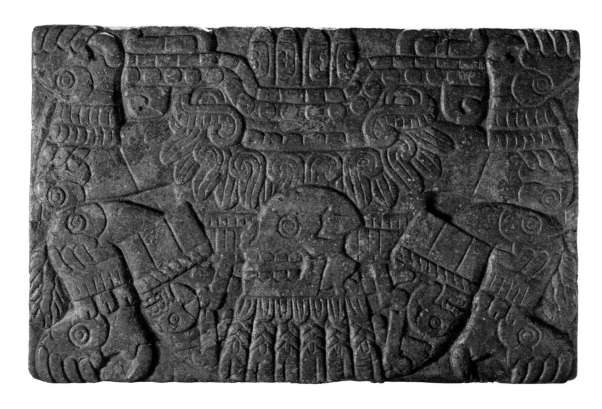

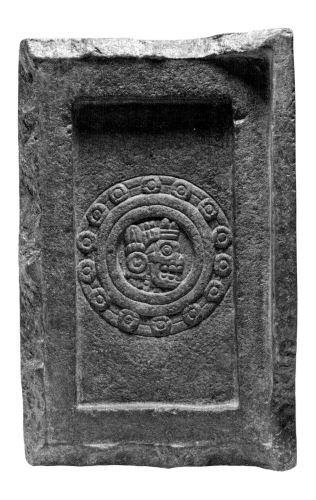

Cats 59, 60 and 61
Three skulls

c. 1500, Mexica
Stone, 21.1 × 19 × 20.7 cm, 20.4 × 16.6 x 32.6 cm and 21.1 × 17.6 × 28.7 cm
Musée du Quai Branly, Paris, inv. 71.1932.62.1, 71.1932.62.2 and 71.1932.62.3

Selected literature: Gendrop 1970, pp. 170–71, 193–94; Brundage 1979, pp. 211–12, 215–16; Brundage 1985, pp. 74, 85–87, 89–90, 95, 160, 170–72, 178; Miller and Taube 1997, p. 173; Serrato-Combe 2001, pp. 93–95; Smith 2003, pp. 228–29; López Luján 2005; López Luján and Fauvet-Berthelot 2005, pp. 115–16

Carved in a porous volcanic rock, these three skulls may once have been covered with stucco and painted, giving them a more realistic appearance. Their comparable size and style indicates that they may come from the same structure. The skulls were found in the early twentieth century at the base of a building next to the Cathedral in Mexico City, the site of the sacred precinct of Tenochtitlan. Illustrations in early colonial chronicles and surviving small Mexica clay representations of buildings suggest that there were a number of different structures, some of which may have borne skull decorations on their façades and roofs. The pegs protruding from the back suggest that these skulls were once attached to some kind of structure or building.

Some of the most striking of Mexica structures were the *tzompantli* or skull racks. These were raised architectural platforms that held wooden crossbeams bearing real human skulls. The term comes from *tzontli*, the Nahuatl word for hair that was used as a figurative name for the head, and *pantli*, which means a row or string. The heads of vanquished enemies and sacrificial victims were publicly displayed as a visual demonstration of Mexica dominance. Colonial accounts, including those by the sixteenth-century chronicler Friar Bernardino de Sahagún (see fig. 40), and the Map of Tenochtitlan (see fig. 17), suggest there were several *tzompantli* in the ritual centre of Tenochtitlan, although their precise locations have yet to be established. However, there is no evidence that these sculptures decorated such a structure.

The best-known archaeological evidence of a building incorporating sculpted skulls is the excavated Structure B adjacent to the Templo Mayor (fig. 12). No evidence of real human skulls or the wooden crossbeams on which they were hung was found in this structure, thus indicating that it did not function as a *tzompantli*. The offerings excavated in its interior (offering H) confirm its association with the Mictlan, the place of the dead. Its location in the northern side of the sacred precinct adds weight to this theory. The present three skulls therefore probably adorned a similar building.
EVLL

Cat. 62
Cuauhxicalli

c. 1500, Mexica
Basalt, 56 × 30 cm
Trustees of the British Museum, London, Am, +.6185

Selected literature: Seler 1902, pp. 913–52, no. 17; Joyce 1912, fig. 11b; Umberger 1981; Pasztory 1983, p. 236, fig. 243; Baquedano 1984, p. 84, fig. 55; Washington 1991, pp. 36–37; Taube 1993; McEwan 1994, p. 77; London 2002, p. 437, no. 152; McEwan 2009, p. 133

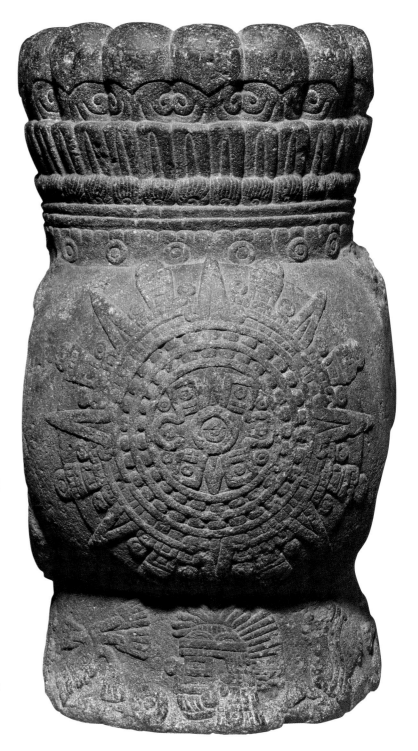

The Mexica used a wide range of vessels for rituals and public ceremonies. This unique *cuauhxicalli*, or 'eagle vessel', is a magnificent example of lapidary art, combining three-dimensional elements and relief carving.

Its unique form, which echoes the shape of a *pulque* container, is in three sections. The top part, which forms the basin of the vessel, is decorated around the rim with sixteen three-dimensional hearts graphically indicating the vessel's purpose as a container for the hearts of sacrificial victims. Beneath are bands of eagle feathers and eagle down, signifying sacrifice. The decoration of this section is completed with a further undulating band with circles symbolizing precious greenstones. Despite the stylized iconography of Mexica art, the sculptural elements here are rendered with exquisite naturalism and attention to detail, in a similar composition to that of the greenstone *cuauhxicalli* currently in Berlin, the only other known example with hearts around its rim.

The middle section encompasses the widest part of the vessel, with carvings in low relief on two of its sides. The solar disc with an *Ollin* (Movement) symbol at its centre represents instability and earthquakes. The Mexica believed that their era would end with an earthquake so made constant sacrifices to the gods and to the sun itself in an attempt to avoid this destiny. A partially obliterated 'U' shape is carved on the opposite side. This symbol both represents the moon and mimics a container that is periodically filled and emptied. It also represents a type of nose ornament (*yacametztli*) worn by the gods of *pulque* (see fig. 91). These three symbols reinforce the vessel's association with the night, the moon and the intoxicating drink. Liquid containing conch shells and *chalchihuitl*, symbolizing blood, flows from four stylized hearts flanking the central carving.

On the base and beneath the solar disc is carved the date glyph 1 Rain. According to the sixteenth-century chronicler Bernardino de Sahagún, this date, which also appears below the sun on the Calendar Stone (fig. 28) was associated with the sacrifice of prisoners and slaves. It was also dedicated to the *cihuateteo*, the spirits of women who die in childbirth (*mociuaquetzque*), and to Ilamatecuhtli, the goddess who created the stars. On the other side of the base is an incomplete glyph for the date 2 Rabbit, the date name of the *pulque* god Ometochtli who was also associated with the moon, making a direct reference to the half-crescent carved above. The dates 1 Rain and 2 Rabbit marked a 52-day period in the Mexica calendar, which may have symbolized the complete cycle of day and night, light and darkness. Both dates are flanked by stone glyphs (*tetl*) and broken flowering branches (*cuahuitl*).

Seler and Taube have pointed out that the union of the glyphs *tetl-cuauhuitl* (stone-branch) relates to the idea of punishment and to the attacking of the sun by lunar and *pulque* demons (*tzitzimime*). Thus, it is not a coincidence that the date dedicated to the sacrifice of captives and the name glyph of the lunar and *pulque* god is flanked by those glyphs. Probably this scene also represents a cosmic battle between the sun and the moon, whose destiny will be resolved by the hearts offered in sacrifice. EVLL

Cat. 63
Censer

1325–1521, Mexica
Fired clay and paint, 7.4 × 61 × 22.7 cm
Museo Nacional de Antropología, Mexico City, inv. 10-220158

Selected literature: Batres 1902, pp. 120–28; Peñafiel 1910, p. 12; Batres 1979; London 2002, p. 471, no. 285

In 1900 Mexico City saw the excavation of a long drain that traversed the city from east to west, passing through the remains of the ritual precinct of the Mexica. The curator of Mexico's archaeological monuments, Leopoldo Batres, was responsible for retrieving the precious Pre-Hispanic monuments found by the workmen. On 16 October, Batres recovered a substantial number of pieces from the most valuable discovery yet made. The excavation unearthed a highly significant store with connections to the Huitzilopochtli temple, the cult of the sun god Tonatiuh, and the eighth *tlatoani* Ahuitzotl (reigned 1486–1502), since the objects found were made in the construction period coinciding with his reign.

This cache is distinguished by the strong links between the ceramic objects, all of which have devotional and symbolic characteristics. Stylistically, they correspond to the polychrome ceramic tradition of the 'international style' (see cat. 55). Although most of the pieces were broken, some of the intact objects have associations with the main Mexica deities.

This censer is one of the eight ritual objects that were recovered unbroken. The incense bowl bears the image of the rain god Tlaloc, identifiable by the six curved fangs emerging from his jaws. His face resembles a mask, with a nose-plug typical of warriors and the ear-spool in the form of a sectioned femur similar to those found on images of Mictlantecuhtli, the god of death. The long handle bears a solar ray, along with feathers and a paper knot, and the head at the end has been identified as a *Tlacatecolotl*, or owl man.

FSO

Cat. 64
Figure of Chalchiuhtlicue

c. 1325–1521, Mexica
Resin and wood, 34.1 × 18.7 × 16.5 cm
Musée du Quai Branly, Paris, M.Q.B. 71.1878.1.336

Selected literature: Lehman 1948, p. 270; Seler 1960–61, vol. II, no. 1, pp. 884–85; Bernal and Simoni-Abbat 1986, p. 360, fig. 335; London 2002, p. 460, no. 241; López Luján and Fauvet-Berthelot 2005, pp. 60–61; López Luján 2006, vol. I, pp. 208–09

Most surviving Mexica sculptures are made from stone, but others constructed or carved from lighter, perishable materials, such as wood, amaranth and copal resin, were also common. Their portability may have made them suitable for certain rituals. Furthermore, the fact that they would decay, some of them were edible, easily mutilated or burned, may have being intended as part of their function. Copal and resin were often burned as a means of communicating with the gods, the smoke carrying messages towards the skies. The dark clouds created by the smoke symbolized the fertilizing rains. However there is little evidence of resin images being burned as offerings, although resins were offered in solid form. Several examples in the shape of rain and water deities have been excavated at both the Templo Mayor and at the El Volador site.

This image is made of resin and may once have contained a wooden armature within its structure. Wooden fragments inside the holes at the top and bottom might have formed part of the support on which the sculpture was constructed. Effigies were sometimes adorned with costumes and paper decorations while others were decorated with stucco finishes. This sculpture was originally painted, as can be seen from the remains of red and black pigments on the face.

Chalchiuhtlicue was the goddess of ground water, and as such was associated with rivers, lakes, lagoons and the sea. She acted as the female counterpart of Tlaloc (see cat. 66), who ruled celestial waters and rain. Sculptures of Tlaloc made from the same materials have also survived. Similar effigies have been found in caves at the base of the Iztaccihuatl volcano and offerings at the Templo Mayor of Tenochtitlan. The goddess is seated in the traditional kneeling female position with her hands resting on her knees. She is dressed in an ankle-length skirt (*cueitl*) and a tasselled tunic (*quechquemitl*) and is adorned with a three-stranded necklace, an ear-spool and a cylindrical headdress with applied decorations. Two beaded cords hang from the back of the headdress over the *amacuexpalli*, a pleated paper ornament worn by water and fertility deities at the nape of the neck. *EVLL*

155

Cat. 65
Commemorative monument

1459 or 1511, Mexica
Greenstone (serpentine), 68 × 39 × 28 cm
Museo Nacional de Antropología, Mexico City, inv. 10-136175

Selected literature: Solís Olguín 1976, p. 6, no. 5; Umberger 1981, pp. 87, 237, 259, 282, nos 56, 34b; Chimalpáhin 1998, vol. 31, p. 303 and vol. 2, p. 147

This schematic sculpture displays a very rough carving that delineates, on its upper face, the glyph for the year 6 Reed (above right). The front bears the face of Tlaloc, the rain god, flanked by two rows of five *chalchihuitl* (the symbol for greenstone), which here refers to the day sign 10 Rain. The back of the block is carved with Moctezuma's name glyph, consisting of the *xiuhuitzolli* (crown or diadem) and the nose-plug that served as the insignia for warriors (above left). The inscriptions on the monument can be associated with both the fifth and ninth *tlatoani*: Moctezuma Ilhuicamina (reigned 1440–69) and Moctezuma Xocoyotzin (reigned 1502–20). Both their reigns coincided with the calendar combination of the year 6 Reed: 1459 and 1511, respectively.

A passage in plate 130 of the Codex Vaticanus describes the

defeat of the Mixtec town of Tlachquiauhco (now Tlaxiaco, Oaxaca), or 'the place where it rains on the ball game', which opened up the way for conquering Icpatepetl and the Oaxaca valley. Domingo Chimalpáhin confirms this information in the third volume of his chronicle during the reign of the Moctezuma II. The same plate shows the place glyph of the conquered city, comprising a ball game beneath raindrops, with a prisoner of war dressed in sacrificial costume on the playing area. Both the Codex Vaticanus and Chimalpáhin's account reveal that rain during these years was viewed as especially beneficial, not only because a terrible famine had struck barely five years previously but also because the Mixtecs called themselves *ñuu dzavi* ('the people of rain'). Thus the Mexicas recalled the help Tlaloc had given them in their conquest, while the conquered people assumed that the rain was on their side.

By capturing the Mixtec cities, Moctezuma II won definitive control of these rebellious territories, as well as their tributes of precious stones, feathers and gold. Therefore this monument may commemorate the victory by adding a sculptural insignia to a building in Tenochtitlan, using the precious stone that was locally abundant in Oaxaca, its new tributary region. *RVA*

Cat. 66
Tlaloc mosaic mask

1350–1521, Mixtec–Mexica
Turquoise, shell and wood, 17.3 × 16.7 × 12.5 cm
Trustees of the British Museum, London, AOA Am 1987, Q3

Selected literature: Carmichael 1970, pp. 25, 36; Pasztory 1983, pp. 275–77, fig. 60;
García Moll, Solís Olguín and Bali 1990, p. 178; Miller and Taube 1993, pp. 166–67;
McEwan 1994, p. 74; McEwan *et al.* 2006, pp. 42–43, 45, 47, 50; McEwan 2009, p. 96

Two serpents of blue and green turquoise mosaic entwine to form this stylized mask. Their interwoven bodies create the prominent twisted nose and the goggle eyes associated with Tlaloc, the god of rain (see cat. 65 and fig. 42). The eyebrows, which double as the two rattles from the serpents' tails, are made from pine resin and beeswax and would originally have been gilded. The teeth are depicted in white *Strombus* shell.

Snakes copulate by intertwining, sometimes in a vertical position. In Mesoamerica, this act of procreation may have been observed and adapted, both visually and metaphorically, to symbolize the fertilizing rains sent by Tlaloc. The striking green and blue colours of the mosaic evoke the waters and vegetation covering the earth's surface. On the mask's forehead an engraved mosaic tile in the shape of a bivalve shell may symbolize water, while the large green mosaic tile on the opposite snake perhaps represents vegetation, both aspects associated with Tlaloc. Mosaic representations of feathers flanking the face may have mimicked part of a larger headdress that once complemented the mask.

Open cavities in the eyes and suspension holes indicate that this mask may once have been worn. The priest who served Tlaloc in the Templo Mayor at Tenochtitlan was known as Quetzalcoatl Tlaloc Tlamacazqui, and may have worn a mask like this as part of his ritual attire. Another example of a Tlaloc wooden mask, painted in blue, has recently been excavated from the Templo Mayor (offering 102). It bears similar perforations and may have been worn by a deity impersonator.

EVLL

Cat. 67
Huitzilopochtli

c. 1500, Mexica
Greenstone, 6.7 × 4.1 × 4.7 cm
Musée du Quai Branly, Paris, M.H.30.100.43

Selected literature: Lehman 1906; New York 1970, p. 314, no. 304; Nicholson 1988, pp. 242–47, fig. 21; Boone 1989, p. 10; Olivier 1997, pp. 80–81; Los Angeles 2001, p. 385, no. 165; London 2002, pp. 430–31, no. 128; López Luján and Fauvet-Berthelot 2005, pp. 72–73

Carved in highly polished greenstone, this seated figure is the only known three-dimensional representation of Huitzilopochtli. In Nahuatl the god's name means 'left-sided hummingbird' or 'hummingbird of the south' and corresponds to the sun's position as it rises from the left horizon at the zenith of the sky, reinforcing the deity's celestial and solar associations. In the northern hemisphere, during most of the year, the sun tilts towards the south, hence the name 'hummingbird of the south'. Moreover, following the path of the sun, the south is located on its left side, hence the name 'left-sided hummingbird'.

Huitzilopochtli was the tribal god of the Mexicas, leading them on their long migration from Aztlan, their mythical place of origin, to the founding of the imperial Mexica capital of Tenochtitlan. He was also associated with war and sacrifice. Huitzilopochtli was worshipped on the southern side of the Templo Mayor, the dual pyramid that stood in the sacred precinct at the heart of Tenochtitlan, and his cult was probably restricted to elite figures. He was the counterpart of the god Tlaloc, an ancestral deity from the Basin of Mexico associated with rain and fertility, whose shrine was situated on the northern side of the pyramid.

In this carving Huitzilopochtli wears two large annular shell pendants on his chest and back, held in place with leather straps. His headdress is decorated with heron and eagle feathers; both birds associated with the sun. He wears a cape adorned with skulls and crossbones and a serpent's head replaces his left foot. As a god of war, Huitzilopochtli is armed with a spear-thrower (*atlatl*) and sacrificial knife. In his right hand he holds a round shield (*chimalli*) decorated with his attributes: six balls of eagle down, three horizontal ropes and a banner (see cat. 89).

Conceptually and iconographically, Huitzilopochtli was often merged with Tezcatlipoca (see cat. 72), with whom he shared a number of features, but he is here distinguished by the hummingbird (*huitzitzilin*) carved on his back. *EVLL*

Cat. 68
Turquoise mask

c. 1350–1521, Mixtec–Mexica
Wood faced with turquoise, shell and mother-of-pearl, 24 × 15 cm
Museo Nazionale Preistorico ed Etnografico 'Luigi Pigorini',
Rome, 4213

Selected literature: Lehman 1906, pp. 320–21; Saville 1922, pp. 3–8, 21–102; Nicholson 1961, p. 14; Carmichael 1970, no. 296; New York 1970, no. 296; Pasztory 1983, p. 269, fig. 62; Washington 1983, pp. 170–73; Hildesheim-Munich-Linz-Humlebæk-Brussels 1986, no. 344; García Moll, Solís Olguín and Bali 1990, pp. 172, 175; Miller and Taube 1993, p. 141

The complexity of the openwork carving and the enigmatic iconography on this mask indicate that it is an example of Mixtec craftsmanship. The inclusion of some larger mosaic tiles and protruding turquoise nubs adds texture to the surface. A similar technique can be seen in the turquoise mask at the British Museum (see cat. 99).

An anthropomorphic face, adorned with a stepped nose ornament bordered by *Spondylus* shell, emerges from a zoomorphic mouth. The gums of both upper and lower jaws are also delineated in fragments of red *Spondylus* shell. Sculptures depicting anthropomorphic figures emerging from a serpent's mouth are common in Mexica art. These often represent Quetzalcoatl (see cat. 69), the feathered serpent, and symbolize the god's life-giving associations and representation as the breath of life. Here, however, the mouth lacks any fangs and the head is not fully depicted, making its attribution more problematic.

The most striking elements in the mask are two intertwined serpents on its forehead, with *Spondylus* red shell decorations delineating their profiles, flanking the temples with their decorated tails. The heads of both serpents, with inlaid eyes similar to those seen in other Mixtec works (see cat. 99), face towards the back of the mask, framing it as though part of a headdress decoration. The serpents' angular curving snouts identify them as *xiuhcoatl* (see cat. 76), the mythical fire serpents recurrent in Mexica iconography. The association of a *xiuhcoatl* with a turquoise mosaic is relevant since the bodies of these mythical creatures were covered in turquoise scales. Two *xiuhcoatl* with anthropomorphic faces emerging from their mouths also appear around the monolithic Sun Stone (see fig. 1), however, they wear different facial ornaments and have been associated with other gods. Thus, the identity of this mask is uncertain, as a number of different deities are depicted emerging from the mouths of animals in Mexica iconography.

Quetzalcoatl wears an intertwined feather headdress in the Codex Borgia 62 and Codex Vaticanus B50, but those serpents are not identified as *xiuhcoatl*. However, given the possible Mixtec execution of this object, Nicholson has identified it with the water-fertility goddess '9 Reed' represented in Mixtec codices, who wears intertwined serpents in her headdress and a nose ornament very similar to the one portrayed in this mask. Similarly, in the Nahuatl-speaking world, Chalchiuhtlicue, the jade covered goddess of ground water, emerges from the mouth of the earth, and sometimes wears a similar stepped nose ornament.

It is possible that the enigmatic iconography of this mask stems from the Mixtec artisans' reinterpretation of Mexica iconography for their new patrons, who allowed some liberty in their compositions such as the inclusion of Mixtec iconographic elements. *EVLL*

Cat. 69
Quetzalcoatl

c. 1350–1521, Mexica
Greenstone, 32.5 × 23 cm
Trustees of the British Museum, London, AOA Am 1825,1210.11

Selected literature: New York 1970, nos 281–82; Burland 1972, pp. 180, 198–99; Turin 1978, pp. 73, 75, no. 52; Washington 1983, pp. 142–43; Hildesheim-Munich-Linz-Humlebæk-Brussels 1986, pp. 45, 189–211, nos 162, 204, 311, 312; Seler 1990–98, vol. IV, pp. 199–208; Miller and Taube 1993, pp. 141–42; Taube 1993b, pp. 31–33; McEwan 1994, pp. 68–69; López Luján and Fauvet-Berthelot 2005, pp. 120–23; Aguilar-Moreno 2007, pp. 88–89; Brumfiel and Feinman 2008, pp. xiv, xviii

Quetzalcoatl was the patron deity of rulers, the god of wind and the creator of humankind, among other attributes. During Postclassic times, the mythical 'feathered serpent' (*quetzalli* means quetzal feather, from the bird *Pharomachrus mocinno*, and *coatl* can be translated as snake, usually represented as a rattlesnake) took on a human form and attributes. In Mexica stone carvings he is commonly represented with a human face emerging from a serpent's jaws and with a feathered serpent's body. However, the anthropomorphic portrayal of his hands and feet in such sculptures is relatively rare, with the exception of an example at Musée du Louvre in Paris.

In this greenstone sculpture, the god is portrayed with a naturalistic face and wears round ear-plugs (*nacochtli*) made of obsidian and copper – similar to examples excavated in the Templo Mayor – and curved conch shell ornaments (*epcolloli*), the attributes of Ehecatl-Quetzalcoatl and his 'twin' Xolotl. The headband across his forehead has a central knot, also typical of Ehecatl-Quetzalcoatl, and a series of quincunxes which, when painted white, are attributes of Quetzalcoatl, Xolotl and Venus. The headdress has a ruff of short feathers with longer ones hanging down the back. From one side of the headdress is a suspended element consisting of a bone (*omitl*) with a flower and white eagle down feathers. At the top of the headdress is a conch shell ornament or 'wind jewel' (*ehecacozcatl*), one of the main attributes of Ehecatl-Quetzalcoatl and Xolotl. A solar disc around his head includes solar rays, feathers and ornaments associated with the sun. In one hand he holds a stick with a curved end known as *ehecahuictli* (staff of wind). In the other he holds a skull with a nose-bar, a feather headdress and elaborate ear ornaments.

On the back of the figure is carved an ascending feathered serpent whose undulating body bears several *ehecacozcatl* on its green feathers. A smaller greenstone sculpture at the Museo Civico di Numismatica, Etnografia e Arti Orientali in Turin has a similar style and iconography. Here, a speech scroll emerges from the serpent's open mouth with its menacing fangs and bifurcated tongue. Made up of three individual volutes, including a feathered volute at the top, the scroll is similar to the one found in Moctezuma's glyph (see cats 15 and 58), perhaps indicating that the figure is casting his breath of life, as the life-giving aspect of the wind.

Xolotl, the 'twin' of Quetzalcoatl, embodies Venus as the evening star and is usually portrayed in skeletal form. As his twin companion, Ehecatl-Quetzalcoatl embodies Venus as the morning star, also known as Tlahuizcalpantecuhtli. Thus the two gods represent the two halves of the solar cycle. Quetzalcoatl is therefore probably represented here as the morning star that leads the sun to its zenith.

EVLL

Cat. 70

Feathered serpent with the date 1 Reed

c. 1519, Mexica
Basalt, 21 × 44 cm
Museo Nacional de Antropología, Mexico City, inv. 10-220930

Selected literature: Umberger 1981, p. 94; London, 2002, pp. 427–28; Monterrey 2007, p. 361

At the height of the city's glory, the various sculpture workshops of Tenochtitlan established formalized templates for symbolic images that were accurately reproduced in other cities across the central region of the country, particularly the sculptors of Calixtlahuaca to the west of Tenochtitlan and neighbouring areas.

One such model is the mythological image of the feathered serpent, the symbol of Quetzalcoatl, which evokes the presence of the ancestral deity responsible for the creation of one of the five cosmological eras or 'Suns', as well as humanity itself and its basic foodstuff, maize. The ancient myths tell how Quetzalcoatl, also associated with the wind god Ehecatl, created the era known as 4 Wind. They also recount the self-sacrifice of the deity who used his blood to mix the paste for modelling human beings, and celebrate the ingenuity with which he turned himself into an ant, to discover where these insects had stored the precious seeds during the last floods. There are several near-identical examples of serpents coiled in a circle, with their tails (complete with rattles) wrapped around their bodies and their heads resting on top. Their open mouths reveal a series of menacing fangs and a large forked tongue covering part of the body.

The serpent's body is carved with a layer of long quetzal feathers, endowing it with a certain grace and elegance. Some examples bear the relief image of Tlaltecuhtli, the earth goddess, on the base, but in this case the deity is identified in its animal manifestation by the calendar date 1 Reed, inscribed in a small panel at the back of the serpent's neck. The serpent's eyebrows bear an interwoven rectangle evoking the mats woven for ritual seats, suggesting a symbolic meaning. Quetzalcoatl was thus the deity who, together with the Mexica sun gods, endorsed the power of Moctezuma II. *FSO*

Cat. 71

Tezcatlipoca with smoking mirrors

Possibly 1507, Mexica
Greenstone, 18.5 × 16.3 × 8.9 cm
Dumbarton Oaks Pre-Columbian Collection, Washington
DC, PC.B.072

Selected literature: Pasztory 1983, figs 268, 269; García
Moll, Solís Olguín and Bali 1990, p. 151; Saunders 1990;
Heyden 1991, p. 195; Miller and Taube 1997, pp. 164–65;
Saunders 2001; Olivier 2003, p. 87; Bühl 2008, pp. 192–93

This sculpture of a face, slightly smaller than life-size, represents Tezcatlipoca, the omnipotent deity of the Mexica pantheon. He was a god of war, destiny, sorcery, divination and night. Tezcatlipoca's name means 'smoking mirror' and he is frequently pictured with a round mirror and smoke scrolls on his left foot, headdress or, as here, at his temples.

The Mexica used mirrors made of highly polished black obsidian (*itztli*) (see cat. 103) which were traditionally asociated with Tezcatlipoca's divinatory powers. Here, the mirrors are accompanied by four balls of eagle down – symbolizing sacrifice – and a smoke scroll. Mirrors framed with down feathers are part of the guise of the deity's alter ego, the night jaguar or Tepeyollotl ('mountain heart'), a predator with powerful night vision. As Tezcatlipoca was the patron god of Mexica royalty, smoking mirrors may have been a metaphor for rulership and power (see p. 91). Mexica rulers claimed that they could use obsidian mirrors to predict the future and observe their subjects. Mirrors were also part of the guise of Huitzilopochtli, a god who shared many attributes with Tezcatlipoca (see cat. 67), with the exception of the hummingbird perched at his back.

On the back of the sculpture is carved the day glyph 2 Reed, which was directly associated with the birth of Tezcatlipoca. However, the date could also be related to the year 1507, the year of the New Fire ceremony that took place during Moctezuma's reign, of which Tezcatlipoca was the patron deity. Two other stone monuments from the same date, the *Teocalli* of Sacred Warfare (cat. 78) and the stone Bundle of Years (cat. 75), bear the glyphs 1 Flint and 1 Death, that have similar mirrors framed with balls of eagle down at their temples.

The sculpture's precise function is unknown, but perforated holes at the back and in the earlobes suggest that it might have been attached to an effigy of the deity or to a funeral bundle. *EVLL*

Cat. 72
Skull with mosaic

c. 1500, Mixtec–Mexica
Human skull, turquoise, lignite, iron pyrite, shell and leather,
19.5 × 12.5 × 12 cm
Trustees of the British Museum, London, AOA Am, St. 401

Selected literature: Joyce 1912, fig. 12; Saville 1922, fig. 19;
London 1965, p. 23; Carmichael 1970, pp. 12–13, 35;
Pasztory 1983, fig. 63; Klor de Alva, Nicholson and
Quiñones Keber 1988, pp. 242–47; Madrid 1992, p. 304,
LXVIII; Day 1992, pp. 44–47; Miller and Taube 1993, pp.
164–65; McEwan 1994, p. 75; London 2002, pp. 323–24,
476, no. 304; López Luján and Fauvet-Berthelot 2005, pp.
71–72; McEwan *et al.* 2006, pp. 24–25, 66–70

In this unique object, mosaic tiles have been
applied directly on to a human skull. The
skull, which probably belonged to a male in
his thirties, has been cut along the frontal
bone and the back has been removed, leaving
only the front of the cranium. In the Templo
Mayor several skulls manipulated in this way,
belonging to both genders and ranging in age
from child to adult, have been excavated.
These are associated with Mictlantecuhtli,
the lord of death, since they incorporate an
obsidian knife representing either a nose
or tongue.

Deerskin leather has been used to line the
interior. The movable lower jaw is attached to

the lining with a hinge, a feature that is also
seen in other skull-shaped objects. Most of
the original teeth are still intact.

Two wide leather straps painted with red
ochre are joined to the lining with fine
maguey (agave) fibre cords. The straps would
have been used to tie the skull around the
waist, either at the front or the back, as can
be seen in numerous Mexica carvings.
Similar skulls frequently appear in depictions
of female deities with bellicose or tellurian
associations (see cat. 58). Tlaltecuhtli,
Coatlicue, Coyolxauhqui, Tzitzimitl and
Mictlantecuhtli, are also represented with
a skull at their waists, and codices show male
warriors wearing similar skulls.

The mosaic decoration is made up of five
different materials attached to the skull with
pine resin. The three black bands around the
forehead, nose and chin are made from large
lignite mosaic tiles, while the two blue bands
are created from turquoise. The eyes are
formed using fragments of white conch shell
encircling orbs of highly polished pyrite. Red
Spondylus princeps shell has been used to line
the nasal cavity, reproducing the appearance

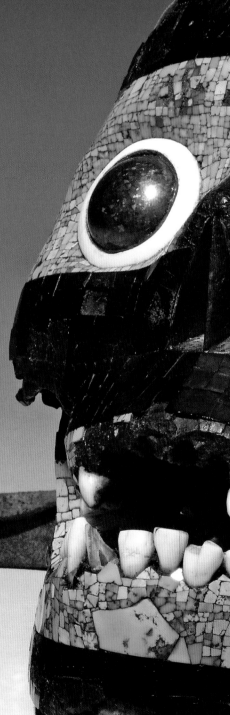

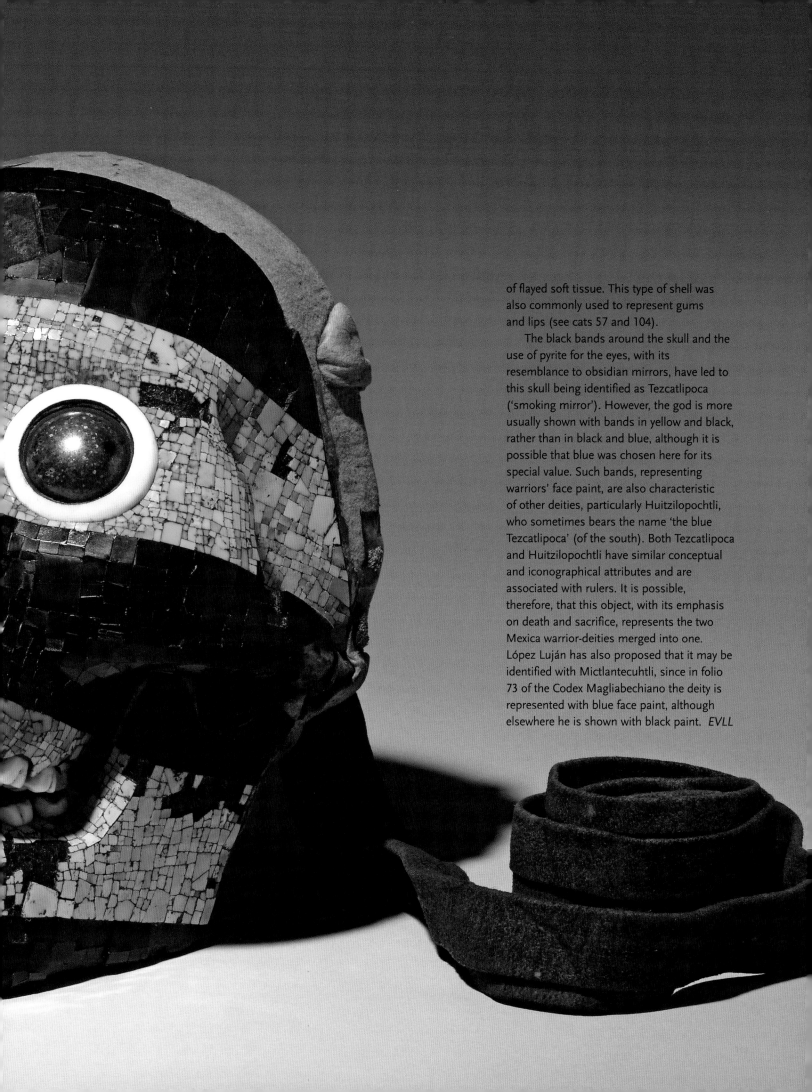

of flayed soft tissue. This type of shell was also commonly used to represent gums and lips (see cats 57 and 104).

The black bands around the skull and the use of pyrite for the eyes, with its resemblance to obsidian mirrors, have led to this skull being identified as Tezcatlipoca ('smoking mirror'). However, the god is more usually shown with bands in yellow and black, rather than in black and blue, although it is possible that blue was chosen here for its special value. Such bands, representing warriors' face paint, are also characteristic of other deities, particularly Huitzilopochtli, who sometimes bears the name 'the blue Tezcatlipoca' (of the south). Both Tezcatlipoca and Huitzilopochtli have similar conceptual and iconographical attributes and are associated with rulers. It is possible, therefore, that this object, with its emphasis on death and sacrifice, represents the two Mexica warrior-deities merged into one. López Luján has also proposed that it may be identified with Mictlantecuhtli, since in folio 73 of the Codex Magliabechiano the deity is represented with blue face paint, although elsewhere he is shown with black paint. *EVLL*

Cat. 73
The New Fire ceremony

Codex Borbonicus
Early Post-Conquest (nineteenth-century facsimile;
the original codex is housed in the Palais Bourbon, Paris)
40 × 40 cm

Selected literature: Couch 1985; Gruzinski 1992; Brotherston 2005

Painted on native bark paper in gatefold format, and probably partly copied from a Pre-Hispanic source, Codex Borbonicus comprises a *tonalamatl* or divinatory almanac, a chapter dedicated to the eighteen feasts of the solar year, and a correlation of the 52-year cycle. It probably originated from Tenochtitlan or the mainland Culhuacan-Iztapalapa area to the immediate south of the capital.

The page narrates the New Fire ceremony, or *xiuhmolpillia* ('binding of the years'), held at the end of every 52-year cycle in anxious anticipation of a cosmic renewal. The event fell in a year 2 Reed (top, centre left), coinciding with the 20-day feast of Panquetzaliztli, the 'Raising of Banners' celebrated in November to December when the cluster of stars known as the Pleiades passes overhead at midnight. The ceremony was held at Mount Huixachtlan, south-east of Tenochtitlan where, after the passing, the New Fire was kindled (top right) and, as the footprints indicate, taken to the ritual precinct. From there, bearers dressed as gods (left) would carry it across the empire.

In the Borbonicus version, the temple is identified by its colour as Tlillan, or 'place (house) of darkness'. Possibly representing stars, the white quincuncial (five-point) elements nevertheless make reference to the cosmic significance of the rites. The four symmetrically configured fire-priests (or possibly night-lords, deities who presided sequentially over the nights) around the central hearth re-emphasize the renewal; they carry further cosmic symbols on their clothing and accoutrements.

During the ceremony, pregnant women were guarded inside grain bins (right, lower centre) lest the flint-knifed *tzitzimime*, the terrible sun-slashing spirits of women who had died in childbirth, descended to prevent the re-kindling. Children (bottom right) were kept awake for in sleep they would turn into mice. The rest of the population, depicted wearing turquoise masks, were obliged to watch and wait on the rooftops of their houses until the new flame signalled that the world would not end.

At top centre, the deity impersonator standing before the temple of the raised banner has been identified as Moctezuma II, who would certainly have presided over the 1507 ceremony. The event served to assert Mexica political domination, for as self-appointed guardians of the sun they also held sway over cosmic renewal.

EW

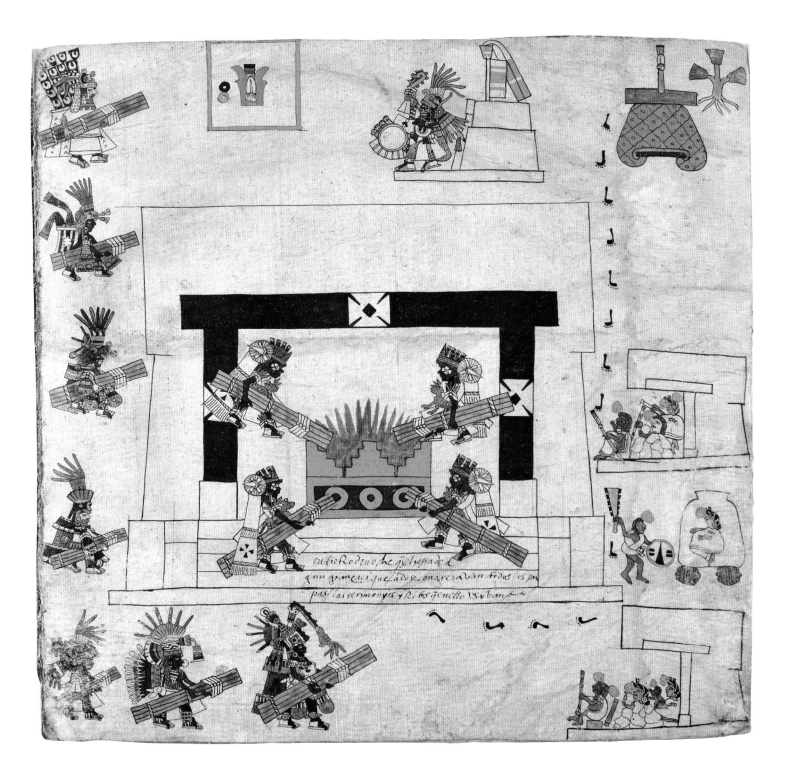

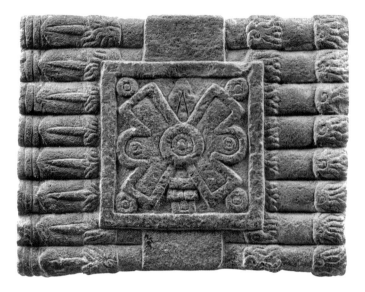

Cat. 74
Solar calendar altar

c. 1507, Mexica
Basalt, 38.3 × 30 × 22.3
Colección Fundación Televisa, Mexico City, 21 PJ. 9

Selected literature: Reyero 1978, pp. 150–52; Codex Borbonicus 1991; London 2002, pp. 440–41, no. 170

The New Fire ceremony that marked the end of each 52-year cycle took place on the top of Mount Huixachlan ('thorn tree place'), now known as the Hill of the Star, to the south-east of Lake Tetzcoco. In a stage of the ceremony known as *xiuhmolpillia* or the 'binding of the years', the fire-priests gathered together 52 rods representing the corresponding years, fastening them with cords and a sacred knot before throwing them onto a holy fire. This act is depicted in plate 34 of the Codex Borbonicus (cat. 73). The carving of a cylindrical sculpture commemorated the event.

This altar is shaped as a rectangular block, a form the Mexica held in great esteem as is evident from the many surviving monuments of this type. The sculpture has a number of features in common with the traditional cylindrical sculptures recording the binding of the years (see cat. 75), but its splendid carvings of the wooden rods are elegantly adorned with eagle feathers, undoubtedly evoking the *cuauhpiyolli*, the supreme decoration granted to warriors capturing more than one live enemy prisoner on the battlefield. Both sides are incised with rows of horizontal and vertical parallel lines, alternating with two groups of six *chalchihuitl* (the symbol for greenstone). These elements associate the altar with the heat of the sun and emphasize the splendour of the ritual, but may also have had a numerical significance.

The present altar is a manifestation of the 52-year calendar ceremony held during the reign of Moctezuma II in the year 2 Reed (1507), as indicated in a large panel on the front of the monument. The main function of this ritual object must, however, have been to serve as a depository for offerings in honour of the 'Fifth Sun', whose name *Nahui Ollin* (4 Movement), is inscribed in another large panel on the top of the altar. These inscriptions demonstrate that on this occasion the celebration of the 52-year cycle not only involved the tying of the years but also honoured the anniversary of the birth of the sun king in Teotihuacan, as recounted in the Legend of the Suns, explaining the mythological five 'Suns' or eras of the world's evolution.

This Pre-Hispanic monument has survived because it was converted into a container, probably a baptismal font, and was therefore in use during the colonial era – albeit with the indigenous ornamentation turned face downwards. *FSO*

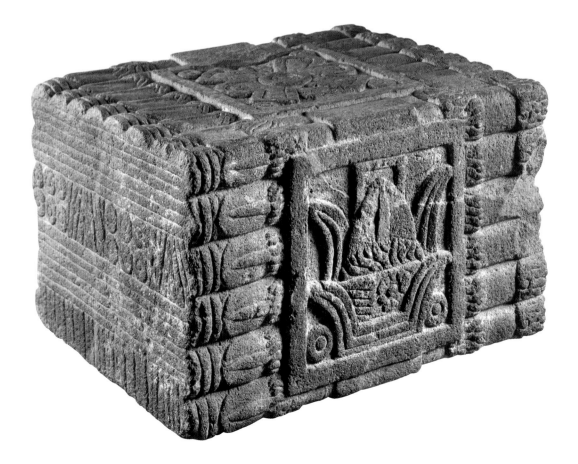

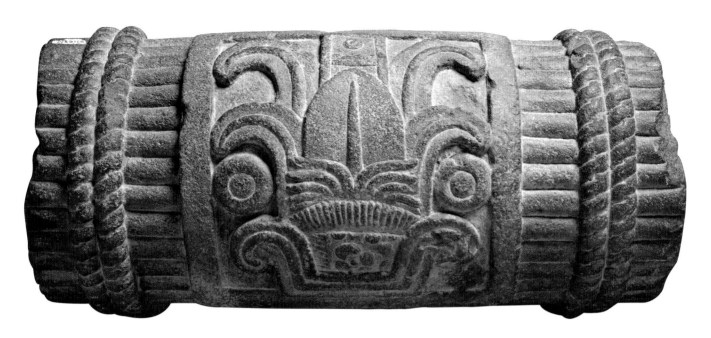

Cat. 75
Bundle of years (*xiuhmolpilli*)

c. 1507, Mexica
Basalt, 26.5 × 61 cm
Museo Nacional de Antropología, Mexico City, inv. 10-220917

Selected literature: Pasztory 1983; Sahagún 1997, pp. 437–38; Bilbao 2005, pp. 57–58

The Mexica used these small cylindrical sculptures to represent the end of a *xiuhmolpillia*. This was the 52-year calendar cycle, comparable to a present-day century, made up of a sequence of thirteen cycles overseen by the four bearers of time: *Acatl* (Reed), *Tecpatl* (Knife or Flint), *Calli* (House) and *Tochtli* (Rabbit).

At the end of each 52-year cycle was held the New Fire ceremony, one of most important Mexica rituals. The ritual, performed in a temple dedicated to the event, involved rubbing together pieces of wood on the chest of a young male sacrificial victim to create the new fire. Four bundles were then assembled, each comprising 52 rods, which were burned in a sacred fire by priests wearing the insignia of Xiuhtecuhtli. Master sculptors preserved these bundles in stone for posterity. This example is directly linked with the ceremony that took place in 1507 during the reign of Moctezuma II, who had revised the calendar by moving the ceremony that had formerly been held on the date 1 Rabbit to the new date of 2 Reed.

Other *xiuhmolpilli* bearing the date 1 Death have been found but this one displays the year 2 Reed on a large panel, while its ends bear the dates 1 Knife or Flint and 1 Death, complete with an obsidian mirror, the symbol of the god Tezcatlipoca. We know that these two years correspond to the first birth of the sun and its subsequent death, so the sculpture can be interpreted as an evocation of the beginning and ending of a solar cycle manifested at the *xiuhmolpillia*. Both these dates, with their symbols of Tezcatlipoca, also appear on the *Teocalli* of Sacred Warfare (cat. 78). *FSO*

Fire serpent (*xiuhcoatl*)

1507, Mexica
Quartz diorite, 43.5 × 45.5 cm
Dumbarton Oaks Pre-Columbian Collection, Washington DC, PC.B.069

Selected literature: Pasztory 1983, p. 252, figs 264, 265; Madrid 1992, p. 198, XL; Miller and Taube 1997, pp. 188–89; Smith 2003, pp. 257–59; López Luján 2006, pp. 186–87; Aguilar-Moreno 2007, pp. 195–96, 298–300; Bühl 2008, pp. 190–91

This coiled snake represents a *xiuhcoatl*, or fire serpent, a mythical creature whose Nahuatl name translates as 'turquoise snake'. Turquoise was a symbolic and highly valued material, imbued with political and religious significance in Mesoamerica since the Postclassic era. The Nahuatl word for turquoise, *xihuitl*, also means 'fire' and 'year'. Turquoise was associated with fire, time, the calendar and celestial bodies, but it also exemplified the power of rulers and political succession. For example the diadem used by rulers, known as the *xiuhuitzolli*, was made of turquoise. Fire serpents were related to several Mexica gods including Huitzilopochtli (see cat. 67) – who carried one as a weapon – and Xiuhtecuhtli (see cat. 79), the fire god at the centre of the earth. Two fire serpents also flank the Sun Stone (see fig. 28).

The head of this coiled serpent is damaged. The entire snout is missing although three sets of curved fangs remain, a bifurcated tongue or symbolic sacrificial knife might once have protruded from its mouth. The body is segmented with turquoise scales and the two front legs with menacing claws allude to the thoracic legs of a caterpillar, associated with fire and shooting stars. The tail bears a glyph representing a year sign. Two very similar coiled serpents carved in greenstone, one at the Museum für Völkerkunde, Berlin, and the other at the Museo Nacional de Antropología, Mexico City, may have been carved by the same artist to commemorate the same event.

Carved on the underside of the fire serpent are two glyphs. The first shows a *xiuhuitzolli* on short hair with an ear-spool, nose ornament and triple scroll representing speech. Together these form the glyph of Moctezuma II. Below, the glyph 2 Reed appears in a cartouche, corresponding to the year 1507 in which Moctezuma presided over the New Fire ceremony. The reed symbol is bound with a knotted rope, literally representing 'the binding of the years' (see cats 73, 75 and 78).

The New Fire ceremony marked a new era in the cyclical calendar. The serpent shown here, a symbol of fire and time, may therefore have been one of a group of sculptures commissioned to commemorate Moctezuma's patronage of the event. *EVLL*

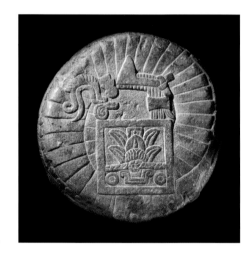

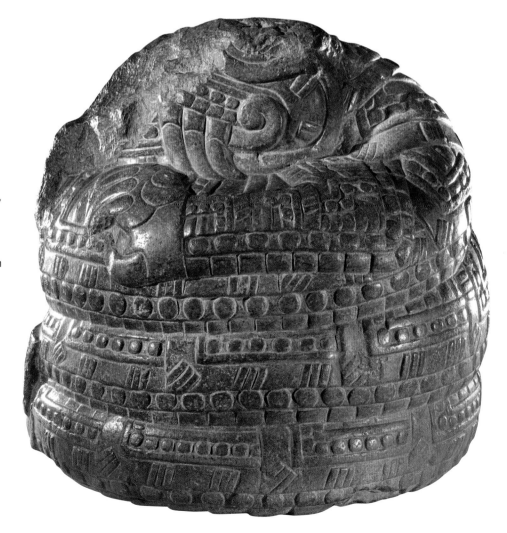

Cat. 77
Fragment of a *cuauhxicalli* with the date 2 Reed

1507, Mexica
Stone, 30.5 × 10.8 cm
Trustees of the British Museum, London, Am, St.376.b

Selected literature: Joyce 1912, pl. II; Pasztory 1983, p. 236, fig. 243; Washington 1983, p. 37; Baquedano 1984, p. 85, fig. 55; McEwan 1994, p. 77; London 2002, p. 437, no. 152

This fragment comes from the base of a stone *cuauhxicalli*, or 'eagle vessel' (see cat. 62). Only half of the solid base is intact and it bears the glyph Reed accompanied by a numeral. Despite the fragmentary state of this object there is no doubt that the original date carved was 2 Reed. Knotted ropes are common in Mexica iconography, but the inclusion of a knotted rope tied round the Reed glyph is only ever associated with the date 2 Reed, which marked celebration of the New Fire ceremony in 1507, presided over by Moctezuma II (see cat. 73).

The fact that the ceremony took place in the year 2 Reed, allowed Mexica artisans to reinforce the significance of this date and its relation to this crucial event. By binding the glyph, a reed like those used in the ceremony, they made a direct visual reference to the ritual that took place on that date.

The image of the binding of the glyph 2 Reed appears in several other important late Mexica monuments associated with the New Fire rites, including the *Teocalli* of Sacred Warfare (cat. 78), the fire serpent (*xiuhcoatl*) commemorating Moctezuma's patronage of this event (cat. 76), the Chapultepec Hill rock carving next to Moctezuma's portrait (see figs 24–25) and the frontispiece of the Codex Mendoza (cat. 3).

The remaining carving on the outside of this stone fragment is composed of circular discs representing precious greenstones (*chalchihuitl*), against a watery background. Two *cuauhxicalli* with the same iconography are carved flanking the stairs of the *Teocalli* of Sacred Warfare. One of them is positioned directly above the 2

Reed date glyph that relates to the New Fire ceremony, and the other directly above the 1 Rabbit date, the old date for the New Fire ceremony. Thus, when intact, this vessel may originally have looked like the one represented in the *Teocalli*. Three fully preserved *cuauhxicalli* of this type are housed in the American Indian Museum in Washington, and the Museums für Völkerkunde in Berlin and Vienna.

Eagle vessels, or *cuauhxicalli* were used to hold the hearts of sacrificial victims before they were burned and offered to the gods. As part of the ceremony, the new fire was lit in the heart of the sacrificed victim. It is therefore possible that this *cuauhxicalli* was used during that ceremony in 1507, and it may even have contained the heart of the last victim to bring light to the Mexica world. *EVLL*

Teocalli of Sacred Warfare

1507, Mexica
Volcanic stone, 123 × 92 × 100 cm
Museo Nacional de Antropología, Mexico City, inv. 10-81548

Selected literature: Palacios 1918; Caso 1927; Townsend 1979, pp. 49–63; Pasztory 1983, pp. 165–69; Solís Olguín 1991, pp. 128–31; Alcina Franch 1992, pp. 236–39; Graulich 2001

This extraordinary votive sculpture commemorates the New Fire ceremony of 1507, which took place during the reign of Moctezuma II. The monument is shaped as the base of a pyramid with steps leading to a temple, a type of structure that was sacred

to the Mexicas. The *Teocalli* celebrates the triumph of the sun in the universe and legitimizes the power of the Mexicas after the founding of their city in the year 2 House (1325), the date inscribed on the top of the monolith. All the characters and symbols depicted on the monument – including the calendar dates and the eagle perched to the rear – unite in a glorious paean to warfare and the symbolic intermingling of fire and water.

On either side of the steps the *cuauhxicalli* (vessels containing sacrificial offerings), one covered with jaguar skin and another with eagle feathers, bear the calendar dates 1 Rabbit and 2 Reed. Some experts have interpreted these as representing the year in which the universe was created and the end of a 52-year cycle. Graulich, however, suggests that the combination of the two dates confirms

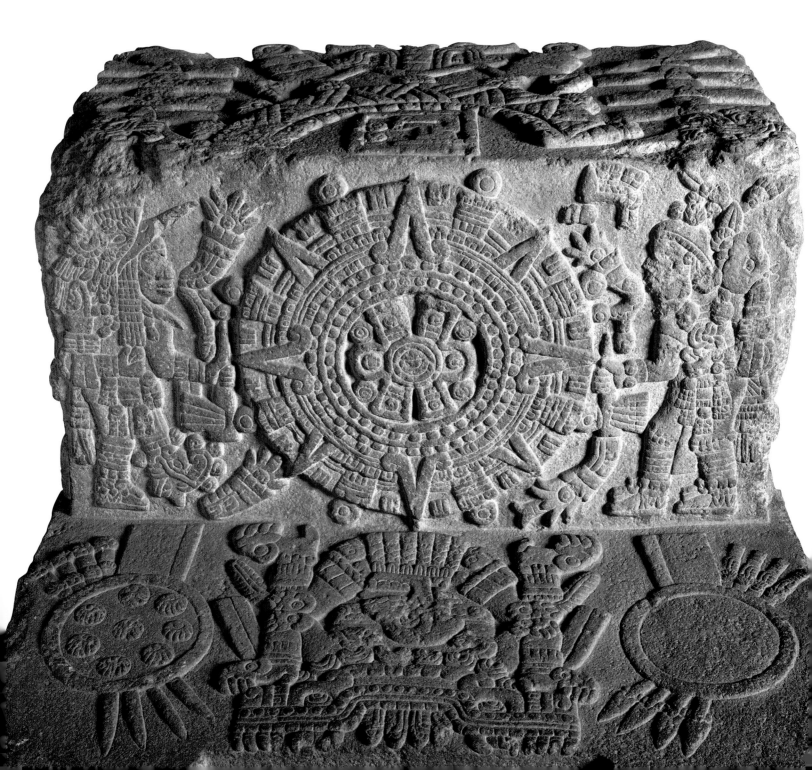

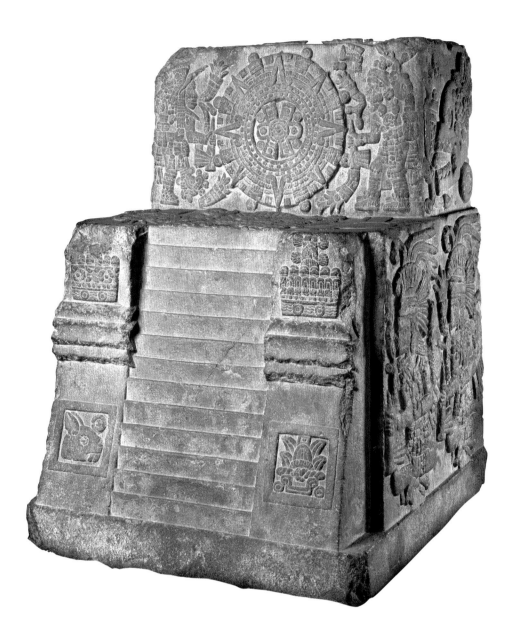

the change of year for the New Fire ceremony overseen by Moctezuma II. This was in response to the natural disasters, particularly famine, which occurred in the days around the date 2 Reed. The ceremony was performed during the annual Panquetzaliztli festivities devoted to Huitzilopochtli.

The solar disc, with the earth monster beneath it, recalls the basic purpose of the sacrifice. The sun is flanked by Huitzilopochtli on the left and Moctezuma on the right. The sides of the temple (see overleaf) bear the dates 1 Flint and 1 Death, as well as the smoking stone or mirror associated with Tezcatlipoca, the god of night and destiny. The sides of the base display four gods identified as Tlaloc (rain), Tlahuizcalpantecuhtli (dawn), Xiuhtecuhtli (fire) and Xochipilli (flowers, music and song), three of them displaying their teeth. The relief on the back (fig. 38) reiterates the grandeur of the Mexica people, who offer their hearts, just as the cactus offers prickly pears, consumed by the triumphant eagle, the symbol indicated to them by Huitzilopochtli. *FSO*

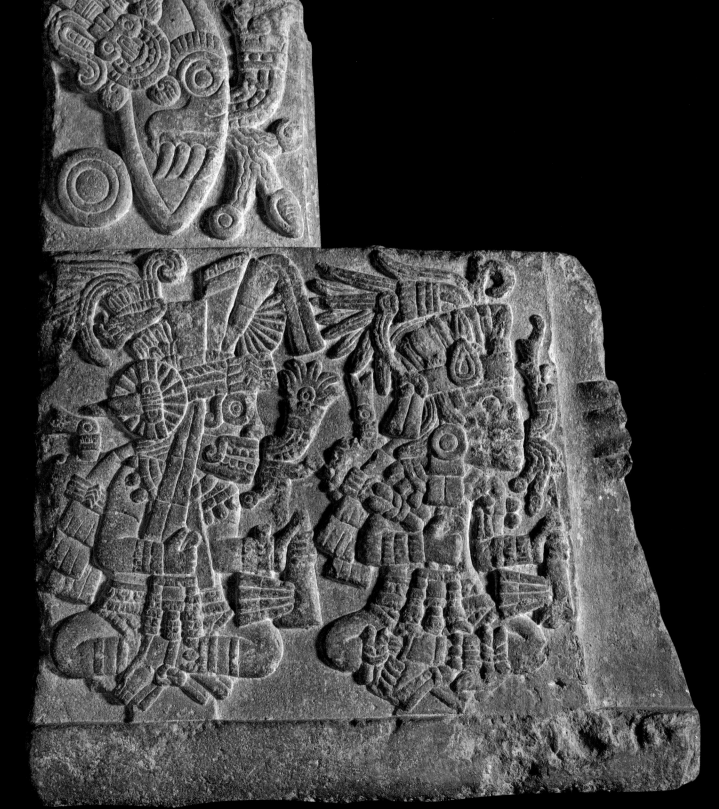

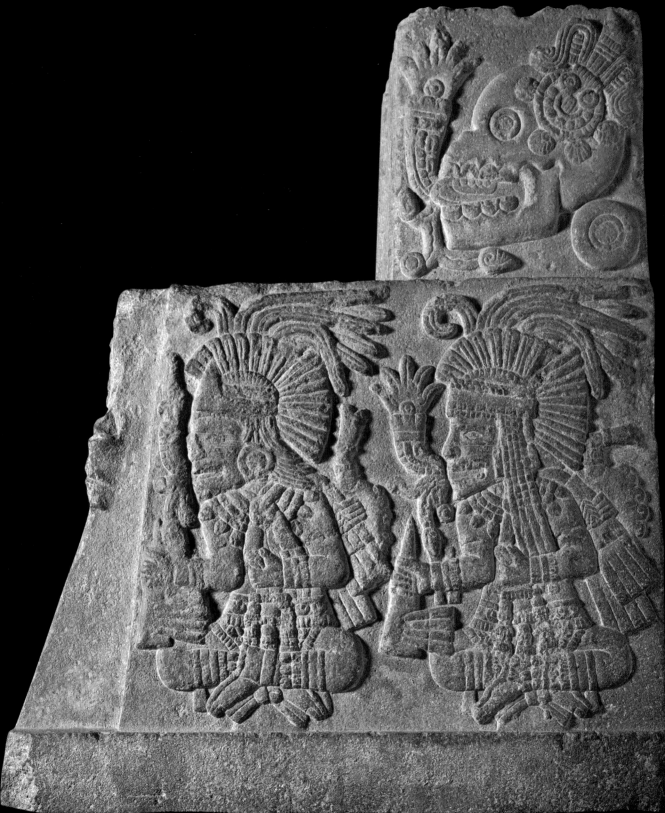

Cat. 79
Statue of Xiuhtecuhtli

1325–1521, Mexica
Stone, 80 × 32 × 18 cm
Museo Nacional de Antropología, Mexico City, inv. 10-81575

Selected literature: New York 1940, p. 53; Umberger 1981; Pasztory 1983;
Matos Moctezuma 1989; Solís Olguín 1991, pp. 65–66; London 2002, p. 411,
no. 42

Moctezuma II imposed new rules regarding imperial
etiquette, the most important of which forbade the entire
population from looking upon his face. Another decree
prohibited anyone from turning their backs to him. In this
way, Moctezuma gave material form to the concept that
the Mexica *tlatoani* was the personification of Xiuhtecuhtli.
This deity was the Mexica incarnation of the ancient deity
Huehueteotl, the god of fire, associated with heat and the
sun. During ceremonial rites associated with the sun god
Tonatiuh, Moctezuma represented his subjects in the guise
of Xiuhtecuhtli, the lord of turquoise and the patron of the
day and of heat.

This sculpture displays all of the god's distinguishing features,
including the headdress, clothing and sandals. Moctezuma II
would have worn similar clothing when receiving nobles, allied
kings and enemy leaders into his palace. The headdress is the
xihuitzolli or *copilli*, the crown or diadem made from a gold sheet
and decorated with turquoise. The damaged section at the front
would originally have featured a solar ray. The ear-spools would
have been made of greenstone or turquoise.

The figure is clothed in the distinctive *xicolli*, a type of tunic
tied in the front with four circles on the front and back. Its
ornamentation is completed by a row of greenstones and feathers.
The long hanging strips of the *maxtlatl* (loincloth) are covered by
the triangular apron worn by warriors to evoke the role of the sun
as the foremost heavenly warrior. The bangles made from three
strips of leather incorporate small copper bells that would have
tinkled when moved, while the elegant *cactli* (sandals), have solar
rays on their heels to emphasize the god's role as the lord of
the *tlatoani*. *FSO*

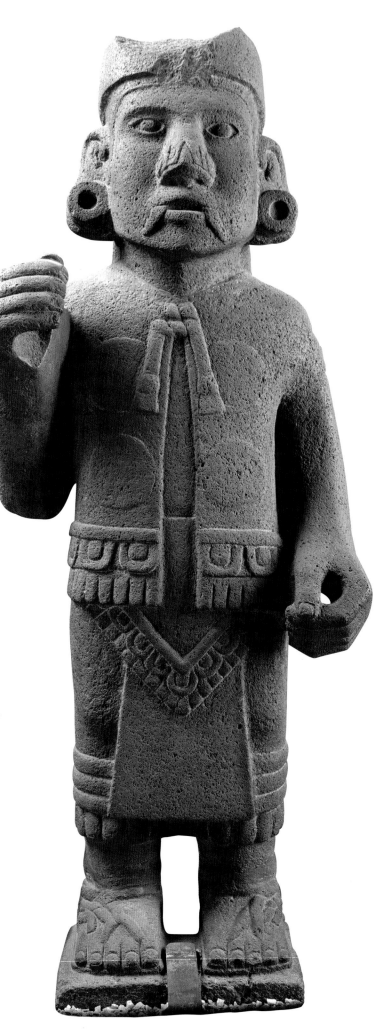

Cat. 80
Anthropomorphic sculpture (*macehualli*)

c. 1500, Mexica
Basalt, 80 × 28 × 19 cm
Museo Nacional de Antropología, Mexico City, inv. 10-220926

Selected literature: Durán 1995, chapter IX, pp. 121–31; London 2002, p. 409, no. 34; Bilbao 2005, p. 18, no. 27

Around 1427, the city of Tenochtitlan was preparing for war against its former lords. The kingdom of Azcapotzalco had declared its aggressive intentions towards the Mexicas by killing its ruler. When the male *macehualtin*, or commoners, found out about the conflict, they sought an audience with the recently elected *tlatoani* Itzcoatl, Moctezuma II's great-grandfather. The *macehualtin* considered themselves to be far removed from the conflicts between the nobles of Mexica and Azcapotzalco, so they asked permission to flee the city. In a desperate bid to gain their support, the Mexica nobility promised to invert their roles in the case of defeat. In return, the *macehualtin* swore to recognize the nobles' authority by obeying them and even paying them tributes in the case of a victory. Mexica emerged victorious and the nobles reminded the *macehualtin* about the agreement to which they were bound.

Henceforth, the *macehualtin* were destined to lead a simple life although they gradually earned themselves important roles in the ranks of the warriors, as well as administrative posts within the empire. When Moctezuma II came to power, he abolished these rights and the noble, military and political class was exclusively confined to the royal family.

This sculpture has been interpreted as a representative portrait of a *macehualli*. His strength, submission and loyalty are expressed through the simplicity of his clothing – little more than a loincloth – and the sturdiness of his physique. The sculpture may have served to recall the pact between the nobility and the common people, thereby emphasizing the obligation and duty to the Mexica empire to which the *macehualtin* had been committed by their ancestors. *RVA*

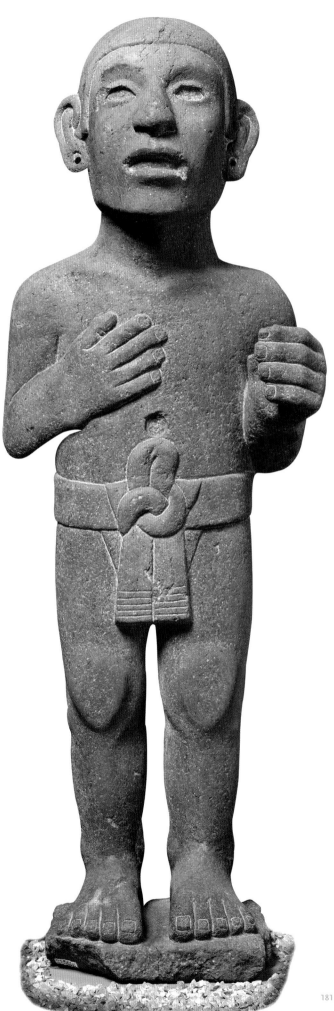

Chapter 5

Moctezuma's military and economic rule

Frances F. Berdan

MOCTEZUMA Xocoyotzin assumed rulership with the avowed intention of securing and consolidating the territories conquered by his predecessors. This entailed two primary military goals: first, to suppress rebellions and assure the submission of conquered subjects, and second, to conquer the Mexica's persistent enemies, the Tlaxcalans and their allies. Moctezuma also needed to maintain a constant and predictable flow of subsistence and luxury goods into Tenochtitlan through tribute payments from conquered peoples and the maintenance of unrestricted trade routes, especially to tropical lands with desirable commodities. An additional priority was the reorganization of the royal court, restoring hereditary nobles to their rightful high positions and removing commoners who had been promoted to those positions by his predecessor Ahuitzotl. Overall, Moctezuma's fundamental mission was to promote Mexica superiority, making his people the most feared and wealthy ever known.

Moctezuma's inheritance

Moctezuma inherited an already extensive and wealthy empire, which had been created from successful military conquests and yielded rich and varied tribute payments. Details of these are known to us primarily from two related pictorial codices, the Matrícula de Tributos and part II of the Codex Mendoza. Almost all of the conquered provinces recorded in these documents paid tribute in the form of clothing and feathered warrior

Fig. 49
Stone head of a warrior wearing an eagle helmet (see cat. 85).
Museo Nacional de Antropología, Mexico City.

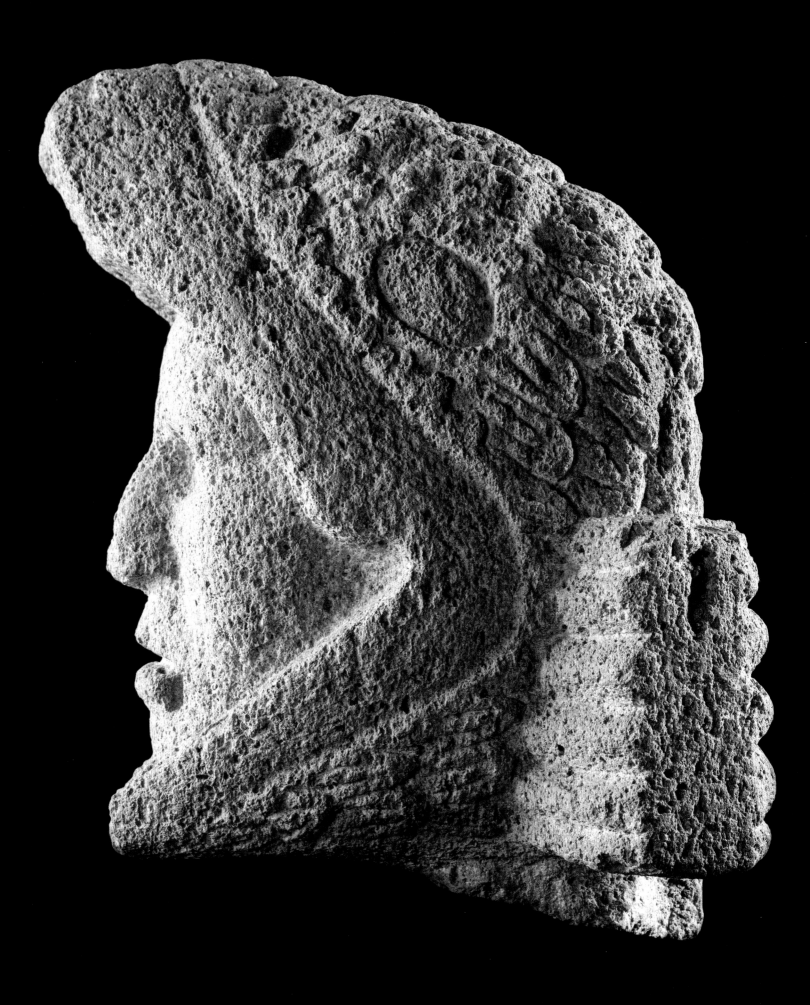

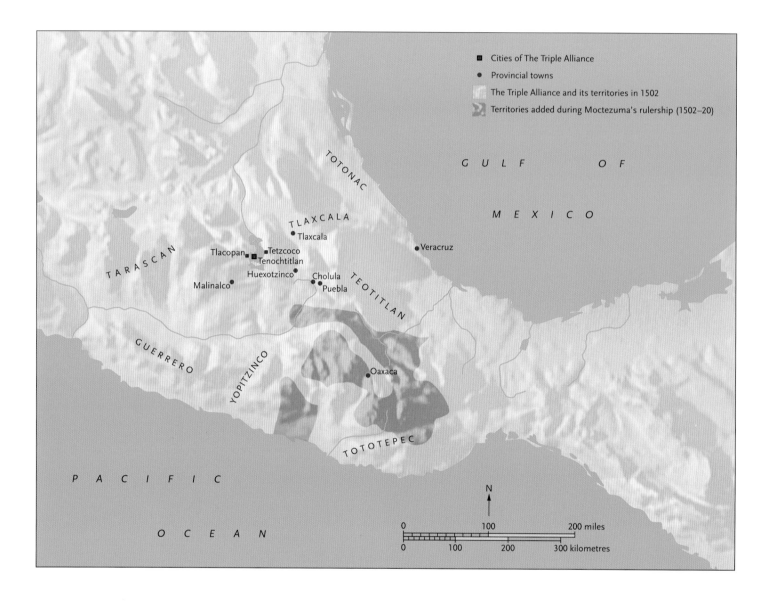

Fig. 50
Map showing the expansion of the empire during Moctezuma's reign.

costumes with accompanying shields. Provinces closest to Tenochtitlan contributed staple foodstuffs such as maize, beans, chia and amaranth. Specialized goods came mainly from the more distant provinces: maguey honey, limes and eagles from the north; wood and salt from the west. The southern provinces paid especially rich and diverse tributes ranging from paper, gourd bowls, cochineal and copal (for incense) to tropical feathers, precious greenstones, gold, copper axes, cacao and jaguar pelts. And from the eastern provinces, as far as the Gulf Coast, came cotton, rubber, precious stones, gold, feathers and more cacao. Some of these tributes consisted of raw materials but much was paid in manufactured objects such as feathered warrior costumes, paper, lip-plugs and greenstone beads. All of these tributes were paid annually, semi-annually or every eighty days to Tenochtitlan.

The Mexica ruler also controlled some more distant domains, although generally through diplomacy rather than outright conquest. These 'strategic provinces' lay primarily along hostile borderlands or across critical trade routes, and economic relations with the imperial powers consisted more of gift giving than formal tribute payments.

Moctezuma inherited a tradition of military expansion: he was expected to go to war, to capture enemy warriors for religious sacrifices and to secure quantities of in-coming

tribute. Hostilities involved a pre-inaugural military expedition, the suppression of rebellions wherever they occurred, and ongoing skirmishes with the Tlaxcala, Huexotzinco and Cholula enemies to the east. Moctezuma also inherited certain rules of operation. His reasons for conquest might include failure of a city-state to comply with 'requests' to supply specific materials, harassment of Mexica diplomats or merchants, or combative relations with city-states already part of the empire. Likewise, city-states rebelled in predictable ways (usually by attacking and robbing Mexica merchants), and were subdued by ruthless re-conquest and subsequent harsher treatment. His long-standing rivalries with Tlaxcala and its neighbours followed the ritualized procedures that governed all warfare.

Moctezuma also inherited a tradition of lavish spending. Although perhaps not as extravagant as his predecessor Ahuitzotl, he nonetheless engaged in expensive wars, gave luxurious gifts to foreign rulers at sumptuous feasts, rewarded his noble officers and successful warriors with costly status symbols, contributed to elaborate religious ceremonies and paid his skilled artisans generously. While Moctezuma was arguably the most elitist of Mexica monarchs, he also honoured the traditional custom of presenting alms to orphans, widows and the poor. As with his predecessors, such expenditure was viewed as a means of winning military conquests, the gaining of tributes, and the intimidation of military foes and restless imperial subjects. He also used his riches to win the loyalty of his noble cadres, appease the gods, commission fine craftsmanship and assure the welfare of his people.

Moctezuma's problems

Following his election as leader, it was critical that Moctezuma immediately establish his authority as *huey tlatoani* (supreme speaker). It was not uncommon for conquered city-states to take advantage of the uncertainties surrounding changes in rulership. His pre-inaugural conquests proclaimed him as a strong and committed military leader and initiated his agenda of imperial conquests and re-conquests.

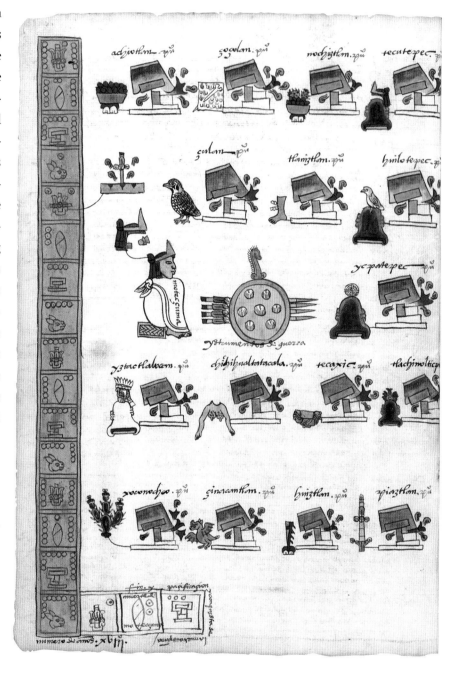

Fig. 52
A page from the Codex Mendoza detailing some of the towns Moctezuma captured during his reign. Moctezuma himself is identified by his name glyph.
Fol. 15v. Bodleian Library, Oxford.

He also needed to sustain imperial as well as personal power, in both act and image, which he managed through a combination of elitism and extravagant gift giving. However, the former broadened the chasm between nobles and commoners, while the latter proved extremely costly. In events contrived to impress visiting enemy rulers, Moctezuma housed them in luxuriously appointed quarters and gave them 'splendid mantles and breechcloths, rich sandals that they called "royal shoes", fine jewels, necklaces, and precious stones'.[1] While he also received rich gifts from his visitors, Moctezuma as host and emperor of the known world demonstrated his power by flaunting his wealth.

On the broader imperial stage, Moctezuma needed to achieve military victories. Unfortunately, several unsuccessful and costly battles against Tlaxcala and its allies seriously

eroded his prestige in the provinces. Rebellions became commonplace and much of Moctezuma's energy was directed towards suppressing these outbreaks.

Moctezuma's wars were expensive, and with every battle his storehouses were further depleted of weaponry and shields. In addition, he was confronted with a rapidly growing population, which needed to be fed and housed. It was essential that he maintain a dependable flow of tributes from already conquered provinces. He was also faced with the problem of an inordinate increase in the numbers of nobles, who expected to be costumed, adorned and rewarded for their loyalty.

These many challenges were confounded by a succession of unanticipated (but not unprecedented) natural disasters. Famines struck in 1505, 1506 and 1514; earthquakes in 1507, 1512 and 1513; and deadly snowstorms in 1511–12. Such adversities placed an even greater burden on an increasingly stressed imperial rulership.

Moctezuma's priorities and strategies

These interrelated problems shaped Moctezuma's objectives as an imperial ruler. It was essential that he sustained and increased tribute payments, confronted Tlaxcala and its allies, suppressed rebellions, and secured trade routes.

Moctezuma's first priority was to increase the flow of tribute goods into Tenochtitlan. Foodstuffs were supplied by relatively cooperative nearby provinces and Moctezuma probably increased his demands accordingly. However, in the world of luxury goods, Moctezuma was an aggressive conqueror and subsequently his military campaigns were concentrated heavily in the southern parts of the empire. Rather than expanding the empire's overall footprint beyond Ahuitzotl's military achievements, he focused on consolidating and 'filling in the blanks' in this rich southern region, primarily Oaxaca and Guerrero, areas capable of providing him with luxury goods. Listed in the imperial tribute rolls from these regions was a type of turquoise stone used to manufacture a variety of fine mosaics, both in Tenochtitlan and its neighbouring cities (see cats 90 and 99). Recorded tributes from Moctezuma's conquests and re-conquests repeatedly list cotton clothing, cochineal (for dyeing), precious feathers, gold, greenstones, cacao and fine woods for carving.[2] With few exceptions, these were raw materials, suggesting some re-prioritizing of his predecessors' custom of demanding manufactured goods such as copper axes in tribute (see cat. 96). Moctezuma required resplendent objects decorated with royal and other Mexica designs to demonstrate his power, and these would be most accurately and exquisitely fashioned by his own craftsmen.

Moctezuma also exercised his political control by imposing exceptional tribute and labour demands, sometimes calling on subject city-states to provide additional services and goods. On one occasion, he ordered that the largest and most splendid stone be found and brought to Tenochtitlan to be carved for the Tlacaxipehualiztli gladiatorial sacrifices. Finding such a stone in Chalco, numerous men from seven nearby city-states used poles and ropes to move it to Tenochtitlan. Failing in this, despite lavish offerings made to the gods by accompanying priests, Moctezuma solicited more and more men from additional city-states. Finally, the rock spoke, saying it would move only as far as it wished.

Fig. 53 *following pages*
Tribute lists identifying the types and quantities of raw materials and finished products to be delivered to the Mexica royal court. From the Codex Mendoza, fols 47r and 37r. Bodleian Library, Oxford.

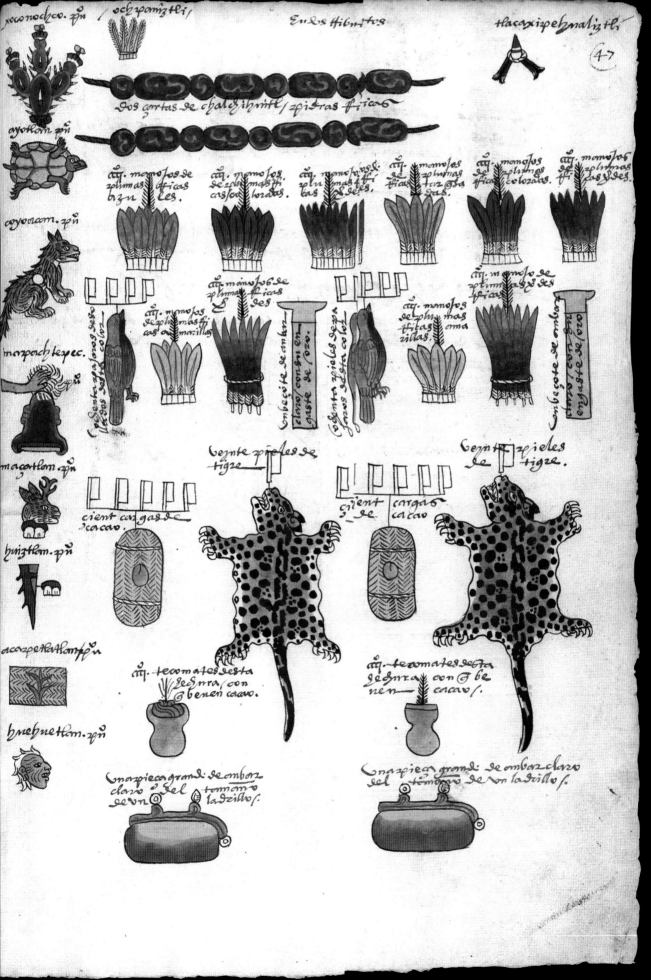

dos sartas de chalchihuitl / piedras fias

ayotlam. pu̅

coyolacom. pu̅

xoxpachteyec. pu̅

maçatlom. pu̅

huiztlom. pu̅

acaxpetlatlompu̅n

hvehuetlom. pu̅

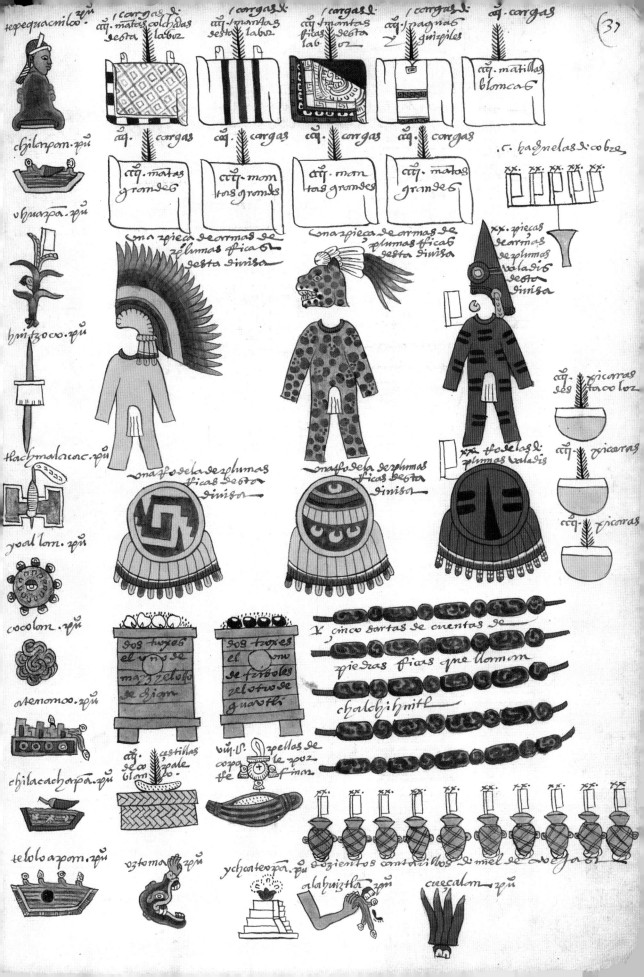

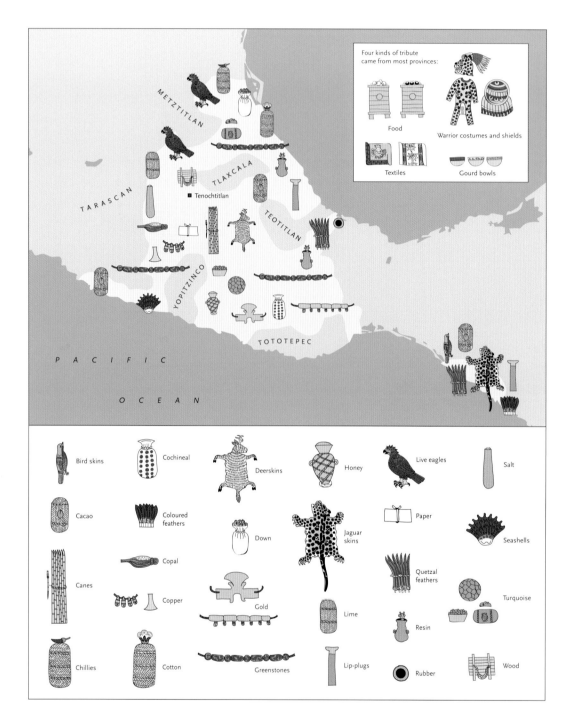

Fig. 54
Map showing tribute extracted
from the different provinces
of the empire and brought to
the capital Tenochtitlan.

The men ultimately managed to move the rock, but much to Moctezuma's consternation, it dropped into Lake Tetzcoco before miraculously returning to its original location.[3] Moctezuma also exploited his power in his treatment of Tenochtitlan's sister city Tlatelolco. At the time when he assumed the throne, Tlatelolco had been remiss in its tribute payments; Moctezuma reinstated that tribute and later shamed Tlatelolco into providing large amounts of battlefield provisions.

Mexica rulers had a long history of military campaigns against Tlaxcala, Huexotzinco and Cholula in the broad valley beyond the volcanoes to the east of Tenochtitlan. Earlier, these wars were described as 'flower wars' and their goals couched in terms of ritual battlefield contests designed to capture prisoners (on both sides) and provide military practice.

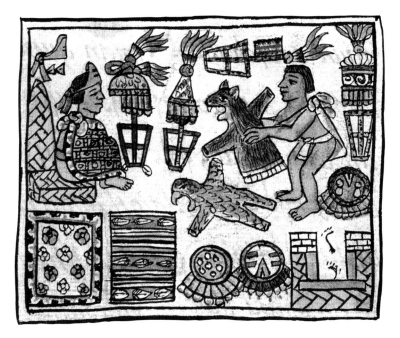

However, it is clear that Moctezuma was deadly serious about these encounters, which had become intense campaigns of conquest in which he was losing both warriors and prestige.

Moctezuma's greatest warriors were titled jaguars and eagles (see cats 85 and 86), personifying the fiercest predators in the Mexica universe. These bold and accomplished warriors had captured at least four enemies in battle; they sat on military councils and played a central role at some of the major ceremonies. At one of these, Tlacaxipehualiztli, two jaguar warriors and two eagle warriors were designated to fight a valiant captured warrior in a gladiatorial sacrificial rite celebrating renewal. Spectacular ceremonies such as these were accompanied by the playing of flutes, the blowing of conch shells, and the rhythmic beating of decorated wooden drums (figs 57 and 58; cats 83 and 84).

Fig. 55
Moctezuma seated on his throne being offered tribute goods, including featherwork and jaguar and eagle costumes. From the Florentine Codex, Book 8, fol. 33v. Biblioteca Medicea Laurenziana, Florence.

One of the most important Mexica military centres was Malinalco, south-west of Tenochtitlan. This key city-state was conquered by Axayacatl, Moctezuma's father, and paid tribute in foodstuffs and plain white cotton cloaks. A prominent and unusual rock-cut temple highlights the high status of elite jaguar and eagle warriors at Malinalco. Featuring eagles and felines sculpted into the architecture, this impressive structure was probably also used as a political chamber for high-ranking officials, demonstrating the intricate interweaving of Mexica political, religious and military life.

Moctezuma's determination to subjugate Tlaxcala stemmed from his overall desire to consolidate the boundaries of his empire and his need to secure trade routes to the rich Gulf Coast. Despite Moctezuma's grievous battlefield losses, it was clear that he was tightening the noose around Tlaxcala. He mounted successful military campaigns in the present-day state of Veracruz, cutting off Tlaxcala's access to the coast and directing its wealth to his own palace and empire. Newly available resources included prized shells that were used in mosaics or designed as delicately carved pieces (see cat. 101). Nonetheless, Tlaxcala's penchant for inciting conquered provinces to rebel against the Mexica and its aggravating presence within Mexica imperial boundaries emboldened Moctezuma's restless conquered provinces.

Fig. 56
Circular rock-cut temple of the eagle and jaguar orders at Malinalco.

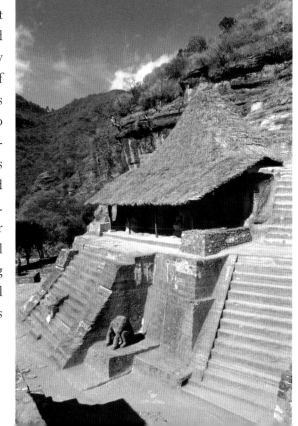

While revolts had always been a part of Mexica conquest history, they became prominent events during Moctezuma's reign. The documentary evidence suggests that as many as one-third of his campaigns were re-conquests. A defiant province meant loss of tributes, so suppressing rebellions and returning these city-states to the imperial fold was a high priority in Moctezuma's military ventures.

Trade in Mesoamerica was well established before the Mexica arrived in the Basin of Mexico, but during the time of Mexica hegemony, trading activities greatly increased. Much as Moctezuma controlled tribute payments, the Mexica economy was highly commercialized. The simple commodity of obsidian, a type of volcanic glass, exemplifies the importance of trade. Tools made from this staple material were not included on the imperial tribute rolls, although they must have moved through the constant and lively trading networks. Individual householders, selling their own surpluses in markets, and small-scale merchants, carried out much trade. Yet the trade in luxury goods was in the hands of professional merchants, or *pochtecas*. As private entrepreneurs, they travelled both within the empire and beyond its bounds. As agents of the imperial enterprise they maintained close ties with their rulers, serving them as diplomatic envoys as well as spies in foreign lands. Rich commodities accompanied diplomacy: these merchants transported the most expensive and exquisite goods from tropical lowlands to highland rulers, including Moctezuma.

Some of Moctezuma's conquests can be seen as guaranteeing strategic trade routes for imperial merchants. Indeed, one of the most frequent motives for war was the killing and robbing of Mexica merchants in outlying regions. The Mexica military met these outrages with rapid reprisals. A successful campaign not only brought loot to the Mexica warriors and tribute to the imperial coffers, but it also secured the trade routes and a relatively reliable supply of tropical luxuries.

Fig. 57
Sporting feather ornaments and bearing rattles, dancers move in unison to the rhythmic tempo beaten out on vertical and horizontal drums. From the Florentine Codex, Book 8, fol. 28r. Biblioteca Medicea Laurenziana, Florence.

Fig. 58
Wooden vertical drum (*huehuetl*), with a dancing jaguar warrior (see cat. 83). Museo de Antropología e Historia del Estado de Mexico, Toluca.

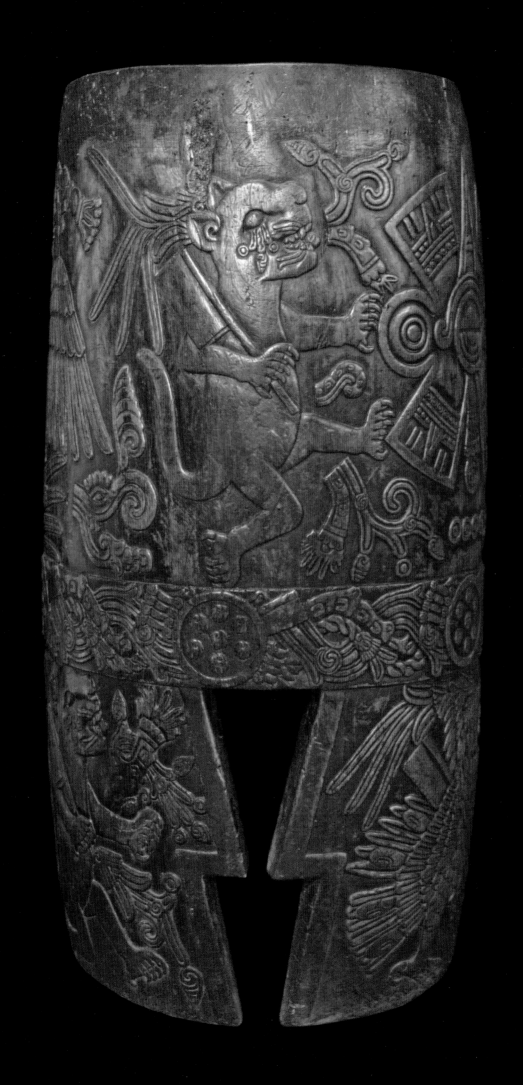

Moctezuma's luxury commodities

In Moctezuma's empire, two of the most valued commodities that were obtained via tribute payments or traded by the *pochtecas* were cacao beans and fine feathers. Cacao (*Theobroma cacao*) grew in the hot, humid southern lowlands and coastal regions. There were at least four different varieties of cacao in Mesoamerica,[4] two of which are clearly represented in the imperial tribute records. Sahagún[5] makes finer distinctions, distinguishing cacao from the Gulf and Pacific coasts. Moctezuma gained access to this treasured commodity from five distant tribute-paying provinces: Tochtepec, Cuetlaxtla and Quauhtochco on the Gulf Coast, and Cihuatlan and Xoconochco on the Pacific. Combined, these provinces paid Moctezuma 840 loads of cacao and 160 loads of red cacao annually (one load equalled approximately 24,000 beans). In addition to this, nearby Tlatelolco gave Moctezuma 40 baskets of ground cacao every 80 days; this was probably obtained from Tlatelolco's lively marketplace, the largest in the realm. A prized commodity, cacao was also traded throughout the empire and beyond by producers and by regional and long-distant merchants. The sculpture of the man holding a cacao pod (cat. 93) could be a producer or a merchant, although the latter would be unlikely to transport the heavy, full pods. Cacao beans were sometimes reportedly counterfeited. This was done by piercing a small hole in the outer husk, removing the chocolate and replacing it with materials such as sand or ground avocado stones before sealing the hole. Sold in a batch, the illegal beans were barely noticeable.

To be made into the chocolate drink, the beans and accompanying sweet, white pulp were extracted from their pods and both pulp and beans fermented (each pod typically containing 30–40 beans).[6] The beans were dried and roasted and the bitter chocolate removed from its outer almond-like husk, ground into a fine powder, mixed with water and then poured from one vessel to another to yield a delicious liquid with a tantalizing frothy top (see fig. 32). The foam was considered a special delicacy. To enhance its flavour, honey, chilli and other flavourings could be added. Chocolate was sometimes mixed with maize gruel, but this was considered to be an inferior drink (and if commoners did consume chocolate, it may have been in this form). Large quantities of cacao must have continually entered the imperial capitals, since it was an indispensable part of the lavish and frequent feasts, including those given by professional merchants.

Cacao also served as a form of currency. Its widespread presence in markets and its use as small denomination money suggests that while the drink was supposedly restricted to nobles for consumption on special occasions, cacao beans also passed through

Fig. 59
Two specialist artisans put the finishing touches to feather ornaments ranging from shields to fans. From the Florentine Codex, Book 9, fol. 62v. Biblioteca Medicea Laurenziana, Florence.

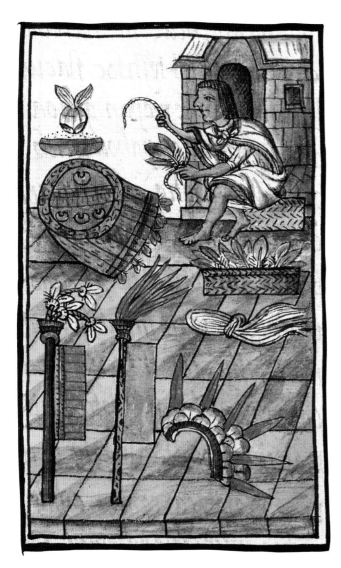

Fig. 60
A craftsman with an array of feathers in a basket at his feet attaches an arrangement of these to a twisted fibre rope. Other completed objects range from a shield to banners and a headdress. From the Florentine Codex, Book 9, fol. 63. Biblioteca Medicea Laurenziana, Florence.

commoners' hands with some frequency. This practice continued well into the colonial period; in Tlaxcala's 1545 market, one large tomato equalled one cacao bean, a small rabbit was worth 30 cacao beans, and one good turkey hen cost 200 cacao beans.[7]

Five distant imperial provinces paid tributes in colourful tropical feathers, amounting to thousands of feathers annually. Two of these were on the Gulf Coast, one on the Pacific Coast, and two in the Mixtec country of Oaxaca. These feathers ranged from the flowing green plumes of the male quetzal and the long primary feathers of the scarlet macaw, to the small back and breast feathers of the cotinga, the Mexican trogon, the roseate spoonbill and the yellow-headed parrot. In addition, Moctezuma consistently demanded rich feathers in tribute from his conquests in the Oaxaca area (many not recorded in the Matrícula de Tributos or Codex Mendoza, but known from other documents such as the colonial Relaciones Geográficas). Professional merchants also trafficked in tropical feathers – found only at great distances from Tenochtitlan. This lightweight but high-value commodity undoubtedly yielded rich returns, and feathers must have circulated widely throughout the empire, since nearly all conquered provinces paid some of their tributes in feathered warrior costumes and shields.

The feathers were fashioned by highly skilled workers into exquisite objects that were either glued into intricate mosaics or tied into flowing ensembles and accoutrements. Feathered banners were displayed on ceremonial and political occasions, royal ambassadors carried feathered fans, the aristocracy wore feathered headdresses and feathered textiles adorned palaces and royal personages. Intricately designed feathered military costumes and shields signalled the level of a warrior's battlefield achievements conforming to symbolic and stylistic conventions.[8] Moctezuma openly and proudly displayed his own splendid feathered adornments, and bestowed feathered items to his loyal and accomplished nobles. His control over such finery and artisanship visibly proclaimed the extent of his political control, which was repeatedly challenged throughout his reign.

Moctezuma stood at the centre of a continual ebb and flow of great wealth – tribute, trade, gifts, offerings and payments. He paid heavily for his wars, conquests and re-conquests, but received tributes in return. He gave and received lavish gifts. He rewarded military feats and was in turn rewarded with the loyalty of his nobles, who performed eagerly in subsequent wars. He deployed some of his wealth to the proper performance of flamboyant religious ceremonies, in the hope of receiving the favour of the gods. And he sponsored merchants and artisans and publicly displayed his finery, reinforcing his exalted status and intimidating his enemies and subjects. As a ruler who enjoyed the height of Mexica power yet faced recurring problems and persistent enemies, Moctezuma used his extreme wealth to his best possible political advantage.

Cat. 81
Altar of the warriors

c. 1510, Mexica
Basalt, 118 × 161 × 65 cm
Museo Nacional de Antropología, Mexico City, inv. 10-1155

Selected literature: Bilbao 2005, p. 34, no. 93

The glorious reign of Moctezuma I (1440–1469) prompted
the Mexica to create votive monuments exalting their military
triumphs and proclaiming the important role played by the
warriors in upholding the empire.

Discovered at the south-west corner of the Plaza de la
Constitución, this altar belongs to the characteristic sculptural
tradition of Tenochtitlan. The front has been severely damaged
and the upper part bears traces of the excavations in the colonial

era that destroyed almost all the original relief on this section of
the monolith. After the conquest it may have been reused as a
receptacle, possibly a trough. The altar is a rectangular block with an
impressive procession of fourteen warriors depicted around all four
sides, starting at the rear and ending with a large, partially erased
zacatapayolli. This was a sacred ball of grass used to hold the sharp
bloodletting instruments belonging to devout soldiers. The warriors
march beneath their insignia and protective deity – eight plumed
serpents, with two alternating ornamental variants. Like the warriors,
the serpents are facing towards the sacred *zacatapayolli* at the front.

The precision and quality of the carvings on this altar mark it
out as one of the greatest sculptural achievements of Moctezuma
II's reign. The range of garments, insignia, headdresses and arms
enable us to distinguish the various groups of warriors active in
his empire. *FSO*

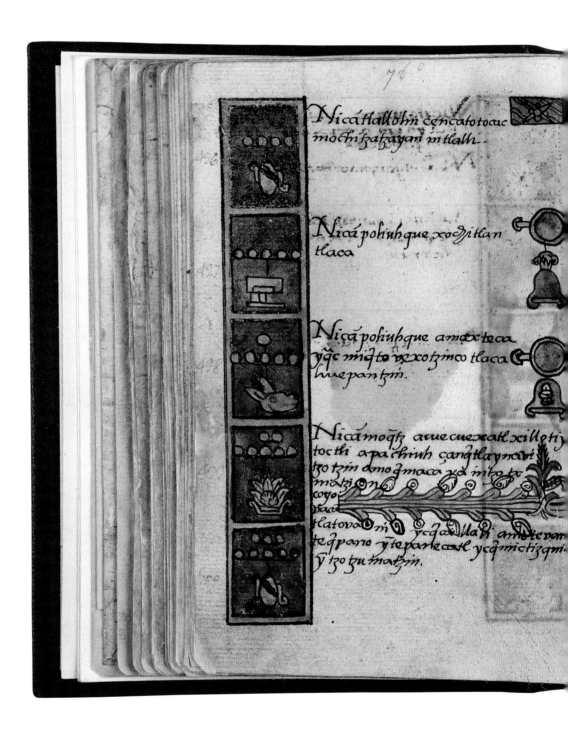

Cat. 82
The temple at Malinalco

Codex Aubin
1576, colonial
Paper, 16.2 × 27.8 cm (open)
Trustees of the British Museum, London, Add. Ms. 31219, fols 39v, 40r

Selected literature: Townsend 1982; Townsend 1995; Boone 2000

Codex Aubin belongs to the *xiuhpohualli* (year-count) genre of historical annals, although its continuous strip form was broken into blocks of five, probably to accommodate the European page size. Organized in three parts, with some blank entries for uneventful years, the annals record the Mexica migration; the history of imperial Tenochtitlan; and conquest and colonization through to 1576. (A further section continues the colonial annals from 1596 through to 1608.)

The pages illustrated here cover the last six years of the reign of Ahuitzotl and the first four of his successor Moctezuma II. Ahuitzotl died in year 9 House (1501), as denoted by his death bundle with name-glyph attachment. Year 10 Rabbit (1502) witnessed Moctezuma's accession. Employing the traditional male posture, the *tlacuilo* (artist-scribe) depicted him seated on the high-backed, woven seat of authority, resplendent in the royal turquoise diadem and mantle. Possibly in recognition of

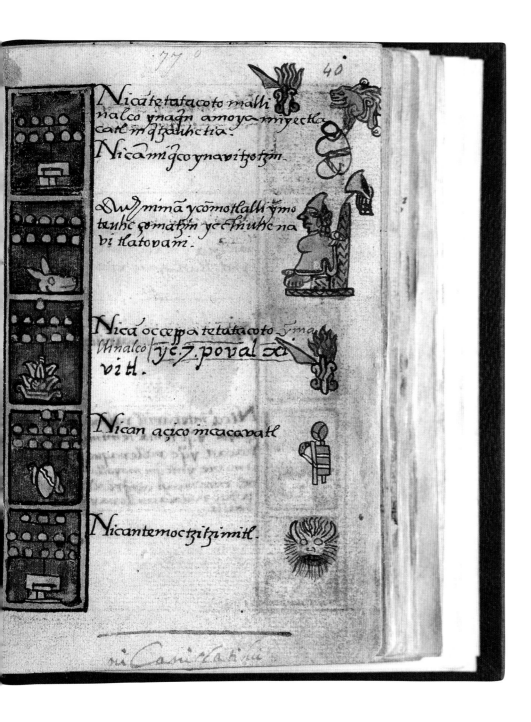

his perceived greatness, Moctezuma's personal glyph does not correspond to his given name, 'He Who Grows Angry (like a) Lord', or 'the Younger' but to the *xiuhuitzolli*, or jewel-encrusted state diadem, often accompanied by the turquoise nose-plug as an insignia of office.

To either side of the accession period, the two glyphs comprising a bunch of twisted *malinalli* grass pierced by a cutting implement record that labourers were sent to extract stone at Malinalco ('Twisted Grass Place'), a Mexica military outpost on the western fringes of the empire. The text in Nahuatl observes that so few came forward that forced labour had to be imposed. Twelve years later, a third comment on stonecutting at the site was made,

this time noting the intrusion of spies from Huexotzinco.

The three entries refer to the construction of the hillside temple at Malinalco, initiated by Ahuitzotl, and carved out of the bare bedrock. Four stone seats in the form of eagles and jaguars were also sculpted on which the four highest Mexica governors were to sit in council. Such emphasis on the project echoes the importance of the site not only as a symbol of centralized rule over an often dissident boundary but also Moctezuma's role as intermediary between his subjects and the life-giving earth from whose body the temple was fashioned. On its completion, and in honour of the sacred entity, he would there perform rites of self-sacrifice and appeasement. *EW*

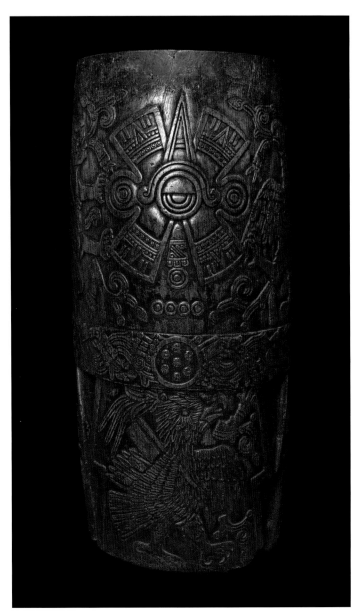

Cat. 83
Vertical drum (*huehuetl*)

c. 1500, Mexica
Wood, 98 × 52 cm
Museo de Antropología e Historia del Estado de México, Toluca, inv. A-36230/10-102959

Selected literature: Castañeda and Mendoza 1933, pp. 101–06; Amsterdam-St Petersburg 2002, p. 116, no. 35; London 2002, p. 438, no. 156

This *huehuetl* or vertical drum is distinguished by its abundant warlike iconography. The carved surface is divided into two large sections by a horizontal stripe. The latter, symbolizing the struggle of opposites, is composed by two intertwined bands: one with watery symbolism and the other related to fire. The stripe is complemented by five bucklers (round shields) adorned with feathers and a banner.

To one side of the top section is the date 4 Movement, symbolizing the 'Fifth Sun', the last era in Nahuatl cosmology. This date is flanked by jaguar (see fig. 58) and eagle warriors, each with an *atl-tlachinolli* ('water-bonfire' or 'water-burnt field') the symbol of holy war emerging from their mouths. On the opposite side is a man dressed as an eagle, probably personifying the sun god Tonatiuh. On the lower section, corresponding to the drum's three supports, are two jaguar warriors and an eagle warrior, singing, dancing and waving flags. The symbolic value of music in Mesoamerican ritual is well documented, and there are both textual and pictorial references to this type of instrument being used during religious ceremonies associated with politics and warfare.

This drum was still used for important festivities by the inhabitants of the Malinalco valley at the end of the nineteenth century.
MB

Cat. 84
Slit drum (*teponaztli*)

c. 1325–1521, Zapotec
Wood, 68.5 × 20.1 cm
Trustees of the British Museum, London, AOA Am +6184

Selected literature: Saville 1925, p. 72; Pasztory 1983, pp. 248, 269–74; Miller and Taube 1997; Townsend 2000; London 2002, pp. 438–39; López Luján and Fauvet-Berthelot 2005, p. 169; Aguilar-Moreno 2007, pp. 209–10

Drums were widely used in Mesoamerica. They were played to accompany songs or poetry readings in festivals, state ceremonies and rituals, and were carried on military campaigns. Several types are known, including vertical drums (*huehuetl*: see cat. 83) and slit drums (*teponaztli*). Illustrations in the codices depict both drums being played together, while richly attired figures and warriors dance to the rhythm of their beats (fig. 57).

Teponaztli were constructed from a single piece of red hardwood. To make the sound box, the cylinder was hollowed out via a slit created at one end using a copper axe (see cat. 96). A second opening in the shape of an H was carved at the top using a red-hot copper needle to create two vibrating tongues which were carved into different lengths and thicknesses to produce different pitches. The opening in the underside was left open, augmenting the volume.

Slit drums were played using rubber-tipped sticks or wooden mallets (*olmaitl*) and would have been supported on a coil of twisted rope or balanced on a folding stand. Alternately, they might be hung from the player's neck using a cord.

Teponaztli were decorated with elaborate carving. On this drum a warrior is depicted lying in a contorted pose with one leg stretched to his underarms and the other curved around one end of the drum. Although barefoot, the figure is adorned with elaborate ornaments including a tortoiseshell as an upper arm bracelet, a carved fish bone hanging from one of his thighs and a feather ornament suspended from a cord around his neck. He wears tubular ear-spools, a nose ornament and a headband, and his short hair is shown with one lock hanging from the side. With his left hand he holds a conch shell under his chin.

A very similar drum in the Museo Nacional de Antropología in Mexico City, with comparable iconography and composition, has been identified as depicting a Tlaxcalan warrior. The Tlaxcalan people were in a state of constant warfare with the Mexica, and were never conquered. The act of drumming on the back of a captive enemy warrior would therefore have held important symbolic significance. *EVLL*

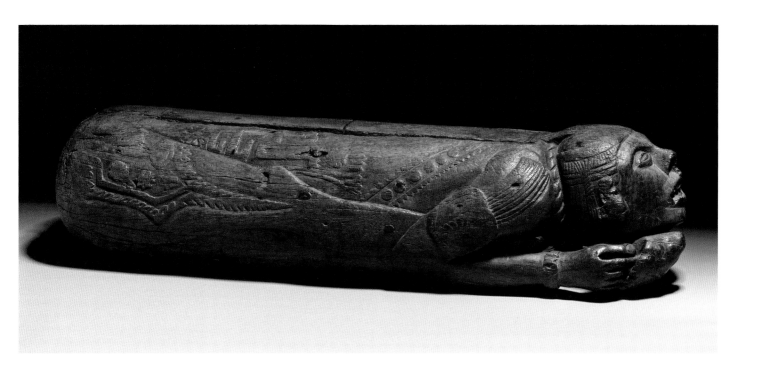

Cat. 85
Head of an eagle warrior

c. 1450–1521, Mexica
Andesite, 38 × 30 × 26 cm
Museo Nacional de Antropología, Mexico City, inv. 10-94

Selected literature: Toscano 1944, pp. 114–15, pl. 172; Soustelle 1969, p. 143, no. 190; Pasztory 1983, pp. 229–31; Bernal and Simoni-Abbat 1986, pp. 279–80; Matos Moctezuma 1989, p. 73; Solís Olguín 1990, pp. 108, 114–15; Solís Olguín 1991, pp. 81–83; Solís Olguín 1991b, p. 235, no. 345; Madrid 1992, p. 243

The order of the eagle warriors, along with the jaguar warriors, constituted the elite group that led the Mexica armies on their expeditions of conquest. They are recognized, as in this famous sculptural fragment, by their helmets in the form of an eagle's head and clothing adorned with wings and claws.

The eagle had been linked with warfare since the earlier civilization of Teotihuacan, as can be seen from surviving murals. The Mexica, however, considered the eagle as the *nahual*, or the supreme incarnation of the sun. When the 'Fifth Sun' of the world's evolution first illuminated the world, the gods sent the eagle to discover its sacrificial requirements. Accordingly, the eagle warriors descended on battlefields in pursuit of victims to offer to their tribal deity Huitzilopochtli, the victorious heavenly warrior who had defeated and decapitated the moon goddess, scattered the stars and thus dissipated the shadows of darkness.

This sculpture displays a bold carving technique that conveys the unyielding nature of the Mexica soldier, whose nobility is indicated by the large *tlaquechpanyotl*, or knot, at the nape of his neck (see also fig. 49). The warrior is distinguished by his eagle's beak helmet and scowling mouth, further emphasizing his ferocity. *FSO*

Cat. 86
Jaguar warrior

c. 1500, Mexica
Basalt, 78 × 56.5 × 53 cm
Museo Nacional de Antropología, Mexico City, inv. 10-81553

Selected literature: Mateos Higuera 1979, p. 235; Pasztory 1983, pp. 175–76; Matos Moctezuma 1989, p. 72

The hierarchy of the Mexica army culminated in the two most important military brotherhoods – the eagle and jaguar warriors – distinguished by their elaborate costumes imitating the plumage and fur of their respective predators.

The military significance of the jaguar is explained in the legend of the five cosmogonic eras or 'Suns' of the world's evolution (see p. 128). The first creation was the work of Tezcatlipoca, the god of night and destiny, who later adopted the form of the jaguar. When the deity Nanahuatzin perished on the sacred fire before rising as the 'Fifth Sun' that would illuminate the era, the jaguar witnessed the birth ritual. He later followed the crow and eagle into the holy ashes, staining his coat for eternity and being transformed into one of the animals defending the glorious destiny of the sun as the conqueror of the universe.

Membership of this prestigious brotherhood in the time of Moctezuma II required not only noble lineage but also the achievement of an outstanding military feat. This sculpture shows the warrior wearing a jaguar helmet, his face emerging from the animal's jaws, and framed by enormous circular ear-spools, probably made of gold. The warrior wears a *tlaquechpanyotl*, the paper knot worn by the nobility, a large necklace with four strings of greenstone beads and an old-fashioned anthropomorphic pectoral, providing a link with former warriors. Around his wrists are bracelets made of beads and leather bangles adorned with small metal bells and the quincunx symbol. The warrior's high status is indicated by his depiction as a great lord seated on a wooden throne decorated with *chalchihuitl* (the symbol for greenstone) and cross-sections of spiral shells. *FSO*

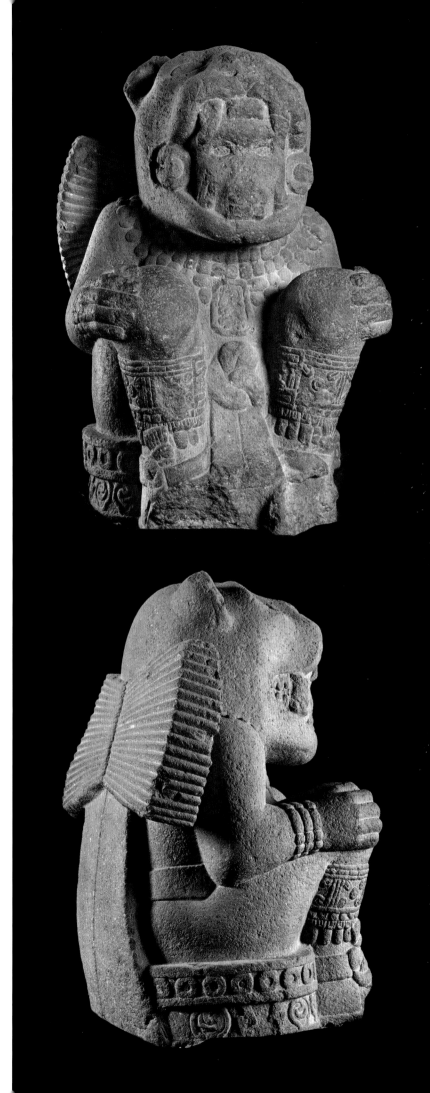

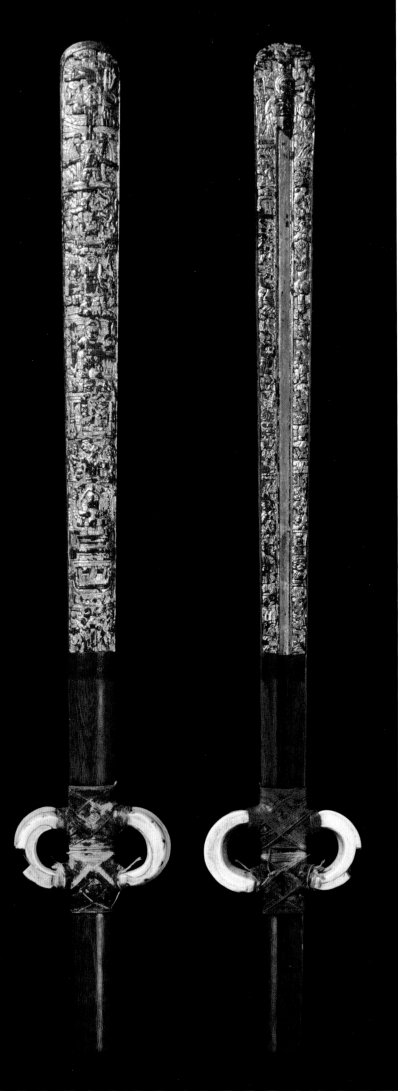

Cat. 87

Spear-thrower (*atlatl*)

c. 1350–1521, Mixtec–Mexica
Wood, gold leaf, shell and cord, 57 × 3.8 cm
Museo Nazionale Preistorico ed Etnografico 'Luigi Pigorino', Rome

Selected literature: Bushnell 1906; New York 1970, no. 293; Benavente 1971, p. 65; Pasztory 1983, fig. 52; Durán 1984, vol. 1, p. 140; Hildesheim-Munich-Linz-Humlebæk-Brussels 1986, no. 347; García Moll, Solís Olguín and Bali 1990, pp. 192–93; Madrid 1992, p. 247, LIX; López Luján *et al.* 2006; Bühl 2008, pp. 196–97

This carved spear-thrower (*atlatl*) is a fine example of the artistic skills and complex imagery used in the decoration of military regalia. Such elaborate objects were generally intended for ceremonial use rather than in combat. The design takes the form of a narrative sequence and the intricate carvings are embellished with gold leaf. The shell finger-loops on either side are attached to the central shaft with cord, making this the only known example of an *atlatl* in which the original loops are still intact.

On one side, a figure wearing an elaborate feathered headdress descends from the wider distal end. Set against a carved solar disc he brandishes a loaded *atlatl* in one hand and carries a shield and darts in the other. The figure may represent the sun god Tonatiuh descending from the sky. His mouth forms the opening from which the projectile is ejected, so that he appears to propel the dart with his breath. On either side of the central chamber, figures with feathered headdresses – some with disembodied heads, masks and abbreviated extremities – combine to create a complex iconographic sequence. Two warriors, one holding an *atlatl* and the other a knife, and two quadrupeds, probably a deer and a jaguar, complete the decoration.

On the other side, a descending armed figure framed in a solar disc mirrors the one on the front. This figure holds a dynamic pose with asymmetrically bent knees. He carries a shield and darts in his left hand and holds the *atlatl* to his mouth with the other, aiming at a figure tied to a wooden rack whose body is already pierced with two darts. The carving depicts the *tlacacaliztli*, a form of sacrifice in which the victim was wounded by darts, allowing his blood to drip to the ground and fertilize the earth.

Below, another ritual scene features two figures, one wearing an animal headdress, the other blowing a conch shell. They are standing on what appears to be the open mouth of Tlaltecuhtli, whom they may be feeding with sacrificial blood. Further down are two warriors dressed in jaguar warrior attire. They are both carrying shields, darts and a loaded *atlatl*, and their helmets identify them as jaguar warriors. Beneath them a jaguar with a spotted pelt leans against the roof of a building containing a figure depicted in profile. He wears an elaborate headdress and ear-spools, and holds a dart.

In the next scene, two figures hold the hands and feet of a sacrificial victim while a fourth cuts open his chest with a knife, perhaps the final fate of the *tlacacaliztli* victim depicted above. Beneath, a figure with a skeletal face and claws, probably Tlaltecuhtli, sits cross-legged in a ballgame court.

The complex iconography of this weapon suggests that it belonged to a high status jaguar warrior. The carvings depict the rituals in which its owner might have participated. *EVLL*

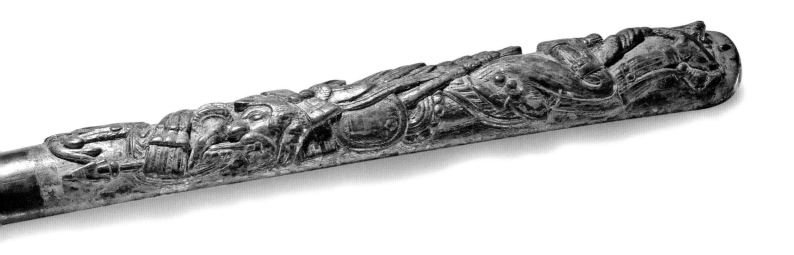

Cat. 88
Gilded spear-thrower (*atlatl*)

1350–1521, Mexica
Wood, gold leaf and cord, 30 × 9.5 × 2 cm
Trustees of the British Museum, London, AOA Am 5226

Selected literature: Nuttall 1891; Noguera 1945; New York 1970, no. 293; Pasztory 1983, figs 53, 293; London 2002, p. 478; Aguilar-Moreno 2007, pp. 111–24; McEwan 2009, p. 59

Spear-throwers (*atlatl*) were used to extend the arm of the user, allowing a dart or spear to be propelled with greater force. These devices were commonly used as hunting, military or ritual weapons (see also cat. 87). This example is made of a single piece of hardwood. Two shell finger-loops (of which the one on the right is a contemporary replacement) are attached with cord. The darts were inserted into the central chamber via a notch at the back.

The wider distal end is carved on both sides and remnants of gold leaf indicate that the carvings were originally gilded. On the back, four serpents flank a central groove. In Mexica iconography serpents often represent fired darts, since some species propel themselves into the air when attacking their prey.

The front is carved in high relief depicting a warrior entwined with the body of a rattlesnake. The figure holds a shield in one hand while thrusting a spear with the other, probably held in an *atlatl*. He wears an elaborate eagle-feather headdress and his face is either painted or covered by a mask with prominent fangs. These attributes identify him as the warrior-god Mixcoatl ('cloud snake') who was associated with undulating serpents and impersonated the Milky Way as he flew through the sky. His ear-spools, resembling the hooves of a deer, and his face paint with its vertical stripes, confirm his identity. This continuous carved narrative is characteristic of Mexica art, in contrast with the individually rendered scenes found in Mixtec iconography.

A rattlesnake with a feathered tail is coiled around the carved anthropomorphic figure. Its head is raised menacingly and its forked tongue projects from between two prominent fangs. The artist may have positioned the serpent's head parallel to the head of the spear to emphasize the weapon's supernatural powers. If the iconography of the *atlatl* is read vertically, as is clearly intended in other examples, both figures appear to be shooting from the sky like celestial darts. *EVLL*

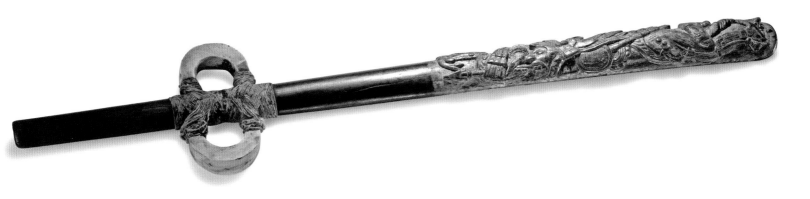

Cat. 89
Round shield (*chimalli*)

c. 1350–1521, Mexica
Stone, 17 × 17 × 5.5 cm
Staatliche Museen zu Berlin:
Preussischer Kulturbesitz, Ethnologisches
Museum, IV Ca 3982a

Selected literature: Durán 1971, p. 73; Pasztory
1983, p. 248; Codex Mendoza 1992, vol. 3, fol. 2r;
Berdan and Anawatl 1997; London 2002, p. 451, no. 208

Cat. 90
Turquoise shield

c. 1325–1521, Mexica–Mixtec
Wood, turquoise and shell, diameter 31 cm
Trustees of the British Museum, London, Am St.397.a

Selected literature: Saville 1922, pp. 69–71; Carmichael
1970, p. 35; Townsend 1979, pp. 37–40; Miller and Taube
1993, pp. 77–78, 186; McEwan 1994, p. 76; Brotherston
1995, pp. 98–109; London 2002, pp. 323–24, 330, 474,
no. 298; McEwan *et al.* 2006, pp. 12, 59–6

Stone or clay representations of functional and ritual objects, normally made of perishable materials, are part of a longstanding Mesoamerican tradition. Caskets, drums, censers, year bundles (see cat. 75) and round shields (*chimalli*) such as this one, are among the objects reproduced in detailed stone carvings by Mexica artists. Some of these stone objects were found in excavations and offerings, while others may have been used to decorate buildings and ritual structures.

This shield is carved on both sides. On the back are depicted the horizontal reeds providing the structural support for the fabric covering the shield. The intricately carved handle would originally have been made of leather or fabric. At the front four small notches indicate the points at which the handle would have been attached to the fabric, providing stronger support.

The front is decorated with nineteen bunches of eagle down. The shield of Huitzilopochtli, the patron deity of the Mexica, was also decorated with rows of eagle down (see cat. 67). A shield bearing a similar decoration of white eagle down with a series of arrows is carved in the *Teocalli* of Sacred Warfare (cat. 78), next to Tlaltecuhtli and below Moctezuma's image, signifying the ruler's conquests and the victims taken for sacrifice. With similar significance the same shields with darts are represented in the Codex Mendoza (see fig. 4). Only rulers carried shields decorated with this iconography, and there are several depictions of Moctezuma himself where he is related to a similar shield (see fig. 52 and cat. 78). A visual and symbolic parallel can therefore be drawn between the shield carried by Huitzilopochtli and the symbol for war and conquest. *EVLL*

Carved in pinewood and inlaid with a mosaic of turquoise and shells (*Spondylus princeps*, conch and mother of pearl), this shield was probably once decorated with colourful feathers around the rim. The sixteenth-century chronicles include descriptions of shields like these being used during festivals and dances. Turquoise mosaic shields were also included in the shipments sent to Spain by Hernán Cortés. Two turquoise shields have been excavated at the Templo Mayor, one in offering 48 dedicated to Tlaloc and the other in offering 99 dedicated to Mixcoatl.

The design of this shield has been planned down to the last detail. In places it is carved in high relief, giving prominence to certain elements. Drilled holes frame some of the images. Small mosaic tiles set in pine resin complete the design. The complex imagery with its small figures, the iconography, and the skill of its execution suggest that the shield is of Mixtec origin. Turquoise shields were among the tribute paid to the Mexica empire but Mixtec

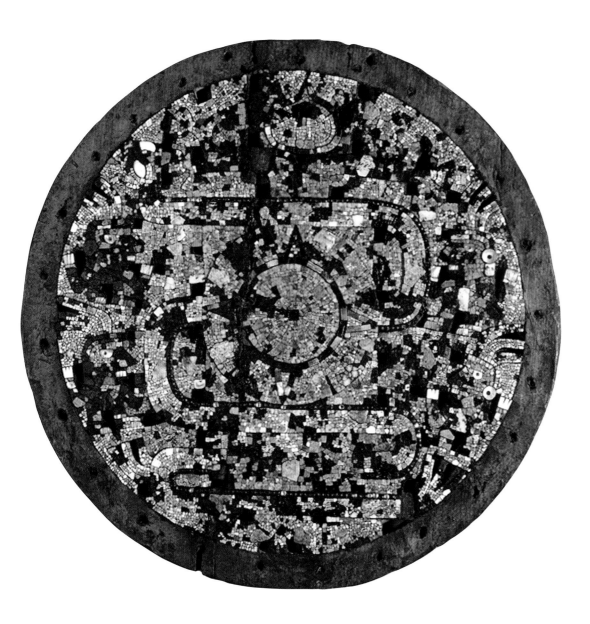

artisans also worked in Tenochtitlan.

The design depicts a schematic cosmogram of the universe, combining both horizontal and vertical views, following Mesoamerican iconographic convention. A tree emerging from the mouth of the earth goddess Tlaltecuhtli acts as an *axis mundi* or 'world axis', the two main branches splitting horizontally across the centre, with flowers at the ends of the smaller branches. A serpent with a feathered tail is coiled around the tree-trunk, metaphorically linking the earthly and celestial aspects of the universe and emphasizing vertical movement. Gilded pine-resin studs delineate the scales on the serpent's body, drawing the eye to its path through the composition. The head, at the top left of the shield, has inlaid white shell eyes and a prominent shell fang.

At the centre of the shield is a sun disc with four solar rays delineated in red *Spondylus* shell pointing towards the cardinal directions. Four skybearers or anthropomorphic figures mark the four cardinal directions. Thus the composition, with its four figures and central tree creates a ritual quincunx map of the cosmos, condensing the vertical and horizontal divisions of cosmic space into a single image.

On the top of the tree, where the two main branches split, a cartouche in the shape of a raindrop contains a reclining figure in profile. In Mixtec iconography dynasties of rulers arise as if born from a tree, a concept that was widespread in Mesoamerica. In contrast, the Mexica presented their Chichimec ancestors emerging from caves located on islands. Thus, the shield's iconography suggests that it may have formed part of a tribute payment from a Mixtec area or been seized following the capture of an important figure. It is also conceivable that during the last years of Mexica supremacy the nobility appropriated Mixtec symbolism to assert and consolidate their power over conquered territories. *EVLL*

Cat. 91
Twin-coned goblet

c. 1350–1550, Mixtec
Ceramic and paint, diameter 23 cm
Staatliche Museen zu Berlin, Ethnologisches Museum, IV Ca 24952

Cat. 92
Urn

c. 1350–1550, Mixtec
Ceramic and paint, 40 × 41 cm
Staatliche Museen zu Berlin, Ethnologisches Museum, IV Ca 44327

Selected literature: Lind 1994, pp. 79–99; London 2002, pp. 421, 453–54; Cologne 2003, p. XXVII, figs 35–36 and p. IX, fig. 15

Ceramics were widely produced throughout the Mexica empire and were used for utilitarian and ritual purposes. The distinctive shapes and decorative styles from different regions were disseminated across a wide area. Some of the most prestigious ceramics were

those made in the Mixtec style. Such distinctive goods were both imported to the Mexica empire and produced by Mixtec artisans who had migrated to the city of Tenochtitlan.

This twin-coned goblet and urn are fine examples of Mixtec ceramics. The goblet is constructed from two cones inverted and joined together at their bases. The polychrome decoration seems non-figurative, with alternate horizontal and vertical bands. The band around the rim may represent a series of eagle feathers attached to a headdress, as indicated by a series of horizontal narrower bands. The remainder of the vessel is decorated in alternate-coloured vertical bands, like those painted on the bodies of sacrificial victims or on deity impersonators. Other goblets bearing similar vertical stripes have been excavated (see cats 45 and 46), and it is possible that this type of highly abstract decoration conveyed further symbolic meaning.

The wide mouth of the urn is finished with a lip and the small lugs in the form of feline heads on either side of the body serve as handles. The polychrome decoration is arranged in horizontal bands. The darker narrow band at the top incorporates a series of eyes with half-closed lids representing the stars. A broader middle band is divided into sections with vertical strips. Each section contains images of maguey (agave) plants and flowers with a paper bow accompanied by the numerical symbol 3 against a background of dark, irregular brushstrokes. A dark band below completes the decoration. Large containers of this type may have been used to hold food or drink for grand feasts and ceremonial occasions, however, in the Puebla and Oaxaca areas similar containers were also used as funerary urns. *EVLL*

Cat. 93
Man carrying a cacao pod

c. 1200–1521, Mexica
Volcanic stone and traces of paint, 36.2 × 17.8 × 19.1 cm
Brooklyn Museum of Art, Museum Collection Fund, 40.16

Selected literature: Soustelle 1961, pp. 59–71; New York 1976, no. 44; Anawalt 1981, pp. 21–23; Pasztory 1983, p. 209, fig. 156; Hildesheim-Munich-Linz-Humlebæk-Brussels 1986, no. 154; Miller and Taube 1997, p. 112; London 2002, p. 410, no. 39; Smith 2003, pp. 257–58; New York 2004, p. 105, no. 20

This statue of a standing man dressed in a *maxtlatl* or loincloth and wearing a headdress has traces of red paint around its mouth, ears and the central ornament of the headdress. Most Mexica sculptures were originally painted in bright colours, including blue, ochre, red, black and white, creating a very different aesthetic to that we are used to seeing today.

The man holds a larger than life-size cacao pod. The Mexicas used the cacao beans (*cacahuatl*) from inside the pod to produce the bitter, but precious, chocolate drink known as *xocolatl*. Long-distance trade or receipt as tribute were the only means of obtaining cacao beans, which were grown in the semi-tropical areas of south-eastern Mexico, making them a luxury item reserved for the Mexica nobility. In late Mexica times the beans became so valuable that they were used as currency.

Professional merchants (*pochtecas*) led caravans of porters from the Basin of Mexico to remote unconquered provinces, acting not only as traders, but also as spies and warriors during their dangerous expeditions. Their partial status as warriors meant that they were granted rights and privileges usually preserved for the nobility. Moctezuma II incorporated *pochtecas* in his court, as he understood the importance of their trade for the empire. Merchants not only supplied foreign commodities for the ruling classes, but they also exported manufactured goods. This apparently secular sculpture may therefore be related to the merchant class and its newly enhanced status in the religious and economic life of Tenochtitlan. The choice of a cacao pod may have represented both their stock in trade and their growing economic power within Mexica society. *EVLL*

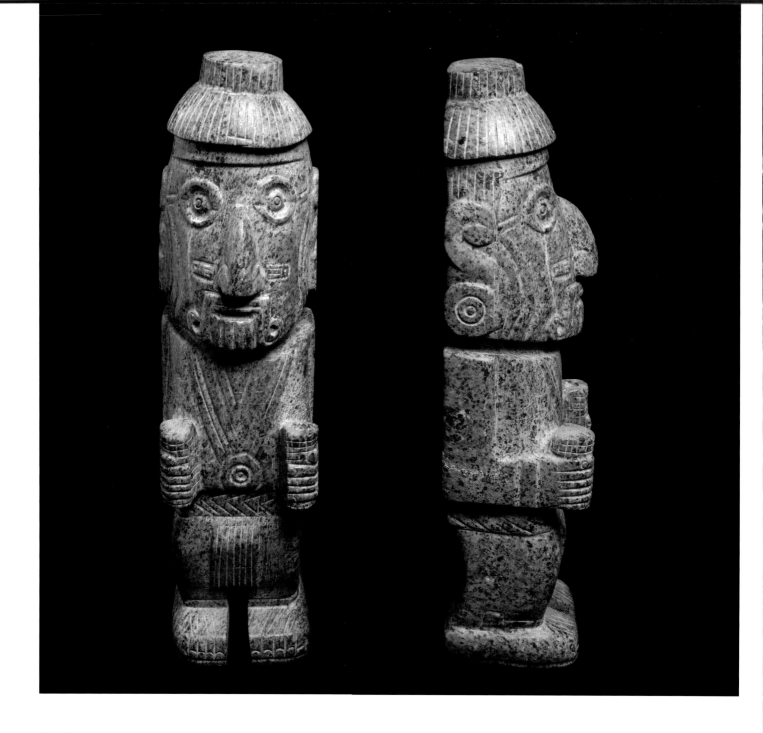

Cat. 94
Figure of Tlaloc

c. 1200–1521, Mixtec
Greenstone, 40 × 10.5 × 10 cm
Museo del Templo Mayor, Mexico City, inv. 10-162938

Selected literature: López Luján 2005, pp. 254–56

This Mixtec-style anthropomorphic figure was shaped by rubbing away the stone before polishing it and making incisions. The subject is shown seated, with his elbows resting on his knees and corncobs in his hands. He is wearing an inverted semi-conical headdress, a necklace with a circular medallion and a *maxtlatl* (loincloth) around his waist. His facial features correspond to those of Tlaloc, the god of rain, characterized by circular ear ornaments and large fangs.

The figure was found in 1978 in the east façade of the Templo Mayor and dates from the latter part of construction Stage IVb from about 1469. It belongs to a group of pieces with similar features found in various offerings, suggesting that the Mexica preferred to store the objects obtained as tribute in their main temple. In around 1458, Moctezuma I conquered the province of Coaixtlahuaca in the heart of the Mixtec region (modern state of Oaxaca). The Mexica established a garrison there, along with a storehouse for the collection of tribute. *CJGG*

Cat. 95
Greenstone figure

c. 600 BC – AD 900, Mezcala, Guerrero
Greenstone, 22 × 8 × 3 cm
Trustees of the British Museum, AOA Am 1997, Q.499

Selected literature: Madrid 1992, pp. 113–14

Stylized anthropomorphic figures carved in greenstone using a combination of abrasion and polishing are traditionally associated with the area of modern-day Guerrero in western Mexico. They are known as Mezcala figures, named after the Mezcala River, which gave its name to the culture in which they were made. Such figures have been found in offerings excavated at the Templo Mayor. The Mexica treasured these kinds of sculptures as relics, not only because of the high value they placed on greenstone but also for their ancestral associations and distant origins.

The anatomical features of Mezcala figures are rendered using only the most suggestive lines and details. Standing figures are usually carved from the basic form of an axe, a shape produced in greenstone in Mesoamerica since Olmec times. The face is conveyed with straight diagonal eyebrows joined at the nose. The mouth is marked with a slightly indented line and a short neck divides the head from the rigid body. The arms are incorporated into the body, indicated only by two diagonal lines at waist level. The legs are divided by a central incision made by abrasion of the original axe shape. Some surviving examples of these figures have traces of paint, others include additional anatomical features, and the most elaborate may originally have incorporated inlaid elements. *EVLL*

Cat. 96
Copper axe

c. 1325–1521, Mexica
Copper, 12.8 × 16.3 × 0.50 cm
Trustees of the British Museum, London, AOA Am 1943, 06.107

Selected literature: Hosler 1994, pp. 156–69

In Mesoamerica, axes were used as functional tools, but their form was also invested with great power. The axe shape acquired special significance in religious offerings, tribute and payment, as well as being associated with powerful figures. The late sixteenth to early seventeenth-century dramatist Ruiz de Alarcón, mentions that in magical contexts woodcutters' axes were known as 'Red Chichimec', probably in reference to their colour and their aggressive function.

An illustration in the Florentine Codex (appendix, fol. 26r) depicts a Mexica artisan smelting copper before pouring it into axe-shaped moulds. The metal was left to cool before being worked, increasing its hardness and durability. Other colonial imagery, from the Codex Durán and Codex Mendoza, shows how axes were fitted with wooden handles and used for woodcutting and carpentry.

Axes such as this were never intended for use as functional tools. Made from extremely thin copper, they were traditionally known as 'money-axes' and would have been used as currency. The Codex Mendoza lists money-axes as part of the tribute obtained by the Mexica from the Guerrero region (see fig. 54), and they were also sourced from Oaxaca. Such axes would have been packaged and bound into lots, making them easy to stack as repositories of metal. Colonial inventories list payments in copper axes (*hachuelas*) still being made after the conquest. *EVLL*

Cat. 97
Tweezers

c. 1400–1521
Copper, diameter 3.2 cm
Trustees of the British Museum, London, AOA Am 1986, Q.526

Selected literature: Vienna 1997, no. 37

Personal hygiene was important in Mexica culture, both as a ritual practice and a routine of daily life. In aristocratic circles, facial hair was plucked using metal tweezers. These could be made of gold, silver or in copper, as with this example. Tweezers made of gold and silver have been found in Mixtec excavations, while those in copper are mainly found in western Mexico.

Hair was of great symbolic importance in Mesoamerica. One of the Nahuatl words used for the head or cranium was *tzontecomatl*, literally, 'jar of hair'. Rank, status and gender were all signified by hair. Warriors grew long locks of hair to indicate their achievements in the battlefield. The taking of a prisoner by the hair symbolized his defeat, and the hair of captured enemies was sometimes exhibited publicly in small boxes, embodying the soul (*tonalli*) of the captive, which was originally located in the head, heart and liver.

In Mexica art the presence of facial hair is associated with elders and ancient gods. The ancient god of fire Huehueteotl, considered by the Mexica to be the oldest deity of their pantheon, is usually depicted in sculptures wearing a beard. In a number of carvings and in the colonial manuscripts Quetzalcoatl is also represented with a beard. In the Codex Mendoza (cat. 17) and in the *Teocalli* of Sacred Warfare (cat. 78), Moctezuma II is depicted with a beard, perhaps symbolizing his supreme status. *EVLL*

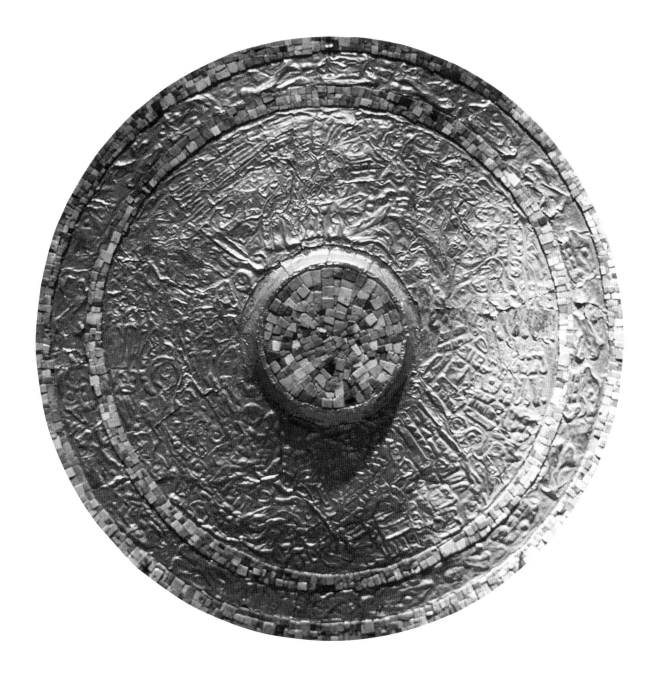

Cat. 98
Gold disc (*tezcacuitlapilli*)

c. 1300, Mixtec–Zapotec
Gold, jadeite and wood, diameter 20.8 cm
Museo Nacional de Antropología, Mexico City, inv. 10-4594

Selected literature: Solís Olguín and Carmona 2004, pp. 113–15; Robles Castellanos
2007, pp. 190–203; Velasco Alonso 2007, pp. 52–53

By the early sixteenth century the Mexica empire had reached its practical limits, and its expansionist policy evolved into a process of consolidating conquered territories. Moctezuma II sought to impose effective control on the lands conquered by his predecessors in order to bring stability to the empire. Around 1507, he sent a large military contingent to his garrison in Oaxaca to prevent any future insurrections and anticipate the predicted conflict with the independent domain of Tototepec, a coastal city set between the coasts of Guerrero and Oaxaca. Moctezuma's concern to ensure his position in this region was inspired by its abundance of precious materials, particularly gold. The goldsmithing tradition of the Oaxacan Mixtec–Zapotecs had been established for over three hundred years and their craftsmen displayed enormous skill.

This disc, found in 1971 in Tomb 3 at Zaachila, is constructed from a sheet of embossed gold with a pair of indistinguishable scenes framed by two concentric bands of encrusted jadeite, the outer ring embossed with animal heads and the inner one with a series of figures in a procession.

It is revealing that plate 24 of the Matrícula de Tributos lists, among the tributes that Oaxaca had to deliver every 80 days to Tenochtitlan, 20 discs of yellow gold, although it does not mention whether these were embossed or decorated at source. It is therefore likely that Moctezuma himself decided whether to inscribe his own words or cosmological visions on such insignia, especially as he had built workshops in his *tecpan* (palace) specifically to house the most talented artists from all over the empire. *RVA*

Cat. 99
Turquoise mask

c. 1400–1521, Mexica–Mixtec
Wood, turquoise and shell, 16.5 × 15.2 cm
Trustees of the British Museum, London, AOA Am St. 400

Selected literature: Carmichael 1970, p. 20–21; Pasztory 1983, fig. 61; García Moll, Solís Olguín and Bali 1990, p. 179; Miller and Taube 1993, pp. 172, 189–90; McEwan 1994, pp. 69–71; Townsend 2000, p. 185; London 2002, p. 476, no. 303; López Austin and López Luján 2004, pp. 403–55, 486; López Luján 2006, vol. I, pp. 186–87; McEwan *et al.* 2006, pp. 42–43, 45–47, 50; Aguilar-Moreno 2007, p. 213

This face is striking for its power and intensity. It has a rounded nose with flared nostrils, mother-of-pearl eyes with eyelids that were once gilded, and large white teeth made from conch shell (*Strombus gigas* or *S. galeatus*).

The turquoise tesserae used to pick out the facial features – the ridge of the eyebrow and the eyes, nose and mouth – are notable both for the precision of their placement and for the delicacy of their cut. Different tones of blue turquoise have also been used to enhance the mask's features. A very similar technique was used to decorate a mask now at the Museo Nazionale Preistorico ed Etnografico 'Luigi Pigorini', Rome (see cat. 68). Not only are the tesserae cut into similar sizes and placed with equal precision, but raised turquoise cabochons are also found in both examples.

Several scholars have identified this mask as a representation of Xiuhtecuhtli, the god of fire, whose name means 'turquoise lord' or 'lord of the years' since the Nahuatl term *xihuitl* refers both to the year cycle and to the precious turquoise stone. The association has been suggested not only because of the construction material, but also because of the stylized butterfly picked out in different shades of turquoise on the cheeks and forehead, a creature associated with fire and metamorphosis. However, the so-called 'butterfly nose ornament' is not delineated here in a colourful contrasting material, a technique that is often used to represent such ornaments on other mosaic objects (see cat. 68), and it does not take the shape usually shown in Mexica iconography. Moreover, similar changes of tonality can also be seen elsewhere on the face, suggesting that these parts were not intended to mark out a specific iconographic element.

Earlier hypotheses have attributed the mask to Quetzalcoatl or to Tonatiuh, the sun god, of which the latter is more plausible. In the Mexica creation myth of the sun, the deities gathered at Teotihuacan ('Place of the Gods') to decide on the future of the present or 'Fifth' era. To create the sun, one of the gods had to sacrifice himself by jumping into the fire. An old and poor god called Nanauatzin, whose body was covered with warts like the ones on this mask, was the only one brave enough to jump into the fire. He emerged as Tonatiuh, thus, this mask could represent the sun, which is also made of turquoise in Mexica accounts, and is accompanied though the sky by Xiuhcoatl. The warts or cabochons may be a reminder of the humble god who sacrificed himself and so became the main giver of life. The association of blue with Nanauatzin might also relate to his role as one of the *tlaloque* who, according to Mexica myths, helped steal maize from Tonacatepetl, the mountain of sustenance, to distribute to humanity.

Each of the hand-cut and filed mosaic tiles decorating this mask has been glued with resin onto a supporting structure. This was carved from cedarwood (*Cedrela odorata*) then slightly curved to produce the contours of the face. Its back was painted with red hematite, a pigment long used in Mesoamerica for burial rituals. Two suspension holes in its temples, once decorated with mother-of-pearl, indicate that it would have been worn tied to a face, effigy or funerary bundle. Upon the death of a ruler, masks were placed on the effigies of gods and on the royal funerary bundle, then probably burned as part of the ritual or deposited with the ashes of the deceased. Similar blue masks are also depicted in the Codex Borbonicus (see cat. 73) worn by various figures, as a protective element, during the New Fire ceremony.

The highest quality Mesoamerican turquoise, which is found in present-day northern Mexico and south-west United States, arrived at the capital of Tenochtitlan as tribute payment or by trade. Its use increased in the central areas of Mexico after 1400 and colonial sources, as the Matrícula de Tributos (fols 20 and 30) and the Codex Mendoza (fols 40r and 52r; see fig. 54), record the turquoise tribute paid from three different provinces (Tochpan, Quiahteopan, Yohuatlepec) to Tenochtitlan. Turquoise might have reached the capital as raw material, where highly skilled Mexica and Mixtec artists then used it to produce the most exquisite works of art.

EVLL

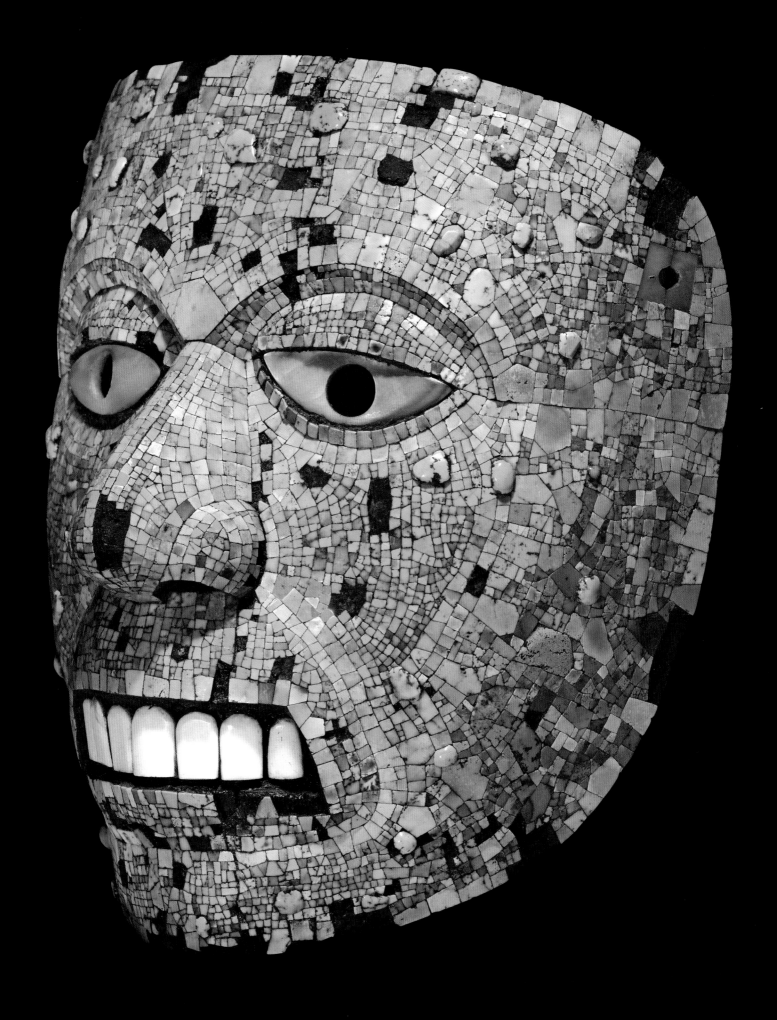

Cat. 100
Greenstone beads

c. 1469, Mexica
Greenstone, 1.5 × 2.0 × 4.2 cm (each)
Museo del Templo Mayor, Mexico City, inv. 10-251965 0/9, 10-252278 0/5, 10-266074
and 10-266075

Selected literature: López Luján 2005, pp. 237–43, 248–50

Greenstone beads, like this group of fourteen, were known in Nahuatl by the word *chalchihuitl*, meaning 'precious'. They are steeped in symbolism linked with fertility, water and blood, believed to be a liquid that renewed life. Although the genuine jade circulating in Mesoamerica in the Pre-Hispanic era came from the Motagua Valley, in today's Republic of Guatemala, a wide range of other green metamorphic rocks was used to make objects that also fulfilled these symbolic requirements.

Most of these beads were located in offerings 20 and 24 of the Templo Mayor, both associated with construction Stage IVb, in around 1469. Offering 20 was found in the middle of the building's rear façade – on the dividing line between the half devoted to Huitzilopochtli, the god of war, and the half consecrated to Tlaloc, the god of rain. Offering 24, in its turn, formed part of a group of offerings set in the main façade, under the large platform and in the centre of the staircase leading to the chapel dedicated to Tlaloc, so the presence there of greenstone beads must indicate a symbolic relationship with water. *CJGG*

Cat. 101
Shell ornament

c. 900–1520, Huastec
Shell, diameter 3.7 cm
Brooklyn Museum, New York, 48.149

Selected literature: Solís Olguín 2004, pp. 300–02

Huastec artisans worked in the 'international style', and the symbolism of the objects they produced was recognizable throughout Mesoamerica. The iconography ranged from complex figurative compositions depicting ritual scenes to more symbolic and abstract elements. Conches and other shells were abundant on the Gulf Coast of Mexico where the Huastec people established themselves during the Postclassic era. Huastec craftsmen produced a wide range of ornaments using the coastal marine resources as raw materials to further enhance their creations.

This piece is made from a fragment of polished conch shell, which has been cut into a circular shape and engraved with four skulls, arranged symmetrically around a central hole. Each skull has an arrow with hanging decorations perforating the ocular cavities and ceptum. The skulls still have eyes and bear the ruff of hair on top of the head decorated with bones often seen on figures associated with the earth and with death.

The speech scrolls emerging from their mouths reanimate these four skulls. Such iconography might have been used to emphasize the ability of the skulls to act as mediators between the worlds of the living and the dead. Skulls were especially important in Mesoamerican iconography (see cats 59 and 72), as they held connotations of sacrifice and war.

The Huastec people were contemporary to the Mexica political domination of the Basin of Mexico. Shell ornaments like these may have been imported to the central highlands, where large marine shells were only available via payment of tribute or the exchange of goods within the Mexica empire and across its borders. *EVLL*

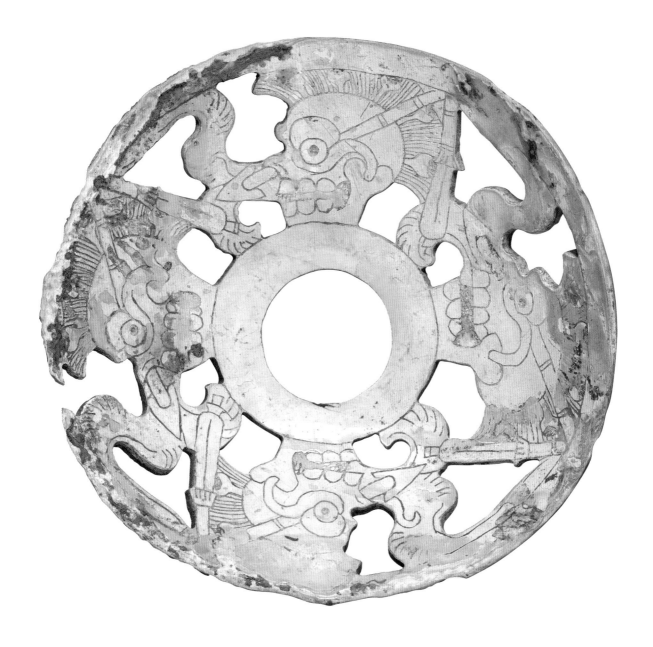

The overthrow of Moctezuma and his empire

John H. Elliott

THE MEXICA year 1 Reed – or 1519 to Europeans – was the moment when two aggressive, expansionist societies, two civilizations and two worlds came face to face. One was the Mesoamerican world of Moctezuma, the semi-divine ruler of a tributary empire extending from the Gulf Coast to the Pacific Ocean, who was now in the sixteenth year of his reign. The other was that of Renaissance Europe, as represented by Hernán Cortés, a gentleman-adventurer from Extremadura in southern Spain, who had sailed to the Spanish Indies in 1506 in search of fame and fortune. He had been somewhat hesitantly appointed by the governor of Cuba, Diego Velázquez, as captain of an expedition deputed to reconnoitre the Mexican coastline and discover something of the land and its inhabitants.

Well before 21 April 1519, the day on which Cortés's fleet of eleven ships with some 450 soldiers on board anchored off the Veracruz coast of central Mexico in the natural harbour of San Juan de Ulúa, disturbing reports had been reaching Moctezuma, in his capital of Tenochtitlan, of the sighting of strange figures and of what looked like 'towers or small mountains floating on the waves of the sea' (fig. 62).[1] Two previous Spanish expeditions from Cuba, in 1517 and 1518, had in fact preceded the much larger expedition led by Cortés. These expeditions had made for the Yucatan peninsula, the land of the Mayas, well outside the empire of Moctezuma. Trading relations existed, however, between the Mayas and the Mexica – and news of the first encounters with these mysterious intruders is likely to have filtered through to Tenochtitlan in 1517. It was alarmingly confirmed in the following year when the second Spanish expedition, led by Juan de

Fig. 61
The Conquest of Tenochtitlan (detail). Oil on panel, seventeenth century. Jay I. Kislak Collection, Library of Congress, Washington DC.

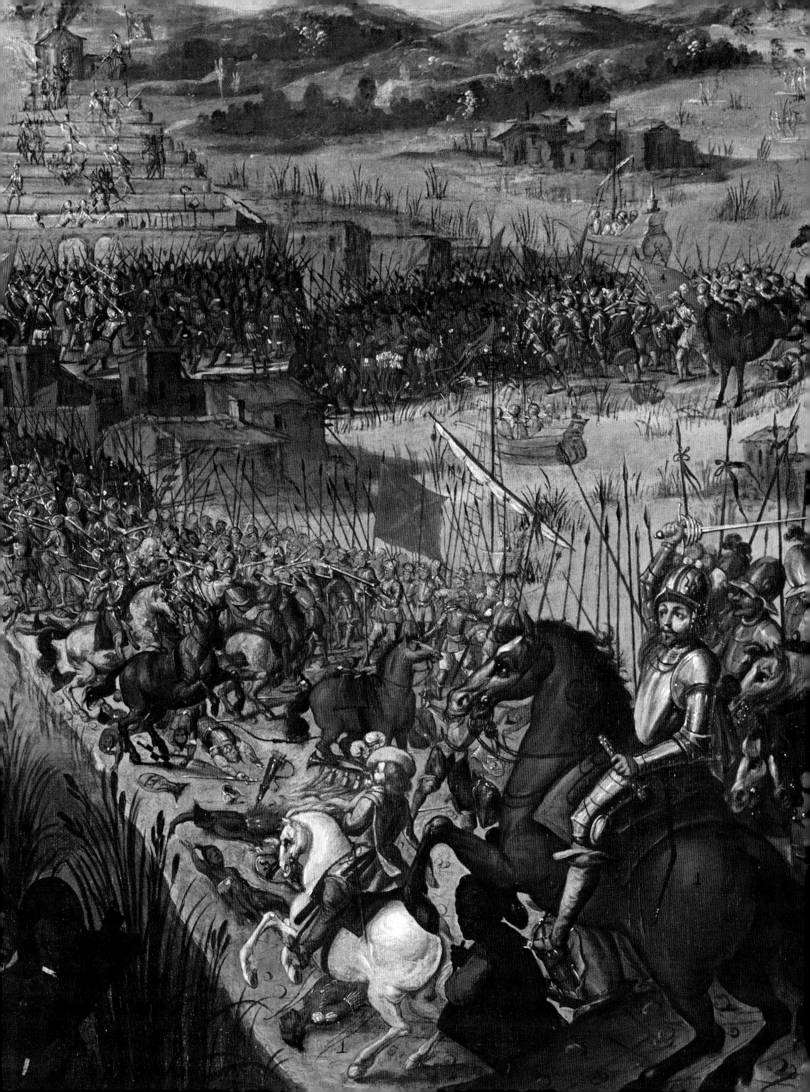

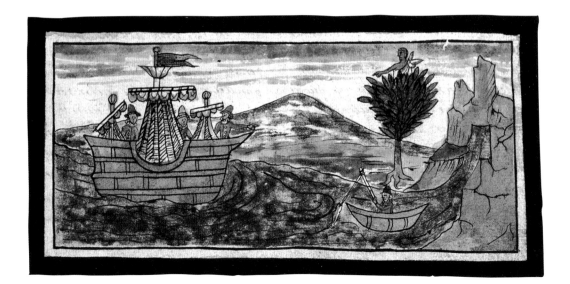

Fig. 62
Spanish ships arriving off the
coast of Mexico. From the Codex
Durán, fol. 197r. Biblioteca
Nacional, Madrid.

Grijalva, following the coastline westwards past San Juan de Ulúa, found itself skirting lands inhabited by Totonac Indians, who were reluctant tributaries of the Mexica. Reports of the arrival of white, bearded men were brought to Moctezuma, who ordered a watch to be kept on the coast.

What was the Mexica emperor to make of the apparition of these alien beings, and what did their arrival portend? For this, as for so much of the evidence about Moctezuma's often bewildering response to the actions of the Spaniards, we are heavily dependent on the account of the conquest of Mexico in Book 12 of the Florentine Codex, the great *General History of the Things of New Spain*, compiled in the 1550s and 1560s from Indian informants by the Spanish Franciscan, Bernardino de Sahagún. Although a wonderfully rich account, which undoubtedly preserves authentic elements of oral tradition dating back to the time of the Spanish expeditions, the Florentine Codex, like all the sources relating to the conquest, whether Spanish or indigenous, needs to be treated with great caution. This was a text produced a generation after the conquest and compiled by a Spaniard who had his own agenda, and his own inevitably partial understanding of the civilization that his compatriots had overthrown. His Nahua informants, for their part, belonged to a generation that had assimilated many aspects of Spanish and Christian culture, and were trying to make sense of the devastating events that had destroyed their world and replaced it with that of conquerors whose behaviour and mentality they were still seeking to understand.

In their retrospective attempt to explain to themselves the overthrow of the ancient gods and of the Mexica empire that worshipped them, Sahagún's informants – many of them his pupils from the Franciscan College of Santa Cruz in Tlatelolco, the junior partner of Tenochtitlan in the Triple Alliance – made Moctezuma the scapegoat for defeat.[2] But their narrative of Moctezuma's behaviour and of the events of the conquest was suffused with fatalism. In retrospect it appeared that the empire of the Mexica was doomed to dissolution, with the God of the Christians inevitably victorious over a pantheon of gods whose falsity, so insistently proclaimed by the missionary friars, had been amply demonstrated by their inability to save the Mexica from defeat. In line with this reading,

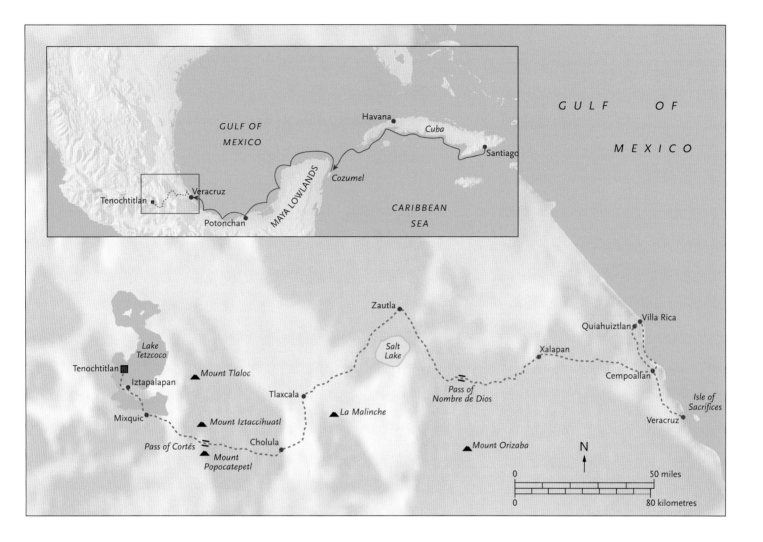

Fig. 63
Map of the route followed by Cortés and his men from Veracruz on the coast to Tenochtitlan.

it is not surprising to find that the narration of the conquest in the Florentine Codex begins with an account of eight successive omens. A tongue of flame appears in the sky; a pillar of the temple of Huitzilopochtli catches fire; another temple is mysteriously struck by a thunderbolt; a comet falls; the waters of Lake Tetzcoco boil; a weeping woman, the earth goddess is heard in the night crying 'we are about to be lost'; fishermen catch a bird like a crane with a round mirror on its head (fig. 64); and monstrous double-headed men appear, only to vanish once Moctezuma has seen them (fig. 65). While portents and auguries were part of Mesoamerican as of European culture, the omens recorded in the Florentine Codex bore striking similarities to those described by classical authors of the western world, such as Josephus and Lucan, whose works were to be found in the library of the College of Santa Cruz.[3]

Yet, while accounts of the omens given in the Florentine Codex and other post-conquest narratives can be read as attempts by a later generation to come to terms with the cataclysmic events of the 1520s, and are deeply coloured by European and Christian influences, they may also tell us something about how the Mexica traditionally perceived their emperor.[4] He was a sacred, untouchable figure, linking the past with the present and the human with the divine. His fate, and that of the cosmos, were inextricably intertwined. As the incarnation of the Mexica tutelary deity, Huitzilopochtli, it was his responsibility

de perder nós. Otras vezes dezia: o hijos mjos, adonde os lleuare?

El septimo aguero fue, que los pescadores, o cacadores del agua, toma

dazon espantados, y no supieron dezir nada.

El oitauo aguero fue, que aparecieron, en muchos lugazes, hombres

Figs 64 and 65
Two of the omens depicted in the Florentine Codex: the seventh omen showing the large bird with a mirror on its head; and the eighth showing the double-headed man. Book 8, fols 12v and 13r. Biblioteca Medicea Laurenziana, Florence.

to maintain the cosmic and the social order, and if he failed in this, disaster ensued. In depicting Moctezuma as frightened by the omens and filled with a sense of foreboding, the post-conquest chronicles implicate him directly in the impending cosmic catastrophe, in line with traditional Mexica beliefs about the workings of the universe. He is the sacred embodiment of their society, but as the narrative of the conquest unfolds, he is gradually desacralized. The untouchable emperor is physically touched by the Spaniards; he is passive where he is expected to be active, and weak where he should be strong. Finally his people turn against him because he has failed them. Yet, in accordance with Mexica theories of the cycles of time, a reign that ends in disaster also marks a new beginning. Moctezuma himself, in interpreting the omens as foretelling the end of the world, can see his own sacrifice as ushering in the new Christian era.

The Mexica who lived through the conquest may thus have sought to relate it to their conception of the nature of the cosmos and the central role of their ruler in holding it in equilibrium. Whether in fact such omens were indeed reported, and, if so, whether

Moctezuma, himself a former priest well versed in Mexica philosophy and religion, allowed himself to be disturbed by them, remains an open question. Although he was the *tla-toani*, the spokesman and supreme ruler, he did not act alone, but was guided by his council of great lords. When news arrived of the landing of Cortés and his men, the natural response of the emperor and his advisers was to attempt to find out as much as possible about them, sending artists to portray everything they saw. In conformity with Mesoamerican traditions of hospitality they also sent emissaries bearing gifts (fig. 66). These offerings, of gold and jewels, naturally whetted the appetite of Cortés for more. He had learnt from the Totonacs of the coastal region something about Moctezuma's wealth and power, and had begun to pick up reports that Mexica domination was much resented by many of the communities and peoples who were compelled to become his tributaries.

As he discovered more, he laid his plans for moving into the interior and encountering Moctezuma face to face. He would claim as his pretext that he was the emissary of a great ruler, the king of Spain, who in fact was not yet himself the ruler of an empire, although he would shortly become so on his election in late June as Holy Roman Emperor, under the name of Charles V. After establishing a settlement on the coast, which he named the Rich Town of Veracruz, and beaching his ships so that there should be no attempt among his men to return to Cuba, Cortés set off on 16 August from the nearby town of Cempoala at the head of some 300 men into an unknown world.

Both Cortés and Moctezuma were operating in the dark. Neither knew the other's intentions, and each could only guess at them by piecing together such fragments of evidence as became available, and then interpreting them within their inherited mental framework. Cortés, avid for gold and glory, possessed the confidence that came from his supreme belief in himself as a man capable of winning new dominions for his royal master and, with God's help, countless pagan souls for salvation. Spanish firearms and horses, both of them a novelty for Mesoamericans, would give him at least an initial tactical advantage. Reports of internal dissensions in the Mexica empire also encouraged him to believe that, if he played his hand with skill, the peoples of the interior hostile

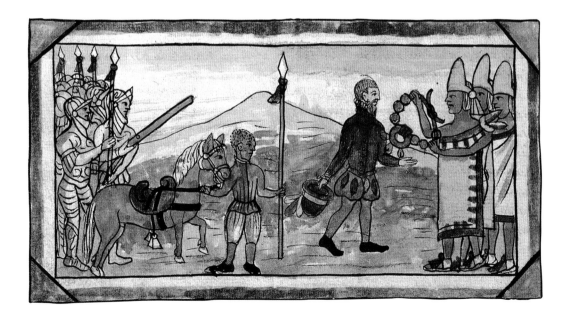

Fig. 66
Cortés with his horse and soldiers behind him meets Moctezuma, who presents him with a necklace of greenstones. From the Codex Durán, fol. 208r. Biblioteca Nacional, Madrid.

to Moctezuma and Mexica domination would, like the Totonacs, be willing to turn to him for help. But, with such a small band of men, marching through difficult and unknown terrain and potentially surrounded by enemies, confidence was bound to be fragile, even if the Spaniards picked up Indian allies along the way.

On the surface at least, Moctezuma, for his part, had more obvious reasons for confidence. As a ruler who had been victorious in his wars, he surely had nothing to fear from such a small number of armed men, however mysterious their origins. But the chronicles depict him as a man in the grip of terror. In the words of the Nahuatl version of the Florentine Codex:

> During this time Moteucçoma neither slept nor touched food. Whatever he did, he was abstracted; it seemed as though he was ill at ease, frequently sighing.... Therefore he said, 'What is to become of us? Who in the world must endure it? ... My heart is tormented, as though chile water were poured on it; it greatly burns and smarts. Where in the world [are we to turn], o our lord?[5]

Is this image of a despairing, panic-stricken Moctezuma faithful to the reality, or is it, as the story of the omens may also have been, another retrospective fabrication?

The passivity of Moctezuma as the Spaniards marched into the interior, stirring up rebellion among the tributary peoples of the Mexica, is indeed striking. He continued to send gifts to Cortés, but he did not attack, and all the time the Spaniards were drawing closer to his capital of Tenochtitlan, raiding and attacking where it suited their purposes. Many explanations have been put forward for Moctezuma's apparently supine response to the Spanish advance, but the evidence is so partial and fragmentary that it will never be possible to pronounce with any certainty on his motivation and behaviour.

The most dramatic explanation, and the one that has resonated the most widely in the literature on the Spanish conquest of Mexico, is that Moctezuma identified Cortés with the god of the sky and the wind, Quetzalcoatl, the 'Plumed Serpent', who had been worshipped by the Toltecs, the predecessors of the Mexica in central Mexico, but had been driven out by the followers of a rival deity, and would one day return from the east to reclaim his own.[6] Since Quetzalcoatl had been born, and had been driven into exile, in the year of Cortés's arrival, 1 Reed, such an identification was easily made. But while myths of a returning leader and culture hero do seem to have circulated in the Caribbean islands and in Mesoamerica around the time of the arrival of the Spaniards, the only evidence in the entire corpus of Nahuatl texts of any such identification by a perturbed Moctezuma comes long after the event, in the suspect Book 12 of the Florentine Codex. By the time this was composed, the prophecy of a returning Quetzalcoatl suited both the indigenous informants of Sahagún, anxious to explain the inaction and fatalism of Moctezuma, and by the Spaniards who believed that the figure venerated by the Indians as Quetzalcoatl, and sometimes described as white and bearded, might be none other than Saint Thomas, who was thought to have preached the gospel in America in the distant past.[7]

Along similar lines to the Quetzalcoatl myth, it has been suggested that the application of the Nahuatl word *teotl* to the Spaniards indicates that the Mexica saw them as

Fig. 67
Quetzalcoatl seated in a litter wearing a feathered headdress. Moctezuma gave Cortés a headdress made of quetzal feathers as he believed the Spaniard to be Quetzalcoatl himself. From the Codex Durán, fol. 228r. Biblioteca Nacional, Madrid.

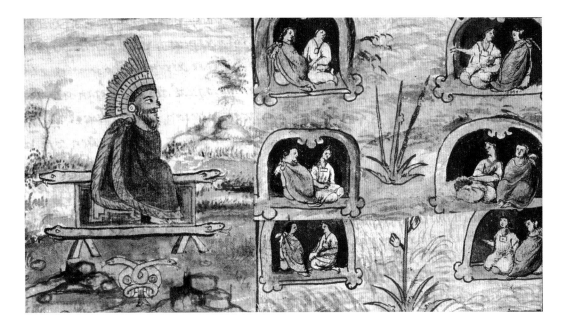

gods. There is still, however, much uncertainty about the range of meanings of *teotl*, which was indeed used of gods, but equally – in a cosmology where the human and the divine were so closely intertwined – could be used of demons.[8] It has also been argued that Moctezuma and his people, primarily dependent on oral communication and ritual discourse, and possessing a cyclical notion of time which bound them to the past, found themselves at an impossible disadvantage against Spaniards who were the products of a literate civilization, and enjoyed greater flexibility of thought and communication. In this reading, Cortés enjoyed a 'mastery of signs', which condemned the Mexica to preordained defeat.[9] But the later stages of the conquest and the early period of Spanish rule suggest that the Mexica were in fact quick learners, and by no means lacked the mental capacity to adapt and improvise.

There are other, more mundane, possible explanations of Moctezuma's behaviour. It was normal Mesoamerican practice to receive ambassadors with honour, and the gifts which Cortés interpreted as signs of submission were more likely to have been intended by Moctezuma as expressions of his overwhelming power and liberality.[10] Indeed, it may have been arrogance rather than fear that persuaded him that the Spaniards should be permitted to come to Tenochtitlan, where they could see for themselves the full extent of his greatness. He may, too, have wanted to make sure of the identity and intentions of the strangers before launching an attack, which anyhow would not have been easy during the rainy summer season when many of the commoners needed for his army were engaged in agricultural pursuits.[11] As priest and ruler, a heavy burden of responsibility rested on his shoulders, and these various considerations suggest that the best strategy, from his standpoint, was to play a waiting game.

In the meantime, the Spaniards were moving steadily inland, in spite of the natural and human obstacles they met on their way. On 18 September, after fierce fighting with the Tlaxcaltecs, they entered their city of Tlaxcala, which had retained its independence from the Mexica empire, and had for decades engaged in ritual 'flower wars' with the Mexica. Following their defeat the Tlaxcaltecs realized that they would gain in Cortés and his men

formidable allies in their conflict with the Mexica, and offered him their assistance, while rejecting his efforts to persuade them to abandon their gods and embrace Christianity.

The Tlaxcaltec alliance was to be crucial for Cortés's prospects, giving him military and logistical support as he resumed his march towards Tenochtilan. The news of this alliance was deeply disturbing to Moctezuma and his advisers, who were now becoming aware that they faced the prospect of a full-scale uprising of the subjugated, or not yet fully subjugated, peoples within the areas of Mexica domination or influence. According to the Florentine Codex, they sent out magicians to bewitch Cortés and his men and dissuade them from continuing any further along the road to Tenochtitlan. On 14 October, oblivious to the enchantments, the Spaniards and their Tlaxcaltec allies entered the wealthy city of Cholula, another independent city-state, but friendly to Tenochtitlan and hostile to Tlaxcala. Cholula, some fifty miles as the crow flies from Tenochtitlan, was the centre of the cult of Quetzalcoatl, but the Cholulans did not give Cortés the kind of reception that would have been due to a returning god. Warned, rightly or wrongly, of an impending attack, and very much on edge, the Spaniards and their Tlaxcaltec allies turned on the Cholulans on 16 October, indulging in two days of wholesale slaughter, and plundering and burning their temples and houses. Leaving the ruined city on 1 November, they moved inexorably onwards, until they had their first glimpse of the splendid lake capital of Tenochtitlan, which famously reminded the footsoldier, Bernal Díaz del Castillo, of some fabled city in that favourite romance of chivalry, *Amadis of Gaul*.

Arrival of the Spanish at Tenochtitlan

There seem to have been divisions in Moctezuma's council as reports came through of the dangerous Tlaxcaltec alliance with the Spaniards and the Cholula massacre. According to fragmentary indigenous sources preserved in the Codex Ramírez, his brother, Cuitlahuac, urged resistance, while his nephew Cacama, the ruler of Tetzcoco, argued that 'it was not proper for a great lord like his uncle to turn away the ambassadors of another great prince'.[12] It was this advice that prevailed, and on 8 November Moctezuma, preceded by the nobility in their rich attire, was carried out on his litter to greet the Spaniards as they moved down the causeway towards the main gate of the city (fig. 69).

Cortés dismounted and reached forward to embrace Moctezuma, but his attendants held him back; the emperor of the Mexica was not to be touched. He was probably wearing an embroidered cloak, a green feather headdress and gold-decorated sandals,[13] and we have an account of his appearance from Francisco López de Gómara, Cortés's secretary and chaplain during the last years of his life, who may well have had the description from the mouth of Cortés himself:

> Moctezuma was a man of middling size, thin, and like all Indians, of a very dark complexion. He wore his hair long and had no more than six bristles on his chin, black and about an inch long. He was of an amiable although severe disposition, affable and well-spoken, and gracious, which made him respected and feared.[14]

After a few formal words of welcome and an exchange of necklaces between the two men, Cortés and his soldiers were conducted to the palace beside the Templo Mayor that had once been the residence of Moctezuma's father, the ruler Axayacatl. Later that day Moctezuma returned with gifts of gold, jewels, feathers and rich clothing, and made a speech of welcome. As had been the practice during the march into the interior, Moctezuma's words were first translated into Maya by Malintzin, known to the Spaniards as Doña Marina, a woman of Nahuatl origins who had been brought up among the Mayas, and then from Maya into Spanish by Gerónimo de Aguilar, who had learnt the language during a period of captivity in Yucatan. The content of the speech, already made problematic enough by the difficulties of translation, becomes still more problematic when it is appreciated that the account of it comes from the pen of Cortés himself, in his second 'letter of relation', written for the Emperor Charles V, and dated 30 October 1520, almost a year after the entry of the Spaniards into Tenochtitlan.

Cortés's strategy, which he was no doubt developing in the light of unfolding events, was somehow to secure the submission of Moctezuma to the overlordship of the Emperor Charles V – in effect, a voluntary transfer of empire. The words he puts into Moctezuma's mouth, which refer to the expected return of a great lord, and contain a promise of obedience, carry suspiciously Christian and biblical overtones.[15] Moctezuma may in reality have been making no more than a traditionally florid speech of welcome, which was either misinterpreted or subsequently manipulated by Cortés for his own purposes. On the day following the speech, Cortés and a number of his companions paid a visit to Moctezuma in his palace, facing the Templo Mayor, and seized the opportunity to expatiate to him on the benefits of Christianity. Later he secured permission to visit the Templo Mayor itself, and, climbing to the top, was duly horrified by the image of Huitzilopochtli and the bloody signs of sacrifice. Apparently Cortés then asked that a cross should be placed on the top of the tower, and a sanctuary set aside for a statue of the Virgin. Moctezuma and the priests angrily refused.

It was probably on 14 November that Cortés took the most audacious decision of his entire career. Alarmed by the news that some of his men had been killed in the costal region of Veracruz, he went to the palace, accompanied by some of his senior captains and thirty armed men, to accuse Moctezuma of stirring up resistance to the Spaniards. In the exchanges that followed, Cortés threatened to kill Moctezuma on the spot unless he accompanied him quietly to his lodgings. A terrified Moctezuma told his entourage that, after consultation

Fig. 68
The right-hand scene shows a conversation between Moctezuma and Cortés, with Doña Marina (Malintzin) behind him acting as translator. The left-hand scene shows the Spanish column on the march accompanied by their Tlaxcalan allies. From the Codex Tlaxcala. University of Glasgow Library.

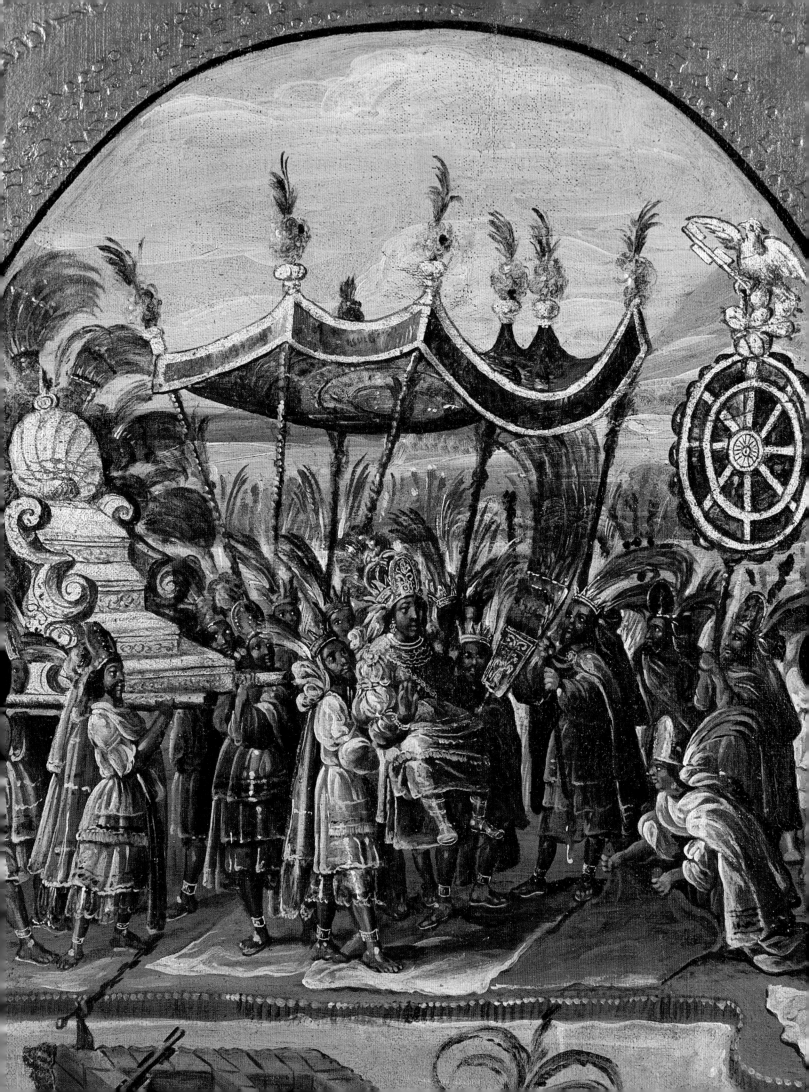

Fig. 69
Moctezuma and his retinue
(detail of cat. 118). Oil on canvas
mounted on wood panel. Museo
Nacional de Historia, Castillo de
Chapultepec, Mexico.

Fig. 70
Banner with the image of the
Virgin Mary carried by Cortés and
his men during his march to
Tenochtitlan. Museo Nacional de
Historia, Castillo de Chapultepec,
Mexico.

with Huitzilopochtli, he was going, as a gesture of friendship, to live for a time with the Spaniards.[16] So it was that, with much lamentation but without resistance, the Mexica emperor was carried by his nobles in a litter to Cortés's quarters, and became a prisoner in his own capital.

Once in Spanish custody, Moctezuma continued to rule, at least nominally, as he had always done. The Spaniards treated him with the deference due to his rank. He was allowed to keep his servants and his women with him, and his lifestyle continued as before. He was, Gómara tells us, 'naturally clean and neat; he bathed twice a day'[17] – a surprise to Spaniards who did not bathe at all. He became friendly with his captors, and would play Cortés at dice and at *totoloque*, a board game played with small gold pellets. Cortés, in turn, used the opportunity to discover all he could about his empire, and seized all the gold he could find. Emissaries, as usual, came to see Moctezuma from his many tributary communities, and, as usual, he would summon nobles and counsellors into his presence.

Beneath the apparently calm surface, however, trouble was stirring. Some time towards the end of the year Cacama, the king of Tetzcoco, turned against the Spaniards, but was apparently taken prisoner before his projected rebellion could be launched. Cortés then persuaded Moctezuma to assemble the leading nobles from across his empire. At this meeting he made the second of his speeches reported by Cortés. As before, he is represented as saying that the Mexica were not natives of the land, and that one day its true lord would return. That day had now come, and henceforth they should offer him their obedience, serving him with their tributes and acknowledging Cortés as his representative. Did Moctezuma in fact relate, or believe, this story about his ancestors being unlawful possessors of the land? Or was it a fabrication by the Spaniards, perhaps embellishing some local myth or legend they had picked up on the way?

Amidst much weeping and lamentation, each of the nobles in turn followed Moctezuma in offering his submission to the overlordship of Charles V, in an act duly witnessed and solemnly notarized. The transfer of empire was now, in Spanish eyes, a legal fact, and Charles, in the words of Cortés, could rightfully call himself 'the emperor of this kingdom with no less glory than that of Germany, which, by the Grace of God, Your Sacred Majesty already possesses.'[18] The reality, however, was much more precarious, and, when Cortés wrote these words in October 1520, the empire which he boasted of winning for his royal master had, to all intents and purposes, slipped from his grasp.

Moctezuma, for weeks a captive in Spanish hands, was already in danger of becoming a discredited figure among his own people, and Cortés's next action could only undermine him further. Indignant at the

continuing human sacrifices in the Templo Mayor, he and a few of his men went to the top of the pyramid, where, according to one Spanish account, Cortés brandished a bar and began attacking the idols, demanding that the priests should clear a sanctuary for images of Christ and the Virgin Mary. Moctezuma appears to have agreed, and wooden images of the Virgin and Saint Christopher (the only other image the Spaniards had to hand) were placed above two specially erected altars; but, over the next few days, the priests began removing the images of Huitzilopochtli, Tlaloc and other gods, and taking them into hiding. The Mexica were accustomed to incorporating other deities into their pantheon, but the exclusive demands of the Christians were intolerable, and threatened their world with destruction.

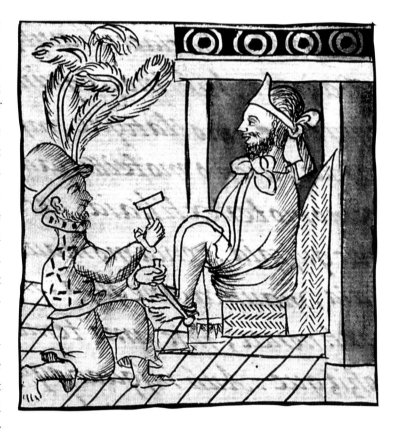

Fig. 71
Moctezuma being shackled by a Spanish soldier. From the Florentine Codex, Book 12, fol. 36r. Biblioteca Medicea Laurenziana, Florence.

If Cortés had so far dominated, through a combination of fear and personal charisma, it shortly became clear to the Mexica that the Christians were not in fact united. In marching into the interior, Cortés had defied the orders of his superior, Diego Velázquez, the governor of Cuba, who ordered his lieutenant, Pánfilo de Narváez, to lead an expedition against him. Around 20 April 1520 Narváez landed, and the news of his arrival compelled Cortés to depart hurriedly for the coast with some 250 men, leaving one of his captains, Pedro de Alvarado, with perhaps 100 of his fellow Spaniards, to hold Tenochtitlan in his absence. Permission had been given, at Moctezuma's request, for the customary annual celebration of the festival of Toxcatl in honour of Huitzilopochtli in the courtyard of the Templo Mayor. As the festivities proceeded, the presence of so many warriors, dressed in their finery, persuaded a nervous Alvarado that an attack was being prepared. On 16 May, after sealing off the entrances to the courtyard, the Spaniards and their Indian allies turned on the dancers and the spectators, taking them by surprise and massacring them in cold blood. Several thousand Mexica were killed, including their elite warriors. The savagery continued in the Spaniards' own quarters, where they killed Cacama, the ruler of Tetzcoco, and many of the lords closest to Moctezuma.

The consequences of Alvarado's action were devastating for the entire Spanish position, and also for that of Moctezuma. The failure to complete the ceremony, which should have included the appearance of Moctezuma in a ritual affirmation of his link to Huitzilopochtli, threatened a cosmic collapse.[19] With their emperor impotent and discredited the Mexica responded with a general call to arms. They destroyed the brigantines that the Spaniards had built for moving around the lake, and Alvarado and his men found themselves cut off from escape and threatened with starvation. Meanwhile, Cortés, having outwitted and then defeated Narváez on the night of 27 May, began the march back from the coast to Tenochtitlan with substantial reinforcements drawn from Narváez's army, which had included among its numbers a black porter infected with smallpox. An even more lethal enemy than the Spaniards would soon be sweeping through the Basin of Mexico.

The death of Moctezuma

When a weary Cortés reached Tenochtitlan on 24 June with an army of some 1,400 Spaniards and 2,000 Tlaxcaltec warriors he found himself entering a silent city. Moctezuma had told his people to call off their attacks, and they had reluctantly obeyed. But his authority was slipping away. Cortés on his return released Moctezuma's brother, Cuitlahuac, from captivity to secure the reopening of the great Tlatelolco market, and Cuitlahuac seized his chance. Within a day the city was up in arms, and the Spaniards found themselves in imminent danger of being trapped. Cortés persuaded Moctezuma to go on to the roof of the palace of Axayacatl, and tell his people to stop their attacks. But, as he sought to remonstrate with the attackers, he was struck and wounded by three stones from among the volley of rocks and arrows directed either at him or at his Spanish guards (see cats 115 and 118). Carried below, he refused to have his wounds dressed, but their gravity is unclear. Three days later, on 30 June, as the Spaniards were planning a night-time retreat from the city, Bernal Díaz del Castillo and his companions learnt to their surprise that he was dead. 'Cortés and all of us captains and soldiers wept for him, and there was no one among us that knew him and had dealings with him who did not mourn him as if he were our father, which is not surprising, since he was so good.'[20]

The exact cause of Moctezuma's death, like so much about the final year of his life, remains a mystery. He may indeed have died of his wounds, as Cortés and other Spaniards reported. On the other hand, Friar Diego Durán, the author of *The History of the Indies of New Spain*, was assured by his Indian informants that, after the Spaniards had been driven from the city, he was found dead with a chain about his feet and five dagger wounds in his chest. 'Near him were many noblemen and great lords who had been held prisoners with him. All of them had been slain before the Spaniards abandoned the building.'[21] There is no doubt that by the time of his death Moctezuma had so clearly lost his authority that he had ceased to be of any use to the Spaniards. To attempt to take him, or members of his entourage, with them as they made their escape would simply have added to their problems. The case for despatching him on the spot was therefore a strong one, but whether at the very end Moctezuma for once got the better of Cortés by dying before the Spaniards could kill him is something that will never be known.

The night of Moctezuma's death, 30 June – 1 July, has gone down in history as the *noche triste*, the night of sorrow. Under cover of darkness, Cortés and his men began their escape along the Tlacopan causeway, which, like the other causeways, had had its bridges removed. Alerted to their retreat, the inhabitants began attacking them from their canoes. During the desperate fighting that followed, Cortés probably lost some 600 of his men, along with large numbers of his Tlaxcaltec supporters. But he, and the shattered remnant of his army, eventually succeeded in making their escape, and, although under constant attack along the road, found refuge in friendly territory. Tlaxcala, in spite of the setback, remained faithful, and the Tlaxcaltec alliance would be decisive for the eventual Spanish victory. Opinion was divided in many of the tributary city-states, but the continuing strength of the Spanish-Tlaxtcaltec alliance and the prospect of an end to Mexica domination were strong inducements to lend support to the Spaniards at their moment

An ignominious end

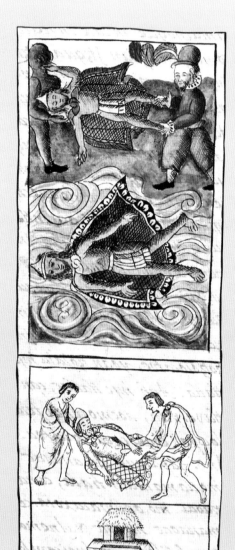

Fig. 72
The disposal of Moctezuma's body. From the Florentine Codex, Book 12, fols 40v and 41r. Biblioteca Medicea Laurenziana, Florence.

Although it remains silent on the nature of Moctezuma's death, the Florentine Codex offers three versions of the disposal of his body and that of Itzquauhtzin, appointed governor of Tlatelolco who died with him. The Nahuatl version informs us that the Spaniards tossed both bodies into a canal, thereby implying Spanish complicity in Moctezuma's death. However, it also plays heavily on his unpopularity as ruler. On its discovery, Moctezuma's corpse was hastily carried away and burnt on a pile of wood, while his subjects berated him for past cruelties and lies. By contrast, Itzquauhtzin is borne home by water for cremation with full honours. The compressed 'translation' tactfully tells the royal reader what he would expect to hear. Omitting the canal incident and, thus, any Spanish involvement, it states that although some of Moctezuma's people maligned their dead ruler, both lords received a state funeral and were cremated, as befitted their status. The native pictographic account seemingly attempts to reconcile both versions but, in the face of the colonial regime, it also incorporates a different indigenous view of the last Pre-Hispanic ruler of Tenochtitlan. Once representative of tyranny and treachery, Moctezuma II here symbolizes a form of native resistance grounded in notions of martyrdom and even dynastic revival.

Through use of the net coronation mantle, the figure of Itzquauhtzin is subsumed in that of Moctezuma. In the canal panel, the narrative overlapping emphasizes both Spanish military and civilian involvement in his death, perhaps denouncing political assassination. Moctezuma is carried away and laid within his funeral pyre, but the angry subjects are absent. The limp body of the deceased lord is supported gently beneath the shoulders and bent knees. With one arm falling to the side and the other lying across him, Moctezuma is here given honour in the manner of contemporary European representations of the Deposition and Entombment of Christ. Finally, surrounded by weeping mourners, he is seen squatting on his mat of authority wrapped in the net mantle with the royal, knot-tied diadem placed on his head. Although with eyes closed in death, this image of Moctezuma defies the traditional deployment of the death bundle by acknowledging his status in life. EW

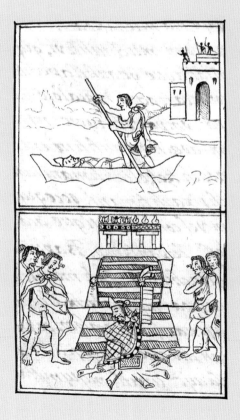

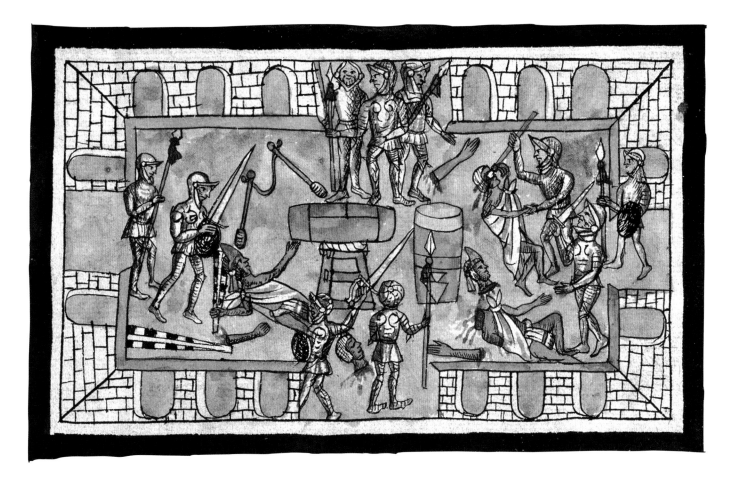

Fig. 73
Massacre of Mexica nobles led by Alvarado. From the Codex Durán, fol. 211r. Biblioteca Nacional, Madrid.

of greatest weakness. In the fragmented Mesoamerican world of a plurality of tribal communities, the presence of these intruders, with their horses and guns, provided an opportunity to throw off the Mexica yoke that was too good to be missed.

While Cortés was regrouping in preparation for what would be a carefully planned attempt to retake Tenochtitlan, the Mexica, who had lost so many of their nobles in the Alvarado massacre and the subsequent fighting, chose Cuitlahuac to succeed his brother as leader. The smallpox epidemic, however, was moving inexorably towards the capital, and by late November 1520 Cuitlahuac succumbed to the disease. His cousin, Cuauhtemoc, who had a reputation for valour, was chosen to succeed him. The ravages of the smallpox, coupled with the death of one leader and the election of another, made it difficult for the Mexica to attack the Spaniards when they were at their weakest. Instead, they chose to assemble a large army and await the enemy in the Basin of Mexico. Cortés for his part sought to dominate the local cities before launching his assault on Tenochtitlan itself. Above all, it was essential for him to control Lake Tetzcoco, and he ordered the building of thirteen brigantines, which proved crucial to his final success. On 31 May 1521 he was at last ready to embark on the siege of Tenochtitlan, and, by the end of two months of desperate fighting, the combined Spanish and Indian forces had clearly won the upper hand. On 13 August the city fell, and Cuauhtemoc was captured while attempting to escape in a canoe. Cortés and his Indian allies had conquered an empire for Charles V, but the beautiful city of Tenochtitlan, which had so entranced the Spaniards when they first caught sight of it, lay in ruins.

New Spain

With the Mexica empire overthrown, the long-awaited time had come for the division of the spoils. The army, and the royal treasurer who accompanied the expedition, were desperate to lay their hands on gold. Cuauhtemoc, the eleventh and last emperor of the Mexica, was interrogated and brutally tortured in an attempt to discover where it was to be found. Left a cripple by his ordeal, and kept captive by the Spaniards, he would eventually be hanged on the orders of Cortés in 1525, on the pretext that he was planning rebellion. Some three centuries later he would become the national hero of an independent Mexico, while Moctezuma would be despised for his pusillanimity and condemned as a collaborator.

Cortés anxiously awaited retrospective royal approval of his original act of defiance of the governor of Cuba. This finally arrived in May 1523 in the form of a decree signed by Charles V appointing him governor and captain-general of 'New Spain', as the conquered land was to be called. But Cortés was already taking the first steps towards consolidating and extending Spanish control over Mesoamerica. Reconstruction began in Tenochtitlan, which would rise from the ashes in the form of Mexico City, laid out in accordance with Spanish norms of urban design. The tribute machinery of Moctezuma's empire had fallen into Spanish hands virtually intact, and Cortés sent out his leading captains to establish Spanish control over different regions, and ensure that the tribute payments continued to flow into the capital, but into Spanish hands. In a bid to reward his restless soldiers and also to begin the process of Spanish settlement and colonization, he handed out entitlements to the labour services of the Indians. These proved to be a licence for ruthless exploitation.

As was normal in the process of Spain's overseas expansion in the sixteenth century, royal officials followed hot on the heels of the conquistadors. In due course, Cortés would find himself sidelined as a royal administration was established and the conquistadors and first settlers were gradually brought under royal control. In 1535 Don Antonio de Mendoza was sent out as the first viceroy of the kingdom of New Spain, which was to be administered by bureaucrats and judges appointed by the Crown.

While military conquest gave way to administrative conquest, a major attempt at spiritual conquest was also under way. In 1523 three Flemish Franciscans arrived in Mexico, and, at the urging of Cortés, twelve more Franciscans, the 'twelve apostles', arrived in the following year, to be followed in 1526 by twelve Dominicans. The first efforts of these mendicant missionaries appeared to be crowned with success. The Mesoamerican deities had gone down in defeat, and their discrediting left a spiritual vacuum waiting to be filled by the victorious, and exclusive, Christian God. Filled with zeal, the first mendicants arranged mass baptisms, and set about teaching and preaching the rudiments of Christianity to Indians who appeared to them to be innocent souls ripe for conversion. It was not long, however, before problems began to surface. The population of Mesoamerica, traumatized by the military conquest and, even more, by devastating European epidemics, assimilated many aspects of the faith of the conquerors, but in ways that accorded with their own sense of the sacred. The idols that Cortés had sought to banish were hidden, but not forgotten.

A new society, however, was in the process of being born in the decades that followed the conquest. Growing numbers of Spaniards arrived, to make a new home and new lives for themselves on the farther shores of the Atlantic, and the more successful among them joined the survivors among those conquistadors who had received grants of Indians, to form the beginnings of a new elite. Many of the pre-conquest indigenous elite had either perished in the struggle against the Spaniards, or were wiped out by the succession of epidemics that swept the country in the aftermath of the conquest. But the survivors, regarded as 'natural lords' by Spaniards imbued with their own acute sense of status, sought to accommodate themselves to the wishes and lifestyles of the conquerors and find a place, not necessarily with success, as intermediaries between the Spaniards and the tribal societies to which they belonged.

Cortés seems to have had a vision of some sort of blending of the world that he had conquered and the world from which he had come. He arranged marriages between leading conquistadors and the daughters of the indigenous nobility, having himself taken as a mistress the favourite daughter of Moctezuma, who was given the baptismal name of Doña Isabel Moctezuma. She bore a daughter to Cortés before she was married off successively to three conquistadors, and her descendants in turn would enter the ranks of the Spanish nobility.[22] Marriages, however, were less frequent than the taking of Indian mistresses. The result of these unions was a growing number of *mestizo* children, straddling the worlds of the conquerors and the conquered and forming an indeterminate element in the new society that was beginning to emerge.

This society was inevitably very different from that which had confronted Cortés when he landed on the Mexican coast in 1519. The peoples of north America were used to conquest and subjugation, but these were conquerors with a difference. They brought with them new technologies, new animals, and new and alien ways of seeing the world. But the greatest change of all came through the diseases that the conquerors brought in their wake. By the end of the sixteenth century, as one epidemic followed another, the indigenous population of Mesoamerica seems to have fallen by something like ninety per cent from its pre-conquest level. It would be a long time before the settling of New Spain by immigrants, the growth of a mixed-blood population, and the slow recovery of the indigenous survivors of demographic catastrophe would begin to fill the void.

Yet in spite of the devastation, many Nahua communities managed to survive and establish their own distinctive place in the society that was growing around them. They were touched, to a greater or lesser degree, by Spanish religion and culture, appropriating some parts of it and rejecting others, depending both on how far it suited their own specific needs and how far they were subject to coercion. But if they were changing in the light of changing circumstances, so too were the descendants of the Spaniards who settled in the country. Exposed to the pervasive presence of a Nahua world that had been defeated but not destroyed, they picked up local tastes, responded to local influences, and became in the process rather less Spanish than they imagined themselves to be. The Mexico that would in due course emerge from the confrontation between Cortés and Moctezuma was the legacy of both.

y entiendo hera, por que le tian por hombre
mas que humano, pues le descubria toposs
temik creyendo tener alguna noticia de las
cossas del cielo y que de alla participaba
lo que sabia.

¶ Los vejotzingas estuvieron A la mira para
ber en que parauan sus Pressos y en lo
que pararon fue que A una Parte dellos
dessollaron medio bibos, o bibos, y su cue-
ros sirvieron quarenta dias de pedir li-
mosna por las Puertas hasta los que
los traian vestidos nolos podian cufrir
Desçedo, los otros quemaron bibos y los
otros a saeteados bibos, en sacrificio y
honrra dela estrena del nuevo templo.
bisto por los vejotzingas lo que de su gente
se auia hecho, combidaron al rey de me
xico a una fiesta que querian haçer a su
Dios camaxtle que assi se llamaba y
no queriendo yr alla embio sus principa-
les en cuya presençia A sonrrar solem̃i
dad de aquel dios desollaron quin

Numero de mexicanos y otros hubieron
por los pessos y a otros quemaron bibos y A
otros a saetearon con la mesma cruel dad q̃
ellos los auian hecho y usado A se los q̃
murieron muchos Principales mexicanos
que fue cossa de gran compasion lo qual
oydo por montecuma dixo ques que es pre-
çisso esso Para esso naçimos y para esso sali-
mos al campo y esta es la muerte bien auen-
turada de que nros Antepassados nos de-
xaron notiçia y tan encomendada y luego
mando llamar a los del tlatilulco para
premiralles lo bien que les auian hecho y ve-
nidos ante el mando les diesen ropa de las
Diuersas de uissas y armas de diuersos
colores y joyas y mantas y otras cossas de
preçio con que los tlatilulcas quedaron
muy contentos y ufanos dando al rey mu-
chas y inumerables gras el qual los despidio
diçiendoles que les hacia Aquella merçed pa-
que afloxasen sino para q̃ trauajasen de lle-
bar adelante su baua y esfuerço y ellos prometen
de le seruir con todo su poder se fueron a su çiudad

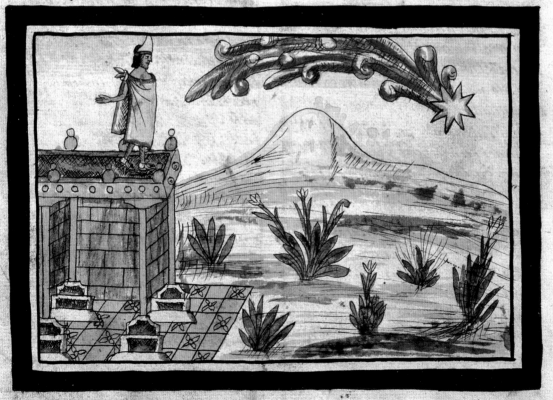

Cat. 102
The beginning of the end

Codex Durán

Diego Durán, *Historia de las Indias de Nueva España y Yslas de Tierra Firme*
c. 1579 – 81
Paper, 30 × 21 cm
Biblioteca Nacional, Madrid, Vit. 26-11

Selected literature: Garibay K. 1984; Codex Telleriano-Remensis 1995; Gillespie 2008

Perhaps the most important of a series of chronicles written by or associated with the Dominican friar Diego de Durán (1537–1588), this extensive illustrated manuscript details Pre-Hispanic religious rites, the workings of the native calendar, a history of Tenochtitlan, and the Spanish conquest, as drawn from native sources. Although in places heavily influenced by European art forms, the accompanying images are probably the work of several native hands.

This page depicts the great comet, the first of eight portents that supposedly announced the Spanish invasion and the fall of Tenochtitlan. Comets were understood to be omens of sickness, death, famine and war, and sometimes the demise of great princes and lords. Although it was seen approaching the city from the east at midnight by the priest-guardian of the temple of Huitzilopochtli, the figure represented here is probably Moctezuma II. According to Durán's text, the following night he watched for the comet from a rooftop.

The awkwardness of the building's perspective, together with Moctezuma's apparently fearful gesture (he had been warned that the comet foretold his death), are in contrast to the powerful graphic elegance of the celestial body, which offers a direct glyphic reading of its Nahuatl name *citlalin popoca* ('smoking star'). It is perhaps not coincidental that the comet's head also takes the form of an eight-pointed star that effectively numbers the portents: a sign within a sign that more are to come. Certainly, when news of the comet spread through the land, 'so great were the clamours and cries directed towards the sky ... it seemed that the world was ending, the end was coming.'

Most scholars now agree that the portents were a post-conquest invention, used to explain the unexplainable, or serving as metaphors for the public dissent surrounding Moctezuma's actions in the face of the invader and the failures of his regime prior to 1519. Others refer to native conventions of reconstructing history on the basis of cosmic principles, through which the events of the conquest came to be portrayed as a series of cosmic disasters. Superstition and fatalism also played an important role in the reconstruction of events: for example, the specific detail that Moctezuma first saw the comet from a rooftop may have been inserted into history as a means of foretelling his death on a rooftop several years later.

The comet is recorded as appearing in 1509, ten years before the Spanish arrival. According to Anthony F. Aveni, no known comet corresponds to that year, the nearest being 1506, or year 1 Rabbit. In native belief, 1 Rabbit was a 'famine' year. Some indigenous sources register that it was a bad year for Moctezuma in other ways, so much so that he changed the date of the New Fire ceremony to 1507. It is therefore not impossible that the 1506 comet was transplanted historically to 1509, as the year when the beginning of the end started to take form in the Mexica world. *EW*

Cat. 103
Obsidian mirror

c. 1325–1521, Mexica
Wood and obsidian, 27.8 × 25.5 × 1.4 cm
Trustees of the British Museum, London, AOA Am 1825,1210.16

Selected literature: Anonymous 1968; Hildesheim-Munich-Linz-Humlebæk-Brussels 1986, nos 353, 354; Serra Puche and Solís Olguín 1994, pp. 185–97; Meslay 2001; Saunders 2001; London 2002, pp. 473, 484; Olivier 2003, pp. 75, 111, 241–42, 252, 261–65, 351

Obsidian is a dark, glass-like stone that derives from igneous rock. The sixteenth-century chronicler Bernardino de Sahagún describes how obsidian was polished with abrasive sand to produce a reflective surface that could be used as a mirror. Obsidian mirrors from the Postclassic period have been found in Michoacan, the Basin of Mexico and Oaxaca. They were among the gifts despatched to Spain by Hernán Cortés and were originally embellished with wooden frames, feathers and other perishable ornaments. Their reflective and deforming qualities meant that they were widely collected in Europe courts.

Sahagún describes two kinds of stone used as mirrors: one white and the other black, the last one identified as obsidian. Obsidian was associated with water, the earth and the underworld, and was linked with Tezcatlipoca (see cat. 71), who is often depicted with obsidian mirrors either at his temples, flanked by eagle down, or as a substitute for one of his feet. Tezcatlipoca's mirror was also connected to the nocturnal aspects of the sun, with a divinatory function as a 'speaking' stone that predicted the future. Furthermore, mirrors were sometimes associated with Huitzilopochtli.

Mirrors had several symbolic meanings and functions relating to knowledge, sorcery and the uncovering of wrongdoing. According to Sahagún and Diego Durán, humans used mirrors to look upon Tezcatlipoca's image while the gods used them to observe mortals. The *tlatoani* himself was said to own a double-faced obsidian mirror, probably similar to this one, through which he could see his people and all that took place in the world. Moreover, the ruler could use a mirror to interpret the wishes of deities who would thus guide him on the right path. *EVLL*

Cat. 104
Turquoise double-headed serpent

c. 1400–1521, Mixtec–Mexica
Wood, turquoise and shell, 20.5 × 43.3 cm
Trustees of the British Museum, London, AOA Am 94-634

Selected literature: Carmichael 1970, p. 17; Pasztory 1983, fig. 58; Miller and Taube 1993, pp. 148–151; McEwan 1994, p. 80; Townsend 1995, p. 185; London 2002, pp. 57, 473, no. 294; López Luján and Fauvet-Berthelot 2005, p. 170; McEwan *et al.* 2006, pp. 12, 20–22, 33, 54–59; Aguilar-Moreno 2007, pp. 213–14; McEwan 2009, p. 16

The Nahuatl term *coatl* can be translated as both serpent and twin. The Mexica considered serpents to be powerful, multifaceted creatures that could bridge the spheres of the cosmos (the underworld, water and sky) owing to their physical and mythical characteristics (see for example cats 69 and 70).

Serpents were also associated with fertility and with water, perhaps owing to the undulating movement of their bodies. In Mexica iconography turquoise serpents (*xiuhcoatl*) are related to celestial events (see cat. 76). On the Mexica Calendar Stone (see fig. 28), two *xiuhcoatl* accompany the sun on its daily journey across the sky.

Double-headed serpents (*maquizcoatl*) were considered to be the bearers of bad omens and were associated with elite figures. The Mexica believed that anyone finding one in their path should place it on their arm. If the serpent could not be moved it meant that death was approaching. Maquizcoatl was one of the names given to the supreme Mexica god Huitzilopochtli. It is therefore no coincidence that four double-headed serpents, worn as bracelets and anklets in the monumental sculpture of his vanquished sister Coyolxauhqui, excavated at the Templo Mayor (see fig. 10).

This double-headed serpent (see overleaf) is carved from a single piece of Spanish cedarwood (*Cedrela odorata*). The front of the serpent and the two heads are covered with turquoise mosaic,

and the hollowed-out reverse of the body was originally gilded. The open jaws have menacing fangs made of *Strombus* shells, with gums and nostrils depicted using fragments of the red thorny oyster (*Spondylus princeps*) (see also cat. 72).

Both snouts are decorated with representations of feathers and a double band of turquoise and shell discs on a black background. The decoration is similar to that which appears on numerous sacrificial vessels or *cuauhxicalli* (see cat. 62), perhaps linking the morbid connotations of this magical animal to the destiny of its victims. The heads may originally have featured inlaid eyes made from pyrite or obsidian, and flickering tongues might have been attached to the holes in the centre of the lower jaws to create the impression of a living creature.

The two holes at the top indicate that this double-headed serpent may have been worn on the chest as a pectoral. Similar large zoomorphic effigies worn in this way are illustrated in fol. 72 of the Codex Magliabechiano depicting the earth goddess Cihuacoatl, and in fols 9, 10 and 34 of the Codex Borbonicus (see cat. 73). This *maquizcoatl* might therefore have been an insignia worn or held by an effigy of Huitzilopochtli or one of his impersonators.

EVLL

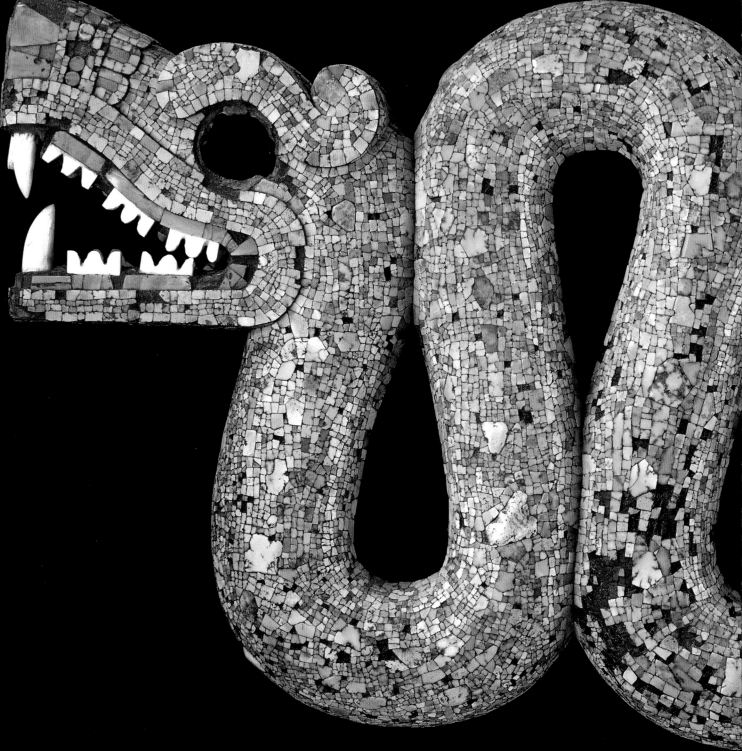

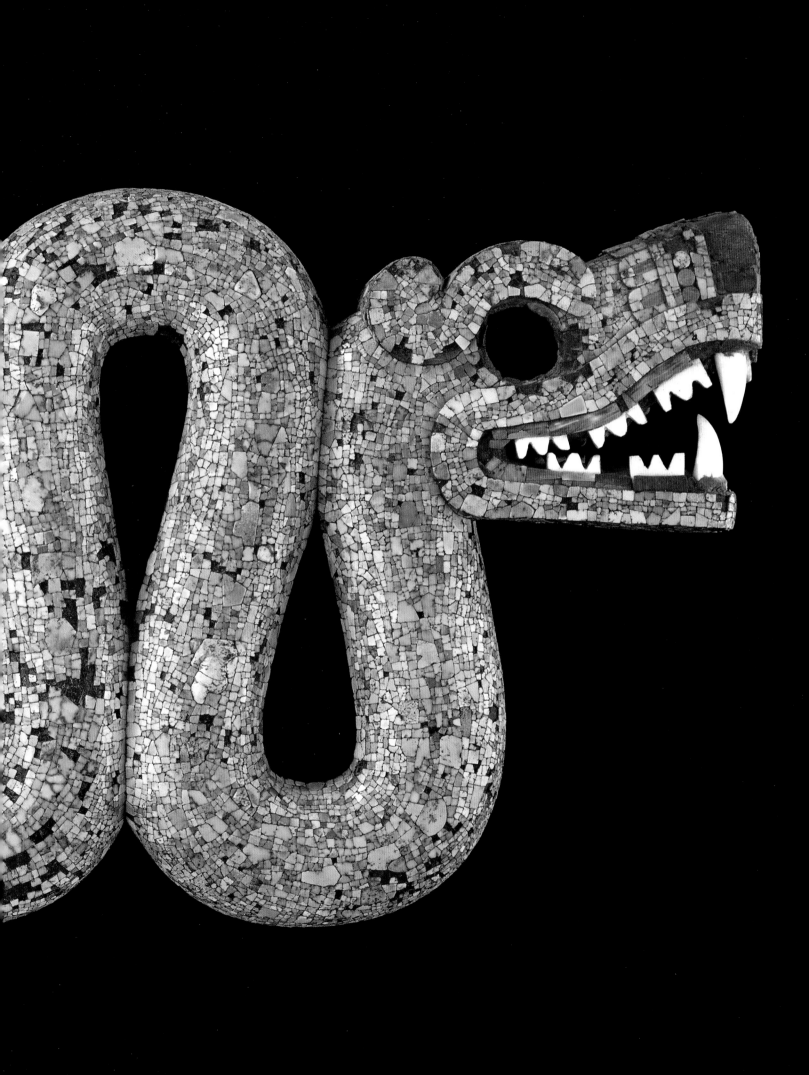

Cat. 105
Armoured breastplate of Pedro de Alvarado

Sixteenth century, European
Iron, 42 × 34 cm, weight 2 kg
Museo Nacional de Historia, Castillo de Chapultepec,
Mexico City, inv. 10-233988

Selected literature: Martínez Chiñas 1994, p. 213

Pedro de Alvarado, the conqueror of both Mexico and Guatemala, was the leading figure in the Spanish invasion after Hernán Cortés. The indigenous population referred to him as Tonatiuh ('Sun') on account of his blonde hair. He won fame for his daring in battle, for having initiated the massacre in the Templo Mayor in Tenochtitlan prior to the capture of Moctezuma, and for the extraordinary leap that saved his life on the night of Moctezuma's death, the *noche triste* (night of sorrow). Over the centuries, however, he was known mainly from literature, paintings, Spanish chronicles and indigenous accounts such as the Codex Telleriano-Remensis. Few objects have survived that endow him with a human dimension. This armoured breastplate is the only piece that reveals his warlike character. How it came into the collections of the Museo Nacional de Historia is unclear, but its exceptional value and provenance have been acknowledged by generations of experts.

The breastplate, which was made in Europe, possibly Italy, bears the word ALVARADO incised on the medallion near the heart. With its intertwined vertical rows of scrolls and spirals, incised and die-cast according to contemporary taste, it was intended for personal adornment rather than self-defence. Fifteen oval medallions contain images of angels, gentlemen, two knights and a full-length Madonna – perhaps a depiction of the Immaculate Conception. These figures were apparently based on illustrations from books, which would have been traced before being transferred onto the breastplate using acid.

The knights in plumed helmets astride restless horses evoke the covers of the chivalric novels that were popular with the Spanish conquistadors.

Although there is no documentation categorically confirming that this breastplate belonged to Pedro de Alvarado, it is one of the oldest pieces in the museum, and nineteenth-century illustrations of the museum's treasures confirm its early presence in the collection. It may have been made shortly before Alvarado's death in 1541. He died after falling from his horse during the battle of Nochistlan against the indigenous Caxcan rebels in the province of Xalisco. *SRS*

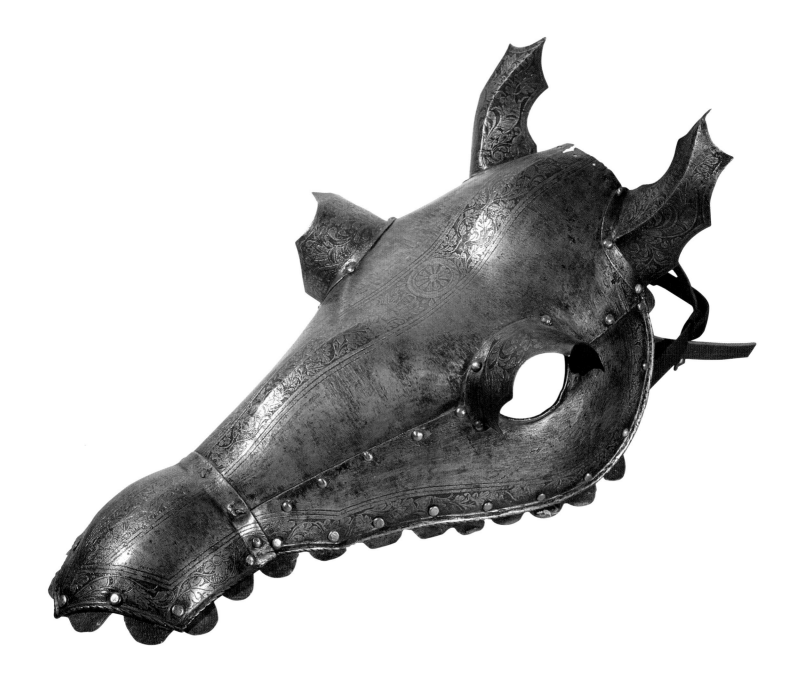

Cat. 106
Chamfron for a horse

Early sixteenth century, Spanish
Riveted and burnished wrought iron with etching,
32 × 56.5 × 33.5 cm
Museo Nacional de Historia, Castillo de Chapultepec,
Mexico City, inv. 10-92271

Selected literature: Benavente 1941, pp. 161–62; Díaz del
Castillo 1944, vol. 1, chapter XXIII, pp. 92–93; Sahagún
1979, Book 12

The indigenous population was terrified
not only by the numbers of horses brought
by the conquistadors but by their mere
presence. The Franciscan Toribio de
Benavente (Motolinía) recorded that the

local people were 'astonished and
frightened to see horses and what the
Spaniards did on top of them', while the
indigenous testimonies collected by
another Franciscan, Bernardino de
Sahagún, described horses as enormous
'deer that bore men on their backs'. These
animals, clad in iron and bells, snorting,
bellowing, exuding 'oceans of sweat', these
roaring creatures that damaged the earth
with their feet, seemed to be the very
embodiment of ferocity. The chronicler
Bernal Díaz del Castillo recounted that
Hernán Cortés's original expedition
included sixteen mares and stallions – not
all of them suitable for battle – that they

had acquired with difficulty in Cuba by
paying their 'weight in gold'. He added that
fifteen mounted horsemen accompanied
Cortés on his entry into the 'Villa Rica de la
Vera Cruz'.

After the fall of Tenochtitlan, chamfrons
like this one adorned horses in festivals
such as the Paseo del Pendón and the
many celebrations involving parades and
'games with poles'. Very few of these pieces
survived into the sixteenth century in a
New Spain that now required iron for non-
military purposes. The metal from the war
of conquest was used to make farming
equipment and other tools, fittings for doors
and chests, nails, spurs and harnesses. SRS

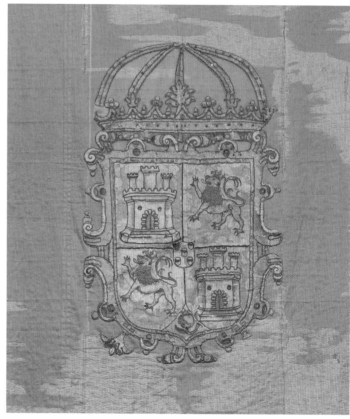

Cat. 107
Standard of Cortés or the Paseo del Pendón

Sixteenth century, colonial
Gold/red damask with silk appliqués embroidered with metal thread and oil on silk,
292 × 245 cm, approximately 8 kg
Museo Nacional de Historia, Castillo de Chapultepec, Mexico City, inv. 10-128950

Selected literature: García Icazbalceta 1896, vol. II, pp. 44ff.; Lomnitz 2006

The colonial rulers assigned 13 August 1521, the feast day of
St Hippolytus the Martyr, as the birth date of New Spain. On that
day, the last Mexica *tlatoani*, Moctezuma's nephew Cuauhtemoc,
was captured on Lake Tetzcoco and so 'the land was won for
Christianity'. To commemorate the event, in 1528 the City Council
instituted a holiday that was appropriately described as 'the first
civic-religious celebration of Mexico City'. In 1529 it was decreed
that 'every year, in honour of the feast of the Lord St Hippolytus,
on whose day this city was won ... the banner is taken ... out of
the City Hall and taken with all the people who could go on
horseback accompanying it to the Church of St Hippolytus, and
there solemn vespers are said and this banner is taken again on
horseback to the said City Council in which ... it is kept ... and
from which it does not come out.' A sum of 40 pesos was
allocated to 'order the royal standard from the best tailor in the
city'. This Castilian standard, along with the host of flags,
banners and processional crosses that had been accumulated

over the years, accompanied the flag hoisted by Hernán Cortés
following the capture of Tenochtitlan.

Some of the indigenous codices include depictions of the form
and symbols of the conquistadors' standard. The Codex Telleriano-
Remensis records a cross on a white background, while the Virgin
Mary graces the version in the Lienzo de Tlaxcala. Paintings
depicting scenes from the conquest, however, display a red banner
with the shield of Castile and León. Although discoloured, the
damask and silk standard preserved in the Museo Nacional de
Historia still bears some traces of the original red colouring. The
metal-embroidered Castilian shield in the centre bears witness
to the banner's role in the annual celebrations.

A royal decree officially named the holiday the 'Paseo del
Pendón'. The civil and ecclesiastic authorities in the viceregal
capital were obliged to celebrate the event by marching solemnly
from the Church of St Hippolytus – built on the spot where the
conquistadors were defeated on the *noche triste* (night of sorrow) –
to the City Hall and then back again to the church. Around the end
of the seventeenth century and the start of the eighteenth the
holiday was celebrated with great splendour, although on several
occasions it was disrupted by a storm. Laws passed in Cadiz in
1812 and Mexico's attainment of independence in 1821 heralded
the official end of the festival celebrating the conquest and, in José
Joaquín Fernández de Lizardi's provocative description of 1822,
signalled the 'death of Don Pendón'. *SRS*

Cat. 108
Medal of Cortés,

1529, Christoph Weiditz (c.1500–1559)
Lead, diameter 5.4 cm
Trustees of the British Museum, CM 1906,1103.1763

The obverse legend dates this medal to 1529, the year after Cortés had returned to Spain to defend himself against accusations made by his enemies in Mexico. The reverse legend translates as 'The justice of the Lord takes hold of them and his fortitude has strengthened my arm', seemingly a reference to the dismissal of those charges. The legend and the image of a muscular arm bathed in divine radiance also point to the courage and faith claimed by Cortés.

The German medallist Weiditz was born in Freiburg and worked in Strasbourg before moving to Augsburg in 1526. From 1529 he was attached to the court of the emperor Charles V, and in that year he travelled to Spain, where he met Cortés and made a drawing of him in his sketch book (now in the Germanisches Nationalmuseum, Nuremberg). Charles V, who decorated Cortés and awarded him a title and land in Mexico, may have commissioned the medal as a further compliment. An alternative possibility is that Cortés, aware that Weiditz was a maker of medals, instigated it himself as an act of self-promotion and in commemoration of the success he had won, but this is perhaps less likely given the incorrect age of forty-two given on the obverse. *PA*

Enconchado series

c. 1680–1700, colonial
Oil on canvas and shell, 112.5 × 67.8 × 8 cm (each)
Museo del Prado, Madrid, inv. 00101; 00109; 00110; 00111; 00112; 00115 and 00116

Selected literature: García Sáiz 1999; Brown 2004; Martínez del Río de Redo 2006; Montes González 2006

These seven works were created in Mexico in the late seventeenth century and form part of a series of twenty-four scenes from the conquest of Mexico. The paintings are in oil on wood with areas of inlaid mother-of-pearl shell whose natural lustre catches the light and enlivens the surface. They have therefore come to be popularly referred to as 'enconchados' (literally enshelled or shellwork). This pictorial technique was inspired by imports from eastern Asia for, during the seventeenth century, New Spain had become the fulcrum of a profitable trade route linking Spain and China via the Philippines. Sumptuous silks and folding screens or *biombos* – from the Japanese word *byobu* meaning windbreak – were landed from the Manila galleon at Acapulco on the Pacific Coast. From there they were transported overland to Mexico City for consumption by Spanish and Creole elites or were taken to Veracruz on the Gulf Coast for onward shipment to Spain.

One work in the series is signed by Miguel González and dated 1698. This almost coincides with the governorship from 1696–1701 of José Sarmiento y Valladares as Viceroy of New Spain. It was he who claimed the title Count of Moctezuma from his first wife – a lineage that is maintained to this day both in Mexico and in Spain. Although there is no surviving documentary proof, it is likely that the governor had a direct hand in commissioning the series. The paintings were designed to narrate the main episodes of the conquest to the growing Creole elite – people of Spanish descent born in New Spain. Under the Spanish Crown they played an increasingly significant role in forging the new colonial society but were denied access to high office. Paintings had a key role in shaping and projecting the signal events and principal protagonists that underpinned the birth of New Spain. Cortés and Moctezuma were portrayed as founders of this new order in which Creoles and Indians sought to co-exist, loyal to Spain but seeking to assert their own distinctive identity.

Cortés dines with Moctezuma's envoys
This scene depicts Hernán Cortés soon after landing at Veracruz entertaining two of Moctezuma's envoys at an al fresco meal waited upon by attendants. The party is seated at a table under an awning with Cortés at the centre. In the background is Cortés's fleet of vessels, grounded on his instruction to prevent his men retreating.

Cortés approaches Tenochtitlan
Cortés is portrayed leading an armed phalanx across the southern causeway on the approach to Tenochtitlan. He carries a red flag at the centre and is accompanied by Spanish horsemen and foot soldiers. Alongside are some of the (Tlaxcalan) allies he acquired en route. These were rivals and enemies of the Mexica who willingly sided with the invading force.

Moctezuma comes to meet Cortés
Moctezuma leads the procession of nobles from the royal court out of Tenochtitlan to meet Cortés. He is borne on the shoulders of his court attendants under a protective awning with his distinctive high-backed woven throne carried behind. In the background attendants play drums and wave large feathered fans.

Cortés visits Moctezuma
Cortés makes an initial diplomatic visit to Moctezuma's palace. In this colonial rendering the portraits of Moctezuma's predecessors hang on the wall behind him to underline his status as the inheritor of a long and distinguished royal lineage. Moctezuma is on the right, gesturing Cortés towards two thrones with the Tenochtitlan city crest of an eagle on a cactus mounted above. The implication is that they are destined to rule together and thus fashion a New Spain in which Creole and Indian will live together.

Moctezuma visits Cortés
Cortés was housed in the palace that once belonged to Axayacatl, Moctezuma's deceased father and a former ruler. Here, Moctezuma visits this palace where Cortés and his party are quartered. Moctezuma places a necklace around Cortés's neck, while his noblemen hold platters bearing fine jewellery and ornaments, which they distribute among the Spanish soldiers.

Moctezuma is captured and shackled
Cortés had persuaded Moctezuma to take up residence under Spanish guard in Axayacatl's palace. He then learned of communication between Moctezuma and a rival Spanish force led by Narváez on the coast. As a precaution he had Moctezuma put in irons as illustrated in this scene. Soon afterwards Cortés ordered the removal of images of the Mexica gods from the Templo Mayor and installed in their place a crucifix and statue of the Virgin Mary.

Moctezuma is presented to his people
Cortés left Tenochtitlan for a brief period. In his absence the Spaniard Alvarado led a massacre of hundreds of Mexica noblemen gathered in the sacred precinct to celebrate the festival of Toxcatl. This provoked outrage among the Mexica, who laid siege to the Spanish in their palace quarters, mounting ferocious attacks. In a final attempt to calm the situation, the Spanish took Moctezuma out onto an upper-storey balcony to address the gathering crowd. In this scene, the angry populace hurl abuse and throw stones at Moctezuma, some of which are said to have struck him. He died a few days later, whether from his wounds, or, being of no further use to the Spanish he was murdered by them, is unclear.

MSGS

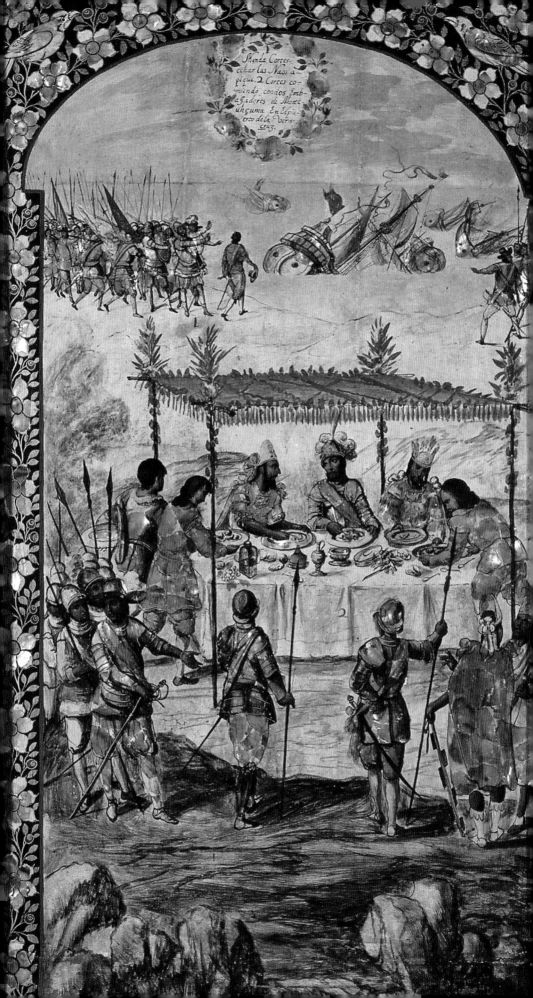

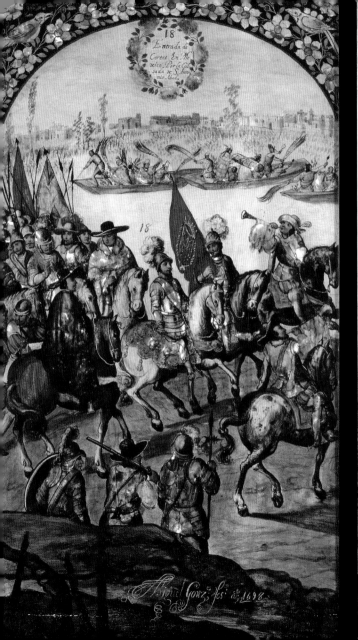

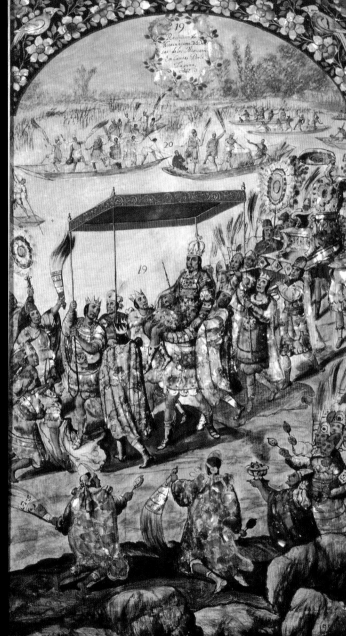

18

Entrada de
Cortes En Me
xico, Por la Cal
sada de S.Anto
nio Abad

18

Miguel Gonz.les a.° 1698

19

Resivese de
Motencuhzoma
asi de los Mexican
os Cortes Por la
Laguna
&.t

20

19

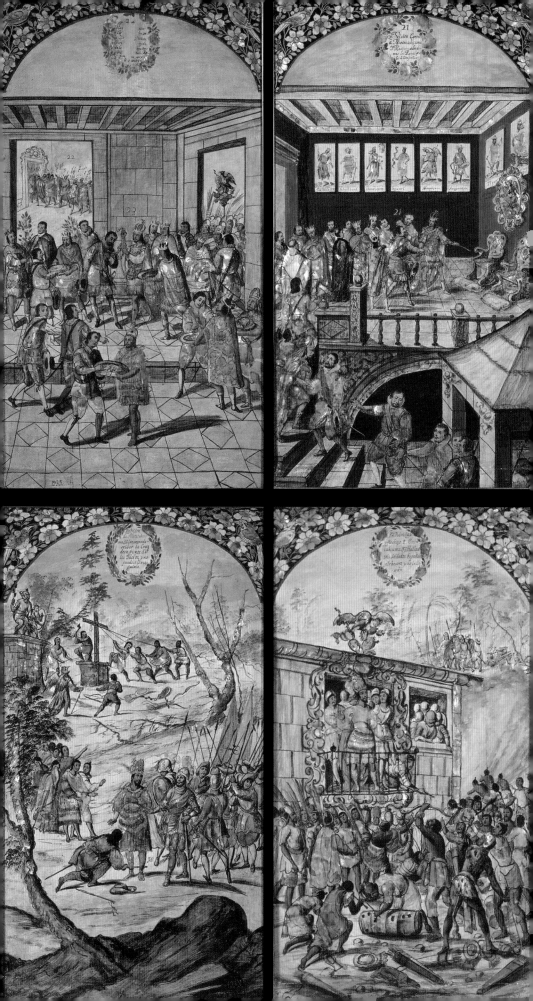

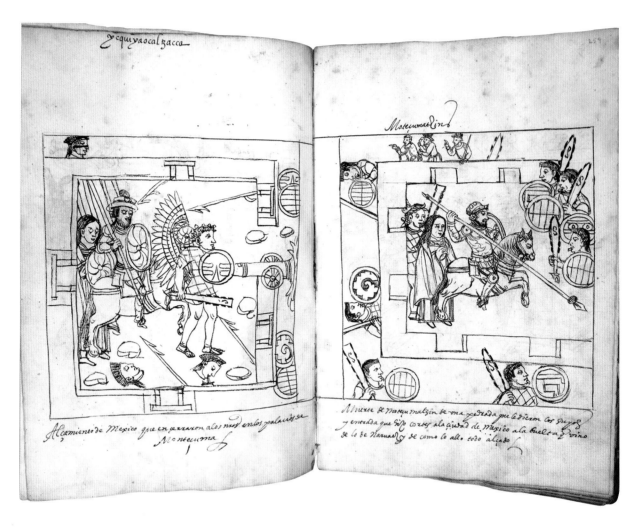

Cat. 116
The death of Moctezuma

Tlaxcala Manuscript
1580–85, Tlaxcala
Paper, 29 × 21 × 3.5 cm
University Library, Glasgow, Ms. Hunter 242 U.3.15

Selected literature: Acuña 1981; Batalla Rosado 1996; Wake 2002

The Tlaxcala Manuscript (also known as Codex Tlaxcala) is an extended descriptive history of the small city-state of Tlaxcala which, against all odds, retained its independence in the face of Mexica imperial expansion. Tlaxcala allied itself with Cortés in the attack on Tenochtitlan and the military conquest of Mexico, and subsequently leaned heavily on past services to curry special favours from the Spanish Crown. Together with earlier despatched copies of the now lost but traditionally written Lienzo de Tlaxcala, the manuscript is a prime example of its means of persuasion.

The codex consists of a text in Spanish by the *mestizo* Diego Muñoz Camargo, a prominent figure in sixteenth-century Indian Tlaxcala, who probably also supervised the parallel pictographic narrative that accompanied it. Comprising 156 pen-and-ink drawings in several hands, the heavily Europeanized pictorial text was based on a series of Tlaxcalan pictographic records that had already produced the Lienzo. Camargo himself joined the 1584–85

diplomatic mission to Madrid where the new manuscript was completed, bound and presented to Philip II.

Cortés, his translator Doña Marina or Malintzin (her Nahuatl name) and a Tlaxcalan warrior are depicted surrounded by angry Mexicas. The text narrates how the Spaniards were obliged to take refuge in Moctezuma's palace after the massacre at the feast of Toxcatl, and the death of Moctezuma that followed.

We might expect a Tlaxcalan account seeking royal indulgence to uphold the version of Moctezuma's death at the hands of his subjects. Yet contrary to the earlier Lienzo and the Spanish commentary beneath the right-hand panel ('Death of Moteçumatzin from stoning by his own people'), the scribe depicted Moctezuma on his palace rooftop ordering his warriors to retreat as two Spaniards approach him from behind with a raised chain in their hands. To draw attention to the detail the ruler's name was written boldly over the scene. One explanation of this and other changes made between the parallel Lienzo and codex panels is that pro-Mexica scribes attempted to sabotage Tlaxcala's efforts to curry favour from the Spanish king by recording that Moctezuma was murdered by the Spaniards. However, by this stage the threat from both Crown and colony to the status and material rights of all Indian groups was very apparent. Rather than ethnic enmity, the changes may therefore represent a form of subtle resistance. *EW*

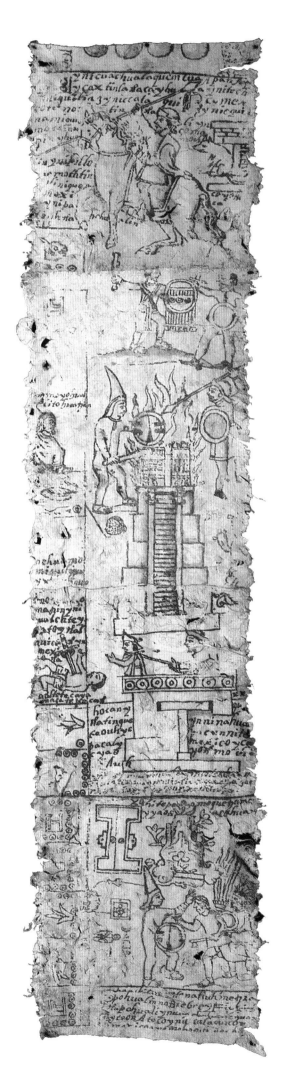

Cat. 117
Codex Moctezuma

Late sixteenth – early seventeenth century, Mexica
Amate bark paper in two fragments, 250 × 20 cm
Biblioteca Nacional de Antropología e Historia, Mexico City, archive of pictographic testimonies, 35-26

Selected literature: Glass 1964, p. 69; Glass and Robertson 1975, p. 170; Barlow 1995, pp. 359–69, figs 1–2; Batalla Rosado 1996, pp. 103, 110–11, 116–17, figs 4, 8; Noguez 2009

The origins of this document, which is virtually unpublished, are unknown. It is a pictographic codex in the form of a *tira* (strip) accompanied by an extensive commentary, written in Nahuatl, which is difficult to read on account of its poor state of conservation. From top to bottom, it records annual indigenous dates from 1419 to 1523, mostly describing events associated with the history of Tenochtitlan.

The text refers to Xochitepec and Mazatepec, towns situated to the south of the city of Cuernavaca in the present-day state of Morelos. This led Barlow to suggest that the document could have been drawn up in this region. Noguez has pointed out that the style is similar to that of the Techialoyan Codices, the group of colonial codices dealing with historical events and land properties that dates from the seventeenth and eighteenth centuries. It is therefore possible that the Codex Moctezuma was also drawn up in this period.

The most outstanding image in this codex – and the one that gives it its name – depicts the public appearance of Moctezuma II in May 1520 to assuage the rage of his people after the outrages committed by the conquistadors. The Mexica *tlatoani* is shown on top of an indigenous building, possibly the *tecpan*, Tenochtitlan's seat of government. He had been taken prisoner and is clearly acting under duress, as is evident from the rope tied around his neck, which is held at the other end by a Spanish soldier. This dramatic scene has been analysed by Batalla Rosado, who stresses that this document is the only one in existence that depicts the death of Moctezuma: to one side of this scene, lies the prone figure of an indigenous man who has a sword impaled in his chest. The blurred commentary that accompanies it seems to indicate that this is Moctezuma himself. If that were the case, it would demonstrate that the *tlatoani* was not stoned by his subjects, as various sources claim, but was in fact murdered by his captors the conquistadors.

ERM

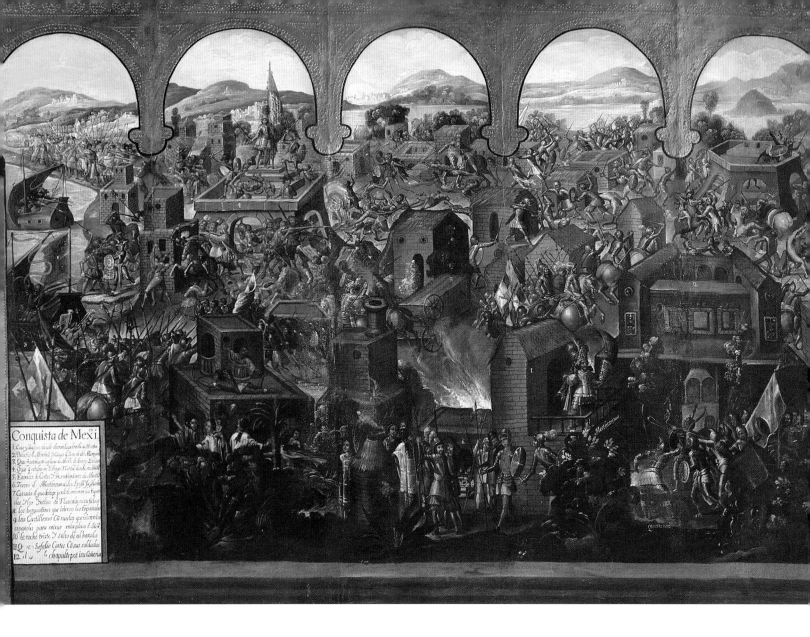

Cat. 118

Screen with scenes from the conquest of Mexico

Late seventeenth – early eighteenth century, colonial
Oil on canvas mounted on ten panels, 191 × 540 cm
Museo Nacional de Historia, Castillo de Chapultepec, Mexico City, inv. 10-092241

Selected literature: Vargaslugo 1994, pp. 32–34

This screen, an item originating from the Far East, has been adapted to local taste by the addition of scenes from the conquest of Mexico. These are depicted with an almost theatrical flourish, ingeniously highlighting the Creole identity of New Spain on this baroque artefact. This heterogeneous vehicle of American pride was also evidence of the high esteem bestowed on Moctezuma as an emperor. The tragic central figure of the conquistadors' drama is usually shown adorned with a diadem, feathers, necklaces and precious stones. Artists often included a double-headed eagle as an identifying symbol, either on the diadem or on feathered fans.

The fashion for oil paintings mounted on screens dates from the second half of the seventeenth century. Here, inlaid mother-of-pearl images by Miguel and Juan González are combined with the paintings, creating a highly distinctive historical narrative. Such screens, made from canvas stretched on folding panels, offered an alternative reading of the conquest as a Christian epic. Painters sought to emphasize the heroic gestures and actions on both sides. They imagined the poses but not the facts, as they drew on the chronicles of Bernal Díaz del Castillo and Antonio de Solís – particularly the latter, whose chronicle, published in Madrid in 1683, endowed the history of the conquest with heroic stature. Both the Spaniards and Moctezuma's warriors were described and then painted as protagonists of what was considered the greatest epic of Christianity: the conquest of one of the principal empires in the New World. None of the participants was more important than the others. The differences lay in the divine design of history. This feature of the baroque sowed the seeds of the Creole nationalism of the Enlightenment and the mythology of the Mexica empire,

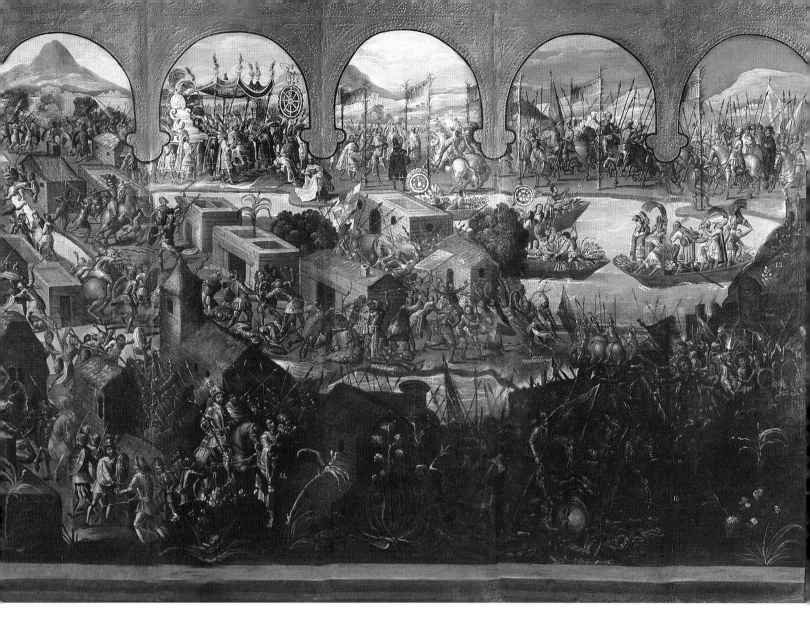

which would grow into a patriotic discourse a century later.

The scenes could be read in two ways. On the one hand, they told the story in a chronological sequence, open to interpretation, starting at the top right with the last section and continuing left to the first section, in a kind of extravagant boustrophedon (in which alternate lines are read in opposite directions). The sequence proceeds across all the panels, but the main focus lies in the centre of the composition. The narrative ends on the lower part of the first section, forming an almost complete circle.

On the other hand, the free and colourful treatment of both characters and buildings allowed the viewer to situate each event in a specific place. Numbers and keys provided by the artist on the bottom left of the first section established the geography of the war within the theatre of New Spain. In the case of the screen from Chapultepec Castle, chronology is subordinated to the dramatic portrayal of events. For example, the focus of the composition is in the first panel, which shows Moctezuma leaning from the balcony to face the angry mob, at the exact moment when Cuauhtemoc is brandishing the sling with the stone that would kill him. A little further on, Pedro de Alvarado saves his own life, and that of his mount, using a pole vault. The last panel corresponds to the viceroy's building on Chapultepec Hill and the aqueduct that supplied Tenochtitlan with clean water.

The screen from Chapultepec Castle, painted in the late seventeenth and early eighteenth centuries, was bought in 1859 by the Mexican historian José Fernando Ramírez who incorporated it into the public collections when he was entrusted with the organization of the Museo Imperial, the distant ancestor of the Museo Nacional de Historia. It originally belonged to the family of the Court of Moctezuma, who probably commissioned it during his time as the viceroy of New Spain (1696–1701). The screen is made up of ten panels and scenes. Although it was dismantled during an insensitive restoration and reassembled as a single canvas, both its style and the existence of a similar piece in the Museo Franz Mayer in Mexico City bear witness to its original configuration. (Details overleaf; see also fig. 69.) SRS

253

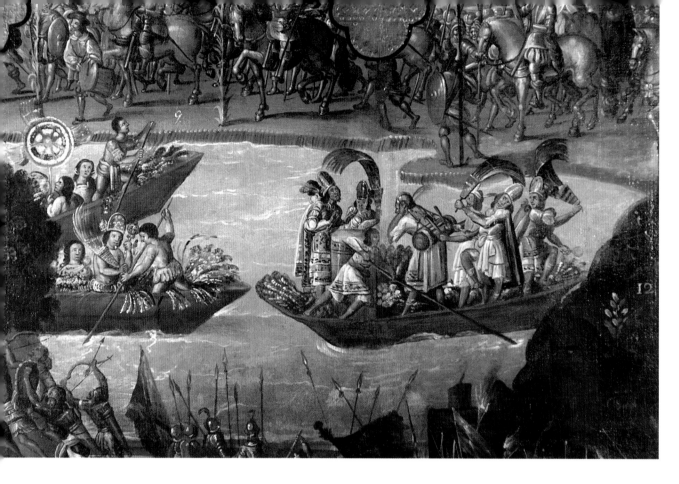

left
Attendants in boats in Lake Tetzcoco play drums and wave feather fans to accompany the Spanish column on its approach to Tenochtitlan.

below
Cortés stands atop a Mexica temple with sword in hand, raising a red standard bearing the Castilian coat of arms.

above
Pedro Alvarado on horseback fights a desperate rearguard action as the Spanish flee for thier lives on the *noche triste* (night of sorrows).

right
With the palace in flames behind him, Moctezuma stands on a balcony in a futile effort to placate the enraged populace. Below him, a figure identified in popular tradition as Cuauhtemoc wields a sling that will deliver the fatal blow.

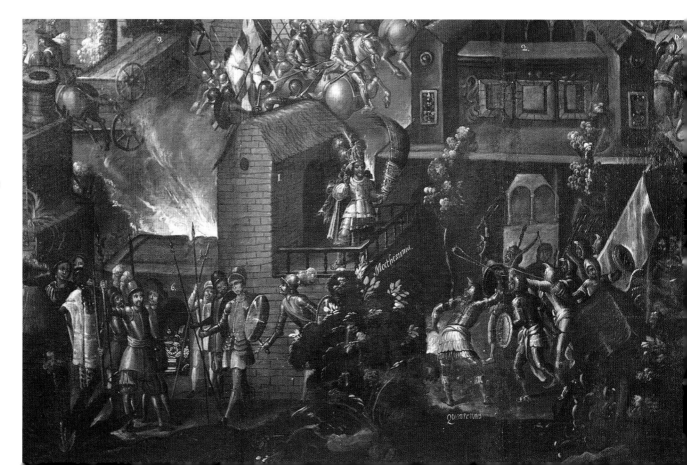

Chapter 7

The rebirth of ancient Mexico

David A. Brading

IN 1990–91 the Mexican government mounted an extraordinary exhibition at the Metropolitan Museum of Art in New York entitled *Mexico: Splendors of Thirty Centuries*. The spectacular range of objects on display derived in equal measure from the three great periods of Mexican history: the millennia of Mesoamerican civilization, the three hundred years of the viceregal empire of New Spain, and the two hundred tumultuous years of the Mexican republic. In the catalogue, the Mexican poet Octavio Paz averred that despite the peculiar heterogeneity of the cultures that had produced these objects, a perceptive eye might observe 'the persistence of a single will ... a certain continuity.... not the continuity of a style or an idea, but something more profound and less definable: a sensibility.'[1] In an earlier publication, however, Paz had attributed that continuity to the decision of Hernán Cortés to build the capital of New Spain amidst the ruins of Tenochtitlan, so that modern presidents and Spanish viceroys were but the political embodiments of the Mexica *tlatloani* or rulers. It was this continuity in state power that allowed the contemporary republic to present itself as the legitimate heir of three thousand years of history.[2] But this hypothesis left much to explain. In the first place, Cortés and the conquerors obliterated the Mexica city; levelled the great stepped pyramids; smashed or burned the images of the Mexica gods; and burnt the sacred books that enshrined Mexica history and theology. How and when was that history disinterred? And when did the Spaniards born in America come more to identify with Moctezuma's empire than with Cortés and Spain? And why did that empire and the conquest that destroyed it continue to loom so large in the twentieth century?

Fig. 74
Virgin of Guadalupe by Josefus de Rivera i Argomanis, 1778. Oil on canvas. Museo de la Basílica de Guadalupe, Mexico City.

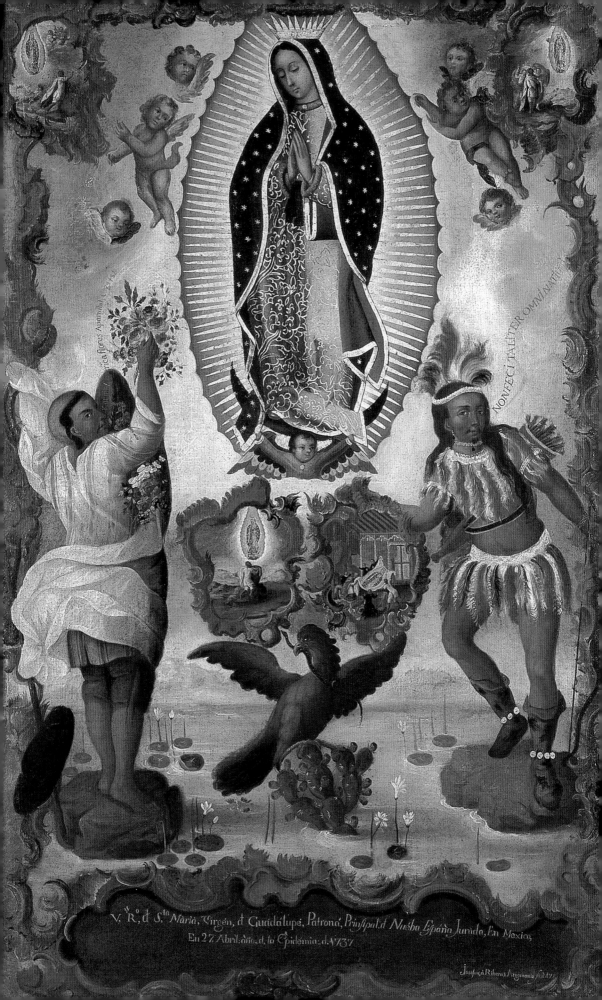

NONFECI TALITER OMNI NATION

V.^R.ª S.^{ta} Maria, Virgen, d Guadalupe, Patrona, Principal d Nueba España Jurada, En Mexico,
En 27 Abril año, d la Epidemia: d 737

Linguistic achievements

After the conquest, the Spaniards relied on the native nobility and their scribes to organize the contingents of labourers that were necessary to build a new capital and create a mercantile economy. So too, the Franciscan and Dominican friars who were responsible for the religious instruction of the native population required workers to build their churches and disciples to help them extirpate idolatry. In 1536 Archbishop Juan de Zumárraga and Viceroy Antonio de Mendoza founded the College of Santa Cruz Tlatelolco to teach the most talented children under their charge not merely how to read and write Spanish, but also to acquire the rudiments of Latin, history and theology. To assist the propagation of Christian doctrine, Zumárraga imported a printing press and in 1539 published the first book ever printed in the New World, a brief manual of Christian doctrine, presented in both Spanish and Nahuatl, the chief language of central Mexico. In the sixty years that followed at least one hundred and twenty-four books were printed, among which were any number of grammars and dictionaries of the leading native languages of New Spain, together with specimen sermons, catechisms and manuals, not to mention theological works in Latin and books in Spanish.[3] None of this linguistic achievement would have been possible without the collaboration of native disciples and of the nobles and scribes who preserved the collective memory of their peoples. The task of a native scribe, a *tlacuilo*, was to record 'the deeds and story of conquests and wars, of the succession of the chief lords', not to mention signs from heaven, droughts and the ritual calendar of the temples. The Nahuas had developed a form of pictographic writing, broken down into 'glyphs' and symbols, which when 'read' by a trained scribe, elicited a narrative, framed in rhythmic prose and often cast in the form of orations. In the first years after the conquest, native elites sought to frame new codices, be it to defend their rights to power and land, or to satisfy the demands of their Spanish rulers. Thus,

Fig. 75
Map depicting the foundation of two colonial churches at Santa Barbara Tamasolco in 1547 and Santa Ana in 1616 in the state of Tlaxcala. The text is rendered in Nahuatl using Latin characters and accompanies a landscape of ancient paths, a water course and houses. Map drawn on bark paper. From *Pintura de propriedades de descendientes de los Senōres Tlaxcala*. The British Museum.

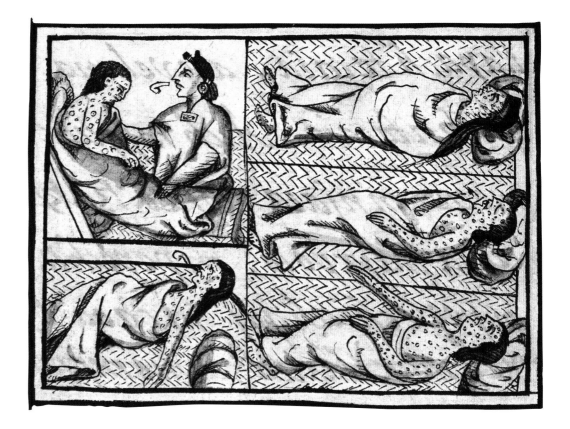

for example, Viceroy Mendoza commissioned a codex that enumerated the tribute paid in kind by each province of Moctezuma's empire.[4]

But as native elites learnt how to read and write Nahuatl in script, so these new codices were at times inscribed with written commentaries. By the 1560s educated noblemen or the *mestizo* offspring of Spaniards and native noblewomen wrote narrative histories of Tenochtitlan, Tetzcoco and Tlaxcala. Moreover, from the start, friars such as Toribio de Motolinía and Andrés de Olmos conducted extensive enquiries about Pre-Hispanic religion and history. The collaborations between the friars and their native disciples in accumulating information about all aspects of native life and thought was most clearly observed in the *General History* of Bernardino de Sahagún, a Franciscan expert in Nahuatl, who in the volumes now known as the Florentine Codex offered parallel versions in Spanish and Nahuatl accompanied by numerous illustrations drawn by native artists. At much the same time, Diego Durán, a Dominican brought up in New Spain, in 1581 completed a lively history of the Mexica, filled with orations and obviously based on native sources. But in the 1570s, the native population of New Spain suffered a virulent plague, the last and apparently the most ferocious of an entire series, from which only a remnant survived, so that whereas the Spaniards had encountered a dense population, possibly of ten million souls, by 1600 less than a million remained. The demoralization of the population brought to an end the fruitful collaboration between the native elite and the friars.[5]

In the same way that Tenochtitlan sank beneath the weight of Mexico City, so also both native codices and mendicant chronicles of the sixteenth century disappeared from view, either dispatched to Europe or deposited in monastic libraries. Moreover, although Hernán Cortés's letters to the emperor Charles V were published individually, they soon

Fig. 77
Spanish friars set fire to images
of the Mexica deities including
Tlaloc, Ehecatl-Quetzalcoatl and
Xiuhtecuhtli. From *Descripción de
la ciudad y provincia de Tlaxcala
hecha por Diego Muñoz Camargo*,
c. 1585, fol. 242r. University of
Glasgow Library.

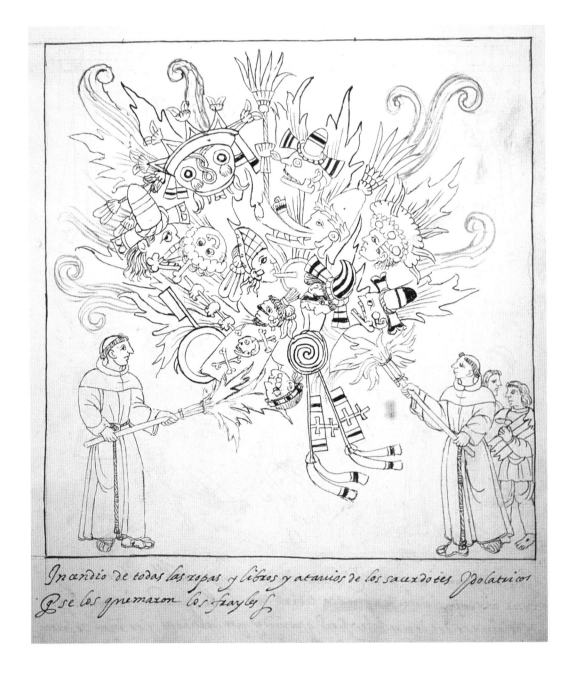

Fig. 78
Baptismal font fashioned from
an inverted Mexica sculpture of
Quetzalcoatl, modified in the early
years of the colonial period (see
cat. 119). The Spanish friars may
well have reused sculptures such
as this to demonstrate to the
indigenous population that their
most powerful deities had been
overthrown and had submitted to
the new order. Museo Nacional
del Virreinato, Tepotzotlán.

went out of print. In effect, the chief account of the fall of Moctezuma's empire was the *History of the Conquest of Mexico* printed in successive editions in 1552–54, and written by Francisco López de Gómara, the chaplain and companion of Cortés in Spain, who provided a triumphant but sober narrative of his hero's achievements, at all points emphasizing his determination to destroy native idols and convert the Indians to Christianity. At the same time, Gómara drew upon the manuscript material of Toribio de Benaverte (Motolinía), to provide brief discussions of native mythology, the calendrical system and ritual, and their austere morality, all of which indicated a relatively high level of civilization. He also described the wealth and extent of the royal palaces and gardens in Tenochtitlan and depicted Moctezuma as an imposing monarch. But all this was undercut by his emphasis on the human sacrifice and ritual cannibalism practised by the Mexica and he concluded: 'There never was, so it would appear, a people more or so idolatrous as this: so given over to the killing and eating of men...'[6]

In the same year of 1552, the Dominican friar Bartolomé de las Casas published his *Most Brief Account of the Destruction of the Indies*, in which he denounced Cortés for the massacre he had perpetrated at Cholula and the destruction and enslavement of the Mexica. Towards the end of his long life, he asserted that Cortés should have been hanged as a common criminal rather than receiving a title of nobility and great riches. During the 1550s Las Casas completed a systematic treatise entitled *Apologética historia sumaria*, in which he assembled a vast amount of data about the government and religion of the Incas and Mexica.[7]

Fig. 79
View of the great pyramid of Cholula upon which a Christian church was later constructed. A plate from *Vues des cordillères, et monumens des peuples indigènes de l'Amérique* by Alexander von Humboldt, 1810.

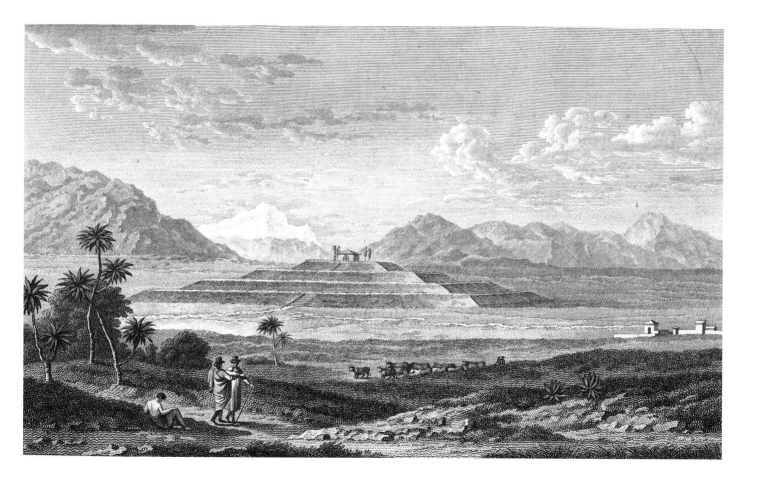

Of decisive importance for any later assessment of Moctezuma's empire was the appearance of the *Natural and Moral History of the Indies* (1590). Its author, José de Acosta, insisted that the laws and institutions of the Mexica and Incas were worthy of respect and indicated that they were far removed from mere savagery. Nevertheless, he attributed their idolatry to the direct intervention of Satan, who had installed a blasphemous parody of the Christian religion in the New World. In Mexico the Devil had assumed the guise of Huitzilopochtli, the tutelary deity of the Mexica, and through oracles and omens, had guided them in their long pilgrimage across the northern wastelands from Aztlan to Tenochtitlan, much in the same way as God had guided the Israelites on their journey across the desert. For all that, Acosta expounded the complexities of the Mexican calendar and accepted that their pictographic glyphs allowed an accurate chronology of their monarchs to be established.[8]

The recorded recuperation of the history, culture and religion of the Nahua peoples of central Mexico reached an unexpected climax in 1615, when the three stout volumes of the *Monarchy of the Indies* (*Monarquía Indiana*), were published in Seville. Its author, Juan de Torquemada (1562?–1624) was a Spaniard, brought to Mexico as a child, who entered the Franciscan order in 1579–80, and soon became distinguished for his knowledge of Nahuatl. In the years 1603–12 he acted as guardian of the priory at Tlatelolco, where 'in the silence of my solitude', he spent seven years writing his great work and teaching the children in the college of Santa Cruz, by then a mere shadow of its previous glory. There he composed a 'chronicle of chronicles', boldly incorporating, often verbatim, entire chapters of works that had remained in manuscript.[9] In his approach to the Indian past,

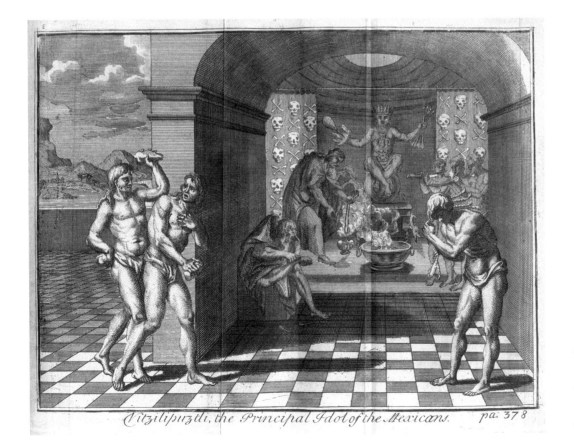

Vitzilipuztli, the Principal Idol of the Mexicans. *pa. 378*

Fig. 80
A depiction of the deity Huitzilopochtli being worshipped in a Mexica temple. Skulls adorn the back wall. From *Descripcion de las Indias Ocidentales de Antonio de Herrera* by Antonio de Herrera y Tordesillas, 1726.

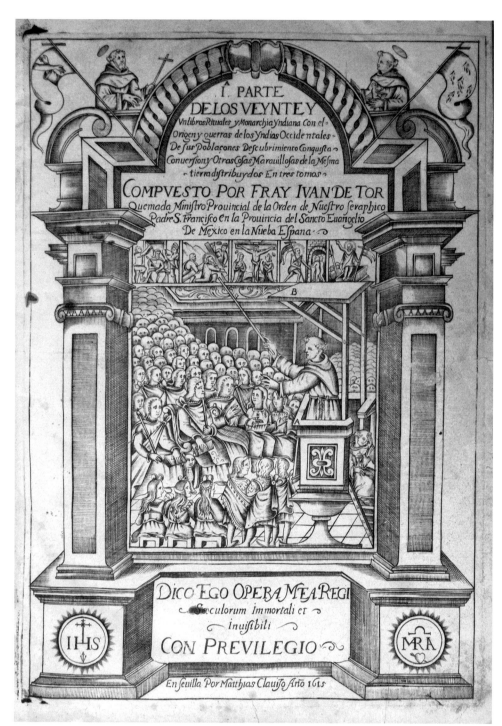

I. PARTE
DELOS VEYNTE Y
Vn libros Rituales y Monarchia Yndiana Con el
Origen y guerras de los Yndias Occidentales
De sus Poblaçones Descubrimiento Conquista
Conuerfion y Otras Cofas Marauillofas de la Mefma
tierra dystribuydos En tres tomos

COMPVESTO POR FRAY IVAN DE TOR
Quemada Ministro Prouincial de la Orden de Nuestro seraphico
Padre S. Francifco En la Prouincia del Sancto Euangelio
De Mexico en la Nueba Efpana.

DICO EGO OPERA MEA REGI
Seculorum immortali et
inuifibili

CON PREVILEGIO

En feuilla Por Matthias Clauifo Año 1615.

Fig. 81
Engraving of the Franciscan
friar, Juan de Torquemada
preaching at the pulpit.
Frontispiece to *Monarquía
Indiana*, 1615.

he benefited from the collaboration of Fernando de Alva Ixtlilxóchitl (1578–1650), a *mestizo* descendant of the royal house of Tetzcoco and a historian in his own right. Both men had studied classical Nahuatl with Antonio Valeriano, the most accomplished of the disciples of Sahagún, who served as governor of San Juan Tenochtitlan from 1570 until his death in 1605. Torquemada had access not merely to codices but also to a range of native annals written in Nahuatl and to the histories of Tenochtitlan and Tlaxcala, respectively written by Ixtlilxóchitl and his predecessors, and Diego Muñoz Camargo, all of whom drew on earlier codices, 'songs' and annals in Nahuatl.[10]

A peculiar feature of Torquemada's account was that the Devil appeared in Anahuac with the advent of the Mexica, so that it was only then that human sacrifice and ritual cannibalism became prevalent. Torquemada praised Moctezuma for his wise decrees and great prudence, but the inclusion of diverse and at times contradictory sources led Torquemada to adopt an ambiguous interpretation of the Spanish conquest. At one level, he defined Cortés as another Moses who liberated the peoples of Anahuac from Satan's dominion, leading them out of the Egypt of idolatry into the Promised Land of the Catholic Church. In this line he accepted the Augustinian thesis of the eternal conflict of the two cities.[11] But when he came to describe the conquest in detail, he countered the version he found in Gómara with the account he found in Sahagún's *General History*, in which Alvarado's unprovoked slaughter of the young Mexica nobility was described in horrific detail. So also, he noted that the same source claimed that Moctezuma had been killed, not by an irate multitude throwing missiles, as Cortés had averred, but rather had been brutally executed by the Spaniards.[12] For all that, Torquemada devoted his third volume to a joyful celebration of the conversion of the Indians to the Christian faith. He

concluded with a contrast between Tenochtitlan, a glittering Babylon, where Satan had been worshipped as Huitzilopochtli by means of daily human sacrifice, and Mexico City, where in 1600 over six hundred daily masses were celebrated in some forty churches and chapels, filled with the divine grace of a New Jerusalem.[13]

Bitter rivalry

By 13 August 1721, the bicentenary of the Spanish conquest, the main source of information that was readily available was the *History of the Conquest of Mexico* (1684), written by Antonio de Solís y Rivadeneira, a leading Spanish dramatist, who turned the information he found in Gómara and other imperial chroniclers into a lively, readable narrative, replete with formal orations and critical opinions. Solís glorified Cortés as a Christian hero but innovated by depicting Moctezuma as an imperious tyrant who after being taken captive by Cortés descended into a state of pusillanimous abjection. At all points, he exculpated Cortés from the charges levelled against him and dismissed the resistance led by Cuauhtemoc as an act of rebellion, since Moctezuma had already recognized the authority of Charles V. The multiple editions of Solís's work testified to the wide readership he attracted both in Europe and America, and served to justify Spain's empire in the New World.[14]

Fig. 82
Saint Thomas the Apostle preaching in the Tlaxcalan countryside, seeking indigenous converts. Museo Nacional de Arte, Mexico City.

By the late seventeenth century, however, the Spaniards who were born and bred in the New World had become increasingly conscious that their *patria*, a term that could apply to both a city or a country, possessed a historical identity and social reality that clearly distinguished it from Castile or Aragon. Indeed, travellers commented on the often bitter rivalry that separated European and American Spaniards in Mexico. An early expression of this nascent 'American' identity can be found in the triumphal arch erected by the Mexico City council in 1680 to welcome the incoming viceroy, the Marquis of La Laguna. Its designer, Carlos de Sigüenza y Góngora, a Mexican savant, loaded the arch with wooden statues of the twelve monarchs of Tenochtitlan who had governed the city since its foundation in 1327. In his printed commentary, he characterized each ruler as the embodiment of specific political virtues, with Moctezuma II saluted as an 'absolute monarch', notable for his liberality. By contrast, the unfortunate Cuauhtemoc figured as a native Cato, ever constant in adversity. The entire symbolic structure was designed in the hope that 'on some occasion the Mexican monarchs might be

reborn from the ashes to which oblivion has consigned them, so that like Western phoenixes, they may be immortalized by fame...'. In effect, the imperial virtues of these rulers offered models as inspiring as any ancient Roman or Greek counterpart.[15]

In his commentary, however, Sigüenza y Góngora pointed to 'the affinity of American and Egyptian idolatry', which was demonstrated by the similarity of their temples, pyramids, clothing and above all their common 'modes of expressing their concepts in hieroglyphs and symbols'. Indeed, he further claimed that the Mexican Indians actually descended from the ancient Egyptians and had migrated to the New World via the lost continent of Atlantis, arriving 'only a little time after the Flood', when they constructed the two great pyramids at Teotihuacan in the Basin of Mexico.[16] Not content with endowing his country with this distinguished ancestry, Sigüenza also averred that Saint Thomas the Apostle had preached the gospel in ancient Mexico, where he was immortalized in the figure of Quetzalcoatl, the plumed serpent.

In 1723 a second, corrected edition of Torquemada's *Monarchy of the Indies* was published. But its glowing account of 'the great emperor Moctezuma' and his impressive palaces challenged the preconceptions of the 'philosophic' historians of the European Enlightenment. In 1768 Corneille de Pauw asserted that not a single book worth reading had ever come out of America and that the American Indians were a childlike race, 'a degenerate species of humanity', without physical force or spiritual elevation.[17] Equally, he dismissed all the historical sources that dealt with the Spanish conquest as self-serving lies, declaring that the 'palace' of Moctezuma was nothing more than a large native hut.[18] None of this would have counted for much had not Guillaume Raynal in his multi-volume *Philosophical History of the Two Indies* (1771), adopted a similar approach and, for example, concluded that Tenochtitlan was but 'a little town, composed of a multitude of rustic huts...', its public edifices merely 'irregular masses of stones heaped one upon another'.[19]

The Scots theologian William Robertson in *The History of America* (1777) adopted a more judicious view, and admitted that the Mexicans and Incas had advanced well beyond savagery, but he questioned how one could call a society civilized that engaged in perpetual warfare and observed 'a gloomy and atrocious religion?' Robertson criticized Torquemada for 'his usual propensity for the marvellous' and rejected his 'improbable narratives and fanciful conjectures'.[20]

It was left to Francisco Javier Clavijero, an exiled Mexican Jesuit, to publish 'a history of Mexico written by a Mexican'. In the introduction to his *Ancient History of Mexico* (1781–82) he provided an annotated bibliography of both printed and manuscript sources. At the same time, he insisted on the historical value of the native codices and the sophistication of a calendrical system that could only have been produced by 'a most cultured nation'. By reason of his exile, however, Clavijero was obliged to rely on one great source, Torquemada's *Monarchy of the Indies*, a reliance that left him exasperated at the Franciscan's failure to reconcile different sources and general lack of critical acumen.[21] He criticized both Acosta and Torquemada for their naivety in identifying Huitzilopochtli as Satan; since idolatry sprang from human fears, ignorance and superstition. It was not acceptable to introduce the Devil as a historical agent. In effect, Clavijero liberated Mexican

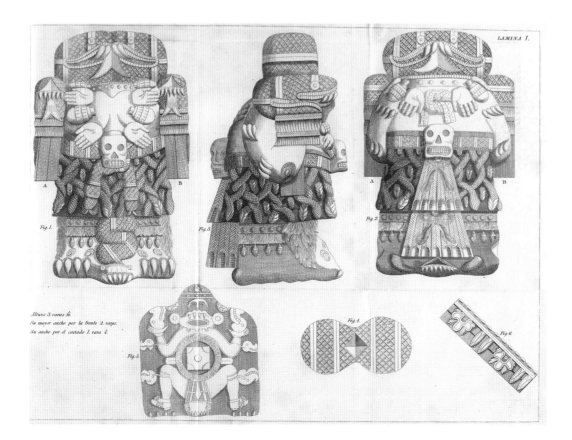

Fig. 83
Copper engraving of the
forbidding Coatlicue monolith
adorned with skulls, serpents
and severed head and hands.
An image of Tlaltecuhtli is
inscribed on the underside.
Plate 1 in *Descripción historica y
cronológica de las dos piedras* by
Antonio de Leon y Gama, 1832.

history from the burden of the Augustinian dualism of Torquemada, especially since he ended his narrative with the fall of Tenochtitlan and gave no account of the evangelization of Mexico. So also, he rejected out of hand the baroque theories of Sigüenza y Góngora, refusing to countenance any notion of a migration from Egypt or of an apostolic mission to Mexico.[22] At all points, Clavijero offered a vigorous defence of the ancient civilization of his country and demonstrated the degree to which Creole intellectuals had come to define Anahuac and in particular Tenochtitlan as the classical past of their *patria* or homeland.[23]

In 1790, when the main square of Mexico City was paved and re-levelled, two Pre-Hispanic monoliths were uncovered and excavated. One stone was a monstrous figure of the goddess Coatlicue, decorated with bulging skulls and intertwined serpents (fig. 83); the other was a great disc, carved with the glyphs of a calendar wheel (fig. 28). Two years later, in response to the public excitement elicited by the discovery, Antonio de León y Gama, a Creole functionary, expert in Nahuatl and mathematics, published a *Historical and Chronological Description of the Two Stones*. The clerical censor exclaimed in his approbation that although Raynal, Robertson, Pauw and other enlightened philosophers had sought to rank 'the Indian nation at the level closest to the beasts ... this single feature of Indian culture will dispel all such gross errors'. For his part, León y Gama seized the opportunity to provide the first systematic interpretation of the Mexican calendar, substantiating Clavijero's claim that Mexico possessed native sources, from which an exact chronology of its ancient history could be reconstructed. Using the Calendar Stone (or *Piedra del Sol*; fig. 28), he demonstrated that the Mexica had employed two parallel systems, a solar year divided into eighteen months, each of twenty days, followed by a dead space of five days, and a lunar, ritual year of twenty weeks of thirteen days each. The calendar also divided the passage of

time into periods of thirteen years and cycles of fifty-two years. After this triumphant explication, the Sun Stone was attached to the walls of the Cathedral of Mexico City and soon became a national symbol.[24]

Achieving independence

In 1810 the parish priest of Dolores, Miguel Hidalgo y Costilla, raised the banner of a popular revolt against Spanish rule, and thereby provoked young Creoles to enlist in a royalist army that in 1821, led by Agustín de Iturbide, finally achieved Mexican independence. The first history of the insurgency, written by an exiled Dominican friar, was published in London in 1813. Its author, Friar Servando Teresa de Mier cited Las Casas's *Brief Account* and argued that as Alvarado had slaughtered the Mexica nobility at Tenochtitlan, so also the royalist general, Félix Calleja, had massacred the population of Guanajuato when the city was re-captured from the insurgents. He presented the achievement of independence as the reversal of the conquest. At the same time, he appended to his history, a dissertation in which he demonstrated that either Saint Thomas the Apostle or a subsequent Syrian bishop of the same name had introduced Christianity into ancient Mexico.

Carlos María de Bustamante, a lawyer and journalist who enlisted in the southern insurgency led by José María Morelos, deployed a similar vein of rhetoric. In 1813 he wrote the opening speech that Morelos delivered at the Congress of Chilpancingo, which had been convoked to proclaim Mexican independence. After a brief comparison of the Mexicans with the children of Israel in Egypt, in an audacious metaphor, Morelos compared Almighty God to a Mexican eagle protecting his chosen people with both wings and talons. The prospect of independence was presented as a restoration: 'We are about to re-establish the Mexican empire, improving its government.' He continued:

> Spirits of Moctezuma, Cacamatzin, Cuauhtimotzin, Xicotencalt and Catzonzi, as once you celebrated the feast in which you were slaughtered by the treacherous sword of Alvarado, now celebrate this happy moment in which your sons have united to avenge the crimes and outrages committed against you, and to free themselves from the claws of tyranny and fanaticism that were about to grasp them forever. To the 12th of August of 1521 there succeeds the 14th of September 1813. On that day the chains of our serfdom were fastened on Mexico Tenochtitlan, on this day in the happy village of Chilpancingo they are broken forever.[25]

In this speech we encounter the emergence of a Mexican nationalism, in which Moctezuma and Cuauhtemoc were united with Hidalgo and Morelos in the same patriotic pantheon. When Bustamante came to describe Iturbide's triumphal parade through the streets of the capital in 1821, he wrote that in his mind's eye, he seemed to see the shades of the Mexican rulers arising from their tombs in Chapultepec in order to place themselves at its head. Soon after, the Act of Independence echoed the identification with

the native past when it declared: 'The Mexican nation, which for three hundred years had neither had its own free will nor free use of its voice, today leaves the oppression in which it has lived.'[26]

Liberated from colonial censorship, a select band of Mexican scholars set about the grand task of publishing and interpreting the manuscript sources of their country's long history. It was Carlos María de Bustamante who in 1829 first published Bernardino de Sahagún's *General History*, using a copy of the version preserved in Spain, in which, however, he interpolated polemical notes and Servando de Mier's dissertation on Saint Thomas in Mexico. In Europe Mexican codices aroused the interest of Edward King, Viscount Kingsborough, who in 1830 published his *Antiquities of Mexico* in seven grand folio volumes, in which he reproduced in facsimile, taken by Augustine Aglio, all the hieroglyphical codices that were then known to exist in European libraries, thereby providing future historians with an invaluable research resource.

Americans also contributed to the revaluation of Mesoamerican civilization. In his *History of the Conquest of Mexico* (1843), the New England historian, William Hickling Prescott, provided a romantic narrative of the encounter between the warriors of Anahuac and the Spaniards, concluding that: 'the Aztec and Texcocan races were advanced in civilization far beyond the wandering tribes of North America … in degree not short of our Saxon ancestors under Alfred….' But he relied upon written sources and adopted a sceptical view of the value of the native codices reproduced by Kingsborough and surmised that their meaning might never be deciphered. When he came to narrate the events of the conquest, however, Prescott presented Cortés as the hero of the story, the representative of 'the expiring age of chivalry', whereas Moctezuma was described as 'effeminate' in character, and 'whose pusillanimity sprang from his superstition'.[27]

In Mexico Prescott's romantic style of history was widely welcomed and swiftly translated. But in the 1844 edition, José Fernando Ramírez, an erudite scholar and politician, added a commentary in which he criticized Prescott's 'racial disdain', since in all the battle scenes the 'Aztecs' were always described as barbarians or savages, who invariably shrieked their war cries. Noting that the American had described Nahuatl as an unmusical language, Ramírez queried how a man accustomed to the tunes of *Yankee Doodle* could judge the tonality of a language he had never heard.[28]

It was Ramírez who in 1833 edited a codex, which until then had been assumed to describe the migration of the Mexica from their northern homeland at Aztlan to the site of Tenochtitlan. Ramírez undertook a rigorous analysis of each glyph, and demonstrated that the migration had been enacted within the limits of the central valley. In 1867 he published the first volume of Diego Durán's invaluable study of native religion and history, which was based on native sources. Among other works, he traced Servando de Mier's identification of Saint Thomas as Quetzalcoatl back to its seventeenth-century documentary origin and demonstrated that the theory was 'without historical or scientific merit'.[29]

The chief disciple of José Fernando Ramírez was Manuel Orozco y Berra, an impoverished functionary and dedicated scholar, whose life work was the four volumes of his *Ancient History and Conquest of Mexico*, published posthumously at the expense of the Mexican government in 1881. At all points, Orozco drew upon a wide range of sources,

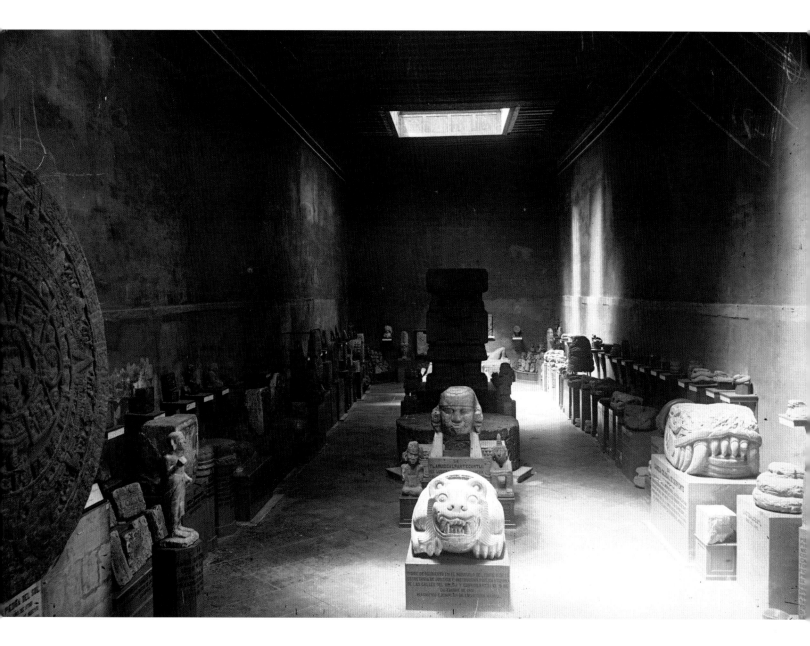

Fig. 84
The 'Gallery of the Monoliths' at the Museo Nacional de Antropología, Mexico City, photographed prior to its opening in 1887.

ranging from codices to native annals, in both Spanish and Nahuatl. He castigated Cortés and Alvarado for their unjustified massacres of Indians at Cholula and Tenochtitlan, but then criticized Moctezuma's decision to admit the Spaniards into the island city, declaring that 'the most stupid of superstitions threw this imbecile monarch at the feet of the invader'. So also, he rejected the version of Moctezuma's death, that the ruler had been killed by missiles hurled by his indignant subjects and instead concluded that, although injured, Moctezuma survived until the flight of the Spaniards from Tenochtitlan, when he and other noble captives were simply murdered by Cortés, a version related in the twelfth book of Sahagún's *General History*. Always anxious to maintain a judicious balance, Orozco concluded that although the conquest was an unmitigated calamity for the native race, nevertheless, it succeeded in incorporating Mexico into European and Catholic civilization.[30]

In 1887 a majestic statue of Cuauhtemoc was unveiled in the Paseo de la Reforma, the central avenue in Mexico City. On its base relief, it depicted the torture of the unfortunate monarch by Cortés. In the same year, the National Museum, situated alongside

the National Palace, opened a room in which all the great Pre-Hispanic monoliths were exhibited. The famous Calendar Stone was detached from the walls of the Cathedral in 1885 and given pride of place in this hall. The degree to which Pre-Hispanic civilization had become Mexico's classical past, was further demonstrated in 1889, when the Mexican pavilion at the Paris World's Fair was constructed in a modern version of an 'Aztec' temple, loaded with statues of the more peaceful deities and a select number of heroes, including figures of Nezahualcoyotl and Cuauhtemoc. It was an impressive pastiche and evoked broadly favourable reactions, even if some ironic critics demanded to know in what room the human sacrifices would take place. Thereafter, virtually all Mexican pavilions at international events were built in 'indigenous' style.[31]

As was to be expected, when the artists who studied at the National School of Fine Arts followed the nineteenth-century fashion of history painting, there were several who depicted scenes from the Mexica empire or from the conquest. There were a number of canvases that fixed upon the foundation of Tenochtitlan, in which a group of semi-naked Indians were portrayed seeing an eagle perched on a cactus with a snake in its claws, with the surrounding valley and lake bereft of human habitation. The unhappy figures of Moctezuma and Cuauhtemoc were also depicted at different stages of their lives.

In 1884–89 there appeared the five folio volumes of *Mexico across the Centuries*, printed in Barcelona and profusely illustrated, with the scarlet boards emblazoned with a golden image of the Sun Stone. Commissioned by the federal government to edit this grand work, General Vicente Riva Palacio, a leading liberal politician and literary man, chose Alfredo Chavero to cover the Pre-Hispanic period; he himself covered the viceroyalty of New Spain; and three other authors, all liberals, described the tumultuous origin and development of the republic. When Chavero came to describe the Mexica empire, he did not add much to the account already provided by Orozco y Berra and followed his friend's conclusion that Cortés had murdered Moctezuma.[32] By contrast, Riva Palacio's survey of New Spain innovated decisively when he argued that during the three centuries of vice-regal dominion there had slowly emerged 'the nucleus of a new race', which was to say, the Mexican *mestizo* race, the offspring of inter-breeding between Spanish conquerors and subsequent settlers and Indian women, unions only rarely blessed by the Church. At first pariahs, these *mestizos* slowly came to thrive and multiply and eventually formed the basis of a new and distinctive nationality. The attraction of Riva Palacio's hypothesis was such that during the Mexican Revolution virtually all the nationalistic thinkers argued that *mestizaje*, racial mixture, constituted the basis of Mexican nationality and culture.

Forging a country

In the wake of the Mexican Revolution of the early twentieth century, *indigenismo*, or nativism, became an integral component of the radical nationalism that characterized that movement. In 1915 Manuel Gamio, Mexico's leading archaeologist, published *Forjando Patria* (*Forging a Country*), in which he argued that judged by the standards of contemporary Germany, France and Japan, Mexico did not yet constitute a nation. In particular,

the Indian villagers who comprised about two-thirds of the republic's population did not participate in national life nor exercise their rights as citizens. In 1917 he led a team of archaeologists and anthropologists to undertake a survey of the district of San Juan Teotihuacan and, in particular, to clean and restore the ancient ceremonial centre. The newly discovered Temple of Quetzalcoatl was restored to its former glory and made ready for tourism. At one stroke, Teotihuacan, which had flourished in the first six hundred years of the Christian era, became the greatest public monument in Mexico, its imposing scale inviting comparison with ancient Egypt. Mesoamerican civilization was thus installed as the foundation of Mexican history.[33]

At the same time, Gamio's team of anthropologists studied the poverty-stricken condition of the native population in the surrounding area and concluded that although only a few spoke Nahuatl well over half were essentially Indian in culture. A poignant moment came, when research in parish records revealed that the lineal descendants of the *mestizo* historian, Fernando de Alva Ixtlilxóchtl and the emperor Nezahualcoyotl lived in the district, albeit reduced to the condition of petty proprietors, blissfully unaware of their distinguished ancestry. The anthropologists recommended that the great estates that dominated the district should be expropriated and their lands partitioned among the peasantry, with families receiving individual plots but ownership vested in the community. For his part Gamio recommended the re-establishment of artisan industry, particularly in ceramics and textiles, since with the advent of tourism a ready market could be found for these products in the ceremonial centre. In all this, Gamio argued that archaeology and anthropology offered the best policies for building a coherent and united Mexican nation.[34]

Gamio's *indigenismo* extended into aesthetics, when he criticized the neo-classical principles that had governed academic art in Mexico throughout the nineteenth century. Was there not, he argued, an impressive similarity between modern Cubism and Mexica art? As it was, no adequate criteria for judging the aesthetic quality of ancient Indian artefacts had been advanced. A more aggressive approach to this problem was expressed in a 'Declaration of social, political and aesthetic principles' that was issued in 1922 by a group of leading Mexican artists:

> The noble work of our race, down to its most insignificant spiritual and
> physical expressions, is native (and essentially Indian) in origin. With their
> admirable and extraordinary talent to create beauty, peculiar to themselves,
> the art of the Mexican people is the most wholesome spiritual expression in
> the world and this tradition is our greatest treasure.

Although these painters, among them Diego Rivera (fig. 86), José Clemente Orozco and David Alfaro Siquieros, were modernists, they eschewed private art in favour of public commissions and in their murals depicted both the horrors of the Spanish conquest and the heroes of republican history.[35] In the post-war period, when Mexico mounted exhibitions abroad, in Europe and the United States, the paintings of these artists were displayed alongside impressive Pre-Hispanic statues and carvings, with native ceramics and textiles forming a background.

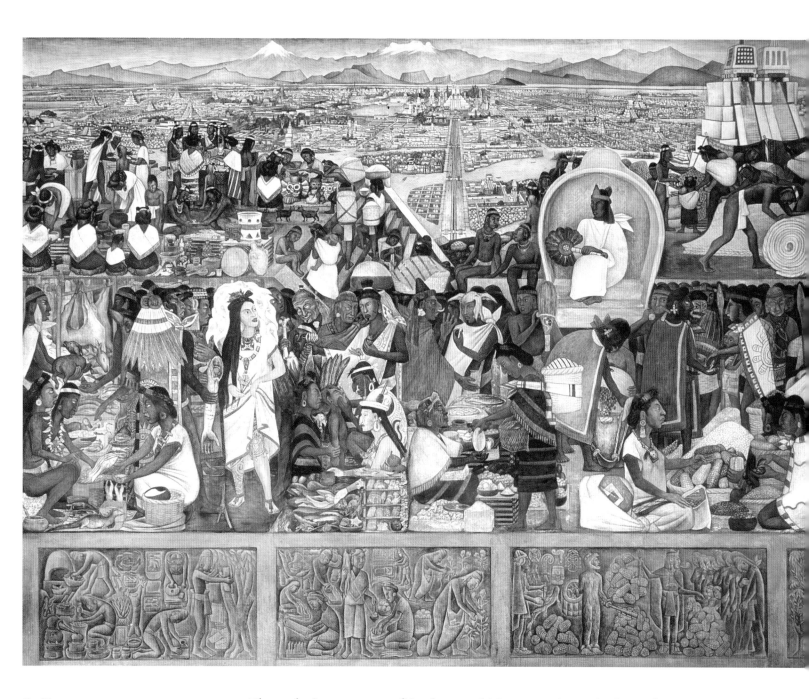

Fig. 86
'The Market of Tlatelolco', a detail from *The Great City of Tenochtitlan*, 1945. Monumental mural by Diego Rivera (1886–1957). Palacio Nacional, Mexico City.

The enduring presence of Anahuac and Moctezuma's empire in modern Mexico was magisterially signalled in 1964 when the new National Museum of Anthropology situated in Chapultepec was inaugurated. For here were arrayed in successive rooms artefacts from the entire range of native cultures, a succession that culminated in the final great hall, where the Sun Stone was hung, suspended above the spectators, a symbol of the nation and surrounded by a multitude of Mexica objects that had been recovered in recent excavations, but still among them the venerable and shocking statue of Coatlicue. Not without reason did Octavio Paz describe the museum as a national shrine and as an expression of the Mexican state's determination to ground its authority in the power and prestige of Moctezuma's empire.[36]

Cat. 119
Baptismal font

c. 1521, Mexica, modified in the early colonial period
Volcanic stone, 35 × 135 cm
Museo Nacional del Virreinato, Tepotzotlan, inv. 10-544945

Selected literature: Fernández *et al.* 2007, p. 357

When the armed phase of the conquest was completed, the Spaniards began the equally arduous spiritual conquest of the inhabitants of their new dominions. Numerous religious buildings were constructed, many of them set in the heart of Pre-Hispanic settlements and on the ruins of old administrative and religious structures. These new buildings served as the launching platforms for the indoctrination of the indigenous population into the Catholic faith.

Many of the materials left over from the demolition of Pre-Hispanic settlements were incorporated into the new structures, including churches and secular buildings. Large stone sculptures were partially destroyed and reused, as was the case with this image of a plumed serpent representing the god-creator Quetzalcoatl. The sculpture found a new function as a baptismal font in the second half of the sixteenth century (see also fig. 78). The serpent's head was removed and a cavity drilled in the body to hold the consecrated water used in the sacrament of baptism. The lower part of the font still bears reliefs in the form of quetzal feathers on the coils of the reptile's body.

The Spanish priests may well have reused these sculptures to demonstrate to the indigenous population that their most powerful deities had been overthrown and had submitted to the new order. Nevertheless, there are reports of indigenous resistance to the new religious symbols and the secret worship of Pre-Hispanic deities would continue for centuries, resulting in a religious syncretism that still echoes through modern Mexico.

MB

Cat. 120
Fragment of a heraldic coat of arms

Eighteenth century
Volcanic rock (grey quarry), 160 × 47 cm
Museo del Templo Mayor, Mexico City, inv. 10-264702 0/3
and 10-264187 0/3

Selected literature: Unpublished

These three blocks of stone originally formed part of a quartered coat of arms (associated with monarchs or royal dynasties) that was integrated into the façade of a building. The upper block, which is cracked, displays a royal crown, while the two lower blocks feature a relief decoration with a rampant crowned lion, the symbol of the kingdom of León, and a castle with three turrets, the emblem of the kingdom of Castile.

This piece was found in 1992, during an excavation organized by the Urban Archaeology Programme of the Museo del Templo Mayor in Mexico City's Palacio Nacional. Given the nature of the coat of arms, it is highly likely that it formed part of the façade of the Viceroy's Palace in the second half of the eighteenth century, as the emblems of Castile and León only came to occupy their pre-eminent position in Spain's royal coat of arms during the reign of Charles III (1759–1788). When Mexico gained its independence in 1821, royal and noble coats of arms were removed from buildings and destroyed or buried, as must have been the case here.

The site of the current Palacio Nacional – and before that of the Spanish Viceroy's Palace – had previously been chosen by Moctezuma II for the construction of a new palatial residence at the start of his reign, in around 1502. This was a replacement for the palace of Moctezuma's father, Axayacatl, which was known as 'Old Houses' and situated to the west of the ritual centre of Tenochtitlan. *CJGG*

Cat. 121
Gold ingot

c. November 1519 – June 1520, early colonial
Gold, 5.4 × 26.2 × 1.4 cm
Museo Nacional de Antropología, Mexico City, inv. 10-220012

Selected literature: López de Gómara 1965–66, p. 249; Sahagún 1997, pp. 741, 756; London 2002, p. 483, no. 333; Velasco Alonso 2007

At the time of the Spanish conquest, the western shore of the great island of Tenochtitlan would have extended along the present-day Alameda Central in Mexico City. Beyond it, the Calzada Mexico-Tacuba was once one of the causeways connecting the imperial city with dry land. This was the site of one of the most dramatic episodes in the conflict between the Spanish–Tlaxcaltec alliance and the Mexica armies.

By 30 June 1520, the European invaders had been in the city for seven months. They had appropriated the enormous treasure trove accumulated by Moctezuma II and his father Axayacatl. Its contents were melted down, poured into moulds dug into the soil of Axayacatl's palace, then slightly bent. Weighing approximately one

kilo each, the resulting – rudimentary – gold ingots were easily transportable, as they could be strapped to a man's body using cloth strips. That night, the invaders fled from the city and were assailed by Mexica arrows and clubs as they headed for Tlacopan (Tacuba), to the west of the island. The fighting then spread to the causeway since the Mexica warriors had destroyed the Europeans' canoes, preventing their escape across the lake. The conquistadors recalled that '...so many [Tlaxcaltecs and Spaniards] fell... that the lake filled up and those that came behind could walk on top of the dead'.

Francisco López de Gómara, Hernán Cortés's secretary, recounts how the Spanish leader wept that night after 'losing so many friends, so much treasure, so much power, such a great city and kingdom'. The chronicler Bernardino de Sahagún describes how later on, once the island had been completely relinquished, the Spanish leader's first enquiry to the lords of Mexica, Tetzcoco and Tlatelolco concerned the whereabouts of the gold that had been lost in battle the year before. He ordered them to find '200 golden ingots, as big as this, indicating with his hands the dimensions of a chalice paten'. It was only in the twentieth century that one of these lost gold ingots was finally recovered at the site of the conflict. RVA

Cats 122 to 123
Bracelets

c. 1200–1521, Mexica–Mixtec
Gold with silver and copper, 8.2 × 2.8 × 1.8 cm
Museo Baluarte de Santiago, Puerto de Veracruz, Fisherman's Treasure collection, inv. 10-213113 and 10-213110

Selected literature: Ortiz Ceballos and Torres 1978; García Moll, Solís Olguín and Bali 1990; Ortiz Ceballos 1990; Nahmad and Besso-Oberto 1993; London 2002, p. 483, nos 330–32; Solís Olguín 2004

These bracelets are made from a single piece of gold and ornamented using lost-wax (see cat. 27) and false filigree techniques. The applied decoration consists of four conical bosses circled by rosettes at their bases, with alternating spider monkeys (*Ateles geoffroyi*) and stepped fretwork (*xicalcoliuhqui*). Spider monkeys were associated with Ehecatl-Quetzalcoatl, the god of wind, and with Xochipilli-Macuilxochitl, the god of music,

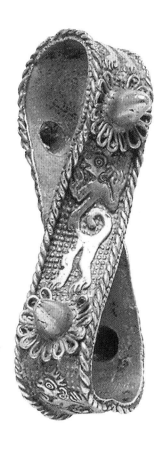

dance and flowers. Here they are depicted full length, dancing, with a lock of hair on their heads, their tongues sticking out, circular ear-spools, long tails and prominent stomachs. A decorative edging of intertwining cords flanks the bosses, monkeys and fretwork. The Tenochtitlan nobility would have worn bracelets of this type to distinguish themselves from the rest of the population.

These bracelets were discovered by an octopus fisherman off the coast of the Gulf of Mexico, 20 km north of the Puerto de Veracruz, along with other treasures including several gold ingots marked with the monogram of the Holy Roman Emperor Charles V. This indicates that they formed part of the cargo of a Spanish ship which ran aground in the Gulf of Mexico. The bracelets have been twisted using long instruments, possibly to make them easier to transport.

DMG

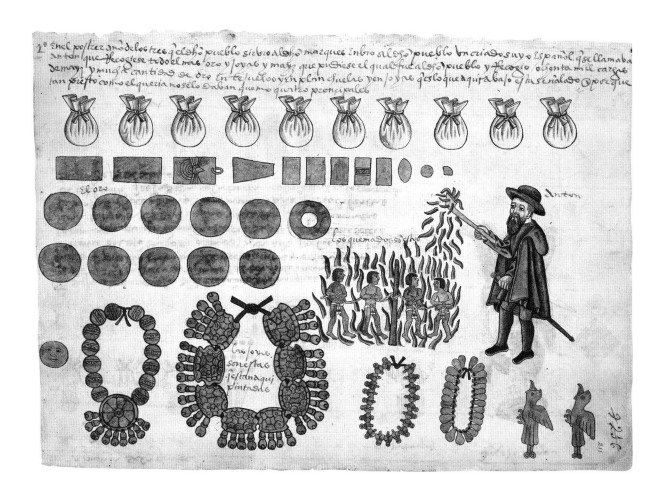

Cat. 124
Extracting tribute

Codex Tepetlaoztoc
1554, colonial
Paper, 30 × 21.5 cm
Trustees of the British Museum, London, AOA Am 2006-Drg13964

Selected literature: Martínez 1990; Valle 1994; Valle 1994b, pp. 40–45, 109–10

Prepared in 1554 in the Tetzcocan village of the same name, Codex Tepetlaoztoc is a legal document painted by several *tlacuiloque* (artist-scribes) in the indigenous tradition, although a command of European artistic technique is evident. With the aid of Spanish commentaries, the main text denounces the excessive tribute demands made by a series of Spanish *encomenderos* (grantees of Indian tribute) and their ill treatment of the town's inhabitants.

Possibly with prior knowledge of the region's gold-working tradition, Cortés assigned many of its tributary communities to himself. Although short, his tenure at Tepetlaoztoc (1523–25) was nevertheless profitable for the annual tribute was set at forty pieces of gold in small, flattened pieces (*tejuelos* and *hojuelas*), for use as coinage, and one gold- and feather-worked shield.

However, the codex also lists further demands over the three-year period, in the form of 3,000 *fanegas* (approximately 4,500 bushels) of maize, 4 *cargas* (approximately 12 bushels) of finely

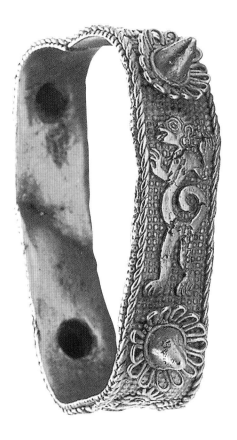

woven mantles, 11 embroidered mantles, and a further *carga* of 20 luxury mantles. Following the indigenous commodity tally system, the quantities are expressed in feathers, dots and counting sticks.

Seemingly aware of the impending reassignment of the tributary rights, in Cortés's third year his steward Anton (at centre right on the first page, with a burning brand in his hand) was sent to collect 'all the gold, jewellery and maize he could'. He took away 80,000 *cargas* of maize in ten sacks, and a 'great quantity of gold' in the form of *tejuelos* and *hojuelas*, and exquisitely wrought jewellery. As punishment for the Indians' late delivery of these items, Anton tied up four of their nobles and burnt them alive.

From other archival sources we learn that in the early autumn of 1526, and as Governor of New Spain, Cortés issued an Ordinance protecting the Indians from ill treatment in the service of Spaniards. Meanwhile, he arranged for the despatch of a large quantity of gold jewellery to Spain as part of his personal gains. The inventory

strongly echoes the style of the pieces from Tepetlaoztoc.

From 1528, the *encomienda* of Tepetlaoztoc fell to the Crown factor, Gonzalo de Salazar. The second page (below) reproduces part of the tributes paid in the third year: 3,200 measures of maize (centre), 18 sacks of cacao beans (top right), together with equally large quantities of mantles, blouses and skirts, and loincloths. Such quantities probably far outweighed the needs of the *encomendero* and his household, however large; any excess was therefore probably destined for commercial purposes.

Terrified by the beatings already meted out by Salazar's steward, the Indians included a large gold jewel (top left), crafted in the form of a ceremonial shield. At the centre, the mosaic *xicalcoliuhqui* motif (a sun symbol) was probably worked in feathers. Not satisfied, Salazar also demanded the wife of Tepetlaoztoc's native ruler. When this was refused, the ruler was stripped of his title and ordered to tend Salazar's sheep for 80 days.

EW

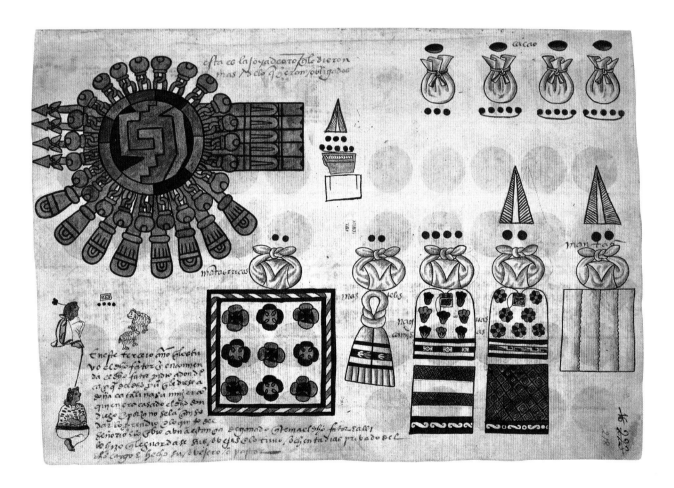

Cat. 125
Moctezuma's heirs

Codex Cozcatzin
c. 1572
30 × 23.5 × 1.5 cm
Bibliothèque Nationale de France, Paris
Manuscrits mexicains 41–45, fol. 1v

Selected literature: Gillespie 1989; Valero de García
Lascuráin *et al.* 1994

The Codex Cozcatzin consists of eighteen
(surviving) double-sided pages of iconic
script with commentary in Nahuatl and
Spanish. The codex denounces late-
sixteenth-century expropriations of
indigenous landholdings in Tenochtitlan,
supported with important historical,
genealogical and economic data.

Above a possible representation of the
island capital, the first page depicts the city's
glyphic toponym (left) over which rests the
xiuhuitzolli, or imperial diadem. Moctezuma
II is seated to one side, on the woven reed
tepotzoicpalli denoting high status and, in his
presence, two of his offspring known in the
colonial period as Isabel and Pedro. The
lines linking them to Moctezuma establish
the genealogical relationship, although the
panel is far from being a family portrait.

With her brother in a secondary and
lower position, Isabel points directly at her
father while at the same time raising her eyes
to the boxed commentary that refers to the
first of her three arranged marriages to
Spaniards. Moctezuma is therefore
represented posthumously but, via Isabel,
is in some way associated with the foreign
spouse. While the emplacement of the royal
diadem over Isabel's head in lieu of her
name glyph might well record a formal title,
such as 'lord's daughter', scholarship has
nevertheless argued that through the female
bloodline Isabel – with a native husband –
was the key to dynastic revival. *EW*

Cat. 126
Portrait of Moctezuma

From André Thevet, *Les vrais poutraits et vies des hommes illustres grecz, latins, et payens ...*
1584, Paris
Copperplate engraving
The British Library, London, 134.f.13

Selected literature: López de Gómara 1552; López de Gómara 1569; Thevet 1584; Díaz del Castillo 1632; Thevet 1671; Keen 1985; Cortés 1986; Schlesinger and Stabler 1986; Berdan and Anawalt 1992; Schlesinger 1993; Hajovsky 2009

The traveller, Franciscan friar and prolific author André Thevet (1502–1590) held various titles, including those of French Royal Cosmographer and chaplain for Catherine de' Medici. His portrait of Moctezuma appeared late in his career and over sixty years after the conquest of Mexico; however, it was the first portrait of the Mexica king to be seen in Europe. Produced during the transition from woodcut to copperplate engravings, Thevet credits an anonymous Flemish engraver for his book's 233 portraits, which include both classic and novel subjects such as explorers, cartographers and conquistadors.

While his portraits were copied from various pictorial sources (sketches, prints, paintings and even stained glass), there was no such basis for Moctezuma's image. Nonetheless, Thevet manages to convey an image of the king from a number of sources, including written first-person accounts and Mexican pictorial manuscripts he held in his collection.

The earliest eyewitness report of Moctezuma came from the Spanish conquistador Hernán Cortés, who described the king, his city and his riches in his Second Letter to Emperor Charles V (1520). Cortés's account was followed by a more thorough description written by his secretary, Francisco López de Gómara, who in 1552 published his *Conquest of Mexico*. Bernal Díaz del Castillo, one of Cortés's men during the 1520 encounter, recollected the king's image from memory in a yet fuller description in 1568. Although Díaz del Castillo's *True History of the Conquest of New Spain* was not published until 1632, it is likely that Thevet had access to this and other manuscripts, as well as the verbal reports of explorers and

conquistadors he met while travelling.

Thevet's portrayal of the Mexica king combines aspects of these three textual descriptions with yet another kind of source – the indigenous pictorial manuscript known as the Codex Mendoza – which he apparently had in his collection by 1553, two years before he made his only voyage to the Americas. His Flemish engraver rendered objects from the Codex in an unprecedented three dimensions: Moctezuma wears a plain robe (*tilmahtli*) and the Mexica royal diadem (*xiuhuitzolli*) while holding an obsidian-tipped spear (*itztopilli*) and pointing to a shield (*chimalli*) hovering in front of his right arm. The artist elaborates further by attaching the skin and plumage of a quetzal bird to the *itztopilli*, and by adding jewels and feathers to his *xiuhuitzolli* and three bivalve shells to the *chimalli*. These objects do not originate from the Codex Mendoza and may have been drawn from a local cabinet of curiosities.

Thevet encourages viewers of the *True Portraits* to compare the Amerindian kings to their conquistador rivals, suggesting

Ovr ainſi qu'vn haut & eminent edifice, tant plus il eſt eſleué,faict vn plus grãd, plus lourd & plus deſolé ſoubre-ſaut, dés qu'il vient à boule-uerſer:auſſi tant plus haut ſont montés les Princes, ſils viennent à treſbucher, c'eſt alors qu'ils ſont plus piteux & plus horrible eſclat que ſils n'euſſent eſté nichés ſi haut. L'experience iuſtifiera de mõ dire, & notamment le preſent diſcours, qui repreſentera vn abbregé de l'eſtat de la magnificence & richeſſe de ce Roy,qui fut en fin telle-

Q Q Q Q q iiij

that the former served 'merely as paper, bronze or marble upon which to inscribe the immortal memory' of the deeds of the latter. It is therefore interesting that his rendition of the Mexica king appears conspicuously without the beard noted in the early eyewitness reports and illustrated in the Codex Mendoza portrait of Moctezuma in his palace (see cat. 17). Thevet sought to feed the public's 'growing appetite for images and accounts' of indigenous kings while heralding illustrious men from the Age of Exploration. Moctezuma is one of several indigenous rulers in Thevet's book who are depicted beardless and decorated with native weapons and featherwork, whereas their conquistador rivals wear full beards (c.f. Hajovsky 2009). The conquistador is given primacy in this account, as he enlightens Europe with new people, riches and objects of beauty. The engraved portrait facilitated comparisons and became a viable way to communicate Moctezuma's personality to an emerging public who wanted not only to hear about, but also see the Mexica king.　　*PTH*

Cat. 127
Portrait of Moctezuma

From Arnoldus Montanus, *De nieuwe en onbekende wereld, of,
Beschryving van America en 't Zuid-land...*
1671, Amsterdam
Copperplate engraving, 48 × 33 cm
The British Library, London, 147.h.4, fol. 244r

Selected literature: Acosta 1590; Dryden 1670; Montanus 1671; Ogilby 1671;
Honour 1975; Pagden 1983, pp. 32–45; Ellingson 2001

In 1671 the Dutchman Arnoldus Montanus and the
Englishman John Ogilby published books about the New
World illustrated with the same copperplate engravings,
which included this portrait of Moctezuma as a truculent
Amerindian warrior. The text concerning Moctezuma was
derived largely from José de Acosta's *Natural and Moral
History of the Indies* (1590), in which the author translates
the king's name as 'he who grows angry (like a) lord'.
Although Montanus cites André Thevet as one of his
sources, he departs dramatically from the Frenchman's
1584 portrait (see cat. 126). Ironically, Montanus depicts
the king's feathered garments as Thevet describes them
in his text, even though Thevet portrays the king in a plain
robe (*tilmahtli*). Montanus also transforms the king's
crown into a jewel-encrusted cloth band supporting a
diadem of feathers. By re-clothing the king, Montanus
turns Thevet's image of a humble servant on its head,
thus producing a visual equivalent of the Noble Savage,
as popularized by the English playwright John Dryden
in *The Indian Emperor*.

Moctezuma, whose name invoked fear and respect,
emerges as a nubile and dark-skinned youth of around
twenty years old. The tensions between savagery and
nobility are evident from the king's feathered costume
and the classical cityscape behind him. Moctezuma's
gaze is detached from the viewer, defying political
subjection, and yet his accoutrements are unlike any
surviving Mexica examples. The shield – with its
interwoven bands (suggesting the reeds used for the
structural support of Mexica shields) and feather down
balls – resembles the 'Huitzilopochtli shield' seen before
each Mexica king in the Codex Mendoza. However,
existing examples reveal that feathers hang downwards,
rather than encircle, Mexica shields. Nevertheless,
Montanus and his engraver represent a politically active
king in Europe, whose feathered costume is a theatrical
reminder of the Noble Savage: truly an 'angry lord'. *PTH*

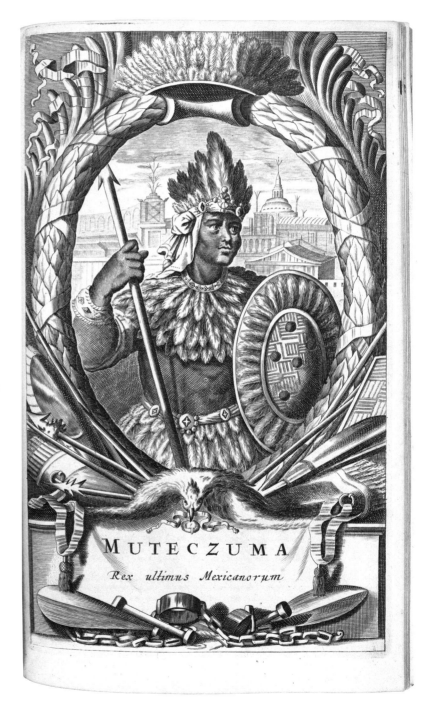

MUTECZUMA

Rex ultimus Mexicanorum

Cat. 128
'Moctezuma names the King of Spain as the successor of his Empire: he gives him allegiance and tribute'

Anonymous, *c.* 1785–1800
Oil on copper, 66.2 × 49.3 cm
Museo de América, Madrid, inv. 00229

Selected literature: Cuadriello 1999

Hernán Cortés is depicted here in an interior scene as a representative of Emperor Charles V, seated under a shield bearing the arms of Spain. He is surrounded by his captains and a notary taking the minutes of the encounter. Moctezuma is also accompanied by his nobles and approaches Cortés on bended knee, offering him gifts. As the text beneath indicates, the picture captures the moment when 'Moctezuma names the King of Spain as the successor of his Empire: he gives him allegiance and tribute'.

Both the text and the image are directly inspired by an edition of a book by the seventeenth-century chronicler Antonio de Solís, *History of the Conquest of Mexico*, that was published in Madrid in 1783. This picture is from a series of twenty-four paintings on copper showing the conquest of Mexico, based on the illustrations to this edition of Solís's work. *MCGS*

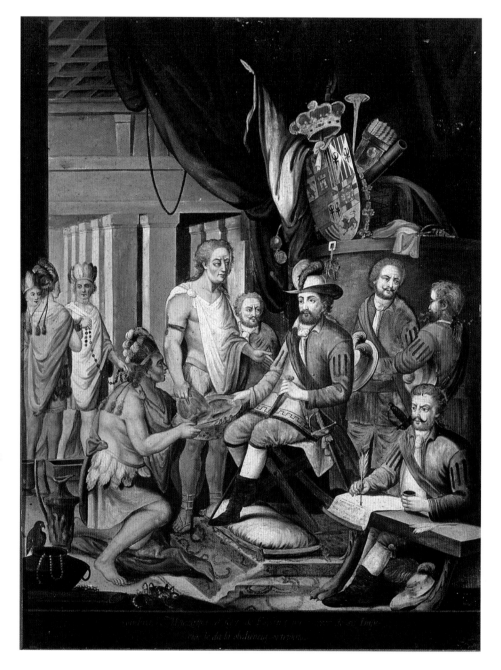

Cat. 129
Portrait of Moctezuma

Attributed to a member of the Arellano family
c. 1700
Oil on canvas, 185 × 100 cm
Colección Familia Maillé

Selected literature: Cuadriello 1999; Cuadriello 2004

Recently brought to light from a private collection in Mexico City, this portrait is a deeply contemplative image of Moctezuma. Cuadriello has suggested that it may have been produced for a hall of royal portraits collected and commissioned by the Viceroy José Sarmiento y Valladares (1696 –1701), who married into the Moctezuma line and carried the title Count of Moctezuma and Tula. The inscription at the bottom reads 'El Monarca Montesuma', and Cuadriello identifies its anonymous artist as a member of the Arellano family who were active at the turn of the eighteenth century. The king's red billowy cape is almost an extension of the curtain that frames him. He is represented at about forty years of age, with a heavy beard, and wears a multicoloured feathered tunic under a Roman military cuirass edged with gold ornaments. His armour includes a belt with a heraldic jewel-encrusted buckle, brooches and necklaces, and a *maquahuitl* (obsidian-edged club) with an eagle head for a handle. Wearing a gold *xiuhuitzolli* (royal diadem) and with his left hand over his heart, he gazes wistfully past his descending sceptre to a European crown lying near his gilded sandals.

As Cuadriello eloquently notes, Moctezuma's gesture is one of spiritual and political subjugation. His gesture associates him with contemporary depictions of the Adoration of the Magi, the fourth king to realize Christ at Bethlehem as King of Kings. The depiction of the two crowns underscores his dual role in colonial New Spain. His Mexica *xiuhuitzolli* now bears the Habsburg double-headed eagle, while the European crown on the ground is topped with the Mexica symbol of Tenochtitlan: the eagle perched on a nopal cactus. This internal dialogue reinforces Moctezuma as interim ruler of Tenochitlan before the advent of the Habsburg monarchy in Mexico under Charles V. By extension, the Mexica empire is given a status analogous to Rome, which served as the ideological centre of the Holy Roman Empire. Moctezuma thus bridges Old and New World political and spiritual domains – a fitting portrayal of the king in the Viceroy's Palace. *PTH*

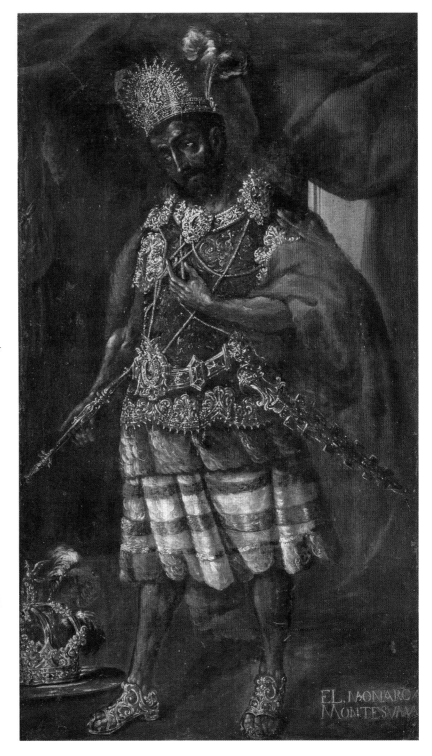

Cat. 130
Portrait of Moctezuma

Attributed to Antonio Rodríquez
Late seventeenth century
Oil on canvas, 185 × 160 cm
Museo degli Argenti, Florence, inv. 1890 no. 5158

Cat. 131
Portrait of Moctezuma

Sister Isabella Piccini
Late seventeenth century
Engraving, 47 × 28 cm
The British Library, London, 1446.k.18

Selected literature: Solís 1684; Solís 1704; Pérez de Ribas
1968; Heikamp 1972; Torquemada 1975–83; Escalante
Gonzalbo 1997; Escalante Gonzalbo 2004

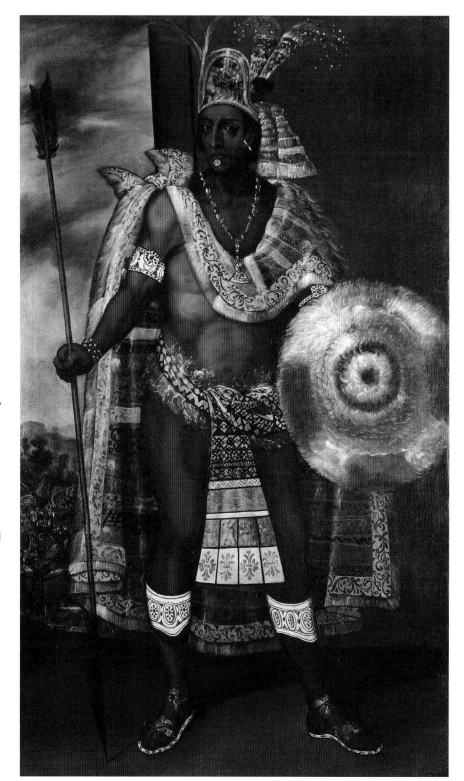

During the late seventeenth century, Cosimo III de' Medici commissioned a portrait of Moctezuma to be painted by a Mexican artist. It appears that the Italian traveller Giovanni Francesco Gemelli Carreri carried out this task, working closely in Mexico with the *criollo* (Mexican-born Spaniard) polymath Carlos de Sigüenza y Góngora to produce this portrait. The painting is the first full-bodied portrait of Moctezuma, created nearly 200 years after the Spanish conquest.

Standing in a natural pose, or *contrapposto*, the king wears a multicoloured cape, loincloth and Mexica crown, all of which are woven with Mexica motifs, embroidered with baroque ornaments and strewn with feathers. His sandals are decorated with gold and he wears golden arm and leg bands. Holding a circular feathered shield, he balances his pose with a long spear pointing to the ground. The young, muscular king stands steadfast and resolute, gazing back at the viewer from a plainly decorated room overlooking a ceremonial scene.

Escalante Gonzalbo attributes the painting to the Novo-Hispanic artist Antonio Rodríguez (1636–1691), and relates it to portraits found in indigenous codices from New Spain (figs 7 and 15). There is no doubt that the painting originated in New Spain and that it is related to portraits in the codices. Yet another model for the image could have been an indigenous performer who participated in the famous 'Dance of Moctezuma' during ceremonies dedicated to the Christian sacrament of the Eucharist. Such ceremonies are described by the seventeenth-century Jesuit Andrés Pérez de Ribas and the Franciscan Juan de Torquemada, and scenes from these

performances were included in contemporary paintings and folding screens (see cat. 118). Such an event can be seen in the lower left corner, depicted at the moment when the emperor enters the dance. Four lords, similarly dressed, carry him into the scene, while a figure off the canvas holds a circular feather canopy over him. Two more figures dressed as lords lay textiles or flowers on the ground, while drummers begin playing. Other attendants bring bouquets of flowers to the ceremony.

While this painting remained in Italy, it was more widely known through the 1704 Italian edition of Antonio de Solís's *History of the Conquest of Mexico*, where it appears as an engraved copy by the nun Isabella Piccini (cat. 130). The print contains the inscription: 'Portrait of Moctezuma, engraved from the original sent from Mexico to the Most Serene Grand Duke of Tuscany.' Solís's original text was published in Spanish in 1684 as a revised history in support of the waning Habsburg monarchy, repeating much of the information from sixteenth-century accounts. While Solís reiterates that Moctezuma conceded his empire to Cortés, and by extension to Charles V, the portrait retains its poignancy as an unyielding and courageous king. One wonders how the painting would have been received in Cosimo's court, as it reinforced colonial notions of indigenous subjectivity.

The portrait offers an insight into baroque pageantry in New Spain, as the ceremony itself stages indigenous devotion to the Christian Eucharist. The figure – perhaps a live model from such a festival – wears the costume regalia of that time, as is also seen in manuscripts and paintings from the sixteenth and seventeenth centuries. The political aspects of the 'Dance of Moctezuma' may not have crossed the Atlantic Ocean to Tuscany, but they are reinforced by the insertion of the portrait into Solís's *History*, which translated the Spanish perspective of the conquest of Mexico into Italian. Like Moctezuma's performance before the Eucharist, the printed portrait supplements Spanish imperial history, while at the same time calling attention both to the painting's Mexican origin and its Italian destination.

PTH

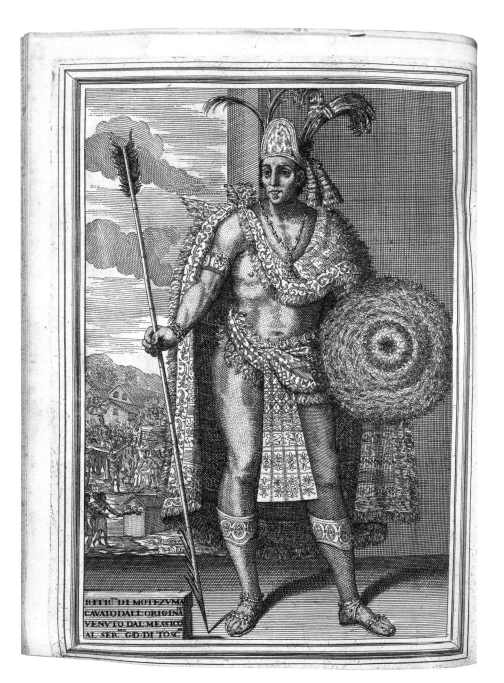

Chapter 8

Rethinking Moctezuma

Salvador Rueda Smithers

IN 1924 Diego Rivera painted the old viceroyal building, which had been turned into the offices of the Ministry of Education. The civil war of the Mexican Revolution was over and a bright future was being dreamed up. The building, which had been grey for centuries, now flaunted colourful walls and uplifting slogans. Diego Rivera, both an artist and an ideologue, painted the new meaning of the cosmos with symbols and allegories. He depicted the birth of the twentieth century as a turning of the tables on history. The Revolution was reinventing justice and Rivera's murals sought to reflect the forms of this new pact with destiny.

Rivera's iconographical references included four martyrs from Mexican history. They were telluric heroes, springing from the earth. Each was distinguished by symbols that confirmed their place in history and in art. Three were portraits of modern heroes, with distinctive, legible faces. The fourth hero, however, was remote and harked back to the country's origins. His symbols were the product of nineteenth-century artistic conventions and provided succour to the nationalist discourse: the fire of torment and the rope with which he was hanged. There was, however, another rather stranger object: a sling with a round stone. The figure was Cuauhtemoc, the last Mexica ruler. The instruments of torture and death identified him, but the sling alluded to an incident that had by then almost been forgotten. Diego Rivera wanted to remind everybody – as is evident from his murals at the old viceroyal building – that it was Cuauhtemoc who, at the start of the defensive war against the Spanish conquistadors in 1520, brandished his sling and killed Moctezuma with a stone.

Fig. 87
Portrait of Cuauhtemoc, the last Mexica leader, by Diego Rivera (1886–1957). Mural, 204 × 134 cm. Secretariat of Public Education, 1924, Mexico City.

History has treated Moctezuma ambivalently over the last two centuries. The tragic baroque figure of a decadent, pagan king, who ruled his empire with an iron fist, according to his whims, before being defeated by brave, resourceful Christians, has been relegated to a minor role. The nineteenth century regarded him with embarrassment. By falling prey to his nightmares – the fear of the legendary return of the god Quetzalcoatl, who would snatch away his power – he had acted as an accomplice in the defeat of the Mexicas. Just as Hernán Cortés went from being a hero to a villain, the dramatic stature of Moctezuma diminished as that of Cuauhtemoc, his worthy and valiant nephew, grew. By decree of official history, the fearful emperor ceded his place to the first hero of the Mexican nation. Curiously, though, he was also considered unequivocally as a key figure in the golden age of Mexican history, as he conjured up the impressive empire of Moctezuma 'the Magnificent', unparalleled in the Americas. The Codex Mendoza had already recounted that 'proud Motecuhzoma made himself feared near and far' and its pages parade the insignia of the peoples whom he conquered and obliged to pay tribute: 'he conquered forty-four peoples ... and subjected them to his sovereignty and empire.' Art teachers and students in the Academia de San Carlos took episodes from his life to develop their compositional and colour skills. Scenes such as Moctezuma's audience with messengers bringing news of the recent arrival of the Spanish inspired historical paintings that conformed with European orthodoxies.

In 1900 Moctezuma was obscured in murky legend. The famous engraver José Guadalupe Posada pictured him as a hesitant king. Inspired by the children's stories of Heriberto Frías. Posada illustrated the covers of various historical tales in which the Mexica emperor watched events unfurl with a mixture of amazement and powerlessness. The little volumes in the *Library of the Mexican Child* gave rise to fantastic fables that showed the emperor beset by misfortunes, as in 'Hernán Cortés before Moctezuma', 'Moctezuma's prison or the last outrage', 'Moctezuma's dream or the prophecy of the Conquest'.[1] In 1925, just as Diego Rivera was painting Cuauhtemoc to remind us of Moctezuma,

Fig. 88
Three covers from the *Library of the Mexican Child* series (*Biblioteca del Niño Mexicano*). Engraved by José Guadalupe Posada, 1900.

Heriberto Frías reiterated the negative judgement that he had previously shrouded in puerility in his historical stories. In the book commemorating the sixth centenary of the founding of Mexico City. Frías declared that the start of the sixteenth century witnessed the appearance of 'the sadly famous Moctezuma Xocoyotzin, doubly cursed as a great general of rapacious, conquering armies and as the Supreme Pontiff of wily, stultifying priesthood, spurred on by his hatred of the working people and the privileges he bestowed on his fortune tellers and on other courtiers who corrupted him still further, making him as despotic and extravagant as he was superstitious and cowardly.' He was duly punished for his transgressions. Held up as a coward, 'the Mexicans stoned Moctezuma and a rock took his life away.'[2] There was no mention of Cuauhtemoc. The logic of this epic tale no longer pitted him against his uncle the emperor but against the invader, Hernán Cortés.

Between 1946 and 1950 – years in which the remains of Cortés and Cuauhtemoc were 'discovered'[3] and ideological debates were conducted in pseudo-scientific language – moves were made to restore the reputation of Moctezuma. In 1947 Francisco Monterde published his academic study *Moctezuma II* for the Imprenta Universitaria, with all the inherent intellectual endorsement. He returned to the chroniclers of the conquest of New Spain to interpret them in a modern light, driven by a desire to understand rather than to pass judgement. Monterde charted Moctezuma's dramatic life, starting with the grim prophecy about Quetzalcoatl, accepted with fatalism; the rise to the throne and the failure to take heed of a religious parable warning against excess; the wealth of Tenochtitlan and the 'golden seat' as circumstantial instruments of ruin; the omens and the arrival of the invaders, coinciding both in dates – the frightening Ce Acatl (1 Reed)[4] marking the return of an avenging Quetzalcoatl – and in images – the white-bearded Quetzalcoatl – thereby confusing myth with destiny. The denouement is barely credible: captivity, outraged gods and the fulfilment of the prophecy. Rather than seeing the death of Moctezuma as the start of Cuauhtemoc's heroic career, Francisco Monterde posited another outcome: the king imprisoned by the Spaniards, throwing scorn on their threats, was stabbed by one of the desperate conquistadors and then taken, wounded, to the terrace, where he was killed off by his former vassals. In a gesture worthy of medieval courtesy, Hernán Cortés handed over his corpse so that it could receive a funeral in keeping with indigenous customs. There is no record of Moctezuma's burial place, which was obliterated by the war.

The distance established between Moctezuma and Cuauhtemoc by the hero-building process of nationalism in the mid-twentieth century made it possible to regard the former with a little more calm. His name was now attached, with no stigma at all, to a brewery dating back a hundred years, to an equally old working-class housing estate in Mexico City, to brands of chocolate and cement, to a Metro station and to a famous restaurant, La Hija de Moctezuma ('Moctezuma's Daughter'). More recently, graphic design has brought together what generations of ideologues have tried to keep apart: Moctezuma and Cuauhtemoc appear together in the logo of the Cuauhtemoc–Moctezuma brewery.

Moctezuma's figure may have lost part of its tragic essence but he had gained in human stature. He was seen as the most powerful man in a territory that prefigured present-day Mexico – a demanding, outspoken ruler, who was synonymous with the prosperity of ancient Mexico. His legacy was paradoxical, however. He was a man capable of

both creating an empire and losing it, trapped by his religion and the cunning of Hernán Cortés. He was both omnipotent and credulous. In the 1960s Mexican children were told that Moctezuma ate fresh fish from the Gulf, brought every day to Mexico City from the Atlantic coast by an army of runners who, in a tireless procession, carried their precious cargo, wrapped in banana leaves, through the mountains. By means of the will of this imaginary Moctezuma, the Atlantic seemed closer to the city that was once Tenochtitlan. His lost treasure was legendary – supposedly still hidden underground in a fit of child-ish spite, out of the reach of both Spanish conquistadors and Mexicans.

The 1970s were more generous and understanding towards Moctezuma. The ver-dict was the same, but there were new attempts to comprehend his strange destiny. In 1972 the historian Eva Uchmany published a book about Moctezuma aimed at the gen-eral reader in which she stated:

> ...the authoritarian *tlatoani* of the first two decades of the sixteenth century was more devoted to a life of contemplation than the forgers and architects of Tenochca power. This is why he saw natural phenomena not only as manifestations revealing messages to the Mexicas, the people chosen by the tutelary god Huitzilopochtli, but also as portents predicting the end of the Fifth Sun. He lived in expectation of a cataclysm that would destroy the harmony that governed personified nature, which would mean both the loss of Mexica supremacy over other peoples and could give rise to a hecatomb for humanity as a whole. ... The baneful omens would soon appear.[5]

Uchmany came up with an interesting hypothesis: Moctezuma was taken hostage and took offence at Cortés's disdainful attitude to the gods in the Templo Mayor, entitling him to give the order to massacre the conquistadors. He did not do this, 'although he replied forcefully to the defiler of his gods. His behaviour can only be explained through his faith, in terms of Quetzalcoatl's manifest opposition to human sacrifices, in contra-vention of Aztec tradition.' Moctezuma ordered sacrifices on a massive scale to appease invaders whom he saw as representing the end of history: 'This sacred and horrible mad-ness was the reflection of the Mexica civilization's great fear of deified nature. This was the fear of total death, which could be remedied through individual death.' Moctezuma thought that the weight of the existence of the universe rested on his shoulders. 'By means of gold offerings, which the Spaniards interpreted as "favours" from the liberal monarch, Moctezuma sought to avoid an imminent clash of deities, which the ancient books described as the cause of the destruction of Tula. For all these reasons, the *tlatoani* allowed himself to be captured, in his own capital, by Captain Hernando Cortés.' The mystical priest-king, 'the human representative of the people chosen by Huitzilopochtli-Tonatiuh was more concerned with preserving the existence of the Universe than his own life. ... This act indicates that the ill-fated *tlatoani* was not a coward.' Perhaps Uchmany's book reflected its times: the popularization of serious studies – such as those by Miguel León-Portilla[6] and Alfredo López Austin[7] on ancient mythical-religious thinking, and the translations of the Nahuatl texts collected by Friar Bernardino de Sahagún between 1550

and 1575, especially the predictions of the conquest that tormented Moctezuma – undoubtedly prepared the way for a quiet change in attitude towards the famous Mexica ruler.

López Austin presented a particularly interesting version in his book *Hombre-dios* ('Man-God') in 1973, based on a meticulous reading of the historical sources. This explained how Moctezuma Xocoyotzin wanted to substitute the old mythical and political Toltec support for power in his urge to unravel the 'Mexica empire' in its true state. He encountered opposition but crushed it. His reputation as an unscrupulous tyrant was derived from this extreme application of force. He wanted Tenochtitlan to be 'the heart of all the earth', and the former god of the nomadic tribe 'to be transformed from the protector of the city into the protector of the world'. By boosting his political status, 'Motecuhzoma showed his vulnerability'. López Austin convincingly argued that Moctezuma's project only started to take on the features of total dominion 'when other conquerors arrived, the sons of Ce Acatl, the men dressed in metal. What could be done against them? Motecuhzoma Xocoyotzin must have been horrified to witness the return of what he had sought to extirpate, and perhaps the Culhua sprung up where he smothered the Mexica. It was hard to go back to believing in the transitory seat of Quetzalcoatl.'[8] It should be remembered that Diego Durán mentioned the fear of looking at Moctezuma's face – anybody who did so was sentenced to death. Nevertheless, he was a man, not a semi-god: when he died he would not go to any of the 'paradises' but to the place commonly reserved for the dead, where his bones would turn to dust and his memory would fade. Obviously, his fate was otherwise – even in the first decade of the twenty-first century.

Nowadays we have a multi-faceted picture of Moctezuma. There is the man who was defeated by his atrocious religious dream, the stereotype of degrading behaviour. At the same time, there is the master of the enormous empire that he bent to his will and the figure in the artistic conventions of the viceroyalty, which all the efforts of Diego Rivera were unable to erase. In 1975 the Cuban writer Alejo Carpentier opened a seam in Mexican awareness. A strange comeback: it was possible to imagine Moctezuma once again recreated by baroque creativity. The Moctezuma – or Motecuhzoma – of the historical events of the conquest was reunited with the theatrical Montezuma of ephemeral screens and arches. Thanks to *Concierto barroco* it was possible to believe in 'a Montezuma somewhere between a Roman and an Aztec, a Caesar with quetzal feathers on his head', whom we now recognize as a character in paintings and museums, 'seated on a throne whose style was a mixture of pontifical and Michoacan, underneath a canopy supported by two halberds; at his side stands an indecisive Cuauhtemoc with the face of the young Telemachus and slightly almond-shaped eyes. In front of him, Hernán Cortés with a velvet hat and a sword in his belt, his arrogant boot on the first step of the imperial throne, was immobilized in a dramatic conquistador pose...'[9]. It is not for nothing that there is an obsessive quest to recover the so-called 'panache of Moctezuma', an object which, under any other name, would be quietly slumbering in its display cabinet, and a drive to unravel his family tree (and publish the Codex García Granados)[10] and undertake the biography of his daughter, Isabel de Moctezuma Tecuichpo. Some traces of the doomed Mexica ruler do remain, however: each generation depicts the greatness and weaknesses of Moctezuma in accordance with what it asks and requires of history.

Epilogue

In search of Mexica kings: current excavations in Tenochtitlan

Leonardo López Luján and Ximena Chávez Balderas

A FEW years ago, the local government of Mexico City ordered the demolition of two buildings in the historic centre that had been irreparably damaged by the 1985 earthquake. This decision aroused great hopes in archaeologists as both these buildings were situated on a plot in front of the ruins of the Templo Mayor of Tenochtitlan. It was known that the funerals of at least three kings – Axayacatl (1469–81), Tizoc (1481–86) and Ahuitzotl (1486–1502) – had taken place right at the foot of the main façade of this pyramid.[1] Historical sources from the sixteenth century had revealed that the corpses of the Mexica kings were cremated here and their ashes were buried along with luxurious offerings and the bodies of the servants sacrificed for the occasion.

An archaeological dig undertaken in 2006 confirmed the enormous importance of this site, as it unearthed the biggest Mexica monolith discovered to date. This was a one-eyed sculpture carved out of pink andesite, measuring 4.17 x 3.62 x 0.38 m and weighing 12 tonnes.[2] This monument depicts Tlaltecuhtli (lady of the earth), a goddess who appears in the myths as the venerated mother who gives birth to all creatures (plants, animals, human beings, the sun and the moon), as well as the monster who devours them when they die.

In March 2007 a new phase of the Templo Mayor Project (founded in 1978) was initiated to explore this area with state-of-the-art technology and meticulous scientific techniques. A few months later, the monolith was temporarily removed from the ground with the help of a long-armed crane in order to be cleaned, restored and analysed. This work

Fig 89
The recently found earth goddess (Tlaltecuhtli) monolith. It was discovered broken into four pieces at the foot of Tenochtitlan's Templo Mayor in downtown Mexico City. Extravagant offerings have since been discovered beneath and around this monument.

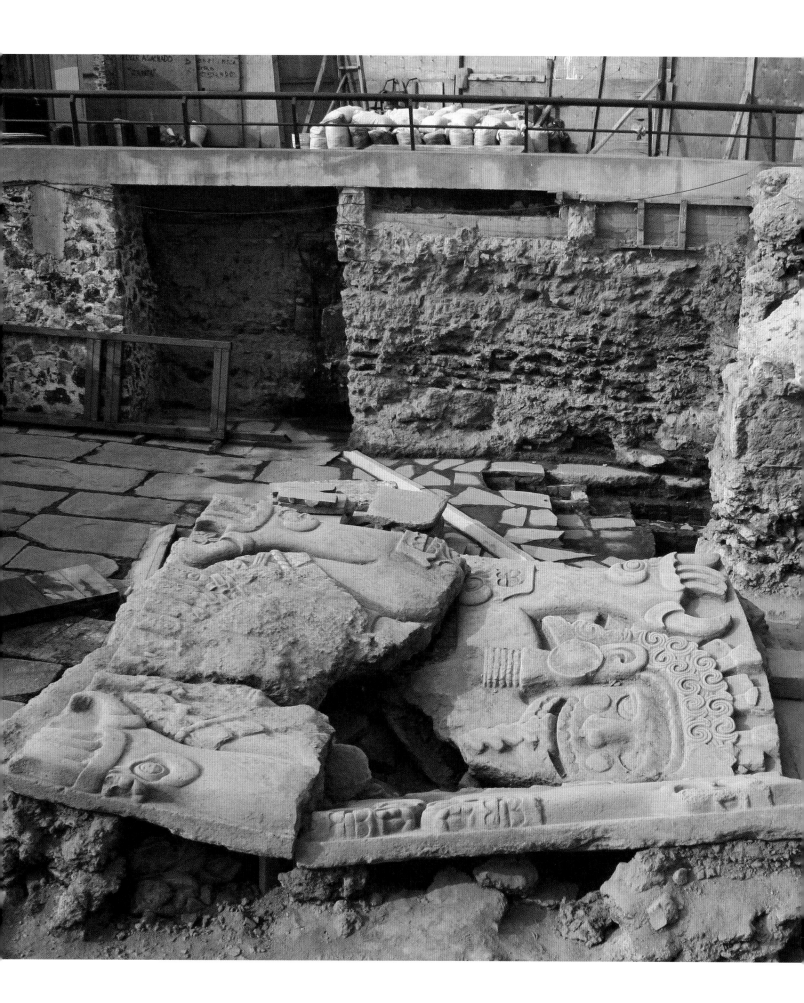

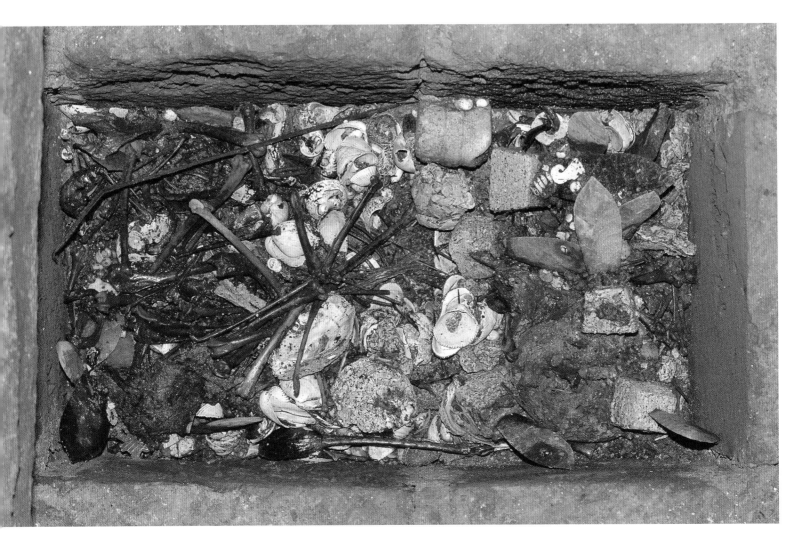

revealed the rich colours used by the Mexica artists to paint the goddess. Meanwhile, geophysical radar studies and archaeological excavations were under way on the site occupied by the monolith. These revealed an entrance to the east of the monolith that may have led to a funeral chamber via a deep vertical shaft.

Thirteen offerings have now been recovered, featuring a wide range of gifts: plants (amaranth and cotton seeds, maguey stalks, bars of tree resin), sea animals (shells, snails, corals, fishes, crabs, prawns, sea urchins, sand dollars, sharks, sawfish), birds (eagles, herons, ibises), mammals (pumas, wolves, lynxes) and ritual objects (pottery jars and censers, wooden masks and sceptres, greenstone ornaments and beads, flint knives and a number of unprecedented gold pieces).

Fourteen of the gold pieces that were recently unearthed are now on display for the first time. Some of these objects were made with hammered, embossed and highly burnished gold sheets, while others were produced using the lost-wax technique. The first group of pieces comes from offering 123, found underneath the monolith of Tlaltecuhtli. They are representations of the pleated paper rosettes known as *ixcuatechimalli* ('shield of the forehead') worn on the heads of gods and priests (fig. 92). These insignia were originally attached to personalized sacrificial knives with large fangs and eyes in the shape of a Maltese Cross – features associated with the four fire priests who

Fig. 90
Offering 125, a stone casket located to the west of the Tlaltecuhtli monolith. Dozens of gold ornaments come from this deposit, along with many sacrificial knives, remains of marine animals, two skeletons of golden eagles and one of a wolf or dog.

made offerings during the New Fire ceremony, as shown in plate 34 of the Codex Borbonicus (see cat. 73). The second group was discovered in offering 125, to the west of the monolith. It comprises one insignia in the form of a femur (*omitl*) and another in the form of a sectioned shell (*ehecacozcatl*) (figs 93 and 94). Both were associated with the personalized sacrificial knives depicting Quetzalcoatl (Venus at dawn), Xolotl (Venus at nightfall) and Pahtecatl (the moon god of *pulque*, an intoxicating drink made from agave), as seen in fols 61r, 62r and 55r of the Codex Magliabechiano, respectively. The third group also comes from offering 125, apart from a nose ornament that was found during operation 4 in the building rubble fill supporting the monolith. All these objects are insignia belonging to the gods of *pulque*: an ornament for the forehead, two rectangular ear-spools with a central jewelled pendant, a moon-shaped nose ornament (*yacametztli*) and six pear-shaped bells (figs 95, 96, 97 and 98). Their position inside the offering indicates that some of these ornaments were linked to sacrificial flint knives, while others were associated with the remains of a spider monkey (*Ateles geofroyi*) pelt, as shown in fol. 55r of the Codex Magliabechiano (fig. 91).

Fig. 91
A *pulque* god or his impersonator with a priest dressed as a Xochipilli spider monkey. From Codex Magliabechiano, fol. 55r. Biblioteca Nazionale Centrale, Florence.

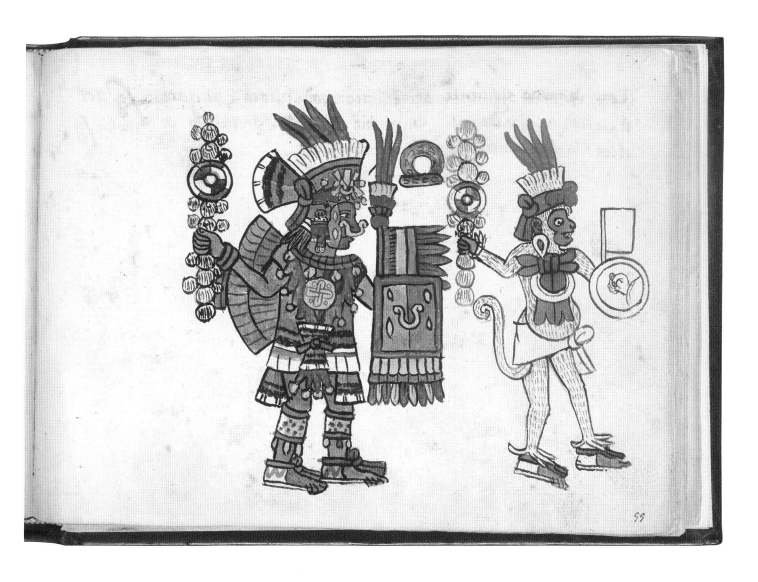

Fig. 92 *above*
Golden representations of pleated paper rosettes, 6.3 × 6.5 × 0.05 cm. Offering 123, artefacts 88 and 102, Templo Mayor (*c.* 1486–1502).

Fig. 93 *far right*
Golden insignia in the form of a femur, 6.2 × 2.4 × 0.03 cm. Offering 125, artefact 215, Templo Mayor (*c.* 1486–1502).

Fig. 94 *right*
Golden pectoral in the form of a sectioned shell, 2.9 × 3.1 × 0.03 cm. Offering 125, artefact 68, Templo Mayor (*c.* 1486–1502).

Fig. 95 *left*
Golden ornament for the forehead,
5.6 × 6 × 0.03 cm. Offering 125,
artefact 13, Templo Mayor
(*c.* 1486–1502).

Fig. 96 *centre, left and right*
Golden rectangular ear-spools,
4.3 × 2.5 × 0.05 cm. Offering 125,
artefacts 11–12, Templo Mayor
(*c.* 1486–1502).

Fig. 97 *centre, middle*
Golden moon-shaped ornament,
1.5 × 1.9 × 0.04 cm. Offering 4,
artefact 113, Templo Mayor
(*c.* 1486–1502).

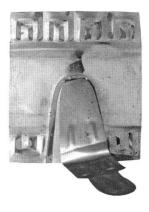

Fig. 98 *left*
Golden pear-shaped bells,
2 × 0.9 cm. Offering 125,
artefacts 475–479 and 578,
Templo Mayor (*c.* 1486–1502).

Glossary of glyphs

Shield and darts: warfare

Ruler seated on woven reed throne

Burning temple: conquest

Footprints: path

Volutes: sound or speech

Hill or 'place'

Drilling tools and smoke:
fire ceremony

Cactus thorn: self-sacrifice

Solar disc

Rain

Heart

Greenstone

Gold

Turquoise

1
Dot

10
Dots

20
Paper banner

60
Paper banners

400
Feather

8000
Incense pouch

Acamapichtli First Mexica ruler (*tlatoani*) (ruled 1375–1395)

Acolhua The first Chichimeca group to arrive in the valley of Mexico, the Acolhua people settled on the north and eastern shores of Lake of Tetzcoco. Their capital city was Tetzcoco.

Ahuitzotl Eighth Mexica ruler (*tlatoani*) (ruled 1486–1502). His name 'the dog of the waters' refers to a mythical aquatic creature.

Amaranth Cultivated plant used for food. Its seeds mixed with human blood were shaped into figures and worshipped.

Anahuac Nahuatl name for the Basin of Mexico.

Atl The day symbol for 'water' in the Mexica ritual calendar.

Atlatl Spear-thrower.

Atzcapotzalco Capital city of the Tepanecs, located on the western shore of Lake Tetzcoco.

Axayacatl Sixth Mexica ruler (*tlatoani*) (ruled 1469–1481). Grandson of Moctezuma Ilhuicamina (Moctezuma I) and Itzcoatl. His name means 'the one who has water on his face', or 'the one that works hard'.

Aztecs 'People from Aztlan'. This term first became widely used in the nineteenth century to refer to the Pre-Hispanic peoples of Central Mexico. It derives from 'Aztlan', the name of a mythical homeland where the Mexica are said to have originated.

Aztlan 'Place of the herons', or 'place of whiteness'. The mythical place of origin of the Mexica.

Cacama Ruler of Tetzcoco (1516–1520). He was Moctezuma II's nephew and Nezahualpilli's son.

Calmecac School run by priests for young nobles and sons of rich merchants, where poetry, religion and warfare were taught.

Calpixcacalli Storeroom used for tribute in Moctezuma II's palace.

Calpulli Community of lower-class people centred around the communal lands they worked.

Chalchiutlicue 'Jade skirt'. Goddess of underground water, lakes, streams and rain, associated with fertility.

Chalmecatecuhtli God of sacrifice. He ruled one of the levels of the underworld.

Chapultepec 'Grasshopper hill'. Location of Moctezuma II's summer palace, baths and his sculpted portrait. An aqueduct was built to supply Tenochtitlan with water from springs at Chapultepec.

Charles V King of Spain (1516–1556) and Holy Roman Emperor (1519–1556).

Chichimeca Nomadic group in the north of Mexico, said to have been the forebears of the Mexica. This term is widely used for every southwards migrating group.

Chicomecoatl / Xilonen 'Seven-serpent'. Goddess of maize, food and agricultural fertility; also known by the name Xilonen.

Chimalpopoca Third Mexica ruler (*tlatoani*) (ruled 1417–1427).

Chinampa Agricultural system of artificial islands and canals used on lake Tetzcoco to grow fruit and vegetables.

Cholula For centuries an important religious and pilgrimage centre dedicated to Quetzalcoatl, located near the modern city of Puebla. This independent town often fought against Tenochtitlan but was friendly to Moctezuma II by the time of the Spanish conquest. Famous for its polychrome pottery sought after by the Mexica and used by Moctezuma.

Citlaltepetl / Cerro de la Estrella 'Hill of the Star'. Located to the south of Tenochtitlan, the New Fire ceremony took place on its summit.

Ciuhacoatl 'Woman serpent'. Title of the secondary ruler of Tenochtitlan. He was in charge of internal affairs.

Coatepetl 'Snake mountain'. This is where Huitzilopochtli was born and defeated his siblings who were trying to kill his pregnant mother Coatlicue. The Great Temple of Mexico (Templo Mayor) represented the *Coatepetl*.

Coatlicue 'She of the serpent skirt'. Huitzilopochtli's mother. A giant sculpture of Coatlicue was found in Mexico City in 1790.

Cochineal Insect from which a natural red dye was extracted as a colouring agent for codices, pottery and textiles.

Codex (pl. codices) Pictorial manuscript painted on paper or leather.

Copal Resin used and burnt as incense.

Coyolxauhqui 'Face painted with bells'. Older sister of Huitzilopochtli, she killed her pregnant mother Coatlicue, but was dismembered by the newborn Huitzilopochtli and his *xiuhcoatl* ('serpent of fire'). She could have been a representation of the moon.

Creole People of Spanish origin that were born and lived in the American colonies.

Cuauhtemoc / Cuauhtimotzin The last Mexica ruler (*tlatoani*) (ruled 1520–1521). He was captured by the Spaniards during the siege of Tenochtitlan. His name means 'falling eagle'.

Cuauhtli / Ocelotl Eagle / jaguar. The two highest ranked military orders of the Mexica were the eagle and jaguar warriors.

Cuauhxicalli Vessel for holding human hearts after sacrifice.

Cuitlahuac Tenth Mexica ruler (*tlatoani*), who was only in power for the first six months of 1520. He was Moctezuma II's brother and died of smallpox.

Culhuacan Located on the southern shore of Lake Tetzcoco, this city was ruled by a noble class recognized as the legitimate heirs of the Toltecs. When the Mexica first settled in the Basin of Mexico they were under Culhuacan rule.

Ehecatl 'Wind'. He is one of the many aspects of Quetzalcoatl (the 'feathered serpent') who, in his guise as the wind deity, was associated with rain and fertility.

Five cosmic ages The Mexica believed their era was the fifth one since the beginning of the universe. The four previous worlds ended in destruction by jaguars, hurricanes, rain of fire and floods respectively.

Flower wars / 'Xochiyaoyotl' Battles between the Triple Alliance and its close enemies which aimed to capture warriors for sacrifice.

Glyph Symbols (pictograms and ideograms) used by the Mexica as a writing system.

Huaxtecs / Huastecs Gulf Coast culture, part of whose territory became a tributary province under Mexica control.

Huexotzinco Independent city located at the southeast of the Basin of Mexico. It fought against Tenochtitlan, forging

alliances with Tlaxcala.

Huey tlatoani 'Great speaker'. Ruling lord of the Mexica and supreme authority in the Triple Alliance.

Huitzilihuitl II Second Mexica ruler (*tlatoani*) (ruled 1396–1417). Son of Acamapichtli. His name means 'hummingbird feather'.

Huitzilopochtli 'Hummingbird of the south' or 'hummingbird on the left'. He is the patron of the Mexica, a major deity associated with sun, fire, war and sacrifice. According to Mexica myth, he guided them during their long migration to Tenochtitlan. One of two temples on top of the Great Temple of Mexico (Templo Mayor) was dedicated to him.

Icpalli High-backed seat or throne used by rulers and made of woven reeds.

Itzcoatl Fourth Mexica ruler (*tlatoani*) (ruled 1427–1440). Son of Acamapichtli. His name means 'obsidian snake'.

Iztaccihuatl 'White woman'. One of two snow-capped volcanoes located southeast of Tenochtitlan, separating the Basin of Mexico from Tlaxcala.

Labret Lip-plug used by noblemen as a sign of status.

Maguey A type of cactus (part of the agave family). Fermented maguey was used to make the alcoholic beverage *pulque*.

Malintzin / Malinche, christened Doña Marina Malintzin, called Malinche by the Spaniards and later christened Marina, was a local woman from the Gulf Coast. She became Cortés' interpreter and consort.

Maxtlatl Loincloth used by men.

Mayahuel Goddess of maguey.

Mesoamerica Geographical and cultural area extending from Central Mexico to Central America.

Mestizo / mestizaje Person of mixed racial origin (European and native American).

Mexica This term refers to the people from Tenochtitlan and Tlatelolco, as well as its synonyms Aztecs and Tenochcas.

Michoacan Western territory, dominated by the Purhepechas Indians, also known as Tarascan. The Mexica were their enemies and fought them on several occasions.

Mictlantecuhtli Lord of death and the underworld.

Mixcoatl 'Cloud serpent'. God of war, hunting and sacrifice, associated with the stars.

Mixtecs Mixtec culture (1200–1525), centred on the Oaxaca valley. Mixtec artisans were skilled in metal- and stone-working and later came to be employed by the by the Mexica.

Moctezuma Ilhuicamina (Moctezuma I) Fifth Mexica ruler (*tlatoani*) (ruled 1440–1469). Son of Huitzilihuitl II. His name means 'angry lord, he who pierces the sky with an arrow'.

Moctezuma Xocoyotzin (Moctezuma II) Ninth Aztec ruler (*tlatoani*) (ruled 1502–1520). Son of Axayacatl and grandson of Moctezuma Ilhuicamina. His name means 'angry lord, the younger'. He was the Mexica ruler of the Triple Alliance when the Spanish arrived in Tenochtitlan.

Nahuas Nahuatl speaking peoples of central Mexico.

Nahuatl The language spoken by the Nahuas, which included the Mexica.

Nezahualcoyotl Ruler of Tetzcoco (1418–1472). His name means 'fasting coyote' and he was a famed philosopher and poet.

Nezahualpilli Ruler of Tetzcoco (1472-1515). Nezahualcoyotl's son. His name means "Fasting noble".

New Fire Ceremony / 52-year cycle Also called the 'binding of the years'. This ceremony marked the moment when the 260-day ritual calendar coincided with the 365-day solar calendar, which happened every 52 years. The New Fire ceremony celebrated the end of one cycle and the beginning of a new one.

New Spain Name given by the Spanish to colonial Mexico.

Nochtli 'Cactus'.

Obsidian Shiny, black volcanic stone used to make knives, blades, polished mirrors and jewellery.

Ometecihuatl 'Two-lady'. Feminine part of Ometeotl ('two-god'), god of duality, original creator of the Gods.

Ometecuhtli 'Two-lord'. Masculine part of Ometeotl ('Two-god'), god of duality, original creator of the gods.

Petatl / petate Woven reed mat.

Petlatlalco Granary in Moctezuma's palace.

Pictographic Representing an idea or a word through a glyph.

Pilli / pipiltin Nobles.

Pochteca Mexica merchants who travelled throughout the Triple Alliance Empire. They also acted as diplomats and spies.

Popocatepetl 'Smoking mountain'. One of two snow-capped volcanoes located southeast of Tenochtitlan, separating the Basin of Mexico from Tlaxcala.

Quetzal Tropical bird, highly valued for its iridescent green feathers.

Quincunx Five-part figure arranged in a square, and representing a miniature cosmogram.

Quetzalcoatl 'Quetzal-feathered serpent', an ancient and Mesoamericam deity and culture hero. He was the god of procreation, Venus, wind, and the patron of the priests. He was also associated with a historical figure, the king of Tula in the tenth century. According to legend, Quetzalcoatl was defeated by his brother Tezcatlipoca and travelled East, promising he would return. This is said to be why the Mexica may have thought that Cortés was possibly an emissary of Quetzalcoatl.

Ritual bloodletting Mexica lords practised ritual bloodletting by piercing various body parts with maguey spines, as a sign of penance and devotion.

Sun Stone/ Calendar Stone A monumental sculpture bearing Moctezuma's name glyph and commissioned during his rule. It was rediscovered in Mexico City in 1791.

Techcatl Sacrificial stone.

Tecpilcalli Court of justice used specifically for noble warriors in Moctezuma's palace.

Tecuani 'Fearsome beast'. The Mexica ruler was compared to this in his enthroning ceremony.

Tecuhtli / tetecuhtin Lords, nobles.

Telluric Related to the earth, the ground.

Temalacatl Round stone on which gladiatorial sacrificial combats took place between a warrior and a captive. The captive's leg was tied to the stone with a rope.

Templo Mayor / Huey Teocalli The Great Temple of Mexico, the main religious building in Tenochtitlan. The two temples on the uppermost platform were dedicated to Tlaloc and Huitzilopochtli.

Tenoch 'Rock-cactus'. He was among the Mexica leaders who following Huitzilopochtli's instructions and identified the place where they were to build the city of Tenochtitlan ('the place of Tenoch') in 1325.

Tenochcas People from the city of Tenochtitlan.

Tenochtitlan The Mexica capital and principal city of the Triple Alliance.

Teocalli 'Temple'.

Teotl 'God'.

Tepanecs People from the city of Tlacopan. One of the Chichimeca groups to settle in the Basin of Mexico before the arrival of the Mexica. They founded the cities of Azcapotzalco and Tlacopan (also known by the name Tacuba).

Tetl 'Rock'.

Tetzcoco Capital city of the Acolhua people, located on the eastern side of Lake Tetzcoco. Part of the Triple Alliance together with Tenochtitlan and Tlacopan.

Tezcatlipoca 'Smoking mirror'. Omnipotent patron of rulers, warriors and sorcerers, associated with the jaguar and the night. He was one of the main deities in the Mexica pantheon.

Tizoc Seventh Mexica ruler (*tlatoani*) (ruled 1481–1486). Older brother of Axayacatl. His name means 'the one that accomplishes penance'.

Tizoc Stone This stone representing Mexica conquests was carved between 1481 and 1486, during the reign of Tizoc. It shows a sun disc on the top and Mexica warriors holding captives or deities of enemy towns on its side. It was rediscovered in Mexico City in 1790.

Tlacateco 'House of the eagles'. The building used by the Mexica military order of eagle warriors.

Tlachinolli 'Fire'.

Tlachtli Pre-Hispanic ball game.

Tlacohcalcatl Highest military title: the second in command after the ruler (*tlatoani*) for military matters.

Tlacopan Capital city of the Tepanecs, located on the western side of Lake Tetzcoco. Part of the Triple Alliance together with Tenochtitlan and Tetzcoco.

Tlacuilo 'Painter' and 'writer'.

Tlahuizcalpantecuhtli 'Lord of the dawn' or 'lord of the morning star'. God of the planet Venus, associated with Quetzalcoatl.

Tlaloc God of rain, water and fertility. He is one of the main Mesoamerican gods. One of two temples on top of the Great Temple of Mexico was dedicated to him.

Tlaltecuhtli 'Earth goddess or lord'.

Tlatelolco Close to Tenochtitlan, this city was under Triple Alliance rule by the time of the conquest. This is where the great market took place.

Tlatoani / tlatoque 'He who speaks' or lord.

Tlaxcala City located south-east of Tenochtitlan. By the time of the Spanish conquest, it still resisted Mexica rule. The Tlaxcaltec people allied themselves with Cortes and supported the Spanish in their conquest of Tenochtitlan.

Toltecs People from the city of Tula.

Tonacatecuhtli 'Lord of our sustenance', god of creations and beginnings, associated with procreation.

Tonacatepetl Tlaloc's 'mountain of sustenance'.

Tonalpohualli Mexica ritual divinatory calendar. The ritual year of 260 days was divided into twenty periods of thirteen days.

Tonatiuh 'He that goes forth shining'. Sun god associated with sacrifice and war.

Totonacs Gulf Coast culture contemporary with the Mexica.

Toxcatl celebration Religious festival celebrating Tezcatlipoca.

Trecena Group of thirteen days. The ritual calendar or *tonalpohualli* was composed of twenty months of thirteen days.

Tribute Goods required to be given regularly by each province (including food, textiles, gold and ceramics) to Tenochtitlan in acknowledgement of its supremacy.

Triple Alliance This term refers to the political confederation established in 1433 between the Mexica from Tenochtitlan, the Tepanecs from Tlacopan, and the Acolhuacans from Tetzcoco, three neighbouring cities in the Basin of Mexico.

Tula Capital city of the Toltecs. Located to the north of Tenochtitlan, it flourished between the tenth and the twelfth centuries. The Mexica claimed Toltec ancestry by allying themselves through marriage with the Culhuacan's ruling class.

Veintena Group of twenty days. The solar calendar was composed of eighteen months of twenty days, with an additional five-day period.

Viceroy / viceroyalty. Highest official representing the Spanish king in his American colonies. He governed the viceroyalty of New Spain, the spanish colonial political system established to rule the Mexican territory.

Xicolli Short and sleeveless fringed jacket tied in the front. Insignia of penitence for the Mexica rulers.

Xicotencatl Tlaxcalan warrior that opposed Cortés and the Tlaxcalan policy of alliance with the Spanish. He was the son of Xicotencatl the elder, one of the Tlaxcalan lords that promoted this policy.

Xipe Totec 'Our lord of flayed skin'. God associated with spring and agricultural renewal.

Xiuhcactli 'Blue sandals'. Insignia of penitence for the Mexica rulers.

Xiuhcoatl 'Turquoise serpent'. This fire snake was Huitzilopochtli's weapon when defeating his sister and brothers on the *Coatepetl*.

Xiuhmolpilli Name given to the ritual bundle of fifty-two reeds on the occasion of the New Fire Ceremony, also called the 'binding of the years'.

Xiuhnacochtli Ear-spool.

Xiuhpohualli Solar calendar of 365 days.

Xiuhtecuhtli 'Turquoise lord'. God of fire also identified as Huehuetecuhtli or Huehueteotl, the aged fire god.

Xiuhtlalpilli tilmahtli Blue cotton tie-dyed net cape embellished with turquoise stones used by the Mexica ruler (*tlatoani*) at his investiture.

Xiuhuitzolli Triangular diadem inlaid with turquoise mosaic and worn by the Mexica ruler (*tlatoani*), as a royal emblem of high office. It formed part of the name glyph of Moctezuma II.

Xiuhyacamitl Tubular nose ornament.

Xochimilco Located on the southern shore of Lake Tetzcoco, this city is still famous for its *chinampas*.

Xochipilli 'Flower lord'. God of flowers, music, feasting, sensuality and games.

Yacaxihuitl Turquoise nose ornament worn by Mexica nobles as a symbol of status.

Notes

Introduction

1 Authored by native, *mestizo* and Spanish chroniclers. Among these early chroniclers are: Hernando Alvarado Tezozómoc, author of the *Cronica mexicáyotl*, Cristóbal del Castillo, author of the *Historia de la venida de los mexicanos*, and the indigenous authors of the Codex Boturini and the Codex Azcatitlan.

2 Aztlan is sometimes depicted graphically (for example in the Codex Aubin in the British Museum) as an 'archetypal' island or ancestral place in a 'world ocean' with four 'house' glyphs marking the cardinal directions.

3 The name Tenochca applied to the citizens of Tenochtitlan itself.

4 Family documents from the sixteenth and seventeenth centuries, located in the Archivo de Indias in Seville, spell the name either as 'Moteçuma' or 'Motezuma'. Nahuatl scholars prefer 'Motecuhzoma' or 'Moteuczoma' and it is perhaps most correctly pronounced in Nahuatl phonemes as mo – teuc – tzo(n) – ma. They note that much of the early confusion stems from the inability in Spanish to capture some of the sounds of Nahuatl, as well as other difficulties of translation and comprehension. Problems occur in the orthographic transcription of his name into Spanish phonemes, especially crossovers between 'u' and 'o', and the spirant consonant-vowel combination that appears in the middle part of his name, yielding both – teuhc – and – tecuh – in the sources.

5 Other variations include Motecuma, Moctecuzoma or Motecuçoma (Motecuhzoma).

6 Following Moctezuma's death Cuitlahuac governed for 80 days only to die of smallpox and Cuauhtemoc, who relinquished independence on 13 August 1521,was later killed in Hibueras.

Chapter 1 Family histories

1 In the native Mexica Nahuatl language this term defines the highest political authority. 'Speaker or great lord' (Molina 1970, p. 140v); 'He who speaks well; hence, great lord, prince, ruler' (Siméon 1977, p. 674).

2 Muriá 1973, pp. 141–43.

3 The versions of events that is most widely accepted among historians specializing in the history of the Mexica people, and that on which the present account is based, is that by Francisco Javier Clavijero in his *Ancient History of Mexico* published in 1781–82.

4 Alvarado Tezozómoc 1949, p. 25.

5 Brotherston 1995, pp. 46–47.

6 Códice Boturini 1964; Barlow 1949.

7 Caso 1927, p. 10. In fig. 3, as in the Codex Boturini, a rectangular block can be seen in the upper section, which we assume corresponds to the location of the deity.

8 Alvarado Tezozómoc 1949, pp. 15–16, took his account from Alonso Franco, a *mestizo* who died in 1602. Franco not only claimed that Moctezuma ruled as king in Aztlan New

Mexico, but also that he had two sons: the eldest was destined to govern the Huastecos, and the youngest, Chalchiuhtlatonac, instructed his people to leave Aztlan and embark on their migration.

9 Chimalpáhin 1998, p. 85, even affirms that the chieftain Moctezuma who ruled in Aztlan also held the position of *huey tlatoani*.

10 These are described as three men, Cuauhcoatl, Apanecatl and Tezcacoatl, and a woman, Chimalma. Chimalpáhin 1998, p. 183.

11 Chimalpáhin 1998, pp. 329–31. The chronicler of Chalco-Amecamecan noted that 'on the death of Tozcuecuextli, who led the Mexica for forty years ... the chieftain Huehue Huitzilihuitl ruled as the first *tlatoani* of the Mexica.'

12 Chimalpáhin 1998, p. 161. Chimalpáhin claims that he was the first *tlatoani* of the Mexica, even though officially, in the sequence of governors of Tenochtitlan, he links this investiture with Acamapichtli.

13 Chimalpáhin 1998, p. 361.

14 Códice Boturini 1964. In the lower section of plate 20, sexual union is expressed graphically with the image of the couple guiding a final journey through their footprints.

15 Durán 1995, pp. 84–87. This episode describes the confrontation between the Culhua under the leadership of Achitometl and the Mexica, following the sacrifice of Achitometl's daughter by the Mexica.

16 In the pictographs of this symbolic scene, a bird sometimes replaces the snake; see fol. 25v of the Codex Aubin. Lehmann and Kutscher 1981, p. 240.

17 *Anales de Tlatelolco* 1948, p. 51. According to the Tlatelolca, this happened the other way round; after the foundation of this city, Tenoch founded Tenochtitlan on an adjacent island.

18 Durán 1995, vol. I, p. 99. '...fearing his kingdom would be left without an heir, the councillors took his advice and determined that each of them should give him one of their daughters, for him to have as his wives, to bear him heirs to his kingdom and successors.'

19 A crown, mitre or diadem adorned with precious stones. Siméon 1997, p. 770.

20 A crown, similar to a mitre, used for coronations. It was tall and ended in a point in the middle of the forehead; the back section hung down the neck. Siméon 1997, p. 126.

21 Sahagún 1993, fols 53r–52r. Significantly, after Cuauhtemoc, the last *tlatoani*, the five governors who ruled over the conquered Mexica were depicted without a headdress, crown or nose-plug and with only a simple mantle, although they were still represented on the *icpalli*.

22 Washington 1983, p. 23.

23 Xaltocan, Tultitlan, Cuauhtitlan, Chalco, Tulantzingo, Otompan and Acolman.

24 Brundage 1982, pp. 61–64.

25 London 2002, p. 51. Eduardo Matos Moctezuma, the director of the Templo Mayor excavations, associates the calendar date with the year 1390.

26 Davies 1992, pp. 58–63.

27 Brundage 1982, pp. 106–07. Tlacochcalcatl, Tlacatecatl, Ezuauacatl and Tlillancalqui (Durán 1995, vol. I, pp. 152–53).

28 Sahagún 1977, vol. III, p. 209.

29 London 2002, p. 51

30 London 2002, p. 51.

31 Durán 1995, vol. I, pp. 155–63.

32 Brundage 1982, p. 128.

33 Previously, the 52-year ceremony had been held in year 1 Rabbit, but since this sign was now considered unlucky, it was moved to year 2 Reed.

34 London 2002, pp. 48–55.

35 London 2002, pp. 51–52.

36 London 2002, pp. 52–53.

37 London 2002, p. 53.

38 Brundage 1982, p. 190.

39 Chavero 1958, pp. 774–76.

40 Chavero 1958, pp. 774–76.

41 Davies 1980, p. 158.

42 London 2002, p. 455, no. 223.

43 London 2002, pp. 53–54.

Chapter 2 The coronation of Moctezuma II

1 Central and southern Mexico including the Gulf Coast and Yucatan Peninsula, Guatemala and parts of El Salvador and Honduras.

2 Durán 1951, pp. 411–12.

3 The term *Tlacochcalcatl* corresponds to a high-level officer of the Mexica army.

4 Alvarado Tezozómoc 1980, pp. 572–73.

5 Durán 1951.

6 Durán 1951, p. 430.

7 *Casas Nuevas de Moctezuma*.

8 Cortés (undated), pp. 207–08.

9 Díaz del Castillo 1944, vol. I, p. 279.

10 Díaz del Castillo 1944, vol. I, pp. 276–77.

11 *Códice Mendoza* 1980.

12 Sahagún 1956, vol. II, p. 312.

Chapter 3 Images of Moctezuma and his symbols of power

1 Alvarado Tezozómoc 1944, pp. 408–09; Fernández de Oviedo 1946, p. 23; López de Gómara 1943, vol. I, p. 213; Alva Ixtlilxóchitl 1985, vol. II, p. 230.

2 Codex Mendoza 1992, vol. 3, fol. 69r; Codex Florentino 1979, Book 12, 26r–26v, 36r–36v, 40v.

3 Díaz del Castillo 1983, p. 248.

4 Aguilar 1977, p. 81.

5 Marcus 1992, pp. 191–96. A glyph is a sign or figure used in the Central Mexican writing system.

6 Nicholson 1961; Umberger 1981, pp. 147–51.

7 See Alvarado Tezozómoc 1944, pp. 408–09.

8 Museo Nacional de Antropología, inv. 10-0081548. See Caso 1927, p. 42; Graulich 1994, pp. 196–98; Olko 2005, pp. 361–62.

9 Hamburgisches Museum für Völkerkunde und Vorgeschichte, inv. B.3763. See Gutiérrez Solana 1983, pp. 41–45; Washington 1983, pp. 64–66.

10 Museum für Völkerkunde, Berlin, cat. IV Ca 26921a-b. See Gutiérrez Solana 1983, pp. 54–55.

11 Museo Nacional de Antropología, cat. 11-3132.

See Gutiérrez Solana 1983, pp. 51–54.

12 Dumbarton Oaks, cat. B.69.AS. See Gutiérrez Solana 1983, pp. 53–54.

13 Museo Nacional de Antropología, inv. 10-0001123. See Umberger 1981, p. 199.

14 See Beyer 1965.

15 Museo Nacional de Antropología, inv. 10-0116583. See Klein 1987, pp. 324–31.

16 López Luján 2009.

17 Art Institute of Chicago, cat. 1990.21. See Washington 1983, pp. 41–42.

18 Broda 1978, pp. 226–33, 251–54; Townsend 1987, pp. 390–405; Graulich 1994, pp. 68–96; López Luján 2006, vol. I, pp. 281–86; Olivier 2008, pp. 78–81.

19 See López Luján 2006.

20 See Obregón and Concepción 1985, pp. 32–39; Olko 2005, pp. 320–23.

21 These leaders also wore a jaguar, coyote or wolf skin, or a coffee-coloured mantle.

22 Noguez 1975; Obregón Rodriguez 1985, pp. 40–49; Olko 2005, pp. 113–36.

23 The glyph of the diadem is read phonetically as *tecuhtli* or lord.

24 See Olivier 2008b.

25 Heyden 1972; Sullivan 1980.

26 Sahagún 1950–82, vol. 6, p. 41.

27 Durán 1984, vol. 2, p. 400.

28 On plate 23 of the Codex Borbonicus, 1991, we see a figure dressed as Xiuhtecuhtli accompanied by the footnote: '*Mocteçuma q' salia cõ los ornamentos de el dios mayor.*'

29 Sahagún 1950–82, vol. 6, pp. 19–20.

30 Sahagún 1950–82, vol. 6, p. 53.

31 Suárez de Peralta 1949, pp. 57–58.

32 Díaz del Castillo 1983, p. 377.

33 Sahagún 1950–82, vol. 8, pp. 33–35.

34 Museum für Völkerkunde, Vienna, cat. 43-380.

35 Museum für Völkerkunde, Vienna, cat. 59.989; Museo Civico di Arte Antica, Turin, cat. 732; The Saint Louis Art Museum, 1978, cat. 275.

36 Codex Ixtlilxóchitl 1996, fol. 106r.

37 Hernández 1986, p. 133.

38 Codex Vaticanus A.3738. 1996, fol. 85v.

39 These are two very similar cylindrical monoliths which were used during the gladiator sacrifices in the Tlacaxipehualiztli festival, an annual rite signifying renewal. Both stones were found in the centre of Mexico City.

40 Morgan 1876.

41 Díaz del Castillo 1983, p. 249.

42 See Durand-Forest 1967.

43 Sahagún 1950–82, vol. 2, pp. 66–77; Olivier 2008, pp. 193–230.

44 Cervantes de Salazar 1985, p. 334.

45 See Lesbre 2008.

46 Torquemada 1975–83, vol. 1, pp. 291–92; Alva Ixtlilxóchitl 1985, vol. 2, pp. 181–82.

47 See Tait 1967. British Museum, London, M&ME 1966,10-1,1.

48 Olivier 2008, pp. 240–68.

49 Sahagún 1950–82, vol. 8, pp. 18–19.

Chapter 4 Moctezuma and the renewal of nature

1 Zantwijk 1963.

2 Matos Moctezuma 1988.

3 Sahagún 1950–82, Book 1, p. 9.

4 Sahagún 1950–82, Book 1, pp. 13–38.

5 Sahagún 1950–82, Book 6, pp. 44–45.

6 Townsend 1992 and Nicholson 2003.

7 Durán 1971, p. 156.

8 Durán 1971, pp. 157–58.

9 Durán 1971, pp. 160–65.

10 Elson and Smith 2001.

11 Sahagún 1950–82, Book 7, p. 4.

12 Sahagún 1950–82, Book 7, p. 6.

Chapter 5 Moctezuma's military and economic rule

1 Durán 1992, pp. 405.

2 Berdan *et al.* 1996, pp. 127, 148.

3 Durán 1992, pp. 477–81.

4 Hernández 1959, vol. I, p. 304; Coe and Coe 1996, p. 81.

5 Sahagún 1950–82, Book 10, p. 65.

6 Coe and Coe 1996, p. 22.

7 Anderson *et al.* 1976, pp. 208–13.

8 Berdan and Anawalt 1992, vol. 3, fol. 64r and *passim*.

Chapter 6 The overthrow of Moctezuma and his empire

1 León-Portilla 1962, p. 13.

2 Lockhart 1993, pp. 6, 18–19.

3 Fernández-Armesto 1992.

4 Gillespie 2008; Magaloni-Kerpel 2008.

5 Lockhart 1993, pp. 76–78.

6 See Carrasco 2000. For the evolution of the Quetzalcoatl myth, see Gillespie 1989, pp. 226–30.

8 Lockhart 1993, pp. 19–20; Clendinnen 1990, p. 93.

9 Todorov 1984.

10 Clendinnen 1990, p. 95.

11 Hassig 1994, p. 77.

12 León-Portilla 1962, p. 61.

13 Thomas 1993, p. 278.

14 López de Gómara 1964, p. 142.

15 Elliott 1989; Cortés 1986, pp. 467–69.

16 Thomas 1993, p. 307.

17 López de Gómara 1964, p. 143.

18 Cortés 1986, p. 48.

19 Gillespie 2008, p. 51.

20 Díaz del Castillo 1963, p. 294.

21 Durán 1964, p. 305.

22 See Chipman 2005.

Chapter 7 The rebirth of ancient Mexico

1 Paz 1990, p. 4.

2 Paz 1970, pp. 110–18.

3 The indispensable source remains Icazbalceta 1954, *passim*.

4 Benavente 1971, p. 31; see also León-Portilla 2003, pp. 117–43.

5 Gruzinski 1992, pp. 141–69; Martínez 1982, *passim*.

6 López de Gómara 1979, pp. 361–67. For a succinct discussion of Las Casas see Brading 1991, pp. 59–101.

7 Acosta 1962, pp. 215–17, 230–35, 324–30, 373–77.

8 Torquemada 1975–83. Vol. 7 consists of editorial commentary and analysis of sources.

10 Alva Ixtlilxóchitl 1975, vol. II, p. 137.

11 Torquemada 1975–83 on Moctezuma II, vol. I

pp. 267–72, 282–85; on Tetzcoco, vol. I, pp. 164–68, 230–40; on Cortés, vol. II, pp. 9–10, 39, 326–40.

12 *Ibid.*, vol. II, pp. 202–17.

13 *Ibid.*, pp. 408–21.

14 Solís y Rivadeneira 1838, pp. 171–75, 307–08, 457.

15 Sigüenza y Góngora 1960, pp. 230, 341–46, 350–53.

16 On Kircher see Evans 1979, pp. 433–42.

17 See Gerbi 1973, *passim*; Pauw 1771, vol. I, p. xii; vol. II, pp. 183–205.

18 Buffon 1747, vol. VII, pp. 27, 39.

19 Raynal 1798, see vol. II, p. 381, where Moctezuma is described as 'sunk in a state of effeminacy and indolence'; on Mexico City see vol. II, p. 398.

20 Robertson 1788, vol. III, pp. 176–77, 198, 386–88.

21 Clavijero 1964, pp. xviii, xxi, xxx. See also Ronan 1977, *passim*.

22 Clavijero 1964, pp. 86, 152–53, 426–31.

23 *Ibid.*, see his Third, Fourth and Fifth Dissertations, pp. 454–524.

24 León y Gama 1978, unpaginated introduction.

25 Lemoine Villacaña 1965, pp. 368–69.

26 Tena Ramírez 1967, pp. 31–35.

27 Prescott n.d., pp. 21, 33, 52, 91, 103, 223.

28 Prescott 1970, pp. 657–99.

29 Ramírez 2001. On Ramírez see Krauze 2005, pp. 63–74.

30 Orozco y Berra 1960, vol. I, p. 86; vol. II, pp. 426–30; vol. IV, pp. 366–82.

31 Martínez Assad 2005, pp. 33–39; Tenorio-Trillo 1996.

32 Riva Palacio 1884–89. Chavero asserted that the Nahuas descended from Basques who had migrated from Europe via Atlantis, whereas the Mayas and Otomis derived from Chinese migration. See vol. I, pp. 62–73.

33 Gamio 1916, pp. 6–8, 12. Gamio 1922, vol. I, pp. xvii–ix.

34 Gamio 1922, vol. I, pp. 546–48; vol. II, pp. 448–70. See also Brading 1988.

35 Gamio 1916, pp. 40–47, 50; Fernández 1972, pp. 495–526.

36 Paz 1970, pp. 140–48.

Chapter 8 Rethinking Moctezuma

1 Frías 1900, 1st series, nos 12, 17 and 28.

2 Frías and Martínez 1925.

3 See further Martínez 1988 and Rueda Smithers 1993.

4 Ce Acatl was the sacred calendar name of Quetzalcoatl.

5 Uchmany 1972, p. 12.

6 León-Portilla 1961, pp. 122ff.

7 López Austin 1973, pp. 178–81.

8 López Austin 1973, pp. 178–81.

9 Carpentier 1975, p. 11.

10 Noguez 1996.

Epilogue

1 López Luján, 2005, 2006; Chávez Balderas, 2007.

2 Matos Moctezuma and López Luján, 2007; López Luján, 2009.

Bibliography

Acosta 1590
José de Acosta, *Historia natural y moral de Indias*, Madrid 1590

Acosta 1962
José de Acosta, *Historia natural y moral de las Indias*, Edmundo O'Gorman (ed.), 2 vols, Mexico City 1962

Acuña 1981
René Acuña (ed.), *Diego Muñoz Camargo. Descripción de la ciudad y provincia de Tlaxcala de las Indias del mar océano para el buen gobierno y ennoblecimiento dellas* [1580–85], Mexico City 1981

Aguilar 1977
Francisco de Aguilar, *Relación breve de la conquista de la Nueva España*, Mexico City 1977

Aguilar-Moreno 2007
Manuel Aguilar-Moreno, *Handbook to Life in the Aztec World*, Oxford 2007

Aguilera 1983
Carmen Aguilera, 'El coxcoxtli y los crácidos mexicanos', in Proceedings of the 44th International Congress of Americanists, *Flora and Fauna Imagery in Pre-Columbian Culture*, Jeanette Peterson (ed.), Oxford, BAR International, series 171, pp. 69–83

Alcina Franch 1992
José Alcina Franch, *L'arte precolombiana*, Milan 1992

Alva Ixtlilxóchitl 1985
Fernando de Alva Ixtlilxóchitl, *Obras históricas 1600–1640*, Edmundo O'Gorman (ed.), 2 vols, Mexico City 1975

Alvarado Tezozómoc 1944
Hernando Alvarado Tezozómoc, *Crónica mexicana*, Mexico City 1944

Alvarado Tezozómoc 1949
Hernando Alvarado Tezozómoc, *Crónica mexicáyotl*, Mexico City 1949

Alvarado Tezozómoc 1980
Hernando Alvarado Tezozómoc, *Crónica méxicana*, Mexico City 1980

Alvarado Tezozómoc 1998
Hernando Alvarado Tezozómoc, *Crónica mexicáyotl*, Mexico City 1998

Amsterdam-St Petersburg 2002
Art Treasures from Ancient Mexico: Journey to the Land of the Gods, Felipe Solís Olguín and Ted Leyenaar (eds), exh. cat., Nieuwe Kerk, Amsterdam; State Hermitage Museum, St Petersburg, 2002

Anales de Tlatelolco 1948
Anales de Tlatelolco (1528) Unos Anales Históricos de la Nación Mexicana y Códice Tlatelolco. Fuentes para la Historia de México 2, Mexico City 1948

Anawalt 1981
Patricia Rieff Anawalt, *Indian Clothing Before Cortés*, Norman 1981

Anders and Jansen 1996
Ferdinand Anders and Maarten Jansen, *Libro de la Vida. Texto explicativo del llamado Códice Magliabechiano*, Mexico City 1996

Anderson *et al.* 1976
Arthur J.O. Anderson, Frances Berdan and James Lockhart, *Beyond the Codices*, Berkeley 1976

Anderson and Dibble 1982/1975
Arthur J.O. Anderson and Charles E. Dibble (trans. and ed.), *Florentine Codex. General History of the Things of New Spain*, Santa Fe/Salt Lake City, Part 1 (1982), Part 13 (1975)

Anonymous 1968
'Recent Museum Acquisitions: The Magical Speculum of Dr Dee (British Museum)', *Burlington Magazine*, vol. 110 (January 1968), pp. 42–43

Ávila Sandoval 2004
Santiago Ávila Sandoval, 'La vida cotidiana del último *tlatoani* mexica', in *Historia de la vida cotidiana en México*, Pablo Escalante Gonzalbo (ed.), Mexico City 2004, vol. I, pp. 279–300

Baquedano 1984
Elizabeth Baquedano, *Aztec Sculpture*, London 1984

Barlow 1949
Robert H. Barlow, 'El Códice Azcatitlán', *Journal de la Société des Américanistes*, vol. XXXVIII (1949), pp. 101–35

Barlow 1987
Robert H. Barlow, 'Tlatelolco, rival de Tenochtitlan', in *Obras de Robert H. Barlow*, vol. 1, INAH-UDLA, Mexico City 1987

Barlow 1995
Robert H. Barlow, 'El códice Moctezuma', in *Obras de Robert H. Barlow*, Jesús Monjarás-Ruiz, Elena Limón, María de la Cruz Paillés H. (eds), Mexico City 1995, vol. 6, pp. 359–69

Batalla Rosado 1996
Juan José Batalla Rosado, 'Prisión y muerte de Motecuhzoma, según el relato de los códices mesoamericanos', *Revista Española de Antropología Americana*, vol. 26 (1996), pp. 101–20

Batres 1902
Leopoldo Batres, *Excavaciones arqueológicas en las Calles de las Escalerillas, año de 1900*, Mexico City 1902

Batres 1976
Leopoldo Batres, 'Exploraciones arqueológicas en la Calle de las Escalerillas 1900', in *Trabajos arqueológicos en el centro de la Ciudad de México*, Eduardo Matos Moctezuma (ed.), INAH, Mexico City 1976, pp. 111–70

Batres 1979
Leopoldo Batres, 'Excavaciones en las Calles de las Escalerillas', in *Trabajos arqueológicos del Centro*, Mexico City 1979, pp. 61–90

Benavente 1941
Toribio de Benavente (Motolinía), *Historia de los indios de la Nueva España*, Mexico City 1941

Benavente 1971
Toribio de Benavente (Motolinía), *Historia de los indios de la Nueva España*, facsimile edition, Joaquín García Icazbalceta (ed.), Mexico City 1971

Berdan 1987
Frances F. Berdan, 'The Economics of Aztec Luxury Trade and Tribute', in *The Aztec Templo Mayor*, Elizabeth H. Boone (ed.), Washington DC 1987, pp. 161–84

Berdan and Anawalt 1992
Frances F. Berdan and Patricia Rieff Anawalt (eds), *The Codex Mendoza*, 4 vols, Berkeley 1992

Berdan and Anawalt 1997
Frances F. Berdan and Patricia Rieff Anawalt (eds), *The Essential Codex Mendoza*, Berkeley, Los Angeles and London 1997

Berdan *et al.* 1996
Frances F. Berdan, Richard E. Blanton, Elizabeth Hill Boone, Mary G. Hodge, Michael E. Smith and Emily Umberger, *Aztec Imperial Strategies*, Washington DC 1996

Bernal 1967
Ignacio Bernal, *Museo Nacional de Antropología de México. Arqueología*, Mexico City 1967

Bernal and Simoni-Abbat 1986
Ignacio Bernal and Mireille Simoni-Abbat, *Le Mexique des origines aux Aztèques*, Paris 1986

Bernal *et al.* 1979
Ignacio Bernal, Román Piña Chan and Fernando Camara-Barbachano, *Tesoros del Museo Nacional de Antropología de México*, Mexico City 1979

Beyer 1921
Hermann Beyer, *El llamado 'Calendario Azteca', Descripción e Interpretación del Cuauhxicalli de la 'Casa de las Aguilas'*, Mexico City 1921

Beyer 1965
Hermann Beyer, 'Algunos datos nuevos sobre el Calendario Azteca', *El México Antiguo*, vol. X (1965), pp. 261–65

Bilbao 2005
El imperio azteca, Felipe Solís Olguín (ed.), exh. cat., Guggenheim Museum, Bilbao 2005

Boone 1989
Elizabeth H. Boone, *Incarnations of the Aztec Supernatural: The Image of Huitzilopochtli in Mexico and Europe*, Philadelphia 1989

Boone 2000
Elizabeth H. Boone, *Stories in Red and Black. Pictorial Histories of the Aztecs and Mixtecs*, Austin 2000

Both 2005
Arnd Adje Both, *Aerófonos mexicas de las ofrendas del recinto sagrado de Tenochtitlan*, Doctoral thesis, Berlin Free University 2005

Brading 1988
D.A. Brading, 'Manuel Gamio and Official Indigenismo in Mexico', *Bulletin of Latin American Research*, vol. 7 (1988), pp. 75–89

Brading 1991
D.A. Brading, *The First America. The Spanish monarchy, Creole patriots and the Liberal state 1492–1867*, Cambridge 1991

Broda 1978
Johanna Broda, 'Relaciones políticas ritualizadas: el ritual como expresión de una ideología', in *Economía política e ideología en el México prehispánico*, Pedro Carrasco and Johanna Broda (eds), Mexico City 1978, pp. 221–55

Brotherston 1995
Gordon Brotherston, *Painted Books from Mexico: Codices in the UK Collections and the World they Represent*, London 1995

Brotherston 2005
Gordon Brotherston, *Feather Crown. The Eighteen Feasts of the Mexica Year*, British Museum Research Publication 154, London 2005

Brown 2004

Jonathan Brown, 'Spanish Painting and New Spanish Painting, 1550–1700', in *Painting a New World: Mexican Art and Life, 1521–1821*, exh. cat., Denver Art Museum 2004

Brumfiel and Feinman 2008
Elizabeth M. Brumfiel and Gary M. Feinman, *The Aztec World*, New York 2008

Brundage 1979
Burr Cartwright Brundage, *The Fifth Sun: Aztec Gods, Aztec World*, Austin 1979

Brundage 1982
Burr Cartwright Brundage, *Lluvia de dardos, Historia política de los aztecas mexicas*, Mexico City 1982

Brundage 1985
Burr Cartwright Brundage, *The Jade Steps: A Ritual Life of the Aztecs*, Salt Lake City 1985

Buffon 1747
George-Louis Leclerc Buffon, *Natural History*, 10 vols, London 1747

Bühl 2008
Dumbarton Oaks: The Collections, Gudrun Bühl (ed.), Washington DC 2008

Burland 1972
C.A. Burland, *Montezuma: Lord of the Aztecs*, London 1972

Bushnell 1906
David I. Bushnell, Jr., 'North American Ethnographical Material in Italian Collections', *American Anthropologist,* new series, vol. 8, no. 2 (April–June 1906), pp. 243–55

Carmichael 1970
Elizabeth Carmichael, *Turquoise Mosaics from Mexico*, London 1970

Carpentier 1975
Alejo Carpentier, *Concierto barroco*, Mexico City 1975

Carrasco 1998
David Carrasco with Scott Sessions, *Daily Life of the Aztecs, People of the Sun and Earth*, Westport and London 1998

Carrasco 2000
David Carrasco, *Quetzalcoatl and the Irony of Empire: Myths and Prophecies in the Aztec Tradition*, Boulder 2000

Carrasco and Matos Moctezuma 2003
David Carrasco and Eduardo Matos Moctezuma, *Moctezuma's Mexico: Visions of the Aztec World*, Boulder 2003

Caso 1927
Alfonso Caso, *El Teocalli de la Guerra Sagrada*, Mexico City 1927

Castañeda and Mendoza 1933
Daniel Castañeda and Vicente T. Mendoza, *Instrumental Precortesiano*, vol. I, Museo Nacional de Arqueología, Etnografia e Historia, Mexico City 1933

Cervantes de Salazar 1985
Francisco Cervantes de Salazar, *Crónica de la Nueva España*, Mexico City 1985

Chavero 1958
Alfredo Chavero, *Historia antigua y de la conquista, México a través de los siglos*, Mexico City 1958

Chávez Balderas 2007
Ximena Chávez Balderas, *Rituales funerarios en el Templo Mayor de Tenochtitlan*, Mexico City 2007

Chimalpáhin 1998
Domingo Chimalpáhin, *Codex Chimalpáhin, Las*

Ocho Relaciones y el Memorial de Colhuacan, 3 vols, Mexico City 1998

Chipman 2005
Donald E. Chipman, *Moctezuma's Children: Aztec Royalty under Spanish Rule, 1520–1700*, Austin 2005

Clavijero 1964
Francisco Javier Clavijero, *Historia Antigua de México*, Mariano Cuevas (ed.), Mexico City 1964

Clavijero 1979
Francisco Javier Clavijero, *Historia antigua de México*, facsimile edition from 1853, Mexico City 1979

Clendinnen 1990
Inga Clendinnen, 'Cortés, Signs, and the Conquest of Mexico', in *The Transmission of Culture in Early Modern Europe*, Anthony Grafton and Ann Blair (eds), Philadelphia 1990, pp. 87–130

Codex Azcatitlan 1995
Codex Azcatitlan, facsimile edition, Robert H. Barlow (ed.), 2 vols, Paris 1995

Codex Borbonicus 1991
Codex Borbonicus, facsimile edition, Mexico City and Austria 1991

Codex Florentino 1979
Codex Florentino, facsimile edition, 3 vols, Mexico City 1979

Codex Ixtlilxóchitl 1996
Codex Ixtlilxóchitl, facsimile edition, Mexico City 1996

Codex Mendoza 1992
The Codex Mendoza, facsimile edition, Frances F. Berdan and Patricia Rieff Anawalt (eds), 4 vols, Berkeley 1992

Codex Telleriano-Remensis 1995
Codex Telleriano-Remensis. Ritual, Divination, and History in a Pictorial Aztec Manuscript, Eloise Quiñones Keber (ed.), Austin 1995

Codex Tudela 1980
Codex Tudela, facsimile edition, Madrid 1980

Codex Vaticanus 1964
Codex Vaticanus, facsimile edition, in *Antigüedades de México*, Mexico City 1964

Codex Vaticanus A.3738. 1996
Codex Vaticanus A.3738., facsimile edition, Mexico City 1996

Códice Boturini 1964
Códice Boturini or *Tira de la Peregrinación*, facsimile edition, in *Antigüedades de México*, Mexico City 1964

Códice Mendoza 1980
Códice Mendoza, facsimile edition, Mexico City 1980

Coe and Coe 1996
Sophie D. Coe and Michael D. Coe, *The True History of Chocolate*, London 1996

Cortés (n.d.)
Hernán Cortés, 'Segunda Carta de Relación', in *Cartas de Relación de la Conquista de América*, Mexico City (n.d.)

Cortés 1986
Hernán Cortés, *Letters from Mexico*, Anthony Pagden (trans. and ed.), New Haven and London 1986

Couch 1985
N.C. Christopher Couch, *The Festival Cycle of the Aztec Codex Borbonicus*, BAR International Series 270, Oxford 1985

Cuadriello 1999

Jaime Cuadriello, 'El origen del reino y la configuración de su empresa: Episodios y alegorías de triunfo y fundación', in *Los pinceles de la historia: El origen del reino de la Nueva España 1680-1750*, Jaime Soler Frost (ed.), Mexico City 1999, pp. 50–107

Cuadriello 2004
Jaime Cuadriello, 'Moctezuma a través de los siglos', in *El imperio sublevado: Monarquía y Naciones en España e Hispanoamérica*, Madrid 2004, pp. 95–122

Dahlgren *et al.* 1982
Barbara Dahlgren, Emma Pérez-Rocha, Lourdes Suárez and Perla Valle, *Corazón de Copil*, Mexico City 1982

Davies 1980
Nigel Davies, *The Aztecs: a History*, Norman 1980

Davies 1992
Nigel Davies, *El imperio azteca, el resurgimiento tolteca*, Mexico City 1992

Day 1992
Jane S. Day, *Aztec: The World of Moctezuma*, Denver 1992

Díaz del Castillo 1632
Bernal Díaz del Castillo, *Historia verdadera de la conquista de la Nueva España*, Madrid 1632

Díaz del Castillo 1944
Bernal Díaz del Castillo, *Historia Verdadera de la Conquista de la Nueva España*, 2 vols, Mexico City 1944

Díaz del Castillo 1963
Bernal Díaz del Castillo, *The Conquest of New Spain*, J.M. Cohen (trans. and ed.). Harmondsworth 1963

Díaz del Castillo 1983
Bernal Díaz del Castillo, *Historia verdadera de la conquista de la Nueva España*, Mexico City 1983

Dryden 1670
John Dryden, *The Indian Emperor, or, The Conquest of Mexico by the Spaniards. Being the sequel of the Indian queen*, London 1670

Durán 1951
Diego Durán, *Historia de las Indias de Nueva España e Islas de Tierra Firme*, 3 vols, Mexico City 1951

Durán 1964
Diego Durán, *The Aztecs. The History of the Indies of New Spain*, Doris Heyden and Fernando Horcasitas (trans. and ed.), New York 1964

Durán 1971
Diego Durán, *Book of the Gods and Rites and The Ancient Calendar*, Fernando Horcasitas and Doris Heyden (trans. and eds), Norman 1971

Durán 1992
Diego Durán, *The History of the Indies of New Spain*, Doris Heyden (trans.), Norman 1992

Durán 1995
Diego Durán, *Historia de las Indias de Nueva España e Islas de Tierra Firme*, Mexico City 1995

Durand-Forest 1967
Jacqueline de Durand-Forest, 'El cacao entre los aztecas', *Estudios de Cultura Náhuatl*, vol. VII (1967), pp. 155–81

Easby and Scott 1970
Elizabeth Easby and John F. Scott (eds), *Before Cortés: Sculpture of Middle America*, New York 1970

Ellingson 2001
Ter Ellingson, *The Myth of the Noble Savage*, Berkeley 2001

Elliott 1989
J.H. Elliott, 'The Mental World of Hernán Cortés', in *Spain and its World, 1500–1700: Selected Essays*, J.H. Elliott, New Haven and London 1989, ch. 2

Elson and Smith 2001
Christina Elson and Michael E. Smith, 'Archaeological Deposits from the Aztec New Fire Ceremony', *Ancient Mesoamerica*, 12 (2001), pp. 157–74

Escalante Gonzalbo 1997
Pablo Escalante Gonzalbo, 'Pintar la historia tras la crisis de la Conquista', in *Los pinceles de la historia: El origen del reino de la Nueva España, 1680–1750*, Mexico City 1997, pp. 25–49

Escalante Gonzalbo 2004
Pablo Escalante Gonzalbo, 'Antonio Rodríguez, Attributed', in *Painting a New World: Mexican Art and Life, 1521–1821*, exh. cat., Denver Art Museum 2004, pp. 171–78

Evans 1979
R.J. Evans, *The Making of the Habsburg Monarchy 1500–1700*, Oxford 1979

Feest 1990
Christian F. Feest, 'Vienna's Mexican Treasures: Aztec, Mixtec and Tarascan Works from Sixteenth-century Austrian Collections', *Archiv für Völkerkunde*, 44 (1990)

Fernández 1972
Justino Fernández, *Estética del arte mexicano*, Mexico City 1972

Fernández et al. 2007
Miguel Ángel Fernández et al., *Isis and the Feathered Serpent, Pharaonic Egypt/Pre-Hispanic Mexico*, Monterrey 2007

Fernández-Armesto 1992
Felipe Fernández-Armesto, '"Aztec" Auguries and Memories of the Conquest of Mexico', *Renaissance Studies* 6, nos 3–4 (1992), pp. 287–305

Fernández de Oviedo 1946
Gonzalo Fernández de Oviedo, *Sucesos y diálogos de la Nueva España*, Mexico City 1946

Fischer and Gaida 1993
Manuela Fischer and Marie Gaida, 'Die Geschichte der mexikanischen Sammlung im Museum für Völkerkunde, Berlin', *Die Sammlung vorspanischer Kunst und Kultur aus Mexiko im Museum für Völkerkunde, Berlin, Veröffentlichung des Museums für Völkerkunde Berlin*, n.s., 57; *Abteilung, Amerikanische Archäologie*, vol. 7 (1993)

Flores Gutiérrez 1991
J. Daniel Flores Gutiérrez, 'Venus y su relación con fechas antiguas', in *Arqueoastronomía y etnoastronomía en Mesoamérica*, Johanna Broda, Stanislaw Iwaniszewski and Lucrecia Maupomé (eds), Mexico City 1991, pp. 343–88

Frías 1900
Heriberto Frías, *Biblioteca del Niño Mexicano, ilustrado por José Guadalupe Posada*, Mexico City 1900

Frías and Martínez 1925
Heriberto Frías and Rafael Martínez, *Album Histórico Popular de la Ciudad de México*, Mexico City 1925

Galindo y Villa 1897
Jesús Galindo y Villa, *Catálogo del Departamento de Arqueología del Museo Nacional. Primera parte: Galería de monolitos*, 2nd edition, Mexico City 1897

Gamio 1916
Manuel Gamio, *Forjando Patria*, Mexico City 1916

Gamio 1922
La población del Valle de Teotihuacan, Manuel Gamio (ed.), 2 vols, Mexico City 1922

García Icazbalceta 1896
Joaquín García Icazbalceta, 'La fiesta del Pendón en México', in *Obras de Joaquín García Icazbalceta*, Mexico City 1896

García Moll, Solís Olguín and Bali 1990
Roberto García Moll, Felipe Solís Olguín and Jaime Bali, *El tesoro de Moctezuma*, Mexico City 1990

García Sáiz 1999
María Concepción García Sáiz, 'La Conquista Militar y los Enconchados: Las peculiaridades de un patrocinio indiano', in *Las Pinceles de la Historia: el origen del reino de la Nueva España, 1680–1759*, Mexico City 1999, pp. 109–41

Garibay K. 1984
Angel María Garibay K. (ed.), *Fray Diego Durán. Historia de las Indias de Nueva España e Islas de la Tierra Firme*, 2 vols, Mexico City 1984

Gendrop 1970
Paul Gendrop, *Arte prehispánico en Mesoamérica*, Mexico City 1970

Gerbi 1973
Antonello Gerbi, *The Dispute of the New World. The History of a Polemic 1750–1900*, Jeremy Moyle (trans.), Pittsburgh 1973

Gillespie 1989
Susan D. Gillespie, *The Aztec Kings: the Construction of Rulership in Mexica History*, Tucson 1989

Gillespie 2008
Susan D. Gillespie, 'Blaming Moteuczoma: Anthropomorphizing the Aztec Conquest', in *Invasion and Transformation: Interdisciplinary Perspectives on the Conquest of Mexico*, Rebecca P. Brienen and Margaret A. Jackson (eds), Boulder 2008, pp. 25–55

Glass 1964
John B. Glass, *Cátalogo de la Colección de Códices*, Mexico City 1964

Glass and Robertson 1975
John B. Glass and Donald Robertson, 'A Census of Native Middle American Pictorial Manuscripts', in *Handbook of Middle American Indians*, Robert Wauchope (ed.), Austin 1975, vol. 14, pp. 81–252

Graulich 1994
Michel Graulich, *Montezuma ou l'apogée et la chute de l'empire aztèque*, Paris 1994

Graulich 1995
Michel Graulich, *Codex Azcatitlan*, Paris 1995

Graulich 2001
Michel Graulich, 'Motecuhzoma Xocoyotzin, un gran reformador', *Arqueología Mexicana, el Norte de México*, vol. IX, no. 51 (September–October 2001), pp. 74–79

Gruzinski 1992
Serge Gruzinski, *Painting the Conquest. The Mexican Indians and the European Renaissance*, Deke Dusinberre (trans.), Paris 1992

Gutiérrez Solana 1983
Nelly Gutiérrez Solana, *Objetos ceremoniales en piedra de la cultura mexica*, Mexico City 1983

Hajovsky 2009
Patrick Hajovsky, 'André Thevet's "true" portrait of Moctezuma and its European legacy', *Word and Image*, 25, no. 4 (July 2009)

Hassig 1994
Ross Hassig, *Mexico and the Spanish Conquest*, London 1994

Heikamp 1972
Detlef Heikamp, *Mexico and the Medici*, Florence 1972

Hernández 1959
Francisco Hernández, *Historia natural de Nueva España*, 2 vols, Mexico City 1959

Hernández 1986
Francisco Hernández, *Antigüedades de la Nueva España*, Madrid 1986

Hernández Pons 1987
Elsa Hernández Pons, 'Una escultura azteca encontrada en el centro de la ciudad de México', *Antropología*, new series, no. 13 (March–April 1987), pp. 15–19

Hernández Pons 1997
Elsa Hernández Pons, 'El águila-cuauhxicalli', in *La antigua Casa del Marqués del Apartado*, Mexico City 1997, pp. 167–88

Hernández Sánchez 2005
Gilda Hernández Sánchez, *Vasijas para ceremonia*, Leiden 2005

Heyden 1972
Doris Heyden, 'Xiuhtecuhtli, investidor de soberanos', *Boletín del INAH*, second series, no. 3 (1972), pp. 3–10

Hildesheim-Munich-Linz-Humlebæk-Brussels 1986
Glanz und Untergang des Alten Mexiko: Die Azteken und ihre Vorläufer, Eva and Arne Eggebrecht (eds), exh. cat., 2 vols, Roemer- und Pelizaeus-Museum, Hildesheim; Haus der Kunst, Munich; Oberösterreichisches Landesmuseum, Linz; Louisiana Museum, Humlebæk; Musées Royaux d'Art et d'Histoire, Brussels, 1986

Honour 1975
Hugh Honour, *The New Golden Land: European Images of America from the Discoveries to the Present Time*, New York 1975

Hosler 1994
Dorothy Hosler, *The Sounds and Colors of Power: The Sacred Metallurgical Technology of Ancient West Mexico*, Boston 1994

Icazbalceta 1954
Joaquín García Icazbalceta, *Bibliografía mexicana del siglo XVI*, 2nd edition, Mexico City 1954

INAH 1970
Instituto Nacional de Antropología e Historia, Mexico City, *Boletín*, 42 (1970)

Joyce 1912
Thomas Athol Joyce, *A Short Guide to the American Antiquities in the British Museum*, London 1912

Keen 1985
Benjamin Keen, *The Aztec Image in Western Thought*, New Brunswick 1985

Klein 1987
Cecelia F. Klein, 'The Ideology of Autosacrifice at the Templo Mayor', in *The Aztec Templo Mayor*, Elizabeth H. Boone (ed.), Washington DC 1987, pp. 293–370

Klor de Alva, Nicholson and Quiñones Keber 1988

Jorge Klor de Alva, H.B. Nicholson and Eloise Quiñones Keber (eds), *The Work of Bernardino de Sahagun: Pioneer Ethnographer of Sixteenth-Century Aztec Mexico*, Texas 1988

Krauze 2005
Enrique Krauze, *La presencia del pasado*, Mexico City 2005

La Niece and Meeks 2000
Susan La Niece and Nigel Meeks, 'Diversity of Goldsmithing Traditions in the American and the Old World', in *Pre-Columbian Gold: Technology, Style and Iconography*, Colin McEwan (ed.), London 2000

Lehman 1906
Walter Lehman, 'Die Mexikanischer Grünsteinfigur des Musée Guimet in Paris', *Globus*, 90 (1906), pp. 60–61

Lehman 1948
Henri Lehman, 'Une statue aztèque en résine', *JSA*, new series, vol. XXXVII (1948), pp. 269–73

Lehmann and Kutscher 1981
Walter Lehmann and Gerdt Kutscher, *Geschichte der Azteken – Codex Aubin und verwandte Dokuemente*, Berlin 1981

Lemoine Villacaña 1965
Ernesto Lemoine Villacaña, *Morelos*, Mexico City 1965

León-Portilla 1961
Miguel León-Portilla, *Los antiguos mexicanos a través de sus cónicas y cantares*, Mexico City 1961

León-Portilla 1962
Miguel León-Portilla, *The Broken Spears. The Aztec Account of the Conquest of Mexico*, London 1962

León-Portilla 2002
Miguel León-Portilla, 'Mitos de los Orígenes en Mesoamérica', *Arqueología Mexicana*, vol. 10, no. 56 (July–August 2002), pp. 20–27

León-Portilla 2003
Miguel León-Portilla, *Códices. Los antiguos libros del Nuevo Mundo*, Mexico City 2003

León y Gama 1978
Antonio de León y Gama, *Descripción histórica y cronológica de las dos piedras*, facsimile of the 1792 and 1832 editions, Mexico City 1978

Lesbre 2008
Patrick Lesbre, 'Recuerdo colonial de la realeza prehispánica: el uso de cerbatanas por los señores de Tetzcoco', in *Símbolos de poder en Mesoamérica*, Guilhem Olivier (ed.), Mexico City 2008, pp. 293–313z

Lind 1994
Michael D. Lind, 'Cholula and Mixteca Polychromes: Two Mixteca-Puebla Regional Sub-styles', in *Mixteca-Puebla: Discoveries and Research in Meoamerican Art and Archaeology*, Henry B. Nicholson and Eloise Quiñones Keber (eds), Culver City, California 1994, pp. 79–99

Lockhart 1993
James Lockhart (trans. and ed.), *We People Here: Nahuatl Accounts of the Conquest of Mexico*, Repertorium Columbianum, vol. 1, Berkeley, Los Angeles and London 1993

Lomnitz 2006
Claudio Lomnitz, *La idea de la muerte en México*, Mexico City 2006

London 1965
Henry Christie: A Pioneer of Anthropology: An Exhibition in the King Edward VII Gallery, exh.

cat., The British Museum, London 1965

London 2002
Aztecs, Eduardo Matos Moctezuma and Felipe Solís Olguín (eds), exh. cat., Royal Academy of Arts, London 2002

López Austin 1973
Alfredo López Austin, *Hombre-dios: Religión e Política en el Mundo Náhuatl*, Mexico City 1973

López Austin 1998
Alfredo López Austin, 'Quetzalcóatl desdoblado: Religión mesoamericana y cerámica mixteca', in *Usos, apropiaciones y desviaciones de la imagen en México*, Mexico City 1998

López Austin 2004
Alfredo López Austin, *Cuerpo humano e ideología, las concepciones de los antiguos nahuas*, Mexico City 2004

López Austin and López Luján 2004
Alfredo López Austin and Leonardo López Luján, 'El Templo Mayor de Tenochtitlan, el Tonacatépetl y el mito del robo del maíz', in *Acercarse y mirar. Homenaje a Beatriz de la Fuente*, María Teresa Uriarte and Leticia Staines Cicero (eds), (Estudios y Fuentes del Arte en México LXXIV), Mexico City 2004, pp. 403–55, 486

López de Gómara 1552
Francisco López de Gómara, *La conquista de México*, Saragossa 1552

López de Gómara 1569
Francisco López de Gómara, *Histoire generalle des Indes Occidentales, et terres nueves, qui lusques a present ont esté descouvertes*, Martin Fumée (trans.), Paris 1569

López de Gómara 1943
Francisco López de Gómara, *Historia de la conquista de México*, 2 vols, Mexico City 1943

López de Gómara 1964
Francisco López de Gómara, *Cortés: the Life of the Conqueror by his Secretary*, Lesley Byrd Simpson (trans. and ed.), Berkeley and Los Angeles 1964

López de Gómara 1965–66
Francisco López de Gómara, *Historia General de las Indias*, 2 vols, Barcelona 1965–66

López de Gómara 1979
Francisco López de Gómara, *Historia de la conquista de México*, Jorge Gurría Lacroix (ed.), Caracas 1979

López Luján 1994
Leonardo López Luján, *The Offerings of the Temple Mayor of Tenochtitlan*, Niwot 1994

López Luján 2005
Leonardo López Luján, *The Offerings of the Templo Mayor of Tenochtitlan*, revised edition, Albuquerque 2005

López Luján 2006
Leonardo López Luján, *La Casa de las Águilas: un ejemplo de la arquitectura religiosa de Tenochtitlan*, 2 vols, Mexico City 2006

López Luján 2009
Leonardo López Luján, 'Bajo el volcán: el memorial de Motecuhzoma II en Amecameca', *Arqueología Mexicana*, vol. XVII, no. 95 (2009), pp. 56–9

López Luján 2009b
Leonardo López Luján, 'Aguas petrificadas: las ofrendas a Tláloc enterradas en el Templo Mayor de Tenochtitlan', *Arqueología mexicana*, vol. XVII, no. 96 (March–April 2009), pp. 52–57

López Luján 2009c
Leonardo López Luján, 'La Tlaltecuhtli', *Escultura*

monumental mexica, Mexico City, Fundación Commemoraciones 2010

López Luján et al. 2006
López Luján et al., 'The destruction of images in Teotihuacan', *Res: Anthropology and Aesthetics*, 49/50 (spring–autumn 2006), pp. 13–39

López Luján and Fauvet-Berthelot 2005
Leonardo López Luján and Marie-France Fauvet-Berthelot, *Aztèques, La collection de sculptures de musée du quai Branly*, Paris 2005

Los Angeles 2001
The Journey to Aztlan: Art from a Mythic Homeland, Virginia M. Fields and Victor Zamudio-Taylor (eds), exh. cat., Los Angeles County Museum of Art; Austin Museum of Art; Albuquerque Museum, Los Angeles 2001

McEwan 1994
Colin McEwan, *Ancient Mexico in the British Museum*, London 1994

McEwan 2009
Colin McEwan, *Ancient American Art in Detail*, London 2009

McEwan et al. 2006
Colin McEwan, Andrew Middleton, Caroline Cartwright and Rebecca Stacey, *Turquoise Mosaics from Mexico*, London 2006

Madrid 1992
Azteca-Mexica, las culturas del México antiguo, José Alcina Franch, Miguel León-Portilla and Eduardo Matos Moctezuma (eds), exh. cat., Sociedad Estatal Quinto Centenario, Madrid 1992

Magaloni-Kerpel 2008
Diana Magaloni-Kerpel, 'Painting a New Era: Conquest, Prophecy, and the World to Come', in *Invasion and Transformation: Interdisciplinary Perspectives on the Conquest of Mexico*, Rebecca P. Brienen and Margaret A. Jackson (eds), Colorado 2008, pp. 125–49

Marcus 1992
Joyce Marcus, *Mesoamerican Writing Systems. Propaganda, Myth, and History of Four Ancient Civilizations*, Princeton 1992

Martínez 1982
José Luis Martínez, *El 'Códice Florentino' y la 'Historia General' de Sahagún*, Mexico City 1982

Martínez 1988
José Luis Martínez, *Hernán Cortés*, Mexico City 1988

Martínez 1990
José Luis Martínez (ed.), *Documentos cortesianos*, Mexico City 1990

Martínez Assad 2005
Carlos Martínez Assad, *La patria en el Paseo de la Reforma*, Mexico City 2005

Martínez Chiñas 1994
Rosalino Martínez Chiñas, 'Curaduría de Tecnología y Armas', in *Tesoros del Museo Nacional de Historia en el Castillo de Chapultepec*, Mexico City 1994, pp. 208–12

Martínez del Río de Redo 2006
M. Martínez del Río de Redo, 'La conquista en una serie de tablas enconchadas', in *La imagen de los naturales en el arte de la Nueva España, Siglos XVI al XVIII*, Mexico City 2006

Mateos Higuera 1979
Salvador Mateos Higuera, 'Herencia arqueológica de México-Tenochtitlán', in *Trabajos arqueológicos en el Centro de la Ciudad de México (Antología)*,

Eduardo Matos Moctezuma (ed.), Mexico City 1979, pp. 205–68

Matos Moctezuma 1986
Eduardo Matos Moctezuma, *Vida y muerte en el Templo Mayor*, Mexico City 1986

Matos Moctezuma 1988
Eduardo Matos Moctezuma, *The Great Temple of the Aztecs*, London and New York 1988

Matos Moctezuma 1988b
Eduardo Matos Moctezuma (ed.), *Obras maestras del Templo Mayor*, Mexico City 1988

Matos Moctezuma 1989
Eduardo Matos Moctezuma, *Los aztecas*, Mexico City 1989

Matos Moctezuma 1993
Eduardo Matos Moctezuma, 'Tenochtitlan', *Arqueología Mexicana*, vol. 1, no. 4, (October–November 1993), pp. 18–21

Matos Moctezuma and Solís Olguín 2003
Eduardo Matos Moctezuma and Felipe Solís Olguín (eds), *Azteken*, Cologne 2003

Matos Moctezuma and López Luján 2007
Eduardo Matos Moctezuma and Leonardo López Luján, 'La diosa Tlaltecuhtli de la Casas de las Ajaracas y el rey Ahuítzotl', *Arqueología Mexicana*, vol. XIV, no. 83 (2007), pp. 22–29

Matrícula de Tributos 1997
Matrícula de Tributos o Códice Moctezuma, Ferdinand Anders, Maarten Jansen and Luis Reyes García (eds), Graz and Mexico City 1997

Matsumoto *et al.* 2007
Ryozo Matsumoto, Ken-ichi Shinoda and Masahiro Ono (eds), *The Three Great Civilizations of Mesoamerica and the Central Andes. The World of Maya, Aztec and Inca*, exh. cat., Japan 2007

Mena 1927
Ramón Mena, *Catálogo de la colección de objetos de jade*, Talleres gráficos del Museo Nacional de Arqueología, Historia y Etnografía, Mexico City 1927

Mendoza and Sánchez 1885
Gumesindo Mendoza and Jesús Sánchez, *Catálogo de las colecciones del Museo Nacional*, Mexico City 1885

Meslay 2001
Oliver Meslay, 'Murillo and Smoking Mirrors', *Burlington Magazine*, vol. 143 (February 2001), pp. 73–79

Miller and Taube 1993
Mary Miller and Karl Taube, *The Gods and Symbols of Ancient Mexico and the Maya: An Illustrated Dictionary of Mesoamerican Religion*, London 1993

Miller and Taube 1997
Mary Miller and Karl Taube, *An Illustrated Dictionary of the Gods and Symbols of Ancient Mexico and the Maya*, London 1997

Molina 1970
Alonso de Molina, 'Vocabulario en lengua castellana y mexicana y mexicana y castellana', *Biblioteca Porrúa*, 44 (1970)

Montanus 1671
Arnoldus Montanus, *De nieuwe en onbekende wereld, of, Beschryving van America en 't Zuid-land...*, Amsterdam 1671

Monterde 1947
Francisco Monterde, *Moctezuma II: señor del Anahuac*, Mexico City 1947

Monterrey 2007
Isis y la Serpiente Emplumada. Egipto Faraónico/México Prehispánico, Magali Tercero (ed.), exh. cat., Centro Expositivo Nave Lewis, Parque Fundidora, Monterrey 2007

Montes González 2006
Francisco Montes González, 'Apuntes iconográficos a la sere mayor de enconchados de la Conquista de México del Museo de América de Madrid', in *La multiculturalidad en las artes y en la arquitectura*, Las Palmas 2006, vol. I, pp. 803–11

Morgan 1876
Lewis H. Morgan, 'Montezuma's Dinner', *North American Review*, vol. 132 (1876), pp. 265–308

Mundy 1998
Barbara E. Mundy, 'Mapping the Aztec capital: The 1524 Nuremberg map of Tenochtitlan, its sources and meanings', *Imago Mundi*, 50 (1998), pp. 11–33

Muriá 1973
José María Muriá, *Sociedad Prehispánica y Pensamiento Europeo*, SEP – Setentas 76, Mexico City 1973

Nahmad and Besso-Oberto 1993
Daniel Nahmad and Humberto Besso-Oberto, 'Las joyas del pescador: orfebrería prehispánica', *Arqueología Mexicana*, vol. 1, no. 1 (1993), pp. 56–63

New York 1940
Twenty Centuries of Mexican Art, exh. cat., Museum of Modern Art, New York in association with the Museo Instituto Nacional de Antropología e Historia, Mexico City, New York 1940

New York 1970
Before Cortes: Sculpture of Middle America, Elizabeth Kennedy Easby and John F. Scott (eds), exh. cat., Metropolitan Museum of Art, New York 1970

New York 1976
Aztec Stone Sculpture, Esther Pasztory (ed.), exh. cat., Center for Inter-American Relations, New York 1976

New York 2004
The Aztec Empire, Felipe Solís Olguín (ed.), exh. cat., Guggenheim Museum, New York 2004

Nicholson 1961
Henry B. Nicholson, 'The Chapultepec Cliff sculpture of Motecuhzoma Xocoyotzin', *El México Antiguo*, vol. IX (1961), pp. 379–444

Nicholson 1988
Henry B. Nicholson, 'The Iconography of the Deity Representations in Fray Bernardino de Sahagún's *Primeros Memoriales*: Huitzilopochtli and Chalchiuhtlicue', in *The Work of Bernardino de Sahagún, Pioneer Ethnographer of Sixteenth-century Aztec Mexico*, Jorge Klor de Alva, Henry B. Nicholson and Eloise Quiñones Keber (eds), New York 1988

Nicholson 2003
Henry B. Nicholson, 'The Annual "Royal Ceremony" on Mt. Tlaloc: Mountain Fertility Ritualism in the Late Pre-Hispanic Basin of Mexico', in *Mesas and Cosmologies in Mesoamerica*, Douglas Sharon (ed.), San Diego Museum Papers 42, 2003

Noguera 1945
Eduardo Noguera, 'El Atlatl o Tiradera', *Anales del Museo Nacional de Arqueología, Historia y Etnografía*, 5th series, vol. III (1945)

Noguera 1968
Eduardo Noguera, 'Ceremonias del Fuego Nuevo', *Cuadernos Americanos*, vol. 3, no. 158 (1968), pp. 146–51

Noguez 1975
Xavier Noguez, 'La diadema de turquesa (xiuhuitzolli) y las alianzas de los señoríos prehispánicos: acercamiento iconográfico', in *XIII Mesa Redonda de la Sociedad Mexicana de Antropología*, Jaime Litvak and Noemí Castillo (eds), Mexico City 1975, pp. 83–94

Noguez 1996
Xavier Noguez (ed.), *Códice García Granados*, facsimile edition, Mexico City 1996

Noguez 2009
Xavier Noguez, 'Códice Moctezuma', *Arqueología Mexicana*, vol. XVI, no. 95 (2009), pp. 84–85

Núñez Ortega 1885
Angel Núñez Ortega, *Apuntes históricos sobre la rodela azteca conservada en el Museo Nacional de México*, Brussels 1885

Nuttall 1891
Zelia Nuttall, 'The atlatl or spear-thrower of the ancient Mexicans', *Archaeological and Ethnological Papers of the Peabody Museum*, vol. 1, no. 3 (1891)

Obregón Rodríguez 1985
María Concepción ObregónRodríguez, *El atavío de los tlatoque mexicas*, BA dissertation, Mexico City 1985

Ogilby 1671
John Ogilby, *America: being the latest, and most accurate description of the new world...*, London 1671

Olivier 1997
Guilhem Olivier, *Moqueries et metamorphose d'un dieu aztèque. Tezcatlipoca, le 'Seigneur au miroir fumant'*, Paris 1997

Olivier 2003
Guilhem Olivier, *Mockeries and Metamorphoses of an Aztec God. Tezcatlipoca, 'Lord of the Smoking Mirror'*, Boulder 2003

Olivier 2004
Guilhem Olivier, *Burlas y metamorfosis de un dios azteca*, Mexico City 2004

Olivier 2008
Guilhem Olivier, *Mockeries and Metamorphoses of an Aztec God. Tezcatlipoca, 'Lord of the Smoking Mirror'*, Boulder 2008

Olivier 2008b
Guilhem Olivier, 'Las tres muertes simbólicas del nuevo rey mexica: reflexiones en torno a los ritos de entronización en el México Central prehispánico', in *Símbolos de poder en Mesoamérica*, Guilhem Olivier (ed.), Mexico City 2008b, pp. 263–91

Olko 2005
Justyna Olko, *Turquoise Diadems and Staffs of Office. Elite Costume and Insignia of Power and Early Colonial Mexico*, Warsaw 2005

Olmedo Vera 2002
Bertina Omedo Vera, *Los templos rojos del recinto sagrado de Tenochtitlan*, Mexico City 2002

D'Olwer 1987
Luis Nicolau D'Olwer, *Fray Bernardino de Sahagún 1499–1590*, Mauricio J. Mixco (trans.), Salt Lake City 1987

Orozco y Berra 1960
Manuel Orozco y Berra, *Historia Antigua y de la conquista de México*, Miguel León-Portilla (ed.), 4 vols, Mexico City 1960

Ortiz Ceballos 1990
Ponciano Ortiz Ceballos, *Las joyas del pescador: Museo Baluarte de Santiago*, Mexico City 1990
Ortiz Ceballos and Torres 1978
Ponciano Ortiz Ceballos and G. Manuel Torres, 'Dictamen judicial sobre las joyas de Río Medio, Municipio de Veracruz, México', Xalapa 1978

Pagden 1983
Anthony Pagden, 'The Savage Critic: Some European Images of the Primitive', in *The Yearbook of English Studies, 'Colonial and Imperial Themes'*, London 1983, pp. 32–45
Palacios 1918
Enrique Juan Palacios, 'La Piedra del Sol y el primer capítulo de la historia de México', *Memorias de la Sociedad Científica 'Antonio Alzate'*, vol. 38 (1918)
Pasztory 1983
Esther Pasztory, *Aztec Art*, New York 1983
Pauw 1771
Corneille de Pauw, *Recherches philosophiques sur les Americains*, 3 vols, London 1771
Paz 1970
Octavio Paz, *Posdata*, Mexico City 1970
Paz 1990
Octavio Paz, 'Introduction', in *Mexico: Splendors of Thirty Centuries*, exh. cat., Metropolitan Museum of Art, New York 1990
Peñafiel 1910
Antonio Peñafiel, *Destrucción del Great Temple de México antiguo y los monumentos encontrados en la ciudad, en las excavaciones de 1897 y 1902*, Mexico City 1910
Pérez de Ribas 1968
Andrés Pérez de Ribas, *My Life Among the Savage Nations of New Spain*, Tomas Antonio Robertson (trans.), Los Angeles 1968
Prescott (undated)
William H. Prescott, *History of the Conquest of Mexico*, New York (undated)
Prescott 1970
William H. Prescott, *Historia de la conquista de México, anotada por Don Lucás Alamán y con notas y esclarecimientos de Don José Fernando Ramírez*, Juan A. Ortega y Medina (ed.), Mexico City 1970

Ramírez 1846
José Fernando Ramírez, 'Descripción de cuatro lápidas monumentales conservadas en el Museo Nacional de México, seguida de un ensayo sobre su interpretación', in *Historia de la Conquista de William H. Prescott*, 2 vols, Mexico City 1846, pp. 106–24
Ramírez 1864
José Fernando Ramírez, 'Antigüedades mexicanas conservadas en el Museo Nacional', in *México y sus alrededores*, Mexico City 1864, pp. 48–57
Ramírez 2001
José Fernando Ramírez, 'Tira de la peregrinación mexicana', in *Obras*, Ernesto de la Torre Villar (ed.), 5 vols, Mexico City 2001
Raynal 1798
Guillaume-Thomas Raynal, *A Philosophical and Political History of the Settlements and Travels of the Europeans in the East and West Indies*, J.O. Justamond (trans.), 6 vols, 3rd edition, London 1798

Reyero 1978
Manuel Reyero, *Colección Prehispánica Fundación Cultural Televisa A.C.*, Paris 1978
Riva Palacio 1884–89
México a través de los siglos, Vicente Riva Palacio (ed.), 5 vols, Mexico City and Barcelona 1884–89
Robertson 1788
William Robertson, *The History of America*, 3 vols, 5th edition, London 1788
Robles Castellanos 2007
José Fernando Robles Castellanos, *Culhua Mexico, una revisión arqueo-etnohistórica del imperio de los mexica-tenochca*, Mexico City 2007
Ronan 1977
Charles E. Ronan, *Francisco Javier Clavijero S.J. (1731–1787). Figure of the Mexican Enlightenment*, Rome 1977
Rueda Smithers 1993
Salvador Rueda Smithers, 'De conspiradores y motógrafos: entre el mito, la historia y el hecho estético', *Revista Historias*, 29 (1993)

Sahagún 1950–82
Bernardino de Sahagún, *Florentine Codex: A General History of the Things of New Spain*, Arthur J.O. Anderson and Charles E. Dibble (ed. and trans.), 12 vols, Salt Lake City 1950–82
Sahagún 1956
Bernardino de Sahagún, *Historia general de las cosas de Nueva España*, 4 vols, Mexico City 1956
Sahagún 1977
Bernardino de Sahagún, *Historia General de las Cosas de Nueva España*, vol. III, Mexico City 1977
Sahagún 1979
Bernardino de Sahagún, *Códice Florentino: Historia general de las cosas de Nueva España*, 3 vols, Mexico City 1979
Sahagún 1993
Bernardino de Sahagún, *Primeros memoriales*, facsimile edition, Norman 1993
Sahagún 1997
Bernardino Sahagún, *Historia General de las Cosas de Nueva España*, 9th edition, Mexico City 1997
Sanders, Parsons and Santley 1979
William T. Sanders, Jeffrey R. Parsons and Robert S. Santley, *The Basin of Mexico: Ecological Processes in the Evolution of Civilization*, New York 1979
Saunders 1990
Nicholas J. Saunders, 'Tezcatlipoca: jaguar metaphors and the Aztec mirror of nature', in *Signifying animals: human meaning in the natural world*, Roy Geoffrey Willis (ed.), London 1990
Saunders 2001
Nicholas J. Saunders, 'A Dark Light: Reflections on Obsidian in Mesoamerica', *World Archaeology*, vol. 33, no. 2 (October 2001), pp. 220–36
Saville 1920
Marshall H. Saville, *The Goldsmith's Art in Ancient Mexico*, Museum of the American Indian, Heye Foundation, New York 1920
Saville 1922
Marshall H. Saville, *Turquoise Mosaic Art in Ancient Mexico*, Indian Notes and Monographs, no. 8, Museum of the American Indian, Heye Foundation, New York 1922
Saville 1925
Marshall H. Saville, *The Woodcarver's Art in Ancient Mexico*, Indian Notes and Monographs, no. 9, Museum of the American Indian, Heye Foundation, New York 1925
Schlesinger 1993
Roger Schlesinger, *Portraits from the Age of Exploration*, Urbana and Chicago 1993
Schlesinger and Stabler 1986
Roger Schlesinger and Arthur P. Stabler, *André Thevet's North America: A Sixteenth-Century View*, Kingston, Ontario 1986
Seler 1902
Eduard Seler, 'Das Pulquegefäss der Bilimek'schen Sammlung im k.k. naturhistorischen Hofsmuseum', *Annalen des k.k. naturhistorischen Hofsmuseums*, Vienna 1902
Seler 1960–61
Eduard Seler, *Gesammelte Abhandlungen zur Amerikanischen Sprach- und Altertumskunde*, 2nd edition, 5 vols, Graz 1960–61
Seler 1990–98
Eduard Seler, *Collected Works in Mesoamerican Linguistics and Archaeology* (translation of *Gesammetle Abhandlungen zur Amerikanischen Sprach- und Altertumskunde*, 1904), 6 vols, Culver City 1990–98
Serra Puche and Solís Olguín 1994
Mari Carmen Serra Puche and Felipe Solís Olguín (eds.), *Cristales y obsidiana prehispanícos*, Mexico City 1994
Serrato-Combe 2001
Antonio Serrato-Combe, *The Aztec Templo Mayor: A Visualization*, Salt Lake City 2001
Seville 1997
Felipe Solís Olguín and Martha Carmona, *Tesoros de México, oro precolombino y plata virreinal*, exh. cat., Fundación el Monte, Seville 1997
Sigüenza y Góngora 1960
Carlos de Sigüenza y Góngora, 'Teatro de virtudes políticas', in *Obras históricas*, José Rojas Garcíadueñas (ed.), Mexico City 1960
Siméon 1977
Rémi Siméon, *Diccionario de la lengua Náhuatl o Mexicana*, vol. XXI, Mexico City 1977
Smith 2003
Michael E. Smith, *The Aztecs*, 2nd edition, Oxford 2003
Smith and Heath-Smith 1980
Michel E. Smith and C.M. Heath-Smith, 'Waves of influence in Postclassic Mesoamerica? A Critique of the Mixteca-Puebla Concept', *Anthropology*, IV, vol. 2 (1980), pp. 15–50
Solís 1684
Antonio de Solís, *Historia de la Conquista de Mexico. Población y progresos de la América Septentrional, conocida por el nombre de Nueva España*, Madrid 1684
Solís 1704
Antonio de Solís, *Istoria della conquista del Messico, della popolazione, e de' progressi nell' America Settentrionale conosciuta sotto il nome di Nuova Spagna*, Brussels 1704
Solís Olguín 1976
Felipe Solís Olguín, *La escultura de Santa Cecilia Acatitlán*, Mexico City 1976
Solís Olguín 1990
Felipe Solís Olguín, 'Escultura antropomorfa, cabeza de guerrero-águila', in *Arte Precolombino de México*, Madrid 1990, pp. 108, 114–15

Solís Olguín 1991
Felipe Solís Olguín, *Gloria y fama mexica*, Mexico City 1991

Solís Olguín 1991b
Felipe Solís Olguín, *Tesoros artísticos del Museo Nacional de Antropología*, Mexico City 1991

Solís Olguín 1993
Felipe Solís Olguín, 'Aztekische Steinplastik', in *Die Sammlung vorspanischer Kunst und Kultur aus Mexiko im Museum für Völkerkunde, Berlin*, Veröffentlichung des Museums für Völkerkunde Berlin, n.s., 57; *Abteilung, Amerikanische Archäologie*, vol. 7, Berlin 1993

Solís Olguín 1998
Felipe Solís Olguín, *Tesoros Artísticos del Museo Nacional de Antropología*, Mexico City 1998

Solís Olguín 2004
Felipe Solís Olguín, *The Aztec Empire*, New York 2004

Solís Olguín 2004b
Felipe Solís Olguín, 'La Imagen de Ténoch en los monumentos conmemorativos de la capital azteca', in *Acercarse y mirar, homenaje a Beatriz de la Fuente*, María Teresa Uriarte and Leticia Staines Cicero (eds), Mexico City 2004, pp. 357–75

Solís Olguín and Carmona 2004
Felipe Solís Olguín and Martha Carmona, *Oro Precolombino de México*, Mexico City 2004

Solís Olguín and Carmona 1995
Felipe Solís Olguín and Martha Carmona, *El oro precolombino de México, colecciones mixteca y azteca*, Mexico City 1995

Solís Olguín and Morales Gómez 1991
Felipe Solís Olguín and David Morales Gómez, *Rescate de un rescate: colección de objetos arqueológicos de El Volador, Cuidad de México*, Mexico City 1991

Solís Olguín and Morales Gómez 1992
Felipe Solís Olguín and David Morales Gómez, 'La cerámica polícroma de Cholula, Puebla', in *Miniguía*, Mexico City 1992

Solís Olguín, Velázques and Velasco Alonso 2005
Felipe Solís Olguín, Verónica Velázques and Roberto Velasco Alonso, 'Cerámica polícroma de Cholula y de los otros Valles de Puebla', in *La gran pirámide de Cholula*, Mexico City 2005, pp. 79–129

Solís y Rivadeneira 1838
Antonio de Solís y Rivadeneira, *Historia de la conquista de Méjico*, Paris 1838

Soustelle 1961
Jacques Soustelle, *The Daily Life of the Aztecs on the eve of the Spanish Conquest*, Patrick O'Brian (trans.), London 1961, pp. 59–71

Soustelle 1969
Jacques Soustelle, *El arte del México antiguo*, Barcelona 1969

Spranz 1993
Bodo Spranz, *Los dioses en los Códices mexicanos del Grupo Borgia*, Mexico City 1993

Suárez de Peralta 1949
Juan Suárez de Peralta, *Tratado del descubrimiento de las Indias*, Mexico City 1949

Sullivan 1980
Thelma D. Sullivan, 'Tlatoani and Tlatocayotl in the Sahagún Manuscripts', *Estudios de Cultura Náhuatl*, vol. 14 (1980), pp. 225–39

Tait 1967
H. Tait, 'The Devil's Looking Glass: the Magical Speculum of Dr. John Dee', in *Horace Walpole: Writer, Politician and Connoisseur*, Warren Hunting Smith (ed.), New Haven 1967, pp. 195–212

Taube 1993
Karl A. Taube, 'The Bilimek Pulque Vessel: Starlore, calendrics, and cosmology of late Postclassic central Mexico', in *Ancient Mesoamerica*, vol. 1, no. 2 (1993), pp. 1–15

Taube 1993b
Karl A. Taube, *The Legendary Past: Aztec and Maya Myths*, London 1993

Tena Ramírez 1967
Felipe Tena Ramírez, *Leyes Fundamentales de México*, Mexico City 1967

Tenorio-Trillo 1996
Mauricio Tenorio-Trillo, *Mexico at the World Fairs. Crafting a Nation*, Berkeley and Los Angeles 1996

Thevet 1584
André Thevet, *Les vrais pourtraits et vies des hommes illustres grecz, latins, et payens, recueilliz de leurs tableaux, liures, medalles antiques, et modernes*, Paris 1584

Thevet 1671
André Thevet, *Histoire des plus illustres et scavans hommes de leurs siècles*, Paris 1671

Thomas 1993
Hugh Thomas, *The Conquest of Mexico*, London 1993

Todorov 1984
Tzvetan Todorov, *The Conquest of America: the Question of the Other*, Richard Howard (trans.), New York 1984

Torquemada 1975–83
Juan de Torquemada, *Los veinte y un libros rituales y Monarquía Indiana*, 3 vols (Seville 1615, Madrid 1723); 3rd edition, Miguel León Portilla *et al.* (eds), 7 vols, Mexico City 1975–83

Toscano 1944
Salvador Toscano, *Arte precolombino de México y de la América Central*, Mexico City 1944

Toussaint, Gómez de Orozco and Fernández 1990
Manuel Toussaint, Federico Gómez de Orozco and Justino Fernández (eds), *Planos de la ciudad de México. Siglos XVI y XVII*, Mexico City 1990

Townsend 1979
Richard Townsend, *State and Cosmos in the Art of Tenochtitlan*, Studies in Pre-Colombian Art and Archaeology, vol. 20, Dumbarton Oaks, Washington DC 1979

Townsend 1982
Richard F. Townsend, 'Malinalco and the Lords of Tenochtitlan', in *The Art and Iconography of Late Post-Classic Central Mexico*, Elizabeth H. Boone (ed.), Washington DC 1982, pp. 111–40

Townsend 1987
Richard F. Townsend, 'Coronation at Tenochtitlan', in Elizabeth H. Boone (ed.), *The Aztec Templo Mayor*, Washington DC 1987, pp. 371–409

Townsend 1992
Richard F. Townsend, 'The Renewal of Nature at the Temple of Tlaloc', in *The Ancient Americas, Art from Sacred Landscapes*, Chicago 1992, pp. 170–85

Townsend 1995
Richard F. Townsend, *The Aztecs*, London and New York 1995

Townsend 2000
Richard F. Townsend, *The Aztecs*, revised edition, London and New York 2000

Turin 1978
Africa America Oceania: Le Collezioni Etnologiche, Museo Civico d'Arte Antica, Turin 1978

Uchmany 1972
Eva Uchmany, *Motecuhzoma II Xocoyotzin y la conquista de México*, Mexico City 1972

Umberger 1981
Emily Umberger, *Aztec Sculptures, Hieroglyphs, and History*, Ph.D. dissertation, Columbia University, New York 1981

Umberger 1984
Emily Umberger, 'El Trono de Moctezuma', *Estudios de Cultura Náhuatl*, 17 (1984), pp. 63–87

Valero de García Lascuráin *et al.* 1994
Valero de García Lascuráin, Ana Rita, and Rafael Tena (eds), *Códice Cozcatzin*, Mexico City 1994

Valle 1994
Perla Valle (ed.), *Códice de Tepetlaoztoc (Códice Kingsborough). Estado de México*, Toluca 1994

Valle 1994b
Perla Valle (ed.), *Memorial de los indios de Tepetlaóztoc o Códice Kingsborough*, Mexico City 1994

Vargaslugo 1994
Elisa Vargaslugo, 'Comentarios sobre pintura y escultura del arte religioso novohispano', in *Tesoros del Museo Nacional de Historia en el Castillo de Chapultepec*, Mexico City 1994

Velasco Alonso 2007
Roberto Velasco Alonso, 'El Palacio de Moctezuma, Crónica de las Entrañas del Palacio Nacional', in *El Palacio Nacional de México*, Mexico City 2007, pp. 28–57

Vienna 1992
Das Altertum der Neuen Welt: Voreuropäische Kulturen Amerikas, Christian F. Feest and Peter Kann (eds), exh. cat., Museum für Völkerkunde, Vienna 1992

Vienna 1997
Gold und Silber aus Mexiko: Präkolumbisches Gold und koloniales Silber aus dem anthropologischen Nationalmuseum und anderen bedeutenden Sammlungen Mexikos, Wilfried Seipel (ed.), exh. cat., Kunsthistorisches Museum, Vienna 1997

Wake 2002
Eleanor Wake, 'Codex Tlaxcala: New Insights and New Questions', *Estudios de Cultural Náhuatl*, 33 (2002), pp. 91–140

Washington 1983
Art of Aztec Mexico: Treasures of Tenochtitlan, Henry B. Nicholson and Eloise Quiñones Keber (eds), exh. cat., National Gallery of Art, Washington DC 1983

Zantwijk 1963
Rudolph van Zantwijk, 'Principios Organizadores de los Mexicas: Una Introducción al Estudio del Sistema Interno del Régimen Azteca', *Estudios de Cultura Nahuatl*, vol. 2 (1963)

Zantwijk 1985
Rudolph van Zantwijk, *The Aztec Arrangement. The Social History of Pre-Spanish Mexico*, Norman 1985

Illustration acknowledgements

Half-title Detail of fig. 52. Bodleian Library, Oxford
Frontispiece Detail of cat. 130. Museo degli Argenti – Su concessione del Ministero per i Beni e le Attività Culturali
Contents page Museo Nacional de Antropología, CONACULTA–INAH (Jorge Vertiz)
p. 9 Detail of cat. 111. Museo de América, Madrid
Map, pp. 16–17 The Trustees of the British Museum (Paul Goodhead)
Fig. 1 Detail of fig. 28. Museo Nacional de Antropología, CONACULTA–INAH (Javier Hinojosa)
Fig. 2 Museo Nacional de Antropología, CONACULTA–INAH (Javier Hinojosa)
Fig. 3 Jorge Pérez
Fig. 4 Bodleian Library, Oxford
Fig. 5 Biblioteca Nacional de Antropología e historia, CONACULTA–INAH
Fig. 6 The Trustees of the British Museum (Paul Goodhead)
Fig. 7 Courtesy of the John Carter Brown Library at Brown University
Fig. 8 Real Academia de la Historia, Madrid
Fig. 9 The Trustees of the British Museum (Paul Goodhead)
Fig. 10 Museo del Templo Mayor, CONACULTA–INAH (Jorge Vértiz)
Fig. 11 Museo Nacional de Antropología, CONACULTA–INAH (Javier Hinojosa)
Fig. 12 © John Nakata/Corbis
Fig. 13 Biblioteca Nacional, Madrid
Fig. 14 Bibliothèque Nationale de France, Paris
Fig. 15 Courtesy of the John Carter Brown Library at Brown University
Fig. 16 The Trustees of the British Museum (Paul Goodhead)
Fig. 17 Courtesy Edward E. Ayer Collection, The Newberry Library, Chicago, Ayer 655.51 C* 1524d
Fig. 18 Firenze, Biblioteca Medicea Laurenziana, Med. Palat. 219, c.280v. Su concessione del Ministero per i Beni e le Attività Culturali.
Fig. 19 Bodleian Library, Oxford
Fig. 20 Firenze, Biblioteca Medicea Laurenziana, Med. Palat. 219, c.269v. Su concessione del Ministero per i Beni e le Attività Culturali.
Fig. 21 Firenze, Biblioteca Medicea Laurenziana, Med. Palat. 219, c.291r. Su concessione del Ministero per i Beni e le Attività Culturali.
Fig. 22 Firenze, Biblioteca Medicea Laurenziana, Med. Palat. 219, c.361v. Su concessione del Ministero per i Beni e le Attività Culturali.
Fig. 23 Detail of cat. 58. Museum für Völkerkunde Hamburg (photo. John Williams/The Trustees of the British Museum)
Fig. 24 Biblioteca Nacional, Madrid
Fig. 25 Jorge Pérez
Fig. 26 The Trustees of the British Museum (Jim Farrant)
Fig. 27 Detail of cat. 78. Museo Nacional de Antropología, CONACULTA–INAH (Jorge Vértiz)
Fig. 28 Museo Nacional de Antropología, CONACULTA–INAH (Javier Hinojosa)
Fig. 29 Bibliotheque de l'Assemblée nationale, Paris
Fig. 30 Museo Civica d'Arte Antica, Palazzo Madama, Turin (inv. 732)
Fig. 31 Bibliotheque Nationale de France, Paris
Fig. 32 Courtesy Museo de America, Madrid
Fig. 33 Firenze, Biblioteca Medicea Laurenziana, Med. Palat. 219, c.336r. Su concessione del Ministero per i Beni e le Attività Culturali.
Fig. 34 Firenze, Biblioteca Medicea Laurenziana, Med. Palat. 219, c.292v. Su concessione del Ministero per i Beni e le Attività Culturali.
Fig. 35 Museo Nacional de Antropología, CONACULTA–INAH (Jorge Vértiz)
Fig. 36 Jorge Pérez
Fig. 37 Museo de Arte Moderno, Mexico City, Mexico / photo. Arturo Osorno INBA / The Bridgeman Art Library
Fig. 38 Museo Nacional de Antropología, CONACULTA–INAH (Jorge Vértiz)
Fig. 39 The Trustees of the British Museum (Paul Goodhead)
Fig. 40 Patrimonio Nacional, Madrid
Fig. 41 Reproduced by kind permission of the Ministero per i Beni e le Attività Culturali, Italy / Biblioteca Nazionale Centrale, Firenze. This image cannot be reproduced in any form without the authorization of the Library, the owner of the copyright.
Fig. 42 Museo del Templo Mayor, CONACULTA–INAH (Michel Zabé)
Fig. 43 Bibliothèque Nationale de France, Paris
Fig. 44 Bibliothèque Nationale de France, Paris
Fig. 45 Bibliothèque Nationale de France, Paris
Fig. 46 Biblioteca Medicea Laurenziana, Firenze, Med. Palat. 218, c.35r. Su concessione del Ministero per i Beni e le Attività Culturali.
Fig. 47 The Trustees of the British Museum (Paul Goodhead)
Fig. 48 Courtesy National Museum of the American Indian, Smithsonian Institution. N14709, Carmelo Guadagno (back view). T163621 David Heald (front view).
Fig. 49 Museo Nacional de Antropología, CONACULTA–INAH (Jorge Vértiz)
Fig. 50 The Trustees of the British Museum (Paul Goodhead)
Fig. 51 The Trustees of the British Museum
Fig. 52 Bodleian Library, Oxford
Fig. 53 Bodleian Library, Oxford
Fig. 54 The Trustees of the British Museum (Paul Goodhead). After Solís Olguín 2004.
Fig. 55 Firenze, Biblioteca Medicea Laurenziana, Med. Palat. 219, c.283v. Su concessione del Ministero per i Beni e le Attività Culturali.
Fig. 56 © Charles and Josette Lenars / CORBIS
Fig. 57 Firenze, Biblioteca Medicea Laurenziana, Med. Palat. 219, c.278r. Su concessione del Ministero per i Beni e le Attività Culturali.
Fig. 58 Museo de Antropología e Historia del Estado de México, Toluca (Jorge Vértiz)
Fig. 59 Firenze, Biblioteca Medicea Laurenziana, Med. Palat. 219, c.370v. Su concessione del Ministero per i Beni e le Attività Culturali.
Fig. 60 Firenze, Biblioteca Medicea Laurenziana, Med. Palat. 219, c.371r. Su concessione del Ministero per i Beni e le Attività Culturali.
Fig. 61 Image courtesy of the Kislak Collection, Rare Book Division, Library of Congress
Fig. 62 Biblioteca Nacional, Madrid
Fig. 63 The Trustees of the British Museum (Paul Goodhead)
Fig. 64 Firenze, Biblioteca Medicea Laurenziana, Med. Palat. 219, c.262v. Su concessione del Ministero per i Beni e le Attività Culturali.
Fig. 65 Firenze, Biblioteca Medicea Laurenziana, Med. Palat. 219, c.263r. Su concessione del Ministero per i Beni e le Attività Culturali.
Fig. 66 Biblioteca Nacional, Madrid
Fig. 67 Biblioteca Nacional, Madrid
Fig. 68 Glasgow University Library
Fig. 69 Museo Nacional de Historia, Castillo de Chapultepec, CONACULTA–INAH (Jesús López)
Fig. 70 Museo Nacional de Historia, Castillo de Chapultepec, CONACULTA–INAH (Jorge Vértiz)
Fig. 71 Firenze, Biblioteca Medicea Laurenziana, Med. Palat. 220, c.443r. Su concessione per i Beni e le Attività Culturali.
Fig. 72 Firenze, Biblioteca Medicea Laurenziana, Med. Palat. 220, c.447v and c.448r. Su concessione del Ministero per i Beni e le Attività Culturali.
Fig. 73 Biblioteca Nacional, Madrid
Fig. 74 © and courtesy Museo de la Basilica de Guadalupe, Mexico City (Manuel Zavala y Alonso)
Fig. 75 The Trustees of the British Museum
Fig. 76 Firenze, Biblioteca Medicea Laurenziana, Med. Palat. 220, c.460v. Su concessione del Ministero per i Beni e le Attività Culturali.
Fig. 77 © Glasgow University Library, Scotland / The Bridgeman Art Library
Fig. 78 Museo Nacional del Virreinato, CONACULTA–INAH (Jorge Vértiz)
Fig. 79 Photo. The Trustees of the British Museum
Fig. 80 Courtesy of the Rare Book Division of the Library of Congress
Fig. 81 Photo. The Trustees of the British Museum
Fig. 82 Courtesy Museo Nacional de Arte, Mexico
Fig. 83 Photo. The Trustees of the British Museum
Fig. 84 © (351618) CONACULTA–INAH.SINAFO.FN.MÉXICO
Fig. 85 Photo. Raul Grigelmo
Fig. 86 © 2003 Photo Art Resource / Scala, Florence
Fig. 87 © 2009 Photo Art Resource / Scala, Florence
Fig. 88 © 2009 University of Hawaii
Fig. 89 © Proyecto Templo Mayor (INAH)
Fig. 90 © Proyecto Templo Mayor (INAH)
Fig. 91 Reproduced by kind permission of the Ministero per i Beni e le Attività Culturali, Italy / Biblioteca Nazionale Centrale, Firenze
Figs 92–98 Museo del Templo Mayor, CONACULTA–INAH (Jesús López)
Glossary of glyphs (p. 300) The Trustees of the British Museum (Paul Goodhead)

Cat. 1 Museo del Templo Mayor / photo. Michel Zabé / AZA INAH / The Bridgeman Art Library

governor of New Spain 234–35, 256, 277–78
identified with Quetzalcoatl 224–25, *225*, 291
later evaluations of 261, 263, 264, 290–91
letters to Charles V 45, 91, 227, 259, 261, 281
medal of 245, *245*
Moctezuma's treatment of 223–27, *223*, 269, 292–93
route followed by *221*
standard of 244, *244*
tribute paid to 277–78
cosmology 128–29
five Suns 68, *69*, *83*, 84, 128–29, 165, 172
moiety system 131
Templo Mayor 132–6
cotton 184, 187, 191
council of elders 31, 56
Covarrubias, Luis *20*
Coxcoxtli 27, 29
Coyoacan 35, 45
Coyolxauhqui (moon goddess) 33, 36–37, *37*, 38, 49, 112, 133–34, 168, 239
cozoyahualolli 21, 82, 85
craft specialists 67, 187, *194–95*, 213
creation myth 128
cremation 50–51, 70–71, 103, 294
crossroads 68
cuachic 86
Cuauhnahuac 33
Cuauhtemoc 23, 233, 234, 244, 253, 264–65, 267, 269, 271
modern evaluations of 288, *289*, 290–91
cuauhtl ocelotl 86, 96, 146
cuauhxicalli 42, *42*, 153, *153*, 175, *175*, 176
of Moctezuma Ilhuicamina 36
Cuba 218
Cuetlaxtla 194
Cuextlan 59
Cuitlahuac 33, 226, 231, 233
Culhua 20
Culhuacan 20, 27, 29, 31, 33, 44, 139
currency, forms of *194–95*, 209, 212

D

dance 67, 93, 110, 112, *192*, 201
Dee, John 91
diadem 21, 31, *57*, 59, *59*, 60, 65, 70, *70*, 72, 80, 83, 85, 149, 156, *156*, 180
Moctezuma's glyph 80
Díaz del Castillo, Bernal 61, 64, 65–66, 79, 86, 88–89, 120, 226, 231, 243, 252, 281
diet 88–90, 184
see also agriculture
diseases, European 230, 233, 234–35, 259, *259*
divination *see* prophesy and divination
Doña Marina *see* Malintzin
drums 95, 110, 111, 191, *192–93*, 200–1, *200–1*
Dryden, John
The Indian Emperor 283
ducks 99, *99*
Durán, Diego
History of the Indies of New Spain see Codex Durán

E

eagle warriors 86, 96, 146, 191, *191*, 200, 202, *202*
House of Eagles 39

eagles 44, 59, 86, 102, *102*, 176, 184, 202
cuauhxicalli 36, 42, *42*, 153, *153*, 175, *175*, 176
down balls 149, 153, 167, *167*, 206, *206*, 238
eagle helmet *183*, 202, *202*
eagle labret 87, *87*
Tenochtitlan foundation myth *24*, 29, 43, 44, *44*, 130–31, *131*
ear-spools 49, 59, 70, 80, 100–1, *100–1*, 102–3, *102*, 110, 163, 180, *299*
earthquakes 153, 187
economy 182, 184–87
education 86
in New Spain 258
ehecacozcatl 163
ehecahuictli 163
Ehecatl-Quetzalcoatl (wind god) 93, 96, 99, 102–3, *102*, 128, 143, 163, *260*, 276
El Volador 155
embroidery 49
empire, expansion 184–85, *184*, *186*, 192
encomenderos system 234, 235, 277–78
enconchados 246, *247–48*
entertainment 66, 67, 90–1

F

facial hair 212
famines 36, 133, 141, 187
fans 106, *106*, 194
fasting cords 80
feathered serpent *see* Quetzalcoatl
featherwork 67, 87–8, 106–7, *107*, 184, 187, 194–95, *194–95*
cozoyahualolli 21
fans 106, *106*, 194
shields *87*, 88, 108, *109*, *194–95*, 195
female pose 49, *49*
Fifth Sun 68, *83*, 84, 128–29, 143, 146, 202–3, 292
firearms, Spanish use of 223, 233
five suns 68, *69*, *83*, 84, 128–29, 165, 172
flayed skins 118, 169
worn in battle and by priests 88, 115
worn by Xipe Totec *142–43*
Flint (year-bearer) 44, 140
Florentine Codex *64*, 66, 67, 111, 139, *139*, 191, *192*, 194, *195*, 212, 220–1, *222*, 224, *230*, 232, 259
flower wars 36, 190–1, 225
flowers 90, *90*
flutes 100–12, *110–12*, 138, 191
food supply 66, 184, 191
Frías, Heriberto 290–91
funeral rites 90, 99, 103, 214, 294
funerary caskets 70–71, *70–71*, 83
funerary urns 50–51, *50*, *51*, 208

G

Gamio, Manuel 271–72
geometry 22
gladiatorial sacrifices 187, 191
gods
Chalchiuhtlicue (goddess of groundwater) *see* Chalchiuhtlicue
Chicomecoatl (maize goddess) 49
Cihuacoatl (earth goddess) 35, 75

Cihuateotl (goddess of childbirth) 49
Cinteotl (maize god) 110
Coatlicue (earth goddess) *see* Coatlicue
Coyolxauhqui (moon goddess) *see* Coyolxauhqui
Ehecatl-Quetzalcoatl (wind god) *see* Ehecatl-Quetzalcoatl
Huehueteotl (god of fire) 94, 180, 212
Huitzilopochtli (god of sun and war) *see* Huitzilopochtli
Ilamatecuhtli 110, 153
Mayahuel 36
Mictlantecuhtli (god of death) 39, 50, 168–69, *168–69*
Mixcoatl (warrior-god) 205
Nanauatzin 143, 203, 214
Ochpaniztle (maize goddess) 110
Ome Tochtli (god of drinking) 116
Pahtecatl (moon god of *pulque*) 297
Quetzalcoatl *see* Quetzalcoatl
ritual impersonators 90, 107, 111, *138*, 158, 170, *171*, 208
Tecuciztecatl 143
Tezcatlipoca (god of fate and destiny) *see* Tezcatlipoca
Tlaloc (rain god) *see* Tlaloc
Tlaltecuhtli (earth goddess) *see* Tlaltecuhtli
Tonatiuh (sun god) *see* Tonatiuh
Tzitzimitl 168
Xilonen (maize goddess) 49
Xipe Totec (god of war) 81, *81*, 88, 93, 110, 115, *142–43*
Xiuhtecuhtli (god of turquoise and fire) *see* Xiuhtecuhtli
Xochipilli (prince of flowers; god of music, dance and song) *see* Xochipilli
Xochipilli-Macuilxochitl 276
Xolotl 122, 163, 297
gold 95, 184, 187
disc (*tezcacuitlapilli*) 213, *213*
jewellery *see* jewellery
lost-wax technique *92–97*, *93–97*, 102–3, 105, *105*, 276
Spanish ingot 276, *276*
Spanish quest for 223, 229, 234, 276–77, *276–77*
goldsmiths 67, *67*
Gómara, Francisco López de 226, 229, 261, 276, 281
González, Juan 252
González, Miguel 246, 252
granaries 66
Great Pyramid *see* Templo Mayor
greenstone 54, 76, 95, 101, 156, *156–57*, 172, 184, 187
carving of Tezcatlipoca *166–67*, 167
casket 148–49, *148–51*
figure of Tlaloc 210, *210*
heart 43, *43*
Huitzilopochtli 159, *159*
jewellery 95, *95*, 98, *98*, 101, *101*, 216, *216*
Mezcala figures 211, *211*
Quetzalcoatl *162–63*, 163
Grijalva, Juan de 218, 220
Guerrero 187, 211, 212